SOJOURNING
FOR FREEDOM

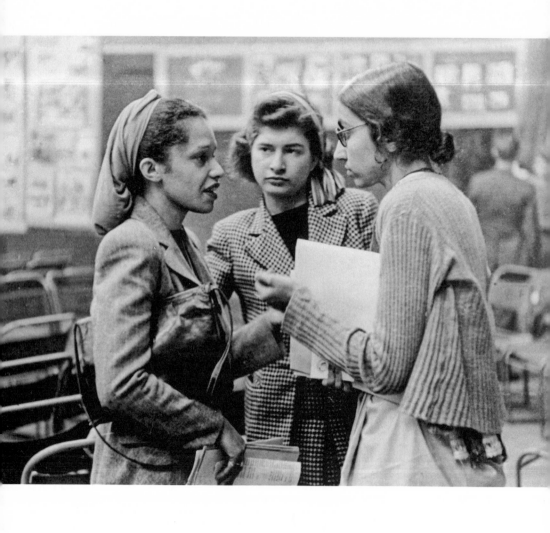

SOJOURNING FOR **FREEDOM**

Black Women, American Communism,

and the Making of Black Left Feminism

Erik S. McDuffie

Duke University Press Durham and London 2011

© 2011 Duke University Press

All rights reserved

Printed in the United States of America on acid-free paper ∞

Designed by Heather Hensley

Typeset in Minion Pro by Tseng Information Systems, Inc.

Library of Congress Cataloging-in-Publication Data appear
on the last printed page of this book.

For my parents,
James and Marion McDuffie;

my wife, Marlah;

and our children, Amaya-Soledad
and Amir Wendell Robeson

In loving memory of

Margaret and Clifford Chandler,
maternal grandparents;

Annie Lou McDuffie,
paternal great-grandmother;

Marian Stanley,
maternal great-grandmother;

and Dorothy Weaks,
great-aunt

CONTENTS

ix Acknowledgments

xiii Abbreviations

1 Introduction

25 **Chapter 1** Black Communist Women Pioneers, 1919–1930

58 **Chapter 2** Searching for the Soviet Promise, Fighting for Scottsboro and Harlem's Survival, 1930–1935

91 **Chapter 3** Toward a Brighter Dawn: Black Women Forge the Popular Front, 1935–1940

126 **Chapter 4** Racing against Jim Crow, Fascism, Colonialism, and the Communist Party, 1940–1946

160 **Chapter 5** "We Are Sojourners for Our Rights": The Cold War, 1946–1956

193 **Chapter 6** Ruptures and Continuities, 1956 Onward

221 Notes

261 Bibliography

297 Index

ACKNOWLEDGMENTS

..

There are so many people I would like to thank. Writing a book on black women and the U.S. Communist Party has been a challenging exercise— and at times an intellectually humbling and emotionally painful one. When I started this project more than a decade ago, there were few books and archival collections related to black women radicals. Plus, there were only a handful of articles on this topic. Today, things have changed. This book joins a growing body of exciting scholarship on black women's radicalism.

Without question, the most exciting aspect of this project has been getting to know my subjects, in particular Dorothy Burnham, Esther Cooper Jackson, and her late husband, James E. Jackson Jr. They literally welcomed me into their homes and families. Over the years, they generously shared their memories and personal papers with me. Getting to know them not only broadened my understanding of black women's involvement in the American Left; they also helped me mature intellectually and emotionally. Any oversights in telling their stories are my own.

This book owes a tremendous debt to archivists and librarians across the United States. I am especially thankful to Randall Burkett and Elizabeth Chase at Emory University's Manuscript, Archives, and Rare Book Library, Diana Lachatanere and Steven G. Fullwood at the Schomburg Center for Research in Black Culture, and Joellen El Bashir and Ida E. Jones at the Moorland-Spingarn Research Center for their immeasurable assistance and accommodation. I am grateful to Michael Nash, Erika Gottfried, and Peter Filardo at the Tamiment Library, as well as Thomas Weissinger and

Mary Stuart at the University of Illinois History, Philosophy, and Newspaper Library for their professionalism and acts of kindness. In London, Donald Hinds and members of the Claudia Jones Organisation shared their warm memories of Claudia Jones with me.

Two grants from the University of Illinois Research Board provided much needed release time from teaching and research support. Travel grants through the Research Board (Illinois) allowed me to present papers drawn from the book at numerous domestic and international conferences. This project benefited greatly from the cogent comments and suggestions offered by colleagues at biennial meetings of the Association for the Study of the Worldwide African Diaspora (ASWAD) in Evanston, Illinois; Rio de Janeiro; Barbados; and Accra, Ghana. Additionally, I wish to thank the teachers and day-care workers who taught my children and whose labor provided invaluable time for me to write, research, and teach.

I would like to thank my colleagues in the Department of African American Studies and the Department of Gender and Women's Studies, in particular Theresa Barnes, Ruth Nicole Brown, C. L. Cole, Karen Flynn, Samantha Frost, Pat Gill, Ronald L. Jackson II, Jacque Khan, Clarence Lang, Cris Mayo, Chantal Nadeau, Fiona Ngo, Mimi Nguyen, Marc Perry, Sarah Projansky, Siobhan Somerville, and Sharra Vostral. I should mention that Cole, Siobhan, and Sarah have been wonderful mentors and friends.

Various chapters and parts of the chapters have benefited greatly from the careful reading and attention of and conversations with Rosalyn Terborg-Penn, Barbara Ransby, Ula Taylor, Rhonda Y. Williams, Ray Fouché, Elsa Barkely Brown, Barbara Bair, Robbie Lieberman, Merle Bowen, Michael Gomez, Carole Boyce Davies, Angela Davis, Bettina Aptheker, Ruthie Wilson Gilmore, David Roediger, Tracy Denean Sharpley-Whiting, James Barrett, Antoinette Burton, James Smethurst, Jessica Millward, Orlando Plaza, Brian Purnell, Minkah Makalani, Carol Anderson, Cheryl Hicks, Deborah Thomas, Celia Naylor, Fanon Che Wilkins, Komozi Woodard, Jeanne Theoharis, Dayo Gore, Premilla Nadasen, Jean Allman, Kirstie Dorr, Mark Solomon, Allison Blakely, Michael Anderson, Abebe Zegeye, Sarah Clarke Kaplan, Marc Goulding, Mireille Miller-Young, Rachel Scharfman, Joy James, Brian Dolinar, Mark Naison, Damion Thomas, Diane Pinderhaus, Gilberto Rosas, Joshua Guild, Robeson Taz P. Frazier, Seth Markle, and Joyce Moore Turner. I would like to thank my graduate research assistants, Perzavia Praylow and Kerstin Rudolph, who diligently combed microfilm

and local archives for me. Virginia Janik, Aprel Thomas, Shirley Olson, and David Ivy provided inestimable administrative assistance for this project.

I am especially indebted to Gerald Horne. Gerald's brilliance and generosity are legendary. He graciously agreed to read an early, unwieldy draft of the manuscript. His cogent comments helped me condense and clarify my ideas. Similarly, Eileen Boris provided insightful editorial suggestions to earlier versions of chapters that helped me present a more polished manuscript.

To my dissertation advisor, Robin D. G. Kelley, I am deeply obligated. Also, I thank Kenneth Kusmer and Bettye Collier-Thomas, who instructed me while I was a graduate student at Temple University. The idea for this project originated in Bettye Collier-Thomas's graduate seminar class on African American women's history during the Progressive Era in the fall of 1997.

At Duke University Press, Valerie Millholland has been an exemplary editor. Ever enthusiastic about this project, her support helped me weather the "pain of writing a book," as she put it. Miriam Angress and Gisela Fosado were also extremely helpful in moving this project toward completion and mollifying my anxiety. The anonymous readers offered insightful comments on how to improve the manuscript. Significant portions of chapter 5 originated in an article published by the *Radical History Review* 101 (Spring 2008). Also, portions of chapter 4 and chapter 6 appeared in Dayo F. Gore, Jeanne Theoharis, and Komozi Woodard's edited anthology, *Want to Start a Revolution? Radical Women in the Black Freedom Struggle* (New York University Press, 2010).

Support and encouragement have come from many quarters, but I take special note of dear friends and family. Orlando and Jeanette Plaza, Brian Purnell and Leana Amaez, Anne and Clarence Taylor, and Diana Foxwell put me up and fed me whenever I was in New York and Washington, conducting archival research. Adrianna Bohm, Mary Stricker, and Tracy Romans always extended a warm welcome when my family and I returned to Philadelphia. Thank you, Kristin Tennant, our first friend in Champaign-Urbana, for copyediting portions of the manuscript. I am forever grateful to my sister and comrade Aishah Shahidah Simmons, the director of the brilliant documentary film, *No! The Rape Documentary*, for passionately supporting my work and loving my family. My parents, Jim and Marion McDuffie, have been my most influential teachers. From an early age, they discussed history and politics with me and took me around the world. More recently, they fre-

quently traveled from Ohio to Illinois to help provide childcare. My aunts, Rose Ann Chandler, Elizabeth Howell, and Gwendolyn Chandler; my uncle Donald Chandler; my cousins, Ronald Howell and Donald Chandler Jr.; and my in-laws, Jessie and Paul Loftland, have provided tremendous emotional support and encouragement over the years for which I will always be grateful.

Thanks to my children, Amaya-Soledad and Amir Wendell Robeson, for their love and patience in helping "Daddy finish his book," as Amaya frequently said. There are portions of this book that I literally do not remember writing due to child-care–induced sleep deprivation. While I certainly do not recommend writing a book while juggling the busy demands of academe and raising two young children far from family, I would not have had it any other way.

I must thank my wife, Marlah, for her patience, love, and support in helping me finish this book. She is my best friend, soul mate, and inspiration. Given that this project began more than twelve years ago, it has often felt like an unwanted house guest who has long overstayed its welcome in our lives. Indeed, writing this book has not been easy. There is nothing that I could possibly write that would make up for lost time that I wish I had spent with her.

For everything else, I am deeply grateful to God and the ancestors.

ABBREVIATIONS

AA	*Afro-American* (Baltimore)
ABB	African Blood Brotherhood
AFL	American Federation of Labor
AN	*Amsterdam News* (New York)
ANLC	American Negro Labor Congress
AYC	American Youth Congress
AYD	American Youth for Democracy
AWD	*Atlanta Daily World*
CAA	Council on African Affairs
CAW	Congress of American Women
CD	*Chicago Defender*
CIO	Congress of Industrial Organizations
Comintern	Communist International
CPA	Communist Political Association
CPUSA	Communist Party, USA
CRC	Civil Rights Congress
DW	*Daily Worker*
DWU	Domestic Workers Union
FBI	Federal Bureau of Investigation
FO	*Fraternal Outlook*
FR	*Freedom*
FSAA	Records Federal Surveillance of Afro-Americans (1917–1925) Records
HDH Papers	Hermina Dumont Huiswoud Papers
HL	*Harlem Liberator*
HTL	Harlem Tenants League
ILD	International Labor Defense

ITUC-NW	International Trade Union Committee of Negro Workers
IWO	International Workers Order
LSNR	League of Struggle for Negro Rights
LTP Papers	Louise Thompson Patterson Papers
NAACP	National Association for the Advancement of Colored People
NAARPR	National Alliance against Racial and Political Repression
NACW	National Association of Colored Women
NC	*Negro Champion*
NCNW	National Council of Negro Women
NLPCW	National League for the Protection of Colored Women
NMU	National Maritime Union
NNC	National Negro Congress
NO	*New Order*
NTWIU	Needle Trades Workers Industrial Union
NUCFAD	National United Committee to Free Angela Davis
NW	*Negro World*
NWC	National Women's Commission
NWP	National Woman's Party
NYA	*New York Age*
NYT	*New York Times*
PA	*Political Affairs*
PC	*Pittsburgh Courier*
PO	*Party Organizer*
PV	*People's Voice*
RA	The Russian State Archive of Social and Political History (RGASPI)
SCHW	Southern Conference for Human Welfare
SNCC	Student Nonviolent Coordinating Committee
SNYC	Southern Negro Youth Congress
SPA	Socialist Party of America
TL	*The Liberator*
TWWA	Third World Women's Alliance
UNIA	Universal Negro Improvement Association
WCEJ	Women's Committee for Equal Justice
WFDY	World Federation of Democratic Youth
WIDF	Women's International Democratic Federation
WP	Workers Party
WPA	Works Progress Administration
YCL	Young Communist League
YWCA	Young Women's Christian Association

INTRODUCTION

..

Over the whole land, Negro women meet this triple exploitation—
as workers, as women, as Negroes.

LOUISE THOMPSON, "TOWARD A BRIGHTER DAWN"

If black women were free, it would mean that everyone else would
have to be free since our freedom would necessitate the destruction
of all the systems of oppression.

COMBAHEE RIVER COLLECTIVE STATEMENT, 1977

On 3 June 1935, "flying squads" of black women and children defiantly
marched down Harlem's 125th Street between Seventh and Eighth avenues,
the neighborhood's main commercial thoroughfare. They were one thousand
strong. Chanting "Prices of meat must come down!" they demanded a 25
percent reduction in meat prices. Protestors held spontaneous street corner
meetings about high-priced food and other pressing community concerns
around high unemployment, bad housing, and inadequate social services.
They meant business. Groups of women darted into white-owned grocery
stores, confronting startled white merchants about why they sold high-
priced, low-quality food to their black clientele. The demonstration was suc-
cessful. Later that evening almost fifty stores agreed to immediately reduce
food prices by 25 percent. The press in Harlem and within the U.S. Commu-
nist Party (CPUSA) reported this impressive victory. *New Masses* magazine,
which was affiliated with the Party, lauded these women's apparent working-
class militancy, calling the action the "Revolt of the Housewives."[1]

By any measure, the protest vividly symbolized the CPUSA's ability to garner mass support and mobilize Harlem women at the grass-roots level around issues of survival and sustenance during the depths of the Depression. This demonstration also highlighted the key role black Communist women played in leading leftist movements. Much of this protest's success can be traced to Bonita Williams, a charismatic, working-class Communist from the Caribbean who headed Harlem Action Committee against the High Cost of Living, a group affiliated with the CPUSA. Her diligent pre-protest efforts gained broad-based community support for the action. Members of Marcus Garvey's Universal Negro Improvement Association (UNIA), the black nationalist African Patriotic League, the Consolidated Tenants League, and the Communist-led League of Struggle for Negro Rights, as well as scores of politically unaffiliated working-class Harlem women, intermingled in the protest. The agreement with store owners brought Harlem Communists widespread praise in the community. Williams was elated.[2] The Party's official newspaper, the *Daily Worker*, quoted Williams: "Because of the unemployment and misery, the women are rallying rapidly to our fight against the high prices [of food]."[3]

Williams's comments succinctly captured the protestors' very practical motivations for taking part in these actions; they also shed light on her radical political outlook. For her, the Communist Party represented a powerful site for realizing black women's freedom, dignity, and respect. From her activism and her own firsthand experiences, she knew how high unemployment, homelessness, police brutality, de facto segregation, poor social services, hunger, and the high cost of living ravaged Depression-era Harlem. The global depression hit black women and their families particularly hard. For the next several years, Williams continued organizing in Party-affiliated groups around survival issues. Linking them to global struggles against fascism, white supremacy, and colonialism, she recognized black women as the gauge by which to measure democracy in the United States and globally.[4]

Williams is one of several black women radicals whom I profile in this book. They actively participated in movements affiliated with the CPUSA during the Old Left period, bookended by the Russian Revolution in 1917 and by Soviet premier Nikita Khrushchev's denunciation of Stalinist atrocities in 1956. Black women community organizers, social workers, artists, domestic workers, teachers, and writers enlisted in the Old Left Communist Party because they saw it as a powerful movement with real and imag-

ined links to the global political stage. Through the Party, they advanced black liberation, women's rights, decolonization, economic justice, peace, and international solidarity. The key figures in this story, who are covered at length here along with black male and white female and male Communists, are Audley "Queen Mother" Moore, Louise Thompson Patterson, Thyra Edwards, Bonita Williams, Williana Burroughs, Claudia Jones, Esther Cooper Jackson, Beulah Richardson (Beah Richards), Grace P. Campbell, Charlene Mitchell, and Sallye Bell Davis.[5] Trailblazing activists and theoreticians, these black women gained reputations as leaders within the global Communist Left.[6] I focus on their work in Harlem, the epicenter of the Communist Party's efforts in building national inroads into African American communities during the Old Left period. But I also examine their activism in Chicago and Birmingham, Alabama, and analyze their international travels to the Soviet Union and to Spain during its violent civil war during the late 1930s. Chronicling their varied, complex journeys through the Communist Left provides a theoretical and empirical template for appreciating how the international Left served as a key site where black women in the United States forged an innovative radical black feminist politics during the early and mid-twentieth-century that laid the groundwork for the black feminism of the 1970s.

A Thesis

mid 20th century communism

Black Left Feminism

By tracing black women radicals' lives, this book recovers "black left feminism," a path-breaking brand of feminist politics that centers working-class women by combining black nationalist and American Communist Party (CPUSA) positions on race, gender, and class with black women radicals' own lived experiences. As coined by the literary scholar Mary Helen Washington, the term "black left feminism" describes the post–World War II literary work of black women radicals.[7] In this book, I draw on, recast, and use this term as a conceptual framework for recovering a distinct radical black feminist politics and subject position forged by a small community of black women in the Communist Left during the Old Left period. Arguably, they constituted the most radical group of black women in the United States and globally during the mid-twentieth century. As I will show, the Communist Left served as a principal site and viable alternative for black women radicals to agitate for black freedom and black women's dignity outside of women's clubs, the church, and civil rights and black nationalist groups. "Black left

feminism" is useful for critically and broadly examining the gender, race, class, and sexual politics within black radicalism, American Communism, and U.S. women's and transnational women's movements from the 1920s through the 1950s and beyond. Black left feminism also provides a lens for appreciating the contours of twentieth-century black feminism and intergenerational linkages between black women of the Old Left and black feminists of the 1960s and 1970s.

Black left feminists' key historical significance rested in their formulation of a theory of "triple oppression." Emphasizing the connections among racial, gender, and class oppression, the theory posited that the eradication of one form of oppression requires the concurrent dismantlement of all types of oppression. This conceptual framework, now referred to by feminist scholars as intersectionality, is most commonly associated with black feminism of the 1970s, arguably most powerfully articulated in the black socialist feminist manifesto of 1977, the Combahee River Collective Statement.[8] However, I show how black Communist women were the first to explicitly articulate this theoretical paradigm.

By analyzing the relationship between race, gender, and class, black left feminists countered prevailing assumptions within the CPUSA and the black Left that constructed the "worker" as a white male factory laborer, the "working woman" as white, and the shop floor as the determinant of class consciousness. Instead, black women in the CPUSA recognized how black women's employment as domestics in white women's homes, their subjugation to racialized sexual violence and the denigration of their bodies and reputations by their oppressors, and the intractable issues facing diasporic communities' very survival were critical in shaping black women's materiality and consciousness. Given black women's location at the interstices of multiple oppressions, black left feminists charged that black women across the African diaspora, not white working-class men, represented the vanguard for transformative change globally. In doing so, black women radicals attempted to rethink Marxism-Leninism and re-center the Communist Left by advancing black working-class women's concerns as central, not peripheral, to black and women's liberation, and the world revolution. For these reasons, black Communist women devoted special attention to organizing and protecting black working-class women and to forging transnational ties of political solidarity with women across the black diaspora and beyond.[9]

Although I use the term "black left feminism," my subjects would prob-

ably not have self-identified as "feminists." (In fact, later in life, after the advent of the modern women's movement, some vocally rejected the term.) Communists during the Old Left period reviled "feminism" as bourgeois and separatist, associating it with the self-identified feminists of the National Woman's Party (NWP). Pursuing a legalistic strategy for women's equality, the NWP agitated against protective legislation and for the Equal Rights Amendment beginning in 1923. By the 1940s, the NWP had become increasingly conservative, anti-Communist, racist, and anti-Semitic. Not surprisingly, Communists wanted nothing to do with this type of feminism.[10]

Nonetheless, naming them as feminists makes analytical sense. They can be called "feminists" because they understood gender, race, and class in intersectional terms and as interlocking systems of oppression. Because black Communist women were convinced that black women possessed a unique standpoint, their work in the Party exemplified an awareness of black women's "multiple consciousness."[11] While calling for self-determination for black people globally, black Communist women nonetheless challenged the CPUSA's masculinist articulations of what it termed the "Negro Question" and the agendas and sexist practices of Communist and non-Communist black male leaders.[12] Black women radicals took seriously the CPUSA's Marxist-Leninist approaches to what it called the "Woman Question." Influenced both by Soviet family policy and traditions of black women's community leadership, black Communist women demanded what the historian Kim Butler has described as "full freedom": exercising all the rights and privileges of first-class citizenship, with special concern for the protection of black women's bodies, rights, and dignity.[13]

The activism of black Communist women at times resembled that of their counterparts in church, women's clubs, and the black nationalist Garvey movement. Like them, black left feminists resourcefully pursued social justice and developed global visions in organizational settings that were not always responsive to their needs. Agitating on multiple fronts and in multiple communities, domestically and internationally, black Communist women often practiced a pragmatic, coalitional approach for political organizing with ideologically divergent black and non-black organizations and people.[14] Indeed, black left feminists saw no contradiction in pursuing interracial, left-wing, separatist, liberal, local, and internationalist political strategies, often simultaneously. They focused on winning tangible victories for underserved, disfranchised black communities and workers, and

for victims of social injustice and racial violence, particularly black female survivors of interracial sexual assault. Foreshadowing U.S. feminists of the 1970s, black Communist women understood the idea that "the personal is political." Black left feminists and some of their male partners and comrades proffered what today would be called "progressive black masculinity," a term the critical race theorist and legal scholar Athena Mutua uses to describe "unique and innovative practices of the masculine self actively engaged in struggles to transform social structures of domination." For black left feminists, eradicating sexism and rethinking prevailing notions of masculinity and femininity constituted a key site of struggle.[15] Their politics were "leftist" in that they unequivocally opposed capitalism and imperialism. For them, socialism was essential to black and women's liberation. And they looked to the Soviet Union as a revolutionary ally to black people everywhere and a model for building new, modern democratic societies.

Interventions

This book moves black women from the margins to the center of narratives about black radicalism, diasporic social movements, U.S. and transnational women's movements, and American Communism during the early and mid-twentieth century. Until recently, scholarship on early and mid-twentieth-century U.S. black women's activism has focused almost entirely on the church, women's clubs, and the Garvey movement. Scholars and writers, among them Deborah Gray White, Bettye Collier-Thomas, Evelyn Brooks Higginbotham, Paula J. Giddings, and Ula Y. Taylor, have written probing accounts of black women's crucial role in making these organizations powerful institutions for political and social change in black communities. Focusing primarily on upwardly mobile, urban, middle-class, educated women, these studies show how club, church, and Garveyite women formulated multiple variants of black feminism. Challenging the sexism of black male spokespersons, these women saw themselves as leaders of the "race." They positioned themselves at the frontlines of struggles against lynching, Jim Crow, and colonialism, as well as for the survival and sustenance of black communities across the globe. These studies also provide useful insight into how gender and sexuality structured relations of power within these organizations and framed discussions of female respectability.[16]

This overwhelming attention to the church, women's clubs, and the Garvey movement has rendered invisible a more radical aspect of black

women's history. My book reveals the ways a small group of black women defiantly rejected the middle-class political agendas and cultural sensibilities of traditional black protest groups and looked to Communism as a fulcrum for radical change and transnational political solidarity. These standard narratives additionally have elided the Communist Left as an important site for black feminist praxis and the practice of transgressive sexualities.

However, black Communist women are beginning to receive their just due. A growing body of exciting work by Carole Boyce Davies, Mary Helen Washington, Robin D. G. Kelley, Dayo F. Gore, Paula J. Saunders, Gerald Horne, Lashawn Harris, Mark Naison, Kevin Gaines, and Marika Sherwood have excavated the life and work of several black women of the Old Left. These include Claudia Jones, Shirley Graham Du Bois, and Victoria (Vicki) Garvin. This work has begun to chart black women's leadership in Communist-affiliated labor and civil rights organizations, trace the connections between black women militants of the Old Left and those of the civil rights–Black Power era, analyze black women radicals' construction of non-normative sexualities, and examine the CPUSA as a site for forging feminism, transnational identities, and political alliances. Uncovering these histories has expanded our understanding of black radicalism by challenging previous phallocentric readings thereof and highlighting the key roles black women played in leftist movements.[17] Still, much work remains to be done on black women's involvement in the Communist Left.

When black Communist women do make an appearance in existing scholarly accounts, these accounts often focus on the Depression or on the post–World War II period, overlooking how black women's radicalism evolved over an extended period of time. Moreover, these studies tend to treat them as individuals. I show how they were part of a community of black women radicals whose collective history spanned more than fifty years. Claudia Jones is a case in point. Many critics have focused singularly on this pioneering Trinidad-born black Communist woman. One of the CPUSA's leading theoreticians on the Negro Question and the Woman Question, as well as the preeminent black woman in the Old Left, she popularized the concept of "triple oppression" in the postwar Communist Left.[18]

Carole Boyce Davies's *Left of Karl Marx: The Political Life of Black Communist Claudia Jones* provides a useful starting point for examining this collective history of black women's radicalism located within the Communist Left. Boyce Davies insightfully discusses Jones's life and legacy. Boyce

Davies asserts that Jones embodied a "radical black female subject," a politics and identity that was internationalist, anti-sexist, anti-capitalist, and anti-imperialist in breadth and committed to the liberation of all people. For Boyce Davies, Jones's burial immediately to the left of Karl Marx's grave in London's Highgate Cemetery is a fitting metaphor for explaining how she expanded and rethought Marxism-Leninism by incorporating race and gender into her political work.[19]

Jones's key intervention, Boyce Davies argues, was her thesis on the "superexploitation of black women." Derived from Marxist-Leninist thought, superexploitation refers to uniquely severe, persistent, and dehumanizing forms of capitalist exploitation.[20] Jones, however, refashioned this concept by accounting for black women. Her thesis referred "to the ways in which black women's labor is assumed; the way they are relegated to service work by all sectors of society, with the complicity of progressive and white women's and labor interests (including those on the Left). It related to their low salary, compared with the level of work they are asked to give in return."[21] In a unique move, Jones located "much of this treatment in the superexploitation of black women as mothers." In other words, the capitalist process brutally exploited black women's role as breadwinners and protectors of families by forcing them to work back-breaking, menial service sector jobs, often under the threat of rape, to ensure the survival of their families and black communities.[22] Jones, however, did not view black women as victims. Rather, due to their place at the bottom of the political economy and their relegation to the service sector, Jones forcefully charged that triply oppressed black women constituted the vanguard for transformative change. Additionally, Boyce Davies calls attention to the virulent persecution Jones endured during what leftists called the McCarthy period, the moment of government crackdowns against left-wing activism in the 1950s.[23] Due to her visibility in the Communist Party and her outspoken criticism of Jim Crow, colonialism, and U.S. Cold War politics, U.S. rulers persecuted Jones, deporting her to Great Britain in 1955. However, Boyce Davies stresses Jones's resilience in the face of Cold War anti-Communist repression. In London, where she lived her final years, Jones continued her radical political work. Reconfiguring Marxism-Leninism by championing black liberation, women's rights, decolonization, and peace, Boyce Davies frames Jones as one of the most brilliant, innovative black feminist and radical thinkers of the twentieth century.[24]

My term "black left feminism" and Boyce Davies's paradigm of the "radical black female subject" have much in common. I have chosen the former because it evokes and usefully grounds black Communist women's lives in the complex history of the U.S. and global Communist movements. Moreover, "black left feminism" illustrates how black women radicals such as Jones did not formulate their ideas in isolation.

I situate Jones's life and work within a community of black women radicals, showing how black Communist women's concerns for and theorization of black women's exploitation, particularly as domestics, were crucial to the making of black left feminism from its very beginnings. Fighting for the dignity, rights, and protection of single, destitute black mothers was central to the work of Grace P. Campbell, a nationally renowned, Harlem-based social worker who held the distinction as the first black woman to officially join the CPUSA. She too wrote about black working-class women's marginal status, appreciating how public policy, structural inequalities, and cultural biases worked in tandem to oppress them. She was not alone in drawing these conclusions. Louise Thompson Patterson, a bohemian, world traveler, and major figure in the Harlem Renaissance, wrote in her prescient article of 1936, "Toward a Brighter Dawn," about the ways in which black women faced "triple exploitation," thereby positioning them as the vanguard of social change. Similarly, Esther Cooper Jackson, a dynamic activist intellectual based in Birmingham, Alabama, historicized and chronicled black female domestics' exploitation and resistance in a master's thesis in 1940. Claudia Jones proffered the most elaborate discussion of "triple oppression" in her landmark essay of 1949, "An End to the Neglect of the Problems of the Negro Woman!" By focusing on the entire Old Left period, I show how black women radicals' thinking evolved over four decades in response to their lived experiences, local and global events, and collaborations between themselves, politically mainstream black women activists, and white Communist women and black male radicals.[25]

Calling attention to black left feminism expands the boundaries of what is commonly understood as black feminism. Black women's participation in the Communist Party reveals the ideological complexities and contours of twentieth-century black women's activism. Recognizing these tendencies affirms the black feminist theorist Joy James's observation that "there is no 'master' narrative that frames the concerns of all black women." She

adds: "Black women activists and feminists are not uniformly progressive."[26] These are insightful points. Without question, black Communist women's staunch anti-capitalist politics differentiated them from their more politically mainstream sisters in the club movement, church, and civil rights and black nationalist organizations. Still, black women radicals often collaborated with them. However, the former were keenly aware of the political and ideological differences between them.

Black leftist women also shift the history of black women's activism by moving beyond the view of women as solely local, grass-roots organizers. Dayo F. Gore, Jeanne Theoharis, and Komozi Woodard's anthology *Want to Start a Revolution? Radical Women in the Black Freedom Struggle* is useful for rethinking this point. They challenge the "bridge leadership" framework that defines black women civil rights activists primarily as behind-the-scenes organizers.[27] I show how many black Communist women functioned both as grass-roots organizers and visible, formal leaders within the Communist Left. This was true for Audley Moore. A brilliant organic intellectual and lifelong Garveyite, she emerged as one of the Harlem Communist Party's most able community organizers and visible leaders during the 1930s and 1940s.[28] Esther Cooper Jackson also fits this description. During World War II, she served as the executive secretary of the Southern Negro Youth Congress, an organization based in Birmingham, Alabama, that was a militant forerunner of the Student Nonviolent Coordinating Committee (SNCC) of the 1960s. But she also agitated at the grass-roots level and traveled internationally. Black women's ranking positions within Party-affiliated movements speak to the unique leadership opportunities they often found outside of traditional black protest groups to agitate for social justice and racial equality.[29]

Another key difference between black left feminists and their politically mainstream counterparts concerned their divergent understandings of female respectability and representations as sites for social intervention. The historian Lashawn Harris provides useful insight into this matter in her study of African American Communist women during the 1930s. She argues that black Communist women "modified or rejected certain aspects of the politics of respectability because they were neither seeking legitimacy from whites for their institution building, nor were these women trying to reconstruct black images through proper etiquette or accomplished housewifery."[30]

By examining the entire Old Left period, my book uncovers how black women radicals formulated unique discourses and practices of respectability

over the course of forty years that both challenged and adhered to what the historian Victoria W. Wolcott has termed "bourgeois respectability."[31] She defines it as early twentieth-century middle-class "black female activists' desire to act as unblemished representatives of the race and to reform the behavior of their working-class sisters." Middle-class activists, many of whom actively participated in the church and women's clubs, often viewed the behaviors of the black female working class as socially dangerous, reinforcing prevailing images of black women's perceived hypersexuality and immorality. As such, the church and women's clubs promoted temperance, thrift, cleanliness of person and property, the nuclear family, and sexual purity to uplift impoverished black women and communities.[32] In contrast to this stance, many black left feminists openly defied heteronormative gender conventions. Some rejected traditional marriage. Others supported free love and willfully participated in the transgressive sexual underworlds found in bohemian and leftist communities. Many were unafraid to speak openly about sexual violence committed against black women by white men.

Black left feminists connected their non-normative articulations of female respectability with representation. Taking a cue from the cultural theorist Stuart Hall, I use the term "representation" to refer to matters of citizenship and grass-roots political organizing on a global scale as well as to how language and systems of knowledge production are created, produced, and circulated to create meanings.[33] I should note that black women radicals did not use the term "representation" to describe their work. This is my intervention. However, their politics did evidence an appreciation of the connection between meaning, language, domination, and resistance.

This intersectional view was most evident in the poem "A Black Woman Speaks of White Womanhood, of White Supremacy, of Peace" by the actress, poet, and leftist activist Beulah Richardson in 1951. Tracing black women's oppression and resistance from slavery through the post–World War II period, she links denigrating images of black women and their disfranchisement to the rape and impoverishment of black women and the genocidal conditions facing black communities.[34] Arguably, she recognized what the black feminist theorist Patricia Hill Collins has termed "controlling images," stereotypical depictions of black women "as mammies, matriarchs, welfare recipients, and hot mommas" used to construct black women as "the Other," thereby justifying their oppression.[35] At the same time, the poem affirms the cultural critic bell hooks's understanding of how representations of black

women stand as a significant site for political resistance and cultural and cognitive transformation: "The issue of race and representation is not just a question of critiquing the status quo. It is about transforming the image, creating alternatives, asking ourselves questions about what types of images subvert, pose alternatives, and transform our worldviews and move away from dualistic thinking about good and bad."[36] For black women radicals, representation was more than simply a contest around the meanings of language and a basis for political organizing. It was a matter of survival.

Black left feminists were hardly the first black women to appreciate representation and respectability as key sites for social contestation. Club and church women since the nineteenth century had centered respectability and cultural representations to their activism.[37] However, black Communist women made a key intervention in this discourse. They often demanded dignity, rights, and protection of black womanhood premised on three fundamentally linked assumptions: first, that adherence to middle-class notions of respectability did not protect black women from rape, violence, denigrating cultural representations, disfranchisement, and economic exploitation; second, that heteronormative, middle-class constructions and practices of sexuality actually inhibited black women's and men's freedom; third, that a socialist revolution that was attentive to dismantling racism, sexism, capitalism, and imperialism simultaneously was essential to black women's liberation. Black women radicals and their male partners and allies were neither always successful nor interested and invested in articulating alternative ideas and practices of respectability. Sometimes they knowingly embraced and strategically employed prevailing gender conventions. Still, black left feminists' efforts in cultivating non-normative gender sensibilities speaks to the diverse understandings of representation and respectability within early and mid-twentieth-century black communities and to how some black women viewed the Communist Left as a site for personal autonomy and sexual freedom.

By uncovering black left women's stories, this book joins a growing literature in reconfiguring the periodization of twentieth-century black feminism and U.S. women's movements. Dayo F. Gore, Jeanne Theoharis, and Komozi Woodard's *Want to Start a Revolution? Radical Women in the Black Freedom Struggle* provides a useful starting point in mapping the connections between black women militants in the struggles of the Old Left and those in the struggles of the civil rights–Black Power era. The anthology emphasizes the intergenerational connections between black women radicals involved

in Communist and non-Communist movements in the 1940s and 1950s with younger militants in civil rights and Black Power groups.[38]

My intention here is to construct an alternative genealogy of twentieth-century black feminism by recognizing black left feminism as an important progenitor for the black feminism of the 1960s and 1970s. Black Communist women's work demonstrates how the years from the 1920s to the 1950s were hardly a period of feminist abeyance as was once believed.[39] By no means am I suggesting that twentieth-century black feminism developed in a linear fashion. It did not. The Cold War, together with local and regional distinctions in African American women's experiences as well as global events, had major implications in shaping the trajectory of black feminism, shrouding and even in some cases discrediting veteran black women radicals' work in the eyes of the younger generation of black female militants in the 1960s and 1970s. But as I show, there were also direct intellectual, political, and personal linkages between black left feminists and younger black women. The term "triple oppression," the signature theoretical paradigm of black feminism in the 1970s, originated with black left feminists. Moreover, many feminists of the Old Left mentored young black feminists, presaging much of their work, most notably their "vanguard center" approach to politics. "Since Black women," the sociologist Benita Roth writes, "were at the intersection of oppressive structures, [black feminists of the 1970s] reasoned that their liberation would mean the liberation of all people."[40]

Uncovering these intergenerational connections reconfigures previous conclusions about the roots of the black feminism of the 1970s. Much of the recent scholarship on black feminist organizations of the 1960s and 1970s, notably by Kimberly Springer, Benita Roth, Premilla Nadasen, and Stephen Ward, has either focused on recovering black women's involvement in "second wave feminism" or charted how black women fashioned their own distinct feminist politics during these years.[41] For the most part, these works identify the civil rights movement as the "parent" movement to black feminism of those two decades.[42] This scholarship also locates the emergence of black feminist groups, such as the Third World Women's Alliance and the Combahee River Collective, primarily as a response to the infamous Moynihan Report of 1965 and the "resurgent masculinism of Black Liberation."[43]

By recovering these linkages, I join historians like Nadasen, who question the usefulness of the wave metaphor for understanding U.S. feminist struggles, which "neatly package[s] the women's rights movement into

peaks and troughs" by excluding women of color's involvement in feminist struggles and by "re-inscribing gender as the primary category of analysis that defines feminism."[44] More problematically, the wave metaphor frames these movements narrowly through a parochial lens of American exceptionalism, overlooking how transnational exchange and global developments informed U.S. feminists' work. Given their transnational sensibility and influence on young activists in civil rights, Black Power, and black feminist movements, the history of black left feminism provides a missing link in the narrative of twentieth-century black freedom and feminist movements.

Excavating the stories of black Communist women renders them visible in broader scholarship on women's involvement in U.S. labor and leftist movements. Employing the term "black left feminism" is useful to this end. The term enables me to engage the growing body of scholarship on "left feminism" and "labor feminism." The historian Ellen Dubois describes the former term as a feminist politics of the Old Left that fused "a recognition of the systemic oppression of women" with an awareness of the intersections between race, gender, and class.[45] Similarly, the latter concept refers to a mid-twentieth-century "variant of feminism that put the needs of working-class women at its core and . . . championed the labor movement as the principle vehicle through which the lives of the majority of women could be bettered" as the historian Dorothy Sue Cobble puts it.[46] While both Dubois and Cobble make nods to an intersectional analysis, black women's participation in leftist movements remains marginal to this scholarship. Given this, examining black women radicals' lives opens up different conversations, revealing not only their presence in the Communist Left, but also how black and white Communist women often grappled differently with issues of race, gender, class, sexuality, and politics.

While I am concerned with uncovering the collective history of black left feminism and its interventions in black women's activism and U.S. women's movements, in this book I also chart black women's political and intellectual engagement with the black radical tradition.[47] Discussions in *Small Axe: A Caribbean Journal of Criticism* (2009) on Carole Boyce Davies's *Left of Karl Marx* and Claudia Jones's life and legacy are a useful starting point in exploring these connections.[48] Boyce Davies notes how, until recently, most scholars have, in essence, written black women out of the black radical tradition. She attributes this to the masculinist framings of black radicalism, together with the legacy of Cold War anti-Communism, in shrouding

black women leftists from scholarly examination of black radicalism. "Black women," she writes, "have become sisters outside of the black radical intellectual tradition." The relative invisibility of Claudia Jones from this scholarship and popular memory is, in Boyce Davies's view, but one example.[49] Extending Boyce Davies's discussions, the historian Kevin Gaines emphasizes how the lingering legacy of Cold War anti-Communism in the U.S. academy led scholars to dismiss the black-red encounter and activists like Jones.[50] Similarly, the black feminist theorist Patricia J. Saunders focuses on "sailing" and deportation to flesh out the role of Cold War repression with its concomitant racist and sexist politics in obscuring Jones's life, as well as her resilience in advancing a diasporic, feminist, radical politics in the face of persecution.[51] For Boyce Davies, Gaines, and Saunders, the recovery of Jones contains broader implications that extend far beyond prising open canonical narratives of black radicalism and black feminism. Acknowledging Jones as a "radical black female subject," these scholars argue, challenges the legacies of Cold War anti-Communism and contemporary U.S. hegemonic global agendas that seek to stifle political debate and dissent and promote war, racism, imperialism, and women's subordination.[52]

In this book, I shift this conversation from its singular focus on Jones and her relation to the black radical tradition to a wider analysis of black leftist women's collective engagement with black radicalism during the entire Old Left period. Calling attention to black left feminism demonstrates how black women collectively forged their own coherent, free-standing, radical praxis within this larger black radical tradition. This occurred often under seemingly intractable obstacles both inside and outside of the CPUSA from the 1920s through the 1950s. Understanding black left feminism in these terms historicizes postwar radical black feminism. This framework also provides an entry point for understanding how black women demanded a voice in the CPUSA, how black left feminism evolved over time and space, and how black radical men, black communities, and the state responded to black women radicals. Most of all, black left feminism shows how black radicalism is not a gender neutral category. Black radicalism has always been gendered; that is, the political programs, articulations, and "freedom dreams" of black radical activists and intellectuals are invariably informed and shaped by a complex interplay of gender, race, sexuality, class, and politics.[53]

Examining the making of black left feminism is critical for understanding key interventions in black feminism and black radicalism and appreci-

ating the contours therein. I am concerned with understanding the process of *how* a small group of black women, who hailed from divergent social backgrounds and geographic locations both inside and outside the United States, became radicalized, joined the CPUSA, came to understand themselves as diasporic and transnational citizens, forged a dynamic community of left-wing activists, and profoundly shaped modern black feminism. Their radicalizations were not inevitable. In order to demonstrate this point, this book provides biographical sketches detailing how a unique interplay between local and global events and their lived experiences brought these women into the CPUSA, shaped their experiences within it, and nurtured their global sensibilities.

Examining a community of black women radicals also provides insight into the making of black left feminist collective identities. They were consciously aware that they constituted a small but dynamic community of black women radicals. Their shared experiences, solidarities, domestic and global traveling, and complicated relationship with the Communist Left as a whole forged this sensibility.[54] Kimberly Springer's work on black feminist organizations of the 1970s is useful for appreciating this process. Combining black feminist theory and social movement theory, she advances the term "interstitial politics" for describing the varied ways black feminists creatively "fit their activism into their daily life schedules" and "developed a collective identity and basis for organizing that reflected the intersecting nature of black womanhood."[55] They forged an oppositional consciousness, a viewpoint rooted in lived experience that provides individuals with "the ability to read the current situations of power and self-consciously choos[e] and adopt . . . the ideological form best suited to push against its configurations." Oppositional consciousness became crucial to collective identity formation.[56] Although not without some tension, black Communist women balanced the rigorous demands of Party work into busy daily schedules, with their politics and collective identities forming in the interstices of "blacks," "women," "Communists," and other subject positions in local and transnational contexts. At the same time, black left feminists' collective identity formation was always in the making. It was neither static nor complete. Moreover, their ideological outlooks did not always cohere. Rather, due to varied social backgrounds, locations within the Party hierarchy, and activism, as well as differing effects of state repression on their lives, black women radicals traveled multiple paths through the Communist Left. Indeed, there was

no monolithic black Communist woman's experience. Rather, there were many. It was this tension between common and individual experiences within the Communist Left that helps explain both the dynamism of black left feminism and its contradictions.[57]

Charting the making and practice of a transnational black women's radical politics also provides insight into black left feminism's interventions in black radicalism and black feminism and reinterpreting the history of the U.S. and African diaspora during the early and mid-twentieth century. Once again, discussions of Carole Boyce Davies's *Left of Karl Marx* are instructive in framing my approach here.[58] The study of Jones as a "radical black female subject" and her persecution, Carole Boyce Davies, Kevin Gaines, and Patricia Saunders argue, provides a framework for reassessing scholarly narratives of black radicalism that often have elided conjectures between African American freedom struggles, African and Caribbean decolonization, feminism, and Cold War anti-Communist repression.[59]

Here, I am especially interested in how black Communist women collectively pursued a transnational political approach. In his book, *The Practice of Diaspora: Literature, Translation, and the Rise of Black Internationalism* (2003), the literary scholar Brent Hayes Edwards provides a point of departure for uncovering a radical, transnational, black feminist politics. He insightfully observes how black diasporic radicals in interwar Harlem, London, and Paris, such as George Padmore, Tiemoko Garan Kouyaté, and T. Ras Makonnen, invented a "'Black International,' an explicitly anticapitalist alliance of peoples of African descent from different countries around the world" through "uneasy, shifting affiliations" with the Communist International (Comintern), Moscow's arm responsible for fomenting world revolution.[60] Diasporic radicals' "experience of migration to Europe," Edwards adds, together with their "exposure to the centers of imperial domination," nurtured this politics. Hence, they led and participated in protest groups, such as the Paris-based Ligue de Défense de la Race Nègre and League Against Imperialism, a leftist, anti-colonial organization established by the Comintern. Women, however, are conspicuously absent in Edwards's account of the "black international."[61]

In this book, I challenge Edwards's erasure of black women's involvement in the production of what I call a "black women's international." Black women radicals never explicitly used this term. But through their activism, journalism, and overseas travel, we can see how they practiced a radical

internationalist, feminist politics within the U.S. and global Communist Left that was committed to building transnational political alliances with women of color and politically progressive white women from around the world. For these reasons, they were constantly on the move, both domestically and internationally. Calling attention to the "black women's international" and following black women radicals to the Soviet Union and across the world reveals the gendered contours of black internationalism. Gender, sexuality, and class always circumscribed black women's ability to travel across territorial boundaries and interpret the world. Black left feminists' special concern for women's status globally shows how internationalism appealed differently to black Communist women than it did to their black male and white comrades. These women's transnational politics often diverged from those of club and church women, providing another example of political and ideological differences between black Communist and non-Communist women.

Traveling to the Soviet Union was vital to nurturing black leftist women's global outlooks. To analyze these encounters, I draw from the recent work of the linguistic scholar Joy Gleason Carew and the historian Maxim Matusevich. Carew examines the impact of the Soviet Union on black travelers: "Frustrated with the limitations of a racist United States and escaping from their own arenas of terror, a number of blacks went to Russia in search of the Soviet promise of a better society." The "quest for dignity and opportunity," she adds, lured black Americans to the Soviet Union from its beginnings to its collapse.[62] Similarly, Matusevich observes how black travelers in their memoirs "often cast their entrance into Soviet society in terms reminiscent of a religious awakening."[63] For these travelers, the Soviet Union enabled them to imagine new kinds of transnational alliances and construct new lives. Inspired by their Soviet encounters, black radicals returned home with a new sense of determination to mobilize black communities against racism and social inequalities. This certainly applied to black women leftists who visited the Soviet Union. But I also emphasize how the Soviet Union had special meaning to them in ways largely unexplored in Carew's and Matusevich's works.[64]

Examining black women's encounters in the Soviet Union reveals its importance as a political terrain for cultivating black left feminism. Several black Communist women spent extensive time in the Soviet Union. These included Louise Thompson Patterson and Williana Burroughs, a New York schoolteacher, journalist, and radical community activist. Treated with dignity and respect there, black women radicals felt a refreshing sense of per-

sonal freedom unknown to them back home as blacks and as women. Soviet women's enhanced rights intrigued them, bolstering their feminist sensibilities and oppositional consciousness. Transformed by these encounters in the Soviet Union, black women radicals rethought dominant gender and sexual norms and came to appreciate the global connections between racism, sexism, capitalism, and imperialism like never before. Traveling to the Soviet Union, moreover, stoked their interest in building transnational women's political alliances and helped to forge community among black women leftists. Sojourning to the Soviet Union also fostered their sense of "transnational citizenship," what Kevin Gaines describes as a notion of international solidarity with racially and nationally oppressed people that informed black women radicals' subjectivities and civic engagement upon returning home.[65] The importance of the Soviet Union in framing their global visions underscores how "black internationalism," as Tiffany Patterson and Robin Kelley remind us, "does not always come out of Africa, nor is it necessarily engaged with pan-Africanism or other kinds of black-isms. Indeed, sometimes it lives through or is integrally tied to other kinds of international movements—socialism, communism, feminism, surrealism, religions such as Islam, and so on."[66]

The Sojourners for Truth and Justice, a short-lived, Harlem-based black left feminist group in the 1950s, best evidenced this point. The only organization of its kind formed during the entire Old Left period, the Sojourners forged a leftist, gendered vision of diaspora that viewed black women as the vanguard for radical global social change.[67] For the Sojourners, cultivating transnational political ties with women across the diaspora and what is now referred to as the Global South, as well as racially sincere white women progressives, against U.S. Cold War policy and colonialism was critical to advancing the group's black left feminist agenda. At the same time, the Sojourners' black radical, feminist, transnational politics made them easy targets for state repression during the height of the McCarthy period, forcing the group to shut down.[68] Uncovering the history of the "black women's international" through the Sojourners and black leftist women's global travels reveals how they collectively formulated their own practice of transnational politics and provides a lens for reconfiguring a range of histories during the early and mid-twentieth-century.

In addition to examining black leftist women's interventions in black feminism and black radicalism, this book also looks at black women's com-

plicated relationship to the CPUSA. Without question, the black-red en-counter and the CPUSA's relationship to the Soviet Union remain contro-versial topics.[69] Harold Cruse's *The Crisis of the Negro Intellectual* of 1967, which argued that a racially insincere Communist Party duped blacks into supporting its conspiratorial agenda and sidetracked the formulation of an independent black political agenda, still looms large in framing scholarly debates and popular memory about the black-red encounter.[70] More re-cent scholarship, however, by Robin D. G. Kelley, Nell Irvin Painter, Gerald Horne, Martha Biondi, Mark Solomon, and Mark Naison have called Cruse's arguments into question. These scholars argue instead that blacks joined the Communist Party because they saw it as a militantly anti-racist move-ment committed to black liberation, economic justice, anti-imperialism, internationalism, the celebration of black culture, and to varying degrees women's rights. Emphasizing that blacks brought their own understandings of freedom and justice rooted in African American traditions of resistance with them into the CPUSA, these scholars discuss how black Communists grappled with its racism, sexism, and sectarianism. Although these scholars discuss black women, their day-to-day encounters in the Party are not cen-tral to these studies.[71]

Emphasizing the agency of black Communist women, I examine how they negotiated the contours of and tensions around gender, race, class, and sexuality, and politics within the CPUSA. Shifting political lines within the CPUSA, its positions on the Negro Question and the Woman Question, and local and global events created unique opportunities and imposed striking limitations on how black Communist women carried out their work. As disciplined Communists, black women radicals certainly tried their best to implement the Party policy, whether it came from Moscow or from local officials.[72] They sometimes defended inexcusable positions taken by Party officials and the Soviet Union. And they proudly and openly identified as Communists. At the same time, I show how black women radicals were unapologetic in challenging the racism and sexism within the Communist Party, as well as the sexist agendas of black men both inside and outside the Party. Black Communist women remained organically connected to black communities, viewing black women as their key constituents and drawing inspiration from them. Additionally, black Communist women consciously and explicitly saw themselves as carrying out the work of their militant pre-decessors, such as Sojourner Truth and Harriet Tubman.

Similarly, I look at how the CPUSA's unique movement culture, which promoted interracialism and "the Marxist analysis of politics and economics into a way of life," both attracted black Communist women and often alienated and marginalized them.[73] They found unique, exciting opportunities to forge political, personal, and sometimes intimate relationships with their white comrades. But they also frequently encountered what Communists called "white chauvinism" and "male chauvinism" within the CPUSA and the internationalist Left.

Given their distinct political ideology and social status as black women in a predominately white, male radical organization, they often functioned as "outsiders within."[74] In other words, although many emerged as ranking leaders within the Communist Left, they were never fully equal participants within it. In this regard their experiences resembled those of more famous civil rights activists of the 1960s, such as Ella Baker and Fannie Lou Hamer, among black male civil rights leaders. As Baker's biographer Barbara Ransby puts it: "[Baker] was close to the centers of power within the black community, but she was always a critical and conditional outsider, a status informed by her gender, class loyalties, and political ideology."[75] This observation applies to black women radicals' positionality as outsiders within the CPUSA. Through speaking with one another, they came to realize that their individual grievances with racism, male chauvinism, and sectarianism within the Party were in fact collective problems facing black women in the Communist Left, prompting some black women radicals to break from it.

Such was the case with Queen Mother Audley Moore. Her frustration, she claimed, with painful encounters with racism, sexism, and sectarianism within the Party eventually drove her out of it in 1950. By the early 1960s, she had reinvented herself into an ardent black nationalist, embracing all things "African" and vehemently rejecting interracialism. Years before Black Power militants made it commonplace, she wore African garb. For her, wearing African clothing was a critical step in decolonizing the mind of internalized racism. Attaining a mythical status as a revered elder mentor to young black nationalists, she emerged as a key founder of Black Power and the modern reparations movement.[76] Moore's break from the Party vividly demonstrated how black women's affiliations with it were always fraught with tensions and contradictions.

This book offers a model for interpreting the continuing debates about the Cold War's impact on the U.S. black freedom movement. Recently, scholars have debated the usefulness of the "long civil rights movement"

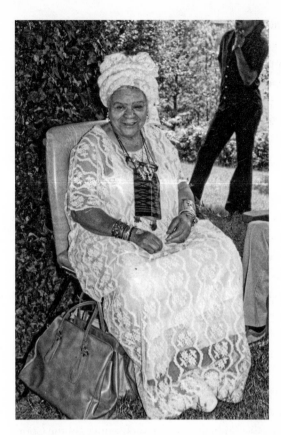

Audley "Queen Mother" Moore, circa 1980s. CREDIT: THOMAS O. WARNER.

paradigm that understands the African American freedom movement from the 1930s through the 1970s as a continuum of struggle.[77] Critics charge that this paradigm overlooks ruptures within the black freedom movement by downplaying the destructive impact of the Cold War on black radicalism and overlooking the ideological differences among black movements.[78]

Taking a different position, this book highlights both the breaks and the continuities in the black freedom movement and black women's struggles before and after the red scare by examining the personal and political costs of anti-Communism on black left feminists.[79] Black Communist women pursued their most sophisticated work during the McCarthy period. Claudia Jones wrote prolifically during these years about black women's triple oppression. Inspired by her writings and Beulah Richardson's "A Black Woman Speaks," postwar African American militancy, and global decolonization, the Sojourners pursued their militant, transnational program.[80]

But the Cold War also marked an extremely difficult moment for other

black women radicals. They suffered tremendously under the onslaught of anti-Communist repression, decimating the Communist Left as a viable social movement. The case of Claudia Jones is but one example. After years of arrests and trials, authorities jailed Claudia Jones for violating the Smith Act of 1940, a law forbidding the advocacy of violently overthrowing the U.S. government, and then deported her. Esther Cooper Jackson, too, suffered during these years. Her husband, James E. Jackson Jr., a Communist Party leader, absconded for nearly five years to avoid arrest for allegedly violating the Smith Act. In addition, anti-Communism played a crucial part in shutting down the Sojourners. This repression seriously isolated many committed anti-racist, internationally minded activists for a brief but crucial moment from the emergent civil rights movement and the global stage.[81] At the same time, I stress that as destructive as McCarthyism was on the Communist Left and on black women radicals' lives, it squelched neither their black left feminism nor their dreams of democracy at home and abroad. That many of these black women emerged from the Cold War committed to building new leftist movements is a testament to their historical importance.

Sources

This book depicts the lives and struggles of black women radicals through archival materials, including their personal papers, records of the CPUSA, the Communist International, black left and non-Communist–affiliated black protest groups, and FBI surveillance files.[82] This book also uses black Communist women's writings, Communist, African American, and mainstream newspapers, more than forty oral interviews I conducted, and interviews by other scholars. Unfortunately, of the women chronicled here only one wrote her autobiography—Louise Thompson Patterson, who received heavy assistance from the literary scholar Margaret Wilkerson. Despite this, Patterson's memoir was neither completed nor published. And while many black women radicals wrote prolifically, most of their work focused on party building, community activism, and political theorizing, with little discussion of their inner lives.[83]

To fill these gaps, I draw heavily on more than forty oral histories that I conducted with veteran black women radicals, many of whom are now in their nineties, as well as their spouses, associates, and children. These interviews helped me appreciate the complexity, brilliance, and legacy of black left feminism in ways that would have been impossible had I relied solely

on archival documents. But these testimonies have limitations. In his study of the links between the personal and the political in the lives of American Communists, the historian James Barrett persuasively observes a prevailing tendency in Communists' autobiographical practice: "The narrative builds to a moment of conversion to socialism and then marches through a process of movement building in which the author is important only insofar as her/his story helps to explain the development of the party and its fate."[84] This accurately describes numerous self-narratives of my subjects. For example, much of what Claudia Jones discloses about her public and personal life comes from one eight-paged, typed letter to William Z. Foster, the CPUSA national secretary, on 6 December 1955, just weeks after her release from prison and days before her deportation. Given that she was a Communist true believer, a victim of McCarthyism, extremely ill in part from her long persecution by anti-Communists, had an investment in publicly defending the Party, and was writing to its head, her self-narrative demands analysis. Similarly, Queen Mother Moore's oral testimonies from the 1970s and 1980s, too, need careful reading. Her reinvention into a strident black nationalist, investment in promoting herself as a revered, elder mentor to Black Power militants, selective memory, and tendency of deliberately obscuring her past requires us to question the reliability of her oral testimonies.[85]

This book is by no means a comprehensive study of black women's involvement in the CPUSA. But it does represent a critical intervention—one that examines and refigures a history that has failed, up to this point, to give sustained attention to black Communist women who struggled formidably to challenge the Communist Left's neglect of black women's issues, and who, despite their frustrations with the CPUSA, still saw it as a powerful vehicle for agitating for the dignity and rights of black people everywhere, particularly women, outside of traditional black protest groups. The women chronicled here were important not only because they enjoyed remarkable careers as key organizers, high-profile leaders, theoreticians, writers, and world travelers. Significantly and more broadly, these women's lives also reveal the complex interplay between race, gender, class, sexuality, and politics within American Communism, provide a genealogy for intersectional thought and black feminism, and reveal the ideological complexities of twentieth-century black feminism and transnational women's movements.

Black Communist Women Pioneers, 1919–1930

> Grace Campbell showed herself an ardent Communist . . . Though
> employed by the City Administration, is frank in her disapproval of it
> and said the only way to remedy the present situation was to install
> Bolshevism in place of the present Government.
>
> BUREAU OF INVESTIGATION, NEW YORK BUREAU FILE,
> 61-6864-1, 4 MARCH 1931

Grace P. Campbell was exhilarated. In May 1920, she spoke passionately at
a rally in Harlem for a candidate of the Socialist Party of America (SPA)
who was running for a seat in the New York State Assembly from the neigh-
borhood's Twenty-First District. A government informant reported that
she "made a few remarks upon the need of women waking up to the fact
that they are being driven to prostitution and other evils by the low scale of
wages. She promised to work hard among the women, not only of her race
but all of the women."[1] In addition to stumping for Socialist candidates,
Campbell ran on the SPA ticket for a seat in the New York State Assembly for
Harlem's Nineteenth District in November 1920. She was the "first colored
woman to be named for public office on a regular party ticket," according
to *The Messenger,* an SPA-affiliated black radical newspaper co-founded by
A. Phillip Randolph and Chandler Owen. They, too, stood for election on the
SPA ticket for state office. The newspaper endorsed Campbell's candidacy,
lauding "her pioneer [sic] social service work for colored girls" in Harlem.[2]
On Election Day, she won nearly two thousand votes, more than any other

black SPA candidate, including Randolph and Owen. The impressive support for Campbell spoke to her reputation in Harlem as a trustworthy, able community organizer and social worker committed to fighting for the dignity, rights, and survival of black women, children, and the entire community. Her high profile in Harlem radicalism also caught the attention of authorities. In the years immediately after World War I, the Bureau of Investigation, the predecessor of the Federal Bureau of Investigation, meticulously monitored her left-wing activism.[3]

Campbell's active involvement in the SPA signified her pioneering role in Harlem's early twentieth-century radicalism. From World War I through the eve of the Depression, she was the most prominent woman in the Harlem Left. By 1923, she had joined the Workers (Communist) Party (WP). She was the first black woman to officially do so. But she was hardly alone. A small, dedicated cadre of Harlem women radicals enlisted in the Workers Party during the 1920s. These included Williana Burroughs, Maude White, and Hermina Dumont Huiswoud. Like Campbell, they earned reputations as well-respected community leaders. Combining a pragmatic approach to community work with a leftist, transnational political vision, they called for world revolution and focused special concern for black women's freedom. Passionately committed to the nascent Communist movement, early black women radicals saw it as a viable alternative to mainstream black protest organizations. Black left feminists embraced this conviction through the entire Old Left period.

Tracing these women's lives, this chapter focuses on the first generation of black Communist women who joined the Party immediately after World War I and prior to the social upheavals of the Depression. Trailblazers, they began formulating black left feminism. The first part of the chapter looks at their varied social backgrounds and journeys into the Communist Left, demonstrating how early black women radicals were hardly a monolithic group. Next, the chapter examines how these women often functioned as outsiders within the early Communist Left. Grappling with the Party's contradictions and neglect of black women's issues, these pioneers nevertheless pressed forward with their black left feminist agenda. They were at the frontlines of building left-wing movements in Harlem for the community's economic survival. Black women radicals understood how struggling for decent housing and jobs was vital to the well-being of Harlem residents. Rethinking Marxism-Leninism, they proffered early articulations of the "triple

oppression" paradigm, the thesis on black women's superexploitation, and the vanguard center approach. They also embraced the "New Woman" ideal, a term referring to early twentieth-century American urban writers, suffragettes, journalists, educators, and bohemians who were less constrained by Victorian gender mores and domesticity and who pursued independent womanhood.[4] This sensibility prompted some to challenge ideals of bourgeois respectability espoused by church, club, and Garveyite women. The latter part of the chapter looks at the importance of traveling to the Soviet Union in helping black Communist women rethink their place in the world and begin forging a "black women's international." Through their experiences in the early Communist Left, black women radicals began building a community and collective identity. Paving the way for black women who joined the CPUSA during its heyday in the 1930s and 1940s and anticipating the black feminism of the 1970s, the lives of first generation black Communist women speak to the radical aspects and ideological complexities of early twentieth-century black feminism.

Local and global events provided the background in which early black Communist women came of age, cultivated an oppositional consciousness, and enlisted in the Workers Party. They were born during the "nadir" in African American life (1880–1915). These years witnessed the consolidation of Jim Crow, the highpoint of lynching, and the beginning of the Great Migration, which, between 1910 and 1930, brought more than one million African Americans from the rural South to the urban North in search of a better life.[5] During these years, nearly forty thousand people from the Caribbean arrived in Harlem.[6] The New Negro movement (1890–1935) emerged in response to these events. Committed to "nation building," New Negro protest organizations and intellectuals promoted "racial uplift ideology," what the historian Kevin Gaines describes as a "black middle class ideology . . . that came to mean an emphasis on self-help, racial solidarity, temperance, thrift, chastity, social purity, patriarchal authority, and the accumulation of wealth."[7]

Black women were visible in the New Negro movement. In 1893, Josephine St. Pierre Ruffin, the prominent Boston newspaper publisher and clubwoman, named her newspaper *Woman's Era*, aptly capturing club and church women's sentiment that the "race could rise no higher than its woman" and that women were best qualified to lead the race.[8] Women's clubs were at the forefront in agitating for the protection of black women

and crusading against lynching and Jim Crow. No organization was more visible in these campaigns than the National Association of Colored Women (NACW), the first national secular black women's organization, founded in 1896. Club and church women also vocally demanded equality with black men. However, by the early 1920s women's clubs had become increasingly elitist. Their growing concern with middle-class female respectability and attempts to police the behaviors of purportedly licentious, lazy black working-class people alienated clubwomen from the very communities they intended to uplift.[9]

Internationally, World War I marked the beginning of the end of European global supremacy. Unprecedented carnage on the battlefield, war-time migrations, strikes, and nationalist revolts in India, Ireland, and China weakened the European colonial grip on Africa and Asia. In 1917, the Russian Revolution established the world's first socialist state, the Soviet Union. Two years later, Bolsheviks organized the Communist International (Comintern) to coordinate the world revolution from Moscow. Inspired by the Bolsheviks' success, short-lived Communist insurrections shook Western and Central Europe immediately after the war.[10]

The World War I era also witnessed a global black revolt as anti-colonial uprisings erupted in Africa and across the diaspora. In the United States, these global upheavals, together with massive wartime black migrations, a spike in lynching, the "race riots" in East St. Louis in 1917 and Chicago in 1919, and a national wave of strikes in heavy industries, spawned "New Negro radicalism," a more militant New Negro tendency. As a political and cultural movement composed of Marcus Garvey's Universal Negro Improvement Association (UNIA), the African Blood Brotherhood (ABB), *The Messenger*, and other protest groups, as well as news and literary journals, New Negro radicalism linked black struggles for self-determination with postwar, anti-colonial struggles across the Global South.[11]

The early twentieth century also proved to be an exciting and tumultuous moment for the U.S. Left. The Russian Revolution both inspired and divided American radicals. In the summer of 1919, two groups of left-wing militants held inaugural conventions, forming the Communist Labor Party and the Communist Party of America respectively. Both organizations claimed to be the legitimate "Communist" party. Authorities immediately targeted both parties as part of a wider government crackdown—popularly known as the red scare—against left-wing organizations, civil rights and black nationalist

groups, and trade unions. Under this intense wave of government repression, both Communist groups functioned as underground organizations. Upon the urging of the Comintern, they merged in 1922, forming a unified, aboveground organization, the Workers Party of America. In 1929, it renamed itself the Communist Party, USA.[12]

Developments in the global Communist Left around the Negro Question and the Woman Question had lasting implications for framing discussions around race, gender, and class within the Workers Party. The Comintern's resolutions of 1922 and 1928 on the Negro Question were key in recruiting black men and women. The resolution of 1922 defined black struggles across the diaspora as key partners in the world revolution, while the resolution of 1928, commonly referred to as the "Black Belt thesis," declared the right of African American self-determination in the South.[13] Soviet women's status also influenced U.S. Communists' thinking. In the years immediately after the Russian Revolution and into the 1930s, the ideal of "the new Soviet woman"—a modern, sexually liberated, revolutionary woman—generated immense interest in left-wing, bohemian, and even politically mainstream circles throughout the West.[14] Soviet laws on women's rights, which on paper were some of the most progressive in the world, granted women full citizenship rights and legalized divorce and abortion (the first nation in the world to do so). Soviets initially adhered to a policy of tolerance toward homosexuals. A small group of Bolshevik feminists, such as Aleksandra Kollontai and Clara Zetkin, argued that women's sexual liberation and the "withering away of the bourgeois family" were vital both to women's liberation and to building a classless society. In 1919, Soviet officials established the Zhenotdel (Women's Department) to raise Soviet women's gender consciousness. In the following year, the Comintern founded the International Women's Secretariat to coordinate Communist women's work around the world.[15]

The world revolution failed to materialize immediately after the war, as Communists had predicted. So the Soviet Union went about constructing a socialist state in isolation. But Communists globally, including a small cadre of black women radicals in Harlem, remained confident that capitalism and imperialism were doomed. Informed by the early Communist Left's positions on race, gender, and class, together with their lived experiences, black women radicals forged their own left-wing politics. Viewing black women as the revolutionary vanguard, early black left feminists both contested and affirmed the politics of middle-class respectability espoused by church and

clubwomen, and rejected the pro-capitalist agendas of New Negro groups and the masculinist articulations of black self-determination advanced by the international Left.

The Social Origins of Early Black Communist Women

Several prominent first generation black Communist women enjoyed successful professional careers as social workers, teachers, and secretaries before joining the Workers Party. This pattern would continue through the entire Old Left period. These women were part of a new middle class that emerged across the African diaspora beginning in the late nineteenth century.[16] Focusing on the uplift and protection of black women and children in the age of Jim Crow and European global supremacy, early black women radicals' work underscored how the New Negro movement was foundational to their political visions before and after they joined the WP.

No person better exemplified this than Grace Campbell, who was born in 1882 in Georgia. Her father was a Jamaican immigrant and teacher and her mother was a woman of mixed African American and Native American heritage from Washington, D.C. Her family eventually settled in Washington where she grew up. She apparently never traveled to Jamaica to visit her father's family. Following in her parents' footsteps, she graduated from the historically black Howard University in Washington. Like many black women reformers of the Progressive era, she never married or had children.[17] By 1908, Campbell had made her way to New York. There, she began her distinguished career as a social worker, community activist, and civil servant. She joined the multiracial, mixed-gendered National League for the Protection of Colored Women (NLPCW), one of three organizations that merged in 1911 to form the Committee on Urban Conditions Among Negroes, later renamed the National Urban League.[18] She also briefly sat on the committee's board. Given that a key tenet of turn-of-the-century black women reformers was their belief that women were best qualified to lead the race and taking into account their demand for equality with black men, her reform work surely helped to cultivate her feminist sensibility.[19]

Meanwhile, Campbell worked on multiple fronts in pursuit of uplifting black women and children. In 1911, she became the first black woman appointed as a parole officer in the Court of General Sessions for the City of New York. She worked as a jail attendant in the women's section at "the Tombs," New York's infamous prison, until her death in 1943. In 1915, she

established the Empire Friendly Shelter for Friendless Girls, a settlement home in Harlem for young, single black mothers. The home solidified her reputation as "one of the best known colored women in New York," as the Harlem-based *New York Age* put it in 1924.[20]

Like many of her better-known Progressive-era black female counterparts, such as Anna Julia Cooper and Alice Dunbar-Nelson, Campbell, at this point in her career, adhered to notions of bourgeois respectability. Often "sound[ing] uncannily similar to the racist arguments they strove to refute," as the historian Evelyn Brooks Higginbotham explains, black middle-class reformers "tended to privatize racial discrimination—thus rendering it outside the authority of government regulation."[21] More significant, like other black women reformers, Campbell embraced conservative views toward domesticity and voiced alarm about the alleged sexual immorality of black urban working women.[22] An interview in 1911 about her work in protecting young black women from prostitution and incarceration reveals these sentiments. She acknowledged that in contrast to white women, black women lacked protection. However, she charged that unscrupulous white employment agencies took advantage of the "temptations of innocent colored girls" newly arrived from the South by steering them into prostitution. While rejecting prevailing racist arguments stigmatizing blacks as innately prone to crime, she nevertheless asserted that "mental deficiency" among all races explained criminality.[23] Clearly, she subscribed to what Kevin Gaines observes as "the commonplace view that the impoverished status of blacks was a matter of moral and cultural deficiency."[24] With her new politics, she began challenging bourgeois notions about respectability.

Not all early black Communist women were reared in middle-class families like Campbell, though many had achieved middle-class status by their early adult years. This was the case of Williana Jones (Burroughs), a committed Communist who spent nearly a dozen years in the Soviet Union over the course of her life. Born in 1882 in Petersburg, Virginia, to an ex-slave, she grew up in grinding poverty in New York. Despite such humble beginnings, Burroughs graduated from what is now Hunter College in 1902 and taught in New York public elementary schools. These accomplishments, together with her marriage in 1909 to Charles Burroughs, a postal worker and former student of W. E. B. Du Bois at Wilberforce University in Ohio, seemingly secured her place in the "talented tenth," the term coined by black scholar activist W. E. B. Du Bois at the turn of the century describing a small group

of upwardly mobile, college-educated African Americans who he believed would uplift the race.[25]

Hermina Dumont (Huiswoud), a radical activist and world traveler, hailed from a significantly different background than Burroughs. Dumont was born in 1908 in British Guiana and was raised in a modestly comfortable family. At the age of fourteen, she and her mother migrated to Harlem in search of a brighter future. Taking classes at Hunter College and City College, she worked as a secretary at the headquarters of the NAACP. By her early twenties, Dumont seemed well on her way toward becoming part of Harlem's elite. However, unforeseen events in the coming year would significantly alter her life trajectory.[26]

The early years of Maude White (Katz), a Communist organizer whose career stretched into the 1970s, contrasted starkly from those of Campbell, Burroughs, and Dumont. White was born in 1908 and was reared in a large, working-poor family in the coal-mining town of McKeesport, Pennsylvania, near Pittsburgh. Despite growing up in poverty, she began moving up the social ladder during her teenage years. She graduated from high school and afterward worked as a teacher with the intention of uplifting the race. Within a few short years, her decision to enlist in the WP would take her far from McKeesport and into the center of the global Communist movement.[27]

Radicalization and Joining the Workers Party

Black women were not blank slates when they joined the Workers Party. Nor were their journeys into the early Communist Left predestined or inevitable. But perhaps nothing better cultivated their oppositional consciousness than their experiences as black women living through the global crisis of the World War I era, their growing frustration with the political agendas of black middle-class reformers, and their interest in the fledgling Soviet Union. Early black women radicals followed multiple paths into the Workers Party, a trend that continued for decades to come.

Details about Grace Campbell's radicalization are sketchy. There is no document in the historical record explaining her entry into the WP. Multiple factors most likely explain her leftward turn. Through her daily encounters as a social worker, court attendant, and prison officer with some of New York's poorest black women, she undoubtedly came to recognize the connections between structural poverty, the trauma of migration, and the racialized and gendered nature of black women's oppression. As a migrant

herself, she could have related to the sense of dislocation that black women newcomers often felt upon arriving in New York.

Sexism within the New Negro movement seems to have been a factor in Campbell's radicalization. Kevin Gaines notes that "gender conflict exposed the contradictions of uplift's vision of progress, a middle-class vision structured in sexual dominance."[28] Such, apparently, was the case for Campbell. In 1913, the male-dominated leadership of the Committee on Urban Conditions among Negroes removed her from the group's board on the grounds of dereliction of duties. However, the historian Minkah Makalani suggests that this charge covered up the real reasons: Campbell's refusal to show proper deference to male leaders. If this was the case, her removal not only infuriated her, it also led her to search for more militant solutions for uplifting black people.[29]

Living in Harlem during the World War I era, with its exciting confluence of people, ideas, and cultures from across the black diaspora, was critical to Campbell's radicalization. On the war's eve she befriended a small group of militant Harlem diasporan intellectuals who were committed to black liberation, socialism, and decolonization. Constituting the left-wing bloc within New Negro radicalism, this group included the journalist Cyril Briggs from Nevis; the bibliophile and orator Richard B. Moore from Barbados; the newspaper editor W. A. Domingo from Jamaica; the labor organizer Frank Crosswaith from St. Croix; the African American journalist A. Philip Randolph, and the bibliophile and orator Hubert Henry Harrison from St. Croix, known by his contemporaries as the "father of Harlem radicalism." The sociologist Winston James correctly notes that they were drawn to Marxism because "they saw the ideology as first and foremost, a means of solving the race problem."[30] All but Briggs joined the Socialist Party prior to the war. By the end of the war, however, Campbell and many Harlem leftists had begun rethinking their affiliation with the SPA. Discomfort with its class reductionist position on the Negro Question explains this. The SPA understood it primarily as an economic issue, ignoring the specificity of black racial oppression and how white workers often embraced racism and benefited materially and psychologically from it.[31]

As such, Harlem leftists organized new groups to pursue an independent black radical politics. The African Blood Brotherhood was the most important one in this regard. Alongside Briggs and Moore, Campbell was one of the "prime movers of the African Blood Brotherhood," a government infor-

mant accurately reported.[32] Formed in 1919, the ABB was the first black radical organization of the twentieth century to formulate a coherent "radical conception of the relationship between race, class, nation, and socialist revolution," observes Minkah Makalani.[33] Initially clandestine and independent of the Workers Party, the ABB's revolutionary nationalist program called for black self-determination, the redemption of Africa, armed self-defense, black-white unity, support for trade unionism, and decolonization. In contrast to the SPA, the ABB viewed black liberation as central, not peripheral, to the global struggle against capitalism and imperialism.[34]

The Communist International's support for black self-determination and anti-imperialist politics surely was a key factor in attracting Campbell to Communism. Writing in 1959 to the historian Theodore Draper, Cyril Briggs made this case: "My interest in Communism was inspired by the national policy of the Russian Bolsheviks and the anti-imperialist orientation of the Soviet State birthed by the October Revolution."[35] Briggs was referring to the resolution on the Negro Question issued at the Fourth Comintern Congress in Moscow in 1922. Defining black liberation as a key part of the global struggle against capitalism and imperialism, the resolution directed Communists to fight for black-white unity. This position rejected the Socialist Party's class reductionist viewpoint on the Negro Question.[36] Given her central role in the ABB, Campbell undoubtedly shared Briggs's sentiments. By bringing "international connections and a place for radical African Americans on the world stage," notes the historian Mark Solomon, the Communist International provided Campbell, Briggs, and Harlem radicals with a sense of confidence owing to their knowledge that they had global allies supporting black liberation.[37] The resolution of 1922 also initiated a process in which black radicals looked to Moscow as a sympathetic arbiter in settling disputes with white Communists at home. As a result, Campbell, Briggs, Moore, and Lovett Fort-Whiteman, a Chicago-based activist, joined the Workers Party in 1923. Two years later, upon the Party's directives, ABB leadership disbanded the organization. In its place, the WP formed the Chicago-based American Negro Labor Congress (ANLC), an organization Communists hoped would win blacks to the socialist cause.[38]

Like the entire generation of the Old Left, the utopian aura surrounding the Russian Revolution attracted Campbell to Communism.[39] Campbell's alleged remarks at a political forum in Harlem in June 1921 affirm this claim. A government informant reported: "[She] devoted about twenty minutes

condemning all other forms of government but the Soviet, which she claims is the only hope of the workingman."[40]

Campbell's belief that socialism held special promise for black women additionally drew her to Communism. A government agent reported she "conduct[ed] an active campaign [in generating interest in socialism] among the colored women."[41] She was not alone in viewing the Soviet Union as a beacon of hope for black women. Helen Holman, a black radical from St. Louis who was based in New York, did as well. Traveling into the Communist Party through the International Workers of the World, the Woman's Suffrage Party, and the Socialist Party, she became widely known in Harlem during the 1920s for speaking on street corners against black women's subjugation under capitalism and for praising Soviet family policies.[42] Both Campbell's and Holman's strident support for black women's freedom and their efforts to link it to the Soviet Union shows how internationalism appealed differently to black women radicals than to their male comrades. For the former, the status of women globally was central to their global vision. The same was not true for black male radicals.

By any measure, Williana Burroughs followed a distinctly different road into the Workers Party than Campbell. While we can only speculate as to how Campbell's lived experiences radicalized her, Burroughs, later in life, claimed how her personal and professional encounters with racism, poverty, and sexism moved her toward the left. Growing up in abject poverty and teaching impoverished black elementary school students sparked her "growing consciousness . . . to help her oppressed race," as she put it years later. She eventually lost her job on account of the New York public school's ban on employing married women. Her dismissal initiated a chain of events that radicalized the infuriated Burroughs.[43] In the coming years, she became a social worker. But she became distraught with the "essential futility of individual efforts while pressure from above was not lifted," she later claimed.[44] In contrast to Grace Campbell's continued involvement in social work even after she embraced left-wing politics, Burroughs became disillusioned with the profession altogether. Frustrated and still searching for answers for uplifting black people, she joined the Socialist Party in the early 1920s. Like Campbell, the SPA's class reductionist position on the Negro Question disappointed Burroughs, prompting her to bolt from it. Impressed with its staunch anti-racist, anti-imperialist politics and captivated by the Soviet Union, she joined the ANLC in 1926 and the WP one year later.[45]

Friendships with black militants and female networks also proved important in radicalizing black women. Hermina Dumont's future husband, Otto Huiswoud, a Communist born in Dutch Guiana and a prominent black spokesperson in the Communist International during the 1920s, introduced her to left-wing radicalism.[46] Before meeting him, she was uninterested in politics. But through him she met W. A. Domingo, Hubert Harrison, Richard Moore, Cyril Briggs, and Grace Campbell. Meeting her was critical to Dumont's radicalization. Like the dynamic civil rights activists Ella Baker and Fannie Lou Hamer of the 1960s, Campbell possessed the adept skill in politicizing young black people. Decades later, Dumont Huiswoud observed this point: "[Campbell] never wavered in her conviction and without proselyting [sic] . . . guided many towards political clarity." In the coming years, the two women became close friends.[47] In 1926, Dumont married Huiswoud, drawing her even closer to the Communist Left. Two years later, she joined the Workers Party, marking the official beginning of her lifelong commitment to left-wing radicalism, which lasted until her death in 1996.[48]

For Maude White, her first introduction to left-wing politics came through her white high school English teacher, Eleanor Goldsmith, who was a Communist. She took an interest in her bright pupil. Accompanying Goldsmith to Party meetings in nearby Pittsburgh, White witnessed black Communists chair multiracial meetings and heard whites denounce racism and imperialism. She had never witnessed anything like this before. Convinced that white Communists were sincere in fighting against racism and imperialism, she enlisted in the Workers Party at the age of eighteen. Her desire to leave McKeesport also motivated her. She saw no future for herself in the town. And, she said later, "[I wanted] to do something for myself and for my people."[49] The Workers Party offered her an exciting new life, an alternative path to upward mobility, and personal freedom. In the coming years, other black women would join the Communist Left for similar reasons. Goldsmith recommended that White move to Chicago, where she could participate in party organizing on the Southside, the city's densely populated black neighborhood that was home to a vibrant cultural and radical political scene.[50]

Black women radicals' decisions to join the Workers Party are all the more interesting in light of the Communist International's silence on issues facing women of color. The resolution of 1922 on the Negro Question framed black liberation in masculinist terms. Similarly, *Theses of the Communist Women's Movement*, issued by the Comintern in 1920, elided black women's issues,

articulating gender oppression narrowly in economic, deterministic terms. (This resolution served as the CPUSA's official line on gender oppression until the late 1940s.) Despite the latter resolution's call for championing gender equality, support for the Woman Question in both the Communist International and the CPUSA during these years lacked priority.[51] The Workers Party's National Woman's Committee, later renamed the National Women's Commission (NWC), evidenced this pro forma recognition of the Woman Question. Founded in 1922 to coordinate "women's work," the poorly organized NWC exerted little real influence in the party's decision making.[52] Moreover, the NWC initially overlooked black women's oppression. Still, black women radicals remained committed to the WP. Disgust with black women's marginal status globally, ardent opposition to European global empires, and enthusiasm for the Soviet Union apparently trumped whatever issues they may have had with the WP at the time. So while black women followed different paths into the Workers Party, they shared a similar belief that the international Left offered a powerful vehicle for freeing black people. Future black Communist women would draw similar conclusions.

Women and Formal Leadership in Black Left Organizations, 1919–28

With the exception of Grace Campbell, black women were conspicuously absent from formal leadership prior to the issue of the Black Belt thesis of 1928. Even in Campbell's case, she functioned as an outsider within the Communist Left. On the one hand, her work was critical to building black left organizations. She sat on the African Blood Brotherhood's executive board, the "Supreme Council," with Briggs, Moore, and Domingo, holding the title of director of consumer cooperatives.[53] On the other hand, her gender-specific involvement in the ABB exposed its masculinist framings of black liberation. For example, she was the only black woman on the group's board, even though women comprised a sizeable segment of the group's membership.[54] Her ABB comrades often relegated her to performing invisible, secretarial work. So while the ABB formulated path-breaking positions on race, class, and nationhood, the same cannot be said of its understanding of gender.[55]

Minkah Makalani claims that Campbell protested her male comrades' sexism and black women's marginal place within the ABB during Supreme Council meetings. However, it is unclear what she specifically said and how her male comrades received her criticisms.[56] Black women were also marginal in the American Negro Labor Congress. Like its predecessor, the ANLC

privileged race, class, and nation over gender. Its leadership board included a handful of black women. Curiously, Campbell was never actively involved in the ANLC. Perhaps her frustration with her treatment in the ABB explains why.[57] What is certain is that black women's marginal positions within these organizations signaled the beginning of a pattern by which black left feminists often found themselves as outsiders within groups affiliated with the Communist Party.

For Campbell, the most accessible way of influencing early black left organizations was from behind the scenes. Her apartment in Harlem served as the ABB Supreme Council's meeting place as well as the office of Briggs's Crusader News Service and the distribution center for the *Crusader*, the ABB's official periodical. Her home remained a busy hub of radical political activity into the 1930s.[58]

The use of Campbell's home for political gatherings is telling. Underscoring how she extended the domestic sphere into political work, her leadership style often utilized the "motherist frame," what the black feminist theorist M. Bahti Kuumba describes as a discourse and practice based on normative gender ideologies that "stressed the need to fight for equality and justice with the characteristics associated with being good mothers."[59] Dumont Huiswoud's recollection of Campbell's interactions with her colleagues fits this description: "I remember her graying hair and jet-black beady eyes that glistened and twinkled as if she were perpetually enjoying something amusing. No wonder that her home was always full of visitors. She kept a permanent open house, offering food and shelter to whomever knocked on her door." Her interactions as a parole officer with women inmates shed additional light on her maternalist leadership style. Dumont Huiswoud described Campbell as a "very quiet-spoken lady." She was able "to assert her authority and command respect from the toughest woman delinquent simply by her motherly appearance and abundance of patience."[60] This gendered description of her interactions with female parolees is revealing. Unmarried, middle-aged, black, and female, Campbell may have consciously constructed and strategically performed this matronly persona to exert influence with women, to challenge the sexist agendas of some black male leaders, and to exercise influence in male-dominated political spaces that understood motherhood as the only way women could assert claims to political leadership. In this regard, her actions resembled those of her contemporary, Amy Jacques Garvey, Marcus Garvey's second wife and a major pan-African thinker and

activist in her own right. Throughout her involvement in the UNIA, Jacques Garvey understood that her political influence within the male-dominated Garvey movement rested on her ability to mediate her leadership claims through her status as Garvey's wife and as the mother of his children.[61]

Campbell's location behind the scenes in black left organizations also may have been a function of her own pragmatic decision to protect her good-paying civil service job from political scrutiny as a red scare swept across the nation. Government informants infiltrated the ABB, attended meetings at Campbell's home, and documented her every move. It is unknown whether she knew exactly how close government informants had gotten to her. But given this moment of intense government repression against black and left-wing organizations, it seems difficult to imagine that she was unaware that authorities were watching her and the ABB. Campbell was not the only black woman radical closely monitored by the state during the early 1920s. Authorities also surveilled Helen Holman. Government authorities carefully watched black women radicals from the Old Left's very beginning, with Holman and Campbell possibly serving as a template for future surveillance of black Communist women.[62]

Black women's marginalization within the early black Left also helps explain why it made few inroads with black women and why it remained comparatively small compared to the UNIA. Both the black Left and the Garvey movement (UNIA) formulated phallocentric understandings of black liberation, but Garveyite women found unique ways to lead the UNIA and to articulate "community feminism," what Ula Taylor described as a feminist politics combining black nationalism with racial uplift that recognized the unequal gendered relations of power and promoted black women's empowerment.[63] Due to the efforts of the UNIA's co-founder, Amy Ashwood (Marcus Garvey's first wife), the organization's constitution mandated that each local division would elect a "lady president" who would oversee women's activities. The UNIA also established the Black Cross Nurses, a women's auxiliary modeled after the Red Cross, giving black women a direct hand in nation building. Amy Jacques Garvey's "Our Women and What They Think" newspaper column discussed black women's involvement in global pan-African struggles, frequently criticizing men, in her view, for not doing their part in elevating the race. Garveyite women encountered considerable sexism within the movement. Yet this did not deter a cadre of talented black women leaders, such as Amy Ashwood Garvey, Amy Jacques Garvey, and Henri-

etta Vinton Davis, from gaining international fame within the organization. In contrast to the UNIA, no such group of women leaders emerged in the ABB or in the ANLC. Nor did these organizations establish women's auxiliaries. So despite its masculinist limitations, the Garvey movement was far more successful than its left-wing counterparts in creating formal structures that provided black women opportunities for uplifting the race and voicing their issues. The Communist Left's failure to address these issues would continually pose serious challenges for Communists during the entire Old Left period.[64]

Community Work, 1919–28

While black women remained largely excluded from formal leadership of early black left organizations prior to the late 1920s, their community work provided them with unique opportunities for shaping Harlem radicalism and diffusing left-wing ideas into the neighborhood. One of the most significant ways they did this was through "stepladder" speaking. Grace Campbell, Elizabeth Hendrickson, a Communist community organizer born in the Danish Virgin Islands, and Helen Holman were widely known stepladder orators, gifted speakers who stood atop crates and stepladders along Harlem's main thoroughfares and busiest street corners.[65] With fiery oratory, they electrified crowds, sometimes for hours, on wide-ranging topics from history, politics, and culture. Harlem street corners, the historian Irma Watkins-Owens observes, "became the most viable location for an alternative politics and the place where new social movements gained a hearing and recruited supporters."[66]

Black Communist women's presence on the stepladder circuit was a transgressive move. By positioning themselves on top of stepladders, pamphleteering, or speaking individually with pedestrians, they stepped into a masculine political terrain. Black men of various ideological persuasions dominated the Harlem stepladder scene. Jockeying with other speakers for the people's ear, male orators' rhetoric and body language often exuded a muscular black nationalism.[67] By advocating women's equality and praising Soviet family policy, black women radicals offered an alternative to masculinist framings of black liberation. It is unknown how Harlem residents responded to these women's street corner orations. But given their years of experience as community organizers, black leftist women surely knew how to perform in male-dominated political spaces in ways that both affirmed

and challenged their socially ascribed roles as mothers and wives for making radical political demands. Sidewalks also provided early black women radicals with a political education. It was on the streets where Harlem residents often first learned of breaking news. By speaking on street corners, black women radicals came to know the pulse of the community. So while the early WP offered them few formal venues to lead, Harlem sidewalks afforded black Communist women physical and discursive space for developing, refining, and diffusing their black left feminist sensibility and for expanding their networks in the community.[68]

Black women were critical to building community among Harlem's small group of left-wing radicals. Campbell, with Richard Moore and W. A. Domingo, was a charter member of the Harlem Unitarian Church (HUC), established in 1920 and pastored by the Jamaican immigrant E. Ethelred Brown, who was widely known for his strident socialist, anti-colonial politics. The "first black liberal Christian church in the United States," the HUC, according to the historian Juan Floyd-Thomas, promoted "social activism and communal outreach to bridge the gap between religion and radicalism within a black culture of opposition."[69] Like other Unitarian churches, the HUC rejected evangelism, religious creeds, and traditional gender and social conventions. The church's mission apparently spoke directly to Campbell. Reared in a staunch Catholic family, she became an atheist as an adult.[70] This move may have come from her burgeoning black left feminism and associations with black and white religious free thinkers in New York, the epicenter of early twentieth-century U.S. radical secularism.[71] Viewing religious orthodoxy as critical to maintaining the racial, gender, and class status quo, she apparently believed that a progressive social ministry was essential for improving the lives of black people. To be sure, Campbell, with Moore, Domingo, Hermina Dumont Huiswoud, Otto Huiswoud, and Hubert Harrison, regularly attended services at the church, revealing how they saw no contradiction in believing in socialism, embracing free thought, and attending church services. Given its religious unorthodoxy, the HUC's membership paled in comparison to Harlem's larger black churches. But it provided an important sense of community to Harlem radicals. The church also linked them to a thriving, multiracial community of free thinkers in New York.[72] That Campbell and Dumont Huiswoud actively participated in the HUC and associated with Harrison, Moore, and Domingo, who were notorious in Harlem for their atheism, is significant. These women's radical secularism

speaks to how they rejected many of the political ideas and cultural mores embraced by Garveyite, club, and church women, few of whom embraced free thought.[73]

This was further evident in early black Communist women's New Woman sensibility and their seeming comfort with what the cultural scholar Christine Stansell has termed "sexual modernism." The term describes practices and ideas that rejected heteronormative, Victorian, middle-class morality by redefining sex inside and outside of marriage through the rejection of women's domesticity, the advocacy of birth control, and support for women's wage work to ensure their economic independence.[74] The "new Soviet woman" and the sexual radicalism associated with Communism also informed early black left feminists' transgressive gender and sexual politics. Little is known about Campbell's sexual politics and inner life. But her active involvement in the early Harlem Renaissance through the *Crusader* located her in a dynamic black cultural movement that was, as the literary scholar Henry Louis Gates notes, "surely as gay as it was black, not exclusively either of these."[75] She was a close friend of Claude McKay, the Harlem Renaissance novelist from Jamaica "whose bi-sexuality bisected his Marxist engagement," the cultural scholar Gary Edward Holcomb observes.[76] Through the *Crusader*, she associated with a coterie of Harlem and downtown white radicals and bohemians, including the future Communist Party leader Elizabeth Gurley Flynn, who championed sexual modernism, socialism, and free thought. Campbell's involvement in the Socialist Party in New York located her in communities of radical women, many of whom were gay and bisexual, self-identified as "feminist," and agitated for birth control, free love, and gender equality.[77]

Similarly, Helen Holman surely would have encountered sex radicals in New York through her affiliations with the International Workers of the World, the Woman's Suffrage Party, the Socialist Party, and the early Communist Left. We cannot say for certain whether Campbell and Holman were involved in lesbian relationships or supported the radical positions around women's emancipation that were espoused by some U.S. and Soviet feminists. But we can safely assume, given their active involvement in left-wing movements and their vocal praise for Soviet women's status, that early black women radicals were not afraid of being publicly associated with sexual modernism. In doing so, their stance resembled those of black female working-class urban blues singers like Gertrude "Ma" Rainey and Bessie

Smith, whose lyrics, performances, and lifeways powerfully articulated an alternative consciousness that celebrated social, moral, and sexual values outside of bourgeois respectability and American mainstream culture.[78]

Black Communist women's staunch support for the Soviet Union and their strident anti-capitalist politics stood as the most significant political differences between them and their non-leftist New Negro female contemporaries. For example, Amy Jacques Garvey expressed ambivalence toward the Soviet Union. In an obituary of V. I. Lenin, printed in her "Our Women and What They Think" column in the *Negro World* on 2 February 1924, she bluntly called Soviet Russia's economic experiment "a failure."[79] Yet, Jacques Garvey was aware of Soviet women's enhanced rights. Writing in 1926, she declared how "the much despised Soviets challenge the white world to exemplify equal rights of women in politics and industry. . . . The Reds have sense enough to realize that if the mothers of men are not treated fairly men are but limiting their own progress and development."[80] On these points, black Communist women undoubtedly would have agreed. Jacques Garvey, however, opposed socialism and trade unionism during the earlier part of her career. Instead, like most UNIA officials, her vision was pro-capitalist. And given the UNIA's embrace of prevailing ideas about women's and men's "natural" roles, Garveyites would have wanted little to do with the sexual radicalism popularly associated with the Soviet Union and American Communism. These contrasts reveal the different ideological underpinnings of Garveyite and black Communist women's feminisms. A pan-African, black nationalist, pro-capitalist perspective informed Garveyite women's community feminism, while a revolutionary black nationalist, anti-capitalist outlook that was open to sexually transgressive ideas and practices informed black Communist women's burgeoning black left feminism. While these feminisms at times overlapped, their divergence helps explain the different political trajectories that Garveyite and Communist women followed during the 1920s.[81]

The Black Belt Thesis

The Sixth Communist International Congress in Moscow in 1928 marked a turning point in the Communist movement's position on the Negro Question and subsequently in its relationship with black women. Convinced that global capitalism was entering its final crisis—or "third period"—the Comintern promoted a sectarian, revolutionary, anti-capitalist, anti-imperialist

agenda. The resolution of 1928 on the Negro Question was key to this new line. Co-authored by the black Chicago Communist Harry Haywood and the Siberian Communist Charles Nasanov, the Black Belt thesis directed American Communists to champion racial equality, with special focus on fighting against lynching and Jim Crow. Calling for the elimination of "white chauvinism" within the WP and for black-white unity, the resolution encouraged the Party to increase its rhetorical attacks against Garveyites, the NAACP, and prominent black ministers as "misleaders" and "betrayers of the Negro people."[82]

The Black Belt thesis contained major implications for the party's thinking on race and gender. As Robin Kelley observes, the resolution promoted a "language of masculinity" that not only prioritized black liberation "over women's struggles, but essentially precluded a serious theoretical framework that might combine the 'Negro' and 'Woman' questions."[83] Despite its masculinist stance, the thesis nonetheless broke new ground in regard to black women. The Black Belt thesis was the first Comintern resolution that specifically discussed black women. Emphasizing that they "constitute[d] a powerful potential force in the struggle for Negro emancipation," the resolution declared black women as "the most exploited" segment within the labor force.[84] The Black Belt thesis had little else to say about black women. Still, black Communist women seized upon it to demand a greater voice within the WP and to begin theorizing on the nature of black women's multiple oppressions in Party-affiliated periodicals. Black women radicals also used the Black Belt thesis to gain institutional support from Party officials for their community work. In doing so, black Communist women began carving out their own space in the Communist Left, enabling Harlem Communists for the first time to build mass movements in the neighborhood on the eve of the Depression. This was most evident in the Harlem Tenants League.[85]

The Harlem Tenants League

The Harlem Tenants League (HTL) stands as the most important site of black Communist women's activism and the WP's most successful mass campaign in the neighborhood prior to the stock market crash of 1929. Formed in January 1928 and initially affiliated with the Socialist Party, Richard Moore, Grace Campbell, and Hermina Dumont Huiswoud wrestled for control of the HTL on behalf of the WP. Its leadership included Richard Moore (president), Elizabeth Hendrickson (vice-president), Grace Campbell (secretary),

Hermina Dumont Huiswoud, and Williana Burroughs. That women figured so prominently in the HTL's leadership reflected their longstanding concern for black people's economic survival and black women's exploitation. Committed to the survival and sustenance of the neighborhood, the HTL organized demonstrations and rent strikes, blocked evictions, and demanded the enforcement of housing regulations. Casting a transnational frame, the HTL linked poor housing to broader struggles against global white supremacy, capitalism, and imperialism.[86]

The HTL's initial success generated nationwide attention within the Workers Party and in Harlem. A report issued by the CPUSA's Negro Department in 1929 praised the HTL as an "instrument for stimulating the struggle of the Negro masses against high rents, vile housing conditions, segregation, etc." across the country.[87] The HTL served as an important model for the Party-led Unemployed Councils formed in late 1929, which emerged as the backbone of Depression-era Communist mass movements across the United States. The *Daily Worker* and *Amsterdam News* ran front-page stories about HTL protests. The group's success helped spark a wave of community forums in Harlem sponsored by women's clubs, fraternal groups, and churches on the high cost of living in the neighborhood. Clearly, the HTL had an impact on life in Harlem.[88]

Rather than calling for uplifting black communities, the HTL spoke directly to black working-class women's concerns. Since many Harlem women were their family's breadwinners and responsible for homemaking, they were well attuned to cost-of-living issues. The group counted perhaps as many as five hundred people, most of whom apparently did not join the WP. Politicized by socially ascribed roles as mothers and homemakers, women historically have dominated consumer movements. Given this, it seems likely that most HTL members were women. Plus, Grace Campbell and the other female HTL leaders likely tapped their immense female social networks in the neighborhood in building the organization. If this was the case, it suggests that working-class Harlem women, not men, were the first to answer the Party's call and to take part in Communist-led mass actions following the Black Belt thesis. To be sure, black women radicals' involvement in the organization demonstrates how they recognized the connections between black women's exploitation, consumption, unemployment, and racial discrimination, thereby challenging Marxist-Leninist notions that the shop floor constituted the key site for producing class consciousness and for ini-

tiating transformative change. The HTL also provided black women radicals with a sense of community. For the first time in the Communist Left's short history, black women in the early Party came together within a WP-affiliated organization, enabling them to exchange ideas, to agitate collectively on behalf of the community, and to forge a collective identity based on their shared radical outlooks.[89]

In addition to fighting for better housing, early black Communist women in Harlem focused their work on organizing black female domestic workers. That the bulk of African American women wage earners toiled in domestic service helps explain why Communists hoped to build inroads with this constituency.[90] But Communists were not the first people to agitate on behalf of black household workers. Since the nineteenth century, women's clubs, protection societies, church auxiliaries, and black domestic workers themselves had identified household workers' economic exploitation and sexual harassment in white homes as one of the most pressing issues facing the "race" and sought to empower household workers.[91] Nannie Helen Burroughs, the founder of the National Training School for Women and Girls in Washington, D.C., and the most prominent advocate for black domestic workers in the Progressive era, preached the gospel of self-help, respectability, and professionalism for uplifting black household workers. But black women radicals' positions contrasted from these mainstream approaches. For them, domestic workers' struggles were part of the larger, worldwide struggle against capitalism, imperialism, and white supremacy, with unions constituting a key piece in household workers' liberation. Over the next three decades, the unionization of black women domestics emerged as a pillar of their black left feminist agenda.[92]

The Party's first efforts in organizing black women domestic workers occurred in the 1920s. The American Negro Labor Congress's newspaper, the *Negro Champion*, publicized the Harlem Women Day Workers League, a domestic workers union. While its exact relationship to the WP is unclear, the group reportedly counted one hundred members. Fanny Austin, a domestic worker, dynamic labor organizer, and Communist, led the organization. The group signaled Harlem Communists' belief that unionization, not bourgeois respectability, offered exploited black domestic workers the best protection.[93]

Black Communist women seized upon the initial success of Party-led mass initiatives in Harlem to demand a greater voice within the WP. In 1929,

Hermina Dumont Huiswoud, Williana Burroughs, and the Harlem community activists Belle Lamb and Fanny Austin were elected to the Workers Party's Negro Department.[94] At a Negro Department meeting in June 1930, Lamb called for the WP's National Women's Commission to appoint a black woman to its board and urged that "Negro women comrades be drawn more into the fore of women's work."[95] However, these recommendations were not implemented. It seems that the Party leadership's belief that black women were marginal to the world revolution—after all few actually were in factories—explains why black women's issues remained largely neglected during these years.

While the Comintern encouraged the Party to focus its attention on the Negro Question like never before, it also proved to be a disruptive force in these matters, with devastating implications for the HTL and Grace Campbell. Following the Sixth Congress in 1928, Moscow instructed the Party to dissolve internal factions based largely in foreign-language federations and neighborhood groups, concentrating instead on organizing industrial workers. A segment of Party leadership, including its chairperson Jay Lovestone and his followers, who became known pejoratively as "Lovestonites," refused to comply with these directives. They did so because they believed that the Comintern had no right to impose its views on the Party's majority. A Party leadership faction led by the future CPUSA head William Z. Foster, who remained loyal to the Comintern line, silenced the opposition, expelling them in June 1929.[96]

Campbell sided with the Lovestonites. In doing so, she found herself on the losing side of a bitter Communist power struggle. Party officials quickly turned against her. In keeping with its practice of publicly assailing Communists who fell out of favor with Party leadership, in October 1929 the *Daily Worker* published a scathing article attacking her and the HTL leader Ed Walsh as "renegade" Lovestonites. Ironically, Campbell's old friend Cyril Briggs wrote the article. He singled her out as the leader of a furtive plot "to disrupt and destroy" the HTL by allegedly forging an "open alliance" with landlords against tenants. He added that she had refused to take part in HTL demonstrations for fear that they "'would jeopardize her job'" as a civil servant.[97] Unfortunately, the historical record does not reveal her side of the story.

By any measure, Campbell must have been shocked by these charges, especially coming from her old friend. To be sure, she left the HTL. By late

1929, the group split into two rival, mutually antagonistic groups, with both claiming to be the legitimate organization. It also divided old friends. Moore led the Party-backed group. Campbell led the other. This infighting crippled both groups, driving away most of their members and foreshadowing harsh internecine disputes that would paralyze countless future black left campaigns.[98]

The HTL's collapse marked a key turning point in Campbell's relationship with the Communist Left. Eventually settling her differences with Briggs and Moore, she continued working with them in the coming years.[99] But the damage was done. She never again benefited from the prominence within the Party that she had once enjoyed. Given the severity of the attacks against her, she seems to have rethought her relationship to the Communist Party, surely questioning its sincerity in fighting for black liberation. Her prominence in the Communist movement since the early 1920s offered her little protection when she crossed the party line. She was a black woman who worked largely behind the scenes and was not married to an influential black Communist male leader like Hermina Dumont Huiswoud was. The HTL's collapse not only marked a turning point in Campbell's affiliation with the Communist Party but also the destruction of a promising mass organization led largely by black women, highlighting their precarious position in the Communist Left as outsiders within.

Early Black Left Feminist Writings

First-generation black Communist women agitated on multiple fronts. One of these was journalism. While often excluded from the leadership of Communist-affiliated movements, they found a voice through writing. From the very beginning, black left literary feminism challenged the Party's positions on the Negro Question and the Woman Question that elided black women from discussion. More significantly, black Communist women's journalism proffered early articulations of the "triple oppression" framework and the thesis on black women's superexploitation that was popularized in the Communist Left two decades later by Claudia Jones. While they never used the terms "superexploitation" and "triple oppression" in their writings, early black left feminists clearly understood the uniquely cruel, interlocking oppressions experienced by black women under capitalism. Laying the groundwork for future theoretical discussions in the Communist Left on race, gender, and class, early black left literary feminism provides insight

into black women radicals' emergent collective identities and oppositional consciousness before the Depression.

Illustrating black women's marginalization in the early Communist Left, a white Communist, Jeanette Pearl, wrote the first article about black women, published in the *Daily Worker* in 1924. Her short article, "Negro Women Workers," condemned the brutal exploitation of black women industrial workers and their exclusion from organized labor. However, she did not issue a call for the Workers Party to unionize black women or to recruit them into its ranks. Nor did she discuss how the interplay between race, gender, and class positioned African American women at the bottom of the U.S. labor force. The article's vagueness and the Comintern's inattention to black women were indicative of how Communist leadership at this moment understood all working women as white and all blacks as men.[100]

Early black left literary feminism would challenge these conclusions. Grace Campbell's journalism proves this point. In a two-part series published in April 1925 by the *New York Age*'s weekly column, "Women in Current Topics," she examined how race, gender, class, and cultural biases shaped black women's relation to the criminal justice system.[101] That her articles appeared here and not in the *Daily Worker* either shows how she had to look outside of the Communist Left to have her work published or how she hoped to reach a broad audience in anticipation of the Popular Front strategies of the 1930s in which Communists downplayed Marxist rhetoric to build left-liberal alliances. Neither article mentioned the Workers Party or her involvement in it. Yet, her arguments show the influence of Marxism-Leninism in framing her thought and her efforts in incorporating race and gender into her leftist political critique.

Underscoring how community organizing and journalism mutually informed each other, Campbell's first article, "Women Offenders and the Day Court," drew from her experiences as a social worker and court attendant. It discussed how gendered cultural biases and legal double standards led to the unjust prosecution and denigration of women charged with prostitution.[102] Her second article, "Tragedy of the Colored Girl in Court," best highlighted the break in her earlier thinking about black women and crime. The article focused on young black women's imprisonment for prostitution. While she continued voicing her long-standing belief that black women were the least protected group, she now rejected prevailing ideas that immorality and personal irresponsibility explained poverty and criminality. Instead, she argued

that the interplay between race, class, gender, and state power explained the high black female incarceration rate for prostitution. While "the economic problem [could not] be looked upon as the sole factor in the question of prostitution among colored girls," she emphasized that poverty and wage disparities between black and white women were nevertheless "a prime factor in [black women's] fall."[103] Black women, she charged, became prostitutes because they had few viable economic options. Given these conclusions, she understood how the capitalist process exploited black women's location as mothers by forcing them into prostitution in order to survive and to provide for their children.[104]

The criminal justice system and cultural biases were additional factors Campbell identified for explaining the high rate of black female incarceration. Calling attention to sentencing disparities between black and white women for prostitution, she noted that courts convicted black women at higher rates and sentenced them to longer prison terms than white women—even white repeat offenders. She attributed these sentencing disparities to the racial biases of white judges who viewed black women as more prone to criminality than white women. She criticized the New York Commissioner of Corrections for instating a de facto policy of racial segregation within prisons and incarcerating first-time black women offenders in older, more densely populated jails with "hardened offenders." So at this point in her life, Campbell believed that black women's high rate of incarceration was the logical outcome of structural inequalities, a racist, sexist criminal justice system, and cultural biases that targeted and marked unprotected, poor, urban black women as deviant and criminal.[105] These arguments prefigured those made by Angela Y. Davis, Ruthie Wilson Gilmore, and other critics of the late twentieth-century "prison industrial complex."[106] They reject, as Gilmore puts it, "the expanding use of prisons as catchall solutions to social problems." Appreciating the relationship between prisons, structural inequalities, racism, public policy, and U.S. empire, Gilmore, Davis, and other critics of the prison industrial complex call for its abolition.[107] Similarly, Campbell understood how prisons were critical to positioning black women at the bottom of American society and to (re)producing and maintaining racialized, gendered, and classed social hierarchies.

In drawing these conclusions, Campbell implicitly argued that only the complete destruction of interlocking systems of domination could realize black women's liberation. In doing so, she challenged a fundamental as-

sumption of Marxism-Leninism that white male workers in the advanced industrial sectors constituted the most exploited segment of the working class and thereby its revolutionary vanguard. She rejected the Communist Left's tendency to portray working-class women as white. These positions did not make it into the African Blood Brotherhood's program or into the early WP's program, revealing again how the black Left and the early WP neglected black women's special issues.[108] Campbell's conclusions also rejected common beliefs within women's clubs that black women's alleged immorality explained their poverty and delinquency and that adherence to middle-class respectability could protect black working-class women. Indeed, women's clubs had moved toward the right in the postwar years; Campbell had moved toward the left.

It is not clear what specific events prompted Campbell to rethink her earlier views on prostitution. But certainly her emerging black left feminism, together with her observations as a professional reformer of poor black women's plight, helps explain her new outlook. It is unfortunate that she did not have more opportunities to flesh out these ideas. Perhaps like Ella Baker, the endless demands of political organizing prevented Campbell from sitting down to write her political philosophy. Nonetheless, these two articles provide an important glimpse into the evolution of her prescient thinking.

Following the Party's adoption of the Black Belt thesis, the Communist Left saw a proliferation of writings by black women radicals examining black women's exploitation and militancy published in the *Negro Champion*. For example, Fanny Austin's article "Women Day Workers" argued that black women household laborers were "amongst the most exploited sections of the working class."[109] Bell Lamb's article "Negro Women in Industry" echoed Grace Campbell's writings by arguing that black women worked as domestics and in menial industrial jobs not "for pleasure but to prevent actual starvation or prostitution." Despite their exploited status, Lamb emphasized how black women "through [their] hard industrial experience developed a considerable degree of class consciousness and thus became material for the foundation of a labor movement along with white men employed in the industrial world." For Lamb, black women were essential to the socialist project.[110]

In addition, early black left feminist writing criticized the racism and sexism within the Communist Left. This was most evident in Maude White's probing article of 1932, "Special Negro Demands," which was published in the Party-affiliated *Labor Defender* magazine.[111] The article was about black

women textile workers and their complex relationship with the Communist-affiliated Needle Trades Workers Industrial Union (NTWIU). Communists had hoped to gain control of New York's massive textile industry through the NTWIU from American Federation of Labor (AFL) rival unions and to organize a feminized workforce in an industry notorious for its racial discrimination and demanding work regimen in which black women held the most menial jobs.[112] Challenging the union to practice what it preached on the issue of black-white unity, White argued that the NTWIU's ability to address "the complaints and grievances of the Negro workers" represented a "sure test of our understanding of the Negro question in the trade union movement." For White, black women textile workers, in essence, constituted the most exploited segment of the workforce due to their race, gender, and class. However, white male Communist trade unionists' racism and sexism prevented them from appreciating black women's exploitation and from tackling these issues. White workers, she asserted, enjoyed some benefits from black women's marginal status, namely a "psychological wage" of what today would be called "whiteness."[113] But this sense of racial superiority was ultimately deleterious for white workers' long-term interests, for it prevented them from uniting with the most militant segment of the working class: black women. These conclusions underscore how she, like other early black Communist women, already had begun refashioning the Negro Question and the Woman Question by centering black women's issues and unequivocally challenging their white comrades' racism and sexism.[114] Moreover, this stance rejected masculinist interpretations of black liberation by calling attention to the gendered nature of black women's oppression. Taken together, early black left literary feminism viewed black women as the revolutionary vanguard, thereby defying the Workers Party's official positions on revolution, race, gender, and class.

The Communist Left did not widely publicize these writings during the 1920s, showing again how black women's issues remained on the WP's margins. Still, early black left feminist writing should not be dismissed. These works provide insight into black women radicals' conversations with one another, suggesting that they began seeing themselves as a group sharing common concerns about black women's marginal place inside the workplace, in the Communist Left, across the globe, and in the vanguard of the world revolution. Their ideas would serve as the basis for future discussions among black left feminists.

Early Soviet Encounters

As the first generation of black Communist women agitated in Harlem, some also traveled overseas in pursuit of their left-wing agendas and global allies. No destination was more important for early black left feminists than the Soviet Union. Maude White, Williana Burroughs, and Hermina Dumont Huiwoud spent extended time there. They traveled to the Soviet Union out of disgust with American racism and in "search of the Soviet promise of a better society."[115] They were hardly the first African American women activists to travel outside U.S. boundaries in the hope of internationalizing the response to Jim Crow and living free of American racism. These motives had underpinned the travels of black women activists such as Ida B. Wells-Barnett and Mary Church Terrell since the nineteenth century.[116] Like the more famous black male radicals Claude McKay, Langston Hughes, W. E. B. Du Bois, and Paul Robeson, who took the "magic pilgrimage" to the Soviet Union during the Old Left period, traveling to the Soviet Union was an exciting opportunity for black women radicals to observe the making of a socialist society.[117] However, traveling to the Soviet Union had special importance to black Communist women.

Sojourning to the Soviet Union was crucial in cultivating black left feminism. The Soviet Union served as a political terrain where black Communist women forged their "New Woman" sensibility and a "black women's international" that was committed to building transnational alliances with women from around the world. Spending extended time in the Soviet Union provided black women radicals with an exhilarating moment of self-discovery and personal freedom. Transformed by their Soviet experiences, they returned home more committed than ever to fighting for black freedom, black women's dignity and rights, and socialism.

Grace Campbell never visited the Soviet Union. Perhaps her concern for safeguarding her civil servant positions from political scrutiny and her complicated relationship with Communist leadership explains why. However, Maude White spent three exciting years in the Soviet Union, an experience critical to the making of her long career as a Communist leader. She had no intention of traveling to the Soviet Union when she first arrived in Chicago in 1927. Soon after her arrival, Party officials recognized her leadership potential. They encouraged her to apply for a scholarship to study at the Communist University of the Toilers of the East (KUTV), an ideological

institute in Moscow founded to train Communist cadres from the colonial world and nationally oppressed people. She won the scholarship and arrived in the Soviet Union in December 1927.[118]

Initially apprehensive about living in the Soviet Union, White soon thrived there. Young and idealistic, she was now at the epicenter of the world revolution. Decades later she described her stay in the Soviet Union as "very stimulating."[119] She found her voice in the Soviet Union. Attending the KUTV was the highlight of her experience. The institute schooled her in Marxism-Leninism, the national question, imperialism, party building, and organizing. Holding the distinction as the first African American Communist woman to attend the KUTV, she was one of the sixty to ninety black people from the United States, the Caribbean, and Africa who studied between 1925 and 1938 at the KUTV and the International Lenin Institute, a select school for training future Communist cadres from around the world. Many KUTV graduates would later become internationally renowned leaders, including Ho Chi Minh, Deng Xiaoping, and Jomo Kenyetta.[120] White sat in on lively discussions on the Black Belt thesis at the Comintern's Sixth Congress in 1928. She traveled across the Soviet Union and "was struck by [its] diversity of peoples and cultures" as she remembered.[121] Often a point of curiosity among Soviet people, many of whom had never seen a black person before, she still felt a sense of camaraderie with them due to what she perceived as their commitment to anti-imperialism, anti-racism, and international solidarity.[122] White never commented on her personal life in the Soviet Union. But she was in her early twenties and thousands of miles from her family and friends. She resided in Moscow, then the center of Bolshevik feminist discussions on women's rights and sexual liberation. It seems hard to imagine that she was unaware of these conversations and that they did not influence her behavior as well as her thoughts.

Ultimately, White returned to New York in early 1930 having been changed by her Soviet experiences. Timid and politically unsophisticated before her trip, she was now a well-trained, confident, cosmopolitan revolutionary. She could not have come home at a more tumultuous time. The United States was in the grip of the Depression, with Communists at the forefront in building mass movements around jobs, social relief, and housing. Recognizing the propaganda value of having a black woman trained in the Soviet Union at the front lines of Communist-led struggles, Party officials immediately assigned her to the Unemployed Council and to the Needle

Trades Workers Industrial Union. White claimed that she was aware of the Party's intentions of using her for promoting its mantra of black-white unity. However, she was unfazed by this move. After visiting the Soviet Union, she wanted to do everything she could for the Party. Most of all, it seems difficult to imagine how her Soviet encounter did not influence her cutting-edge labor journalism of the early 1930s. Her trip bolstered her confidence. Given that few of the American Communists had ventured to the Soviet Union, she probably felt that she had the Soviets' backing as she unapologetically railed against her white American comrades for their racism and sexism.[123]

Similarly, Hermina Dumont Huiswoud's three-year stay in the Soviet Union enhanced her burgeoning black left feminism. In 1930, she and Otto Huiswoud departed for the Soviet Union. The Comintern assigned him to the Anglo-American Section of the Red International of Labor Unions in Moscow. Similar to Maude White's Soviet experience, living in the Soviet Union was a period of intellectual growth and self-discovery for Dumont Huiswoud. During these years, the Huiswouds were often apart, with Otto traveling around the world on behalf of the Communist International. Hermina remained in the Soviet Union. Being childfree and physically separated from Otto gave her time to pursue her own relationship with the Communist International. While Otto received no special training, Hermina completed a fourteen-month program at the Lenin Institute. There, she learned Russian and German. After graduating, Soviet officials assigned her to be an interpreter at the institute. This was a thrilling job. She came to know foreign dignitaries and Communists from around the world, including the famous Spanish Communist leader, Dolores Ibárruri, and Lenin's widow, Nadezda Krupskaya, demonstrating how the Soviet Union provided Dumont Huiswoud with unique opportunities to meet radical women from around the world.[124] Upon the Huiswouds' return to the United States in 1938 after living in the Soviet Union and later in Belgium and France, Dumont Huiswoud was even more committed to socialism and black liberation.[125]

For Williana Burroughs, traveling to the Soviet Union was also critical to bolstering her commitment to Communism and her sense of independence. She made her first of four visits to the Soviet Union in 1928 upon an invitation to serve as an official delegate to the Sixth Comintern Congress. She traveled to Moscow with her two youngest children, ten-year-old Charles and seven-year-old Neal. Her husband remained at home. While all accounts describe him as progressively minded, he appears neither to

have joined the Workers Party nor to have shared his wife's passion for the Soviet Union.[126] After arriving in Moscow, Burroughs participated in discussions on the Negro Question at the Sixth Comintern Congress. She criticized the WP for its "under-estimation" of women's work, particularly of black women's issues, illustrating how black Communist women shrewdly took their grievances with U.S. Communist Party officials to Moscow for redress.[127] One year later, she returned to the Soviet Union and spent ten months there. Again, she left her husband at home. For a woman who was the daughter of an impoverished ex-slave, being courted by Soviet officials and given the opportunity to lead the global Communist movement must have been powerfully affirming.[128]

Burroughs's Soviet encounters had major implications for her children as well. In a bold move, she decided, upon the urging of the Soviet commissar of education, to enroll them in an elite boarding school near Leningrad for children of Soviet and foreign Communist officials before she returned to New York in 1928. Although she had not traveled there for that purpose, the Soviet Union's commitment to black self-determination and internationalism intrigued her. She wanted her children to grow up in a society free of American racism. Her children remained in the Soviet Union for the next fifteen years. Upon her return to the Soviet Union in 1930, she entrusted them to her good friend, Hermina Dumont Huiswoud, who became a surrogate mother to Burroughs's children. Dumont Huiswoud also became good friends with Maude White, demonstrating how the Soviet Union helped black women radicals forge networks between themselves and women revolutionaries from around the world.[129]

For early black women sojourners to the Soviet Union, seeing the world's first socialist nation in action and exchanging ideas with revolutionaries from around the world inspired them and enhanced their sense of transnational citizenship. Courted and treated with respect by Soviet officials, black women radicals returned home determined to fight for racial equality and black women's freedom. The Soviet Union provided a terrain where black left feminists formed a small community. Believing passionately in Communism and black liberation, they shared a belief in women's independence from traditional domestic responsibilities as mothers and wives. Living in the Soviet Union, spending significant time apart from their husbands and, in the case of Burroughs, her children, and working on behalf of the Communist International bolstered these women's sense of confidence and pur-

pose as black women and as revolutionaries. By taking part in the construction of the new socialist world, they were becoming new women as well. The Soviet promise would continue to captivate black women radicals for years to come.

As the United States plunged into economic depression, the Harlem Communist Party counted probably less than a dozen black women members. Despite their small numbers, they were vital to building the first Communist-led movements in Harlem and to formulating black left feminism. Drawing from knowledge they had acquired as community leaders and professional reformers before enlisting in the Workers Party, their activism set the stage for black women who joined the CPUSA after 1930. Like their successors, this first generation of black women who enlisted in the Workers Party did so in part out of frustration with the sexism within traditional black protest groups and the middle-class agendas of the church, women's clubs, and professional reformers. Without question, the international Left's militant anti-racist, anti-imperialist program and global circuitry, as well as the "Soviet promise" of creating a new world, offered black women radicals a powerful alternative to mainstream black protest groups for agitating for the full freedom of black people globally. Joining the Workers Party and in some cases traveling to the Soviet Union transformed black women radicals' lives. They often challenged the bourgeois variants of respectability espoused by church, Garveyite, and clubwomen. Initiating a conversation that lasted for decades, black left feminists began to reframe Marxism-Leninism by viewing black women as the global vanguard. Black women radicals began to form a community and collective identity. Despite their enthusiasm for the Communist cause, black women in the early Party, most notably Grace Campbell, sometimes functioned as outsiders within the Communist Left. Nonetheless, they wrestled with sexism, racism, and sectarianism within the WP and sought to make it their own. This determination was critical to providing the Party with its initial footholds in Harlem by the beginning of the Depression. Growing interest among black intellectuals and everyday people in the Soviet Union, the Depression, and, above all, the Scottsboro case would enable the Communist Party to expand its presence in black communities and to recruit a new generation of black women.

..................................

Searching for the Soviet Promise, Fighting for Scottsboro and Harlem's Survival, 1930–1935

> I found Russia everything I ever hoped and dreamed for.
> JUANITA LEWIS, CAST MEMBER OF THE *BLACK AND WHITE*
> MOTION PICTURE PROJECT, *CHICAGO DEFENDER*, 20 APRIL 1933

> I had joined in with the Communists . . . when I understood they
> could help Africa.
> QUEEN MOTHER AUDLEY MOORE, JUNE 1978,
> *THE BLACK WOMEN ORAL HISTORY PROJECT*

Sojourning to the Soviet Union changed Louise Thompson's life. She made her first magic pilgrimage to the Soviet Union in June 1932. Upon the invitation of the Communist International, she traveled there with a group of twenty-two Americans—twenty-one of whom were black—to star in *Black and White*, a Soviet propaganda film about American race relations.[1] Visiting six Soviet republics, she traveled ten thousand miles across the nation and spent five unforgettable months there. Looking back on her trip, she wrote in her unpublished memoir:

> My journey had an enormous personal and political impact on me and
> shaped my life for many years to come. I had seen more and learned more
> in the Soviet Union than I ever had before in such a short span of time.
> What I had witnessed, especially in Central Asia, convinced me that only
> a new social order could remedy the American racial injustices I knew so

well. I went to the Soviet Union with leftist leanings; I returned home a committed revolutionary.[2]

Following her Soviet trip, Thompson immersed herself in the international amnesty movement on behalf of the "Scottsboro boys." They were nine African American adolescents falsely accused of raping two white women aboard a freight train near Scottsboro, Alabama, on 25 March 1931. Eight defendants were sentenced to death.[3] Communists around the world spearheaded mass campaigns that saved the young men from the electric chair. Thompson participated in these efforts, serving as the principal organizer of the "Free the Scottsboro Boys March" in Washington, D.C., in May 1933. She joined the CPUSA soon afterward. Her Soviet trip and visibility in Scottsboro made her an international celebrity. Due to this, the NAACP's official magazine, *The Crisis*, declared Thompson in 1934 "the leading colored woman in the Communist movement in this country."[4]

This chapter examines the entry of a second generation of black women into the Communist Left during the early 1930s. These women included Louise Thompson, Audley Moore, Thyra Edwards, Bonita Williams, and others. Coming of age during the height of the Depression, traveling to the Soviet Union, and participating in Scottsboro were integral to bringing them into the Communist Left. Comprising a motley collection of social workers, bohemians, and domestic workers, they continued to forge a community of black women radicals. Their initial work in the Communist Left set the stage for their radical activism in Party-affiliated movements for decades to come.

Tracing these black women radicals' lives reveals how black left feminism continued to evolve and take shape during the early 1930s. Key to this was how black women radicals rejected the prevailing organizational and sexual politics of women's clubs, the church, and civil rights and nationalists groups. Although black Communist women often continued working closely with traditional black protest groups, the former's leftist politics and transgressive sexual practices placed them ideologically outside of the political mainstream. Another key intervention of black left feminism of the early 1930s was its reinterpretation of the Black Belt thesis. Black women radicals redefined it through their attempts to center the struggle for black women's freedom, dignity, and survival in the Communist agenda. Women of color, black left feminists believed, constituted the revolutionary vanguard in global struggles for black self-determination and socialism. Extending the

work of their predecessors in Communist movements of the 1920s, this new cadre of black women radicals was at the front lines in leading the Communist Left nationally and in Harlem locally through their grass-roots activism, organization building, global travel, and journalism. Party officials did not always appreciate black women radicals' multiple talents. However, the women became convinced that the Communist Party, not traditional black protest groups, was at the forefront in agitating for racial justice and equality at home and abroad.

The first part of the chapter examines the importance of the Soviet Union to the making of two major black left feminists: Louise Thompson and Thyra Edwards, a prominent social worker, journalist, and world traveler. Thompson's trip in 1932 and Edwards's tour of the Soviet Union in 1934 cultivated their emergent leftist politics, helped them build a "black women's international," and enhanced their New Woman personas that both defied and adhered to prevailing notions of middle-class, female respectability. While in the Soviet Union they grappled with its contradictions. They encountered Soviet misunderstandings of American racism; however, they remained passionately committed to the Soviet Union.

Next, I turn to Scottsboro. The case was critical to bringing this new group of black women into the Communist Left. Paying careful attention to the different roads they followed into the Party, I examine how race, gender, class, and politics positioned middle-class Communists, such as Louise Thompson, and working-class activists, such as Audley Moore and Bonita Williams, differently vis-à-vis one another and white radicals within the CPUSA. Also, I focus on working-class activists' double engagement with nationalism and Communism to flesh out black left feminists' varied locations within the Harlem Communist Party, as well as the national CPUSA's ambivalence toward black nationalism. I then discuss the Harlem-based League of Struggle for Negro Rights (LSNR), the successor of the American Negro Labor Congress, as a site for intergenerational political collaborations between black women radicals.

The chapter concludes by examining black Communist women's visibility in Harlem mass movements around survival issues. Led primarily by working-class activists, such as Bonita Williams and Audley Moore, these campaigns directly touched the lives of ordinary Harlem women and their families. This work revealed black Communist women's vanguard center political approach and their belief that consumption constituted a key site of

struggle. Making the Black Belt thesis their own, black left feminists came to call the Communist Party home. However, their work pushed it in new directions—sometimes in ways their white comrades and mainstream black counterparts neither fully comprehended nor supported.

The Depression provided the backdrop for the entry of the second generation of black women into the Communist Left. The economic crisis decimated Harlem. One-half of the neighborhood's workforce was unemployed. Homelessness and hunger were widespread.[5] Nationally, Communists were at the forefront in demanding jobs, social relief, and immediate government action to end the Depression. The CPUSA's Unemployed Councils, with other Communist and non-Communist groups, regularly staged massive demonstrations around these issues in New York, Chicago, Birmingham, and elsewhere.[6] In response to the economic crisis and social unrest, the Roosevelt administration implemented the New Deal in March 1933 with the goal of giving work to the unemployed, reforming business and financial practices, and promoting economic recovery.[7]

These developments made Harlem fertile ground for new nationalist, left-wing, consumer, and religious movements. Nationalist-led "Don't Buy Where You Can't Work" campaigns against discriminatory white-owned businesses generated immense interest in Harlem during the early 1930s. Father Divine, the charismatic, African American Harlem spiritual leader of the religiously unorthodox Peace Mission, attracted thousands of adherents in the neighborhood.[8] Communists organized protests for jobs, food, and social relief, and blocked evictions.[9]

The Depression, the New Deal, and the rise of new black protest organizations marked the end of the New Negro movement. Established black protest groups, such as the NAACP, the Urban League, the NACW, and the UNIA, were in a state of emergency by the mid-1930s, as the economic crisis called into question the efficacy of their self-help and legalistic approaches to racial equality. These groups' reluctance to participate in mass movements also hurt their standing in black communities. As a result, Communists gained national inroads, especially in Harlem.[10]

The early 1930s signaled the beginning of the CPUSA's heyday. In African American communities, Communists found their greatest success in championing racial justice and equality. No issue in this regard was more important than Scottsboro. With "They Shall Not Die!" as their rallying cry, Communists transformed Scottsboro into a symbol of American racism,

capitalist exploitation, and global white supremacy. The International Labor Defense (ILD), a Communist-affiliated mass legal defense organization headed by William L. Patterson — Louise Thompson's future husband — built a worldwide Scottsboro defense movement. Additionally, Communists organized an amnesty movement of behalf of Angelo Herndon, a nineteen-year-old black Communist organizer who was convicted in Atlanta in 1932 for insurrection under an antebellum slave code for leading an interracial hunger march.[11]

Shifting Communist political lines in the early 1930s affected black women radicals. In response to Adolph Hitler's seizure of power in Germany, the Communist International in March 1933 directed Communist parties worldwide to adopt a new political strategy known as the "United Front." Calling on Communists to work with Socialists and mainstream trade unions to build anti-fascist alliances, this new strategy deemphasized Communist support for anti-colonial, anti-racist struggles. This directive also prompted the CPUSA to Americanize its heavily foreign-born cadre by recruiting native-born members.[12]

In Harlem, the United Front facilitated a new approach to the Communist Party's Negro work. Designating Harlem in June 1933 as one of its "national concentration points," Party officials viewed the neighborhood as a gateway for the CPUSA into black America. Party leadership appointed James Ford, the black Communist leader who ran as vice president on the CPUSA's ticket in 1932, as a "special organizer" to increase membership and impose discipline on the ideologically freewheeling Harlem Communist Party. Ford removed Cyril Briggs and Richard B. Moore, two pioneering Caribbean Communists known for their outspoken black nationalist politics, from leadership positions. In an effort to extend the Party's influence in the neighborhood, Harlem Communists, upon directives from national Party officials, began working with many of their former adversaries for racial and economic justice. These local and international developments set the stage for a new chapter in black left feminism's development.[13]

Experiencing the Promise of the Soviet Union

For Louise Thompson and Thyra Edwards, traveling to the Soviet Union was a transformative experience. They ventured there during the height of African American interest in the Soviet Union. The search for "the Soviet promise of a better society," as Joy Gleason Carew observes, aptly encapsulated

the motivations of black travelers to the Soviet Union in the 1930s, including those of Thompson and Edwards. As the Depression ravaged the capitalist world and years before U.S. cold warriors erected a *cordon sanitaire* around the Soviet Union, a diverse group of black artists, leftist activists, factory workers, educators, sharecroppers, and prominent spokespersons, such as W. E. B. Du Bois and Paul Robeson, eagerly traveled there to see firsthand the world's first socialist state, to seek economic opportunities denied to them at home, and to learn how "to mobilize black communities of resistance back home." Some settled permanently in the Soviet Union.[14]

But the Soviet Union had unique implications for Thompson and Edwards. For them, the country served as a political terrain for nurturing their nascent black left feminism. Like those of black women sojourners of the 1920s, Thompson's and Edwards's travels convinced them, as never before, of the Soviet Union's importance as a revolutionary beacon of hope for African Americans and all oppressed people worldwide. Providing a sense of personal freedom, the Soviet Union helped these women come to think critically about gender, race, and class in a global context. They also wrestled with Soviet contradictions. Still, Thompson and Edwards returned home true believers in the Soviet promise. This enthusiasm for the Soviet Union positioned them politically to the left of mainstream black protest groups and helped them to refashion the Black Belt thesis by locating women of color as the vanguard of the world revolution.

While the Soviet Union was critical in radicalizing Thompson and Edwards, their leftward turns had already begun before they stepped foot on Soviet soil. Their lived experiences as young black women coming of age in Jim Crow America and during the early Depression, together with their frustration with black mainstream reform, politicized them. Louise Thompson Patterson was born in 1901 in Chicago. She grew up poor in small, racist towns across the West Coast before settling by the advent of World War I in Oakland, California, with her mother, Lulu Brown Toles.[15] Her poor, single mother cooked for white families, sensitizing Louise early to the arduous travails of black women. Despite humble origins, she graduated in 1923 from the University of California. Meeting W. E. B. Du Bois when he lectured at Berkeley was a turning point in her life. During his eloquent lecture, she decided to dedicate her life to fighting for racial equality and to doing this work in New York. After his talk, she approached Du Bois and shared her dreams with him. He became her lifelong mentor.[16]

Thyra Edwards followed a different but not less instructive path toward the left. Born in Houston, Texas, in 1897, she moved to Gary, Indiana, after finishing high school. Her mother was a prominent educator who surely instilled in Edwards an ethic for uplifting the race and protecting black women. Resembling Grace Campbell, Edwards became a nationally known expert in urban social problems confronting black women and children, as well as a visible figure in women's clubs by 1930.[17]

Like earlier black leftist women, Thompson's frustration with black middle-class reform and "growing distaste and hatred of white philanthropy," as she recollected years later, was critical to her radicalization.[18] After Berkeley, Thompson briefly taught at the Branch Normal College for Colored People near Pine Bluff, Arkansas, and at the Hampton Institute in Virginia, but she suffocated under the racial conservatism at these institutions. Bitter from these experiences, she visited New York in 1927. There she encountered William L. Patterson, a new Communist recruit from Oakland (she had known him in California). Encouraging her to read Karl Marx's *Capital*, he invited her to study with him in Moscow. She read *Capital* but declined his invitation to travel to Russia. She was not prepared to become a revolutionary. After moving to New York later that same year, she secured a fellowship in social work through the Urban League with the help of Du Bois. But she resigned her position. Like the first-generation black Communist Williana Burroughs, Thompson became troubled by the profession's tendency to blame the poor for being poor. At the same time, she became a central figure in the Harlem Renaissance. Although not an artist herself, she came to know leading Harlem intellectuals, including Aaron Douglass, Zora Neale Hurston, Wallace Thurman, and Langston Hughes, who became an endeared friend. However, Thompson chafed under the movement's control by racist, white benefactors.[19]

Both Thompson and Edwards embraced the New Woman ideal, bolstering their sense of independent black womanhood and interest in racial politics prior to the Depression. Thompson's marriage in 1928 to the gay novelist Wallace Thurman is a case in point. After discovering his homosexuality, she left him, although they remained married until his death in 1934. They had no children.[20] Her marriage and participation in the Harlem Renaissance located her in bohemian communities open to transgressive sexual practices that invariably shaped her sensibility.[21] Similarly, Edwards by the 1930s had rejected traditional marriage and privately supported free love.[22]

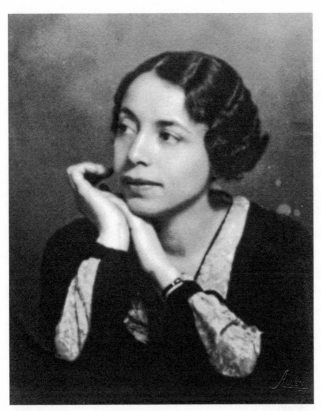

Louise Thompson, early 1930s. SOURCE: LOUISE THOMPSON PATTERSON PAPERS, MANUSCRIPT, ARCHIVES, AND RARE BOOK LIBRARY, EMORY UNIVERSITY.

Thompson's and Edwards's political awakenings were intimately tied to the immersion in homosocial communities of young New Negro women. In Harlem, Thompson closely associated with the poet Marion Cuthbert and the YWCA official Sue Elvie Bailey (Thurman).[23] In 1930, Bailey and Cuthbert helped Thompson secure a position as a research assistant in the Congregational Education Service (CES), a Boston-based reform organization composed mostly of affluent white liberals. Through the CES, she met leading national racial reformers. These included Mary McLeod Bethune, Walter White, and Thyra Edwards, marking the beginning of Edwards's political collaborations with Thompson.[24]

The massive economic and social upheavals caused by the Depression were critical in prompting Edwards and Thompson to search for more radical solutions to social problems. There is no record of Edwards ever joining the Communist Party. But she came to understand that black women were

exploited as workers and that their status was inextricably linked to the labor movement at home and abroad. Given this perspective, in 1931 Edwards resigned her ranking post in the Gary-based Council of Social Agencies, which advocated mutual aid as the solution to hunger and joblessness. She eventually became a labor organizer for the militant AFL-affiliated International Ladies Garment Workers Union. Clearly, Edwards was moving leftward, combining her progressive social work with labor militancy focused on protecting black women and children.[25]

For Thompson, the global depression further stoked her interest in Communism. Upon the urging of William Patterson, who had recently returned to New York after three years in the Soviet Union, she enrolled in the Workers School located in the CPUSA's downtown New York headquarters in 1930. Soon considering herself a fellow traveler, Thompson opened her Harlem apartment as a gathering place where Harlem intellectuals discussed the Soviet Union, Marxism, and Scottsboro. Although she had not officially joined the CPUSA at this point, she had emerged as one of the "well known Harlem radicals and sympathizers" who had traveled, by a circuitous route, into the Communist Left.[26] Touring the Soviet Union would solidify both her and Edwards's drift leftward.

Connections to the Communist Left and labor provided Thompson and Edwards with the opportunity to visit the Soviet Union. Due to Thompson's prominence in Harlem radical circles, the black CPUSA leader James Ford, who had returned in February 1932 from the Soviet Union with authorization for recruiting cast members for the *Black and White* film project, invited her to organize the cast. She accepted his invitation. Forming the Co-Operating Committee for Production of a Soviet Film on Negro Life, she recruited most of the cast, which included Langston Hughes, and corresponded with Soviet officials.[27] Reflecting her growing interest in labor and global affairs, in 1934 Edwards received a fellowship from the AFL to study at the International Peoples' College in Elsinore, Denmark, a nonpartisan peace and labor institute. She spent ten months overseas, including one month in the Soviet Union. The black press widely reported her travels.[28]

From the moment they arrived in the Soviet Union, Thompson and Edwards felt a euphoric sense of personal freedom from American racism. In her first letter from the Soviet Union to her mother, Thompson described the Soviet Union in religious-like terms as the "Promised Land."[29] During their entire stay, Soviet officials treated the cast as "honored guests," she

noted in her memoirs.[30] An interview published in the *Amsterdam News* one week after she returned home best captured her sense of freedom in the Soviet Union. Aptly titled "Prefers Russia Now to Living in America," she emphasized to her interviewer: "Russia was the only place where I was able to forget that I was a Negro. . . . Russians are genuinely interested in us. . . . They were shocked and unable to understand that we were not allowed equal accommodations with whites here in America."[31] Edwards drew similar conclusions. In her interview in Moscow with the former cast member Chatwood Hall, published in the *Chicago Defender*, Edwards stated: "It is only in the Soviet Union that the Negro is recognized as a man. Here he experiences equality of opportunity and of social life."[32] Thompson and Edwards did not correspond about their respective Soviet trips. However, their observations about Soviet life certainly were in conversation with one another.

Although Thompson experienced the time of her life, she nonetheless confronted Soviets' diplomatic opportunism and their misunderstanding of American racism, which resulted in the Soviets' cancellation of the *Black and White* film project in response to American diplomatic pressure in August 1932. Joy Gleason Carew notes that "misinformation" on the part of both Soviet officials and the cast also factored into the film's demise.[33] For instance, the script was unworkable.[34] More significantly, Soviet racial assumptions contributed to the film's cancellation. Believing that all black people were dark complected, the light-skinned cast disappointed Soviet officials and challenged their assumptions about black "visual authenticity." Carew adds: "The Soviets assumed that a certain class solidarity prevailed across African America, but this group, made up primarily of college graduates and professionals and virtually all Northern, urban residents, did not consider itself a group of workers."[35]

Despite the film's cancellation, Thompson stayed in the Soviet Union and she, along with Langston Hughes and other cast members, publicly defended Soviet officials' decision to cancel the film.[36] Edwards traveled there two years later and surely she was aware of the *Black and White* controversy. Several factors explain their continued pro-Soviet views.

In addition to feeling free in the Soviet Union, Thompson's and Edwards's interest in Soviet women's enhanced rights bolstered their support for the country. "Women do everything here: work on building construction, on the street, in the factories . . . everywhere," Thompson explained in her *Amsterdam News* interview, adding: "Women are constantly being encouraged to

assume an equal role in life along side of the men."[37] Thyra Edwards agreed. In her interview with Chatwood Hall, she declared: "The Soviet [Union] has made women free economically by giving them access to all types of employment. It has extended that freedom by freeing them from bearing children against their wishes." American women, she noted, lacked these rights.[38] Also, Soviet women's reproductive rights caught Thompson's attention. In her interview, she stressed that "abortions are legal" in the Soviet Union.[39]

Although they never explicitly stated it, black women sojourners' comments reveal how they sought to build transnational alliances with Soviet women and viewed them as models for black women's freedom. Equally important, Thompson's and Edwards's enthusiasm for Soviet women demonstrates again how internationalism appealed differently to black women radicals than to their male counterparts. While Langston Hughes discussed Soviet women's enhanced rights in his travel account, women's equality did not become a central part of his work or his subjectivity as it did for Thompson and Edwards. Interest in Soviet women's status was crucial to black women's radicalization. The same was not true for black male radicals.[40] Viewing Soviet women as allies, Thompson and Edwards understood women's status as the gauge by which to measure democracy at home, in the Soviet Union, and globally. They also believed that women constituted the vanguard for transformative change. Given this perspective, Thompson and Edwards rejected the pro-capitalist agendas of women's clubs, as well as the masculinist articulations of racial equality espoused both by mainstream black protest groups and the Communist Left.

While visiting the Soviet Union cultivated their growing interest in women's global status, traveling overseas also stoked Edwards's and Thompson's interest in sexual radicalism. In a revealing letter Edwards wrote from Sweden to a friend back home in 1934, she discussed her recent conversation with a Swedish philosopher about sexuality. She noted how they conversed about "those who preach sexual liberty but carefully adhere to orthodoxy." She added that they "talked for hours" about free love and open marriage.[41]

Similarly, the Soviet Union helped Louise Thompson cultivate her public persona as a sexually liberated woman. This was most evident in her interview. Focusing on her body, the *Amsterdam News* reporter emphasized how "she told freely of her reactions towards Russia . . . [with] her Russian cigarette lit, and legs crossed." Given how the American mainstream framed

smoking by women, particularly by unmarried women, as sexually transgressive and believed the myth that Soviets sought to "nationalize" women, her smoking, posture, and publicly expressed enthusiasm for the Soviet Union defied middle-class respectability.[42] Perhaps mindful of her audience, Thompson may have purposefully smoked to convey her sense of independence and to link it to her Soviet experience. Certainly, this performance and her implicit support for radical women's rights challenged the heteronormative sexual politics of the church, women's clubs, the NAACP, and the Garvey movement.

While they cultivated transgressive sexual personas, neither Thompson nor Edwards openly advocated women's sexual freedom. The culture of dissemblance, black women's self-imposed silence on intimate matters to protect them from their oppressors, helps explain their sexual politics.[43] But so does the Old Left's sexual politics. As the historians Kathleen Brown and Elizabeth Faue observe about Edwards, she supported free love but ironically "also viewed sexuality as fundamentally private. Like many American radicals between the wars, Edwards did not consider the advocacy of sexual freedom as politically viable and lacked a public language and space in which to pursue her sexual politics."[44] The noted ex-Communist, feminist scholar Bettina Aptheker affirms this point: "Sexuality, violence against women, reproductive freedom, and other issues that sprang from the [1970s] women's movement did not find their way onto party agendas until the very late 1970s, and then only with considerable resistance from those who considered them personal issues that were not the subject for political discussion." Understanding gender oppression mainly in economic terms, Party leadership viewed sexuality as a "subjective" issue and largely irrelevant to social transformation.[45]

Like Edwards and other Old Leftists, Thompson viewed sexuality as a private matter. Her letters from the Soviet Union to her mother evidenced this. Several cast members engaged in romantic liaisons across the heterosexual and color line. She recounted some of these affairs to her mother. However, Thompson was mostly silent about her private life in the Soviet Union. Even decades later with interviewers, she avoided discussing intimate matters, particularly the more personal aspects of her friendship with Langston Hughes and his alleged homosexuality.[46] In an interview during the 1970s with Hughes's biographer Arnold Rampersad, she claimed, "There was never any relationship between Langston and me other than as a brother." Describ-

ing Hughes as "asexual," she dismissed rumors about his homosexuality: "I never had in any sense any intimation that he was that way [gay]."[47] These claims reflect the Old Left's sexual politics. Lacking a discourse to fully grasp Hughes's sexual identity or its significance to his politics, his sexuality apparently was unimportant to her. Although the Communist Left helped black women radicals cultivate transgressive sensibilities, it also prevented them from appreciating the links between sexuality and politics. Clearly, black women radicals did not completely transcend the gender and sexual politics of their day. These discussions would mostly wait until the late 1960s when a new generation of black feminists centered sexuality in the black feminist agenda.[48]

While Thompson and Edwards refrained from openly discussing their private lives, they were also silent about reversals in Soviet family policy and Stalinist atrocities. Soviet policy increasingly defined femininity and sexuality in traditional terms, cracking down on prostitution and on homosexuals. In 1930, Stalin shut down the Zhenotdel and in 1936 recriminalized abortion. Shifts in Soviet family policy silenced Bolshevik feminists. Stalinist political purges were already under way as well, coinciding with a severe famine in the Soviet countryside.[49] Thompson was not oblivious to problems in the country, remarking in her interview that the Soviet Union was "by no means a paradise." But she did not elaborate on the country's specific shortcomings.[50] Like most Communists at the time, she probably was largely unaware of the darker sides of Stalinist rule and too willing to accept the infallibility of Communist leaders.[51]

Thompson's and Edwards's silence on Soviet contradictions might be interpreted by some scholars as prime examples of how the Soviets duped black radicals.[52] But this was hardly the case. Certainly the Soviets had their own reasons for bringing black people to the Soviet Union. But Thompson and Edwards had their own agendas as well—namely in seeing for themselves the world's only socialist nation and in internationalizing the response to Jim Crow. Even amid the worst excesses of Stalin's rule, some people in the Soviet Union still believed they were creating a new world. While Thompson and Edwards may have been naïve or willfully blind about Stalinist atrocities, they were hardly naïve about the depth of white supremacist practices in the United States and the widespread misery in Depression-era America nor about the violent grip of European imperialism on colonized people. The Soviet constitution professed its solidarity with the world's colo-

nized and nationally oppressed peoples, and Soviets treated Thompson and Edwards with respect that was unimaginable back home. So what they saw in the Soviet Union did represent hope, and revolutionaries from around the world echoed their observations. In this light, their defense of a nation that was the enemy of their enemy makes sense.[53]

No issue was more important in fostering Edwards's and Thompson's support for the Soviet Union than its symbol as an apparent revolutionary ally and model to colonized and racially oppressed people globally. In her interview, Edwards forcefully asserted, "It is necessary that Negroes in America give more attention to the Soviet solution of the race problem. The one thing is certain: that only in a Socialist society can the darker peoples of the world hope for salvation and equality."[54] Thompson drew similar conclusions as she traveled for one month with the eleven remaining cast members, including Langston Hughes, through Soviet Central Asia, a region populated mostly by dark-skinned Muslims. The Communist International sponsored the tour, which was the highlight of her Soviet trip. The tour's purpose was "to study the Soviet policy for National Minorities," as Thompson penned to her mother.[55]

As Thompson and her comrades traveled deeper into Central Asia, they increasingly identified with an imagined, transnational, multiracial community of people struggling against capitalism, imperialism, national oppression, poverty, women's subjugation, and archaic cultural traditions. Further, they understood Afro-Asian solidarity as a critical component of the world revolution.[56] A publicly released statement issued by the cast on 5 October 1932 from Buxara, Uzbekistan, made this point. They credited Bolsheviks for "converting Middle Asia from a czarist colony of oppressed people to an industrialized country under working class rule" and for emancipating women. Impressed by these achievements, the cast declared their intentions to "carry the warm proletarian greetings of the workers and peasants of Uzbekistan to black and white workers and peasants in the United States."[57] The cast's exuberance for the Soviet Union resembled what the historian Robin Kelley observed in his discussions of Depression-era black Alabama sharecroppers' interest in the Soviet Union. Constructing "a folklore that mythologized the Soviet Union," they identified with Russian peasants, viewed Joseph Stalin as the "new Lincoln," and looked to Soviets as the "new Yankees," who would come to the South and finish the battle for black equality that had been thwarted by white supremacists after Reconstruc-

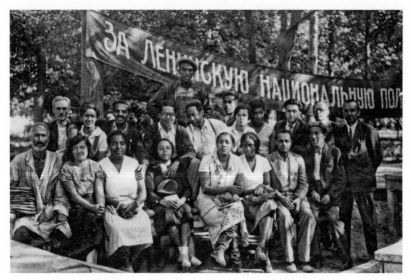

Cast members from the *Black and White* film on a tour of Soviet Central Asia, 1932. Louise Thompson is seated fourth from the left. Langston Hughes is standing behind her left shoulder. The banner in the background reads: "In Support of Lenin's Nationalities Policy."
SOURCE: MATT N. AND EVELYN GRAVES CRAWFORD PAPERS, MANUSCRIPT, ARCHIVES, AND RARE BOOK LIBRARY, EMORY UNIVERSITY.

tion. While Thompson did not draw comparisons between Russian peasant women and black female sharecroppers, she, along with her comrades, saw the Soviet Union as an ally for people of color.[58] For Thompson, her growing interest in the Soviet Union did not subsume her racial or her gender identity into a Communist universalism. Instead, her travels galvanized her multifaceted identity as an African American and as a woman who closely identified with people across the Global South, women in particular.

The complexities of the Soviet relations to its own subaltern populations seemed to have escaped Thompson and Edwards. Despite its anti-imperialist pronouncements, the Soviet Union was, in essence, an imperial power that ruled over millions of non-European peoples, many of whom viewed the Bolsheviks as colonizers. Contrary to the claims by the cast in Buxara, the Soviet borderlands were still an "internal colony" not unlike the Black Belt in the U.S. South and black ghettos in the urban North.[59]

Thompson's Orientalist reading of the status of Soviet Central Asian women stands as the most salient example of her misreading of Soviet society, as she interpreted their lives, as the transnational feminist scholar Chandra Talpade Mohanty puts it, "under Western eyes."[60] Nothing epito-

mized this better than Thompson's outspoken support for unveiling Central Asian Muslim women. Her unpublished memoir notes: "The . . . 'paranja' was a monstrous veil imposed on the women. Many of us in the West had thought of women in veils as romantic and exotic. But when I saw the kind of paraphernalia that women had to wear, I was astounded."[61] Her observations resembled those of early twentieth-century European travelers to the region who, according to the historian Adrienne Edgar, "were unanimous in their condemnation of Muslim society's treatment of women" and "were prone to flowery fantasies about the mysterious 'eastern' women forced to hide behind the veil."[62] Moreover, Thompson's views toward the veil resembled those of Soviet officials, who made unveiling a key part of official Soviet policy of modernizing the region.[63] As the historian Douglas Northrop observes: "The Uzbek veil, in short, became far more than a simple piece of cloth. To Bolshevik activists it represented their 'civilizing mission' and embodied all that was backward and primitive about Central Asia."[64] Thompson failed to mention that veiling was not a uniform, timeless cultural practice in the region or that Bolsheviks sometimes used coercive measures to unveil Muslim women, prompting some Central Asian people to see the veil as a symbol of anti-Soviet nationalism.[65]

The literary scholar Brent Edwards's analytical framework of *décalage*, though applied for critically understanding "what escapes or resists translation" in exchanges of ideas between Anglophone and Francophone black intellectuals and artists in Harlem and Paris during the interwar years, is useful in appreciating how Thompson misread facts on the ground in Central Asia.[66] In her case, she literally could not understand Uzbek women given that she did not speak their language. Her exchanges with local women were mediated by a Soviet translator, whose job was to promote state policy, further confusing matters.

Thompson's Orientalist perceptions of Central Asian women's alleged backwardness speaks to the complexities of transnational exchange between African American women and women from the Global South, underscoring how these encounters do not always occur between equals. Granted, Thompson and Central Asian women were second-class citizens in their respective countries. But in the Soviet Union, Thompson enjoyed immense privilege, as Soviet officials treated her like a foreign dignitary. Separated from her husband and childfree, a status practically unknown to women in the region, she moved freely about the Muslim borderlands at the Soviet govern-

ment's expense. She neither worked on a collective farm or in a factory nor confronted what for many Muslim women was a life-threatening decision of removing a veil. Given this, her relative privilege vis-à-vis Uzbek Muslim women destabilizes "women of color" as a unitary category by exposing the political, cultural, and historical differences between African American women and women from the Global South.[67] So while the global Communist movement could bring women together from around the world, these encounters could simultaneously maintain and reproduce unequal power relations between them. Moreover, Thompson's uncritical support of Soviet policy of unveiling precluded more radical critiques of gender and sexuality, which might have disrupted Soviet discourses of modernity that were intertwined with Muslim women's "emancipation." Again, their enthusiasm for the Soviet promise and their sense of freedom in the Soviet Union explains why Thompson and Edwards overlooked Soviet contradictions.

Like black women radicals before them, Thompson and Edwards returned home transformed by their Soviet experiences. Decades later, Thompson Patterson declared: "Because of what I had seen in the Soviet Union I was ready . . . to make a change. A leap."[68] A leap is what she made when she returned to New York on 19 November 1932. In the weeks thereafter, she emerged as a central figure in Scottsboro. Returning twice to the Soviet Union later in the decade, Edwards would become a leading voice in African American communities against fascism.[69] The Soviet Union solidified both women's black left feminism, propelling them into the international spotlight and global Communist movement. Their Soviet experiences, moreover, show how Thompson and Edwards interpreted the Soviet Union through their emergent black left feminist sensibilities. Certainly, they misread complex realities within Soviet society. But they never lost sight of the Soviet Union as a symbol of hope for black people, women particularly, and as an ally for people of color from around the world.

Scottsboro

While some black women leftists during the early 1930s traveled to the Soviet Union, they also agitated for racial justice at home. No campaign was more important in this regard than Scottsboro. However, the breadth of black women's involvement in Scottsboro has been largely overlooked by scholars. Most scholars have focused mainly on Ada Wright, an intrepid, middle-aged, domestic worker from Chattanooga, Tennessee, and the mother of two

of the Scottsboro defendants, Roy and Andy Wright. Ada Wright emerged an international celebrity for speaking on behalf of the defendants across the United States and Europe during the early 1930s. Although sympathetic to its agenda, Wright apparently never joined the CPUSA. A group of younger black women radicals, however, did. For Louise Thompson, Audley Moore, and Bonita Williams, Scottsboro was critical to their enlistment in the Communist Party. Their visible grass-roots organizing was crucial to building the Scottsboro movement in Harlem and nationally. But they followed varying roads into the CPUSA and functioned differently within it. This can be explained by their divergent class backgrounds and relationships to black nationalism. For Thompson, her middle-class status and connections to leading Harlem intellectuals and national civil rights leaders positioned her at the top of the Communist Left. In contrast, the working-class backgrounds and black nationalist sympathies of Moore and Williams located them in street-level movements around Scottsboro.

No young black woman radical was more visible in building the Scottsboro movement nationally than Louise Thompson. Given her preeminence in the Communist Left following her well-publicized trip to the Soviet Union, as well as her connections to national civil rights leaders and Harlem intellectuals, Thompson was well positioned to become a leading spokesperson for Scottsboro. Immediately after returning from the Soviet Union, she resigned from the Congregational Education Service due to her frustration with white liberalism. She did not enlist in the CPUSA at this point. However, in early 1933 she joined the Party-affiliated National Committee to Defend Political Prisoners, an organization actively involved in Scottsboro.[70]

Thompson was the driving force in organizing the "Free the Scottsboro Boys March," a national march on Washington, D.C., on 8 May 1933 on behalf of the Scottsboro defendants in which the Communist Party was prominent.[71] Keeping with the CPUSA's United Front strategy, she used her connections with prominent community leaders, such as the Reverend Adam Clayton Powell Jr., the young, popular minister of the prestigious Abyssinian Baptist Church, to organize large rallies for the demonstration at Harlem churches.[72] Her hard work paid off. The "Free the Scottsboro Boys March" was an impressive event that brought five thousand protestors to the capital and drew national media coverage. The first major protest for racial equality in Washington, the demonstration presaged future marches on the capital for civil rights. Immediately after the protest, she officially joined the

CPUSA. The march enhanced Thompson's national profile as the leading black woman Communist. The black, Communist, and mainstream press described her as a confident, militant activist, vividly capturing the New Woman public persona she had cultivated for years, particularly following her Soviet trip.[73]

Thompson's New Woman persona and ties to the Communist movement challenged normative ideals about female activism and respectability.[74] In their insightful study of Ada Wright, the historians James A. Miller, Susan D. Pennybacker, and Eve Rosenhaft emphasize how Wright and her Communist supporters utilized her status as mother as a political strategy for establishing Wright's authenticity and as a locus for political mobilization. Her supporters often referred to her as "Mother" Ada Wright and viewed her southern vernacular and working-class background as quaint and racially authentic. Miller, Pennybacker, and Rosenhaft note: "Wright and her supporters adopted an equally modest attitude toward the degree of her political sophistication, but this was to prove a special allure of the campaign." This image sometimes led supporters and detractors alike to view Wright as ignorant.[75] Thompson's public persona contrasted with Wright's. Young, childless, separated, college-educated, northern-born, and vocally pro-Soviet, Thompson's public image did not fit traditional framings of black women's activism and respectability. Instead, her New Woman public persona embodied intellectual sophistication, political independence, and sexual modernism.

At the same time, Thompson's decision to join the CPUSA highlighted her middle-class status. Her enlistment did not constitute a break in her political development. Rather, it formalized a relationship that had been developing for years. She was an ideal recruit for the CPUSA as it adopted the United Front. Native born, middle-class, and not an ardent black nationalist, Thompson possessed connections with civil rights leaders and Harlem intellectuals that would be an asset to the Communist Party. Additionally, she became acquainted with Party leadership. As she recalled: "I knew the top. I came in a sense from the top. I never distributed the *Daily Worker's* [*sic*] or canvassed."[76] Using her connections with Earl Browder, the general secretary of the CPUSA, she secured her first job in the International Workers Order (IWO), a Communist-affiliated fraternal organization that became the main site of her political and cultural work through the 1940s.[77]

Reflecting generational divides, Mary McLeod Bethune, Walter White,

and W. E. B. Du Bois admonished Thompson's decision for joining the CPUSA. She disregarded their criticisms. She was politically independent and had gained class privilege. A college graduate with close connections to Harlem elites and artists, she enjoyed a degree of independence that most black women did not possess. Joining the CPUSA at this moment was hardly exceptional, however, as segments of the black intelligentsia were moving toward the left in response to the economic crisis. Her enlistment in the Party, therefore, did not pose a serious threat to her status within Harlem's black middle-class society. Instead, it solidified her place within it.[78]

Thompson's stature as the leading black woman leftist continued to grow during the mid-1930s. Her arrest and brief jailing in May 1934 in Birmingham, Alabama, while organizing on the IWO's behalf made headlines in the black and Communist press.[79] In addition, her testimony, with other leading Harlem Communists, before a special investigative commission called by Mayor Fiorello La Guardia following the Harlem riot of 19 March 1935 further bolstered her notoriety.[80] Thompson and her comrades effectively communicated the community's frustrations with poverty and racism as the root causes of the disturbance that left three people dead and scores of businesses destroyed.[81] By 1935, she had matured into a savvy, professional revolutionary and had emerged as the preeminent black woman in the international Left.[82]

The journeys of Bonita Williams and Audley Moore into the Communist Party through Scottsboro sharply contrasted from that of Thompson. If she joined the Communist Left through its top, then Williams and Moore certainly entered through its bottom. Their enlistment in the Harlem Communist Party demonstrates how Scottsboro appealed differently to working-class black women radicals with strong nationalist sympathies than to middle-class radicals like Thompson. For Williams and Moore, joining the CPUSA was a distinct break in their respective political journeys. Organizing primarily behind-the-scenes, they interpreted the Black Belt thesis through their own lived experiences as working-class migrants. Their activism reveals the importance of black women proletarian organizers in building the local Scottsboro movement and highlights early tensions between black nationalism and Communism within the Harlem Communist Party.

Fundamentally, Bonita Williams and Audley Moore were working-class, black nationalists. Details about Williams's life are thin. She was born in the British West Indies to a modest family, possessed little formal education, and

probably migrated to the United States in search of a better life. Her experiences with poverty and migration surely shaped her life and politics.[83]

To be sure, coming of age in the Jim Crow South and in a racially defiant family forever shaped Audley Moore's life. Born in 1898 in New Iberia, Louisiana, outside of New Orleans, she grew up keenly aware of the racist violence in her midst. Throughout her childhood, she heard stories about family members who had been lynched and about her paternal grandmother, who had been raped by a white slave master in an act that produced Moore's father. Despite living in a violent, racist world, Queen Mother Moore boasted: "I came from a tradition of fighters."[84] Her father was a racially proud, successful entrepreneur and a former deputy sheriff in St. Charles Parish following Reconstruction. However, the untimely death of Moore's mother forced her to drop out of school at the age of eleven, after completing only half of the fourth grade, to care for her two younger sisters. Not finishing school deeply pained her throughout her entire life. Her father's death a few years later thrust Moore into the southern, black urban working class and the role of the family provider by World War I. Orphaned, Moore took her sisters to New Orleans where she worked as a domestic laborer. White men regularly sexually assaulted her on the job. She never forgot these painful experiences. Despite these horrific encounters, she resourcefully found ways to survive and maintain a sense of dignity. This knowledge would become foundational to her political activism in the coming years.[85] Given Williams's working-class status and her concern for wage-earning Harlem women as a Communist organizer, it seems likely that she, too, toiled in domestic service and was exceedingly familiar with household workers' plight.

Garveyism attracted both Williams and Moore before they joined the Communist Party. In the early 1920s, Moore became a devoted follower of Marcus Garvey after she heard him speak in New Orleans, a hotbed of southern Garveyism.[86] His call for race pride and African redemption mesmerized her, providing her with an ideology to synthesize her experiences with racism and poverty and to understand them within a global context.[87] Garveyism would also inform her gender and sexual politics and her identity as a black woman. The historian Mary Rolinson has observed the deep resonance among southern Garveyites of calls for self-defense and protection of black women and girls from sexual and economic exploitation. Given Moore's experiences as a domestic and her knowledge of her grandmother's

rape by a white man, Garvey's message spoke directly to her. Garveyism probably appealed to Williams for similar reasons.[88]

Following her conversion to Garveyism, Moore, along with her husband, Frank Warner, a Haitian tailor and Garveyite, eventually made her way to New York. There, they intended to help Garvey launch the Black Star Line, a commercial fleet of black ships he envisioned as the capstone for black economic independence.[89] Moore's initial excitement of living in Harlem soon gave way to disappointment. Rampant poverty, misery, and racism in the neighborhood infuriated her. She was outraged by the "slave markets," select street corners in the Bronx and Manhattan where black women stood to be hired for household day labor by white housewives. Concerned with the neighborhood's survival, Moore began working as an organizer for tenants rights groups and the local Republican Party. Neither Moore nor Williams were involved in the Harlem Tenants League or Communist Party at this time. However, Scottsboro forever changed their lives.[90]

The Communist Party's black nationalist framings of Scottsboro were critical in bringing Moore and Williams into the CPUSA. Moore joined the International Labor Defense immediately after she paraded with thousands of people—black and white—in a Harlem Scottsboro demonstration during the early 1930s. The protest's size and strident anti-racist, anti-imperialist, internationalist message deeply impressed her. Listening carefully to black Communist speakers denounce European imperialism in Africa, she remembered hearing them claim that the Communist Party "had a worldwide movement with the working class." After hearing this, she concluded: "This [the CPUSA] was a wonderful vehicle. If they've got a movement like that, and they're conscious of this thing that Garvey had been speaking about, then this may be a good thing for me to get in to help free my people."[91]

Queen Mother Moore's testimony is significant. She was hardly a blank slate when she first encountered the CPUSA. Instead, she read the Party's program for black self-determination through Garveyite lenses. The parade's black nationalist message was reminiscent of the Garvey movement during its heyday. Still, the Communist Party offered her something new. As for Thompson and black Communist women of the 1920s, the Party provided a framework for understanding the contours of racial oppression and capitalist exploitation that Moore had known so well. She never traveled to the Soviet Union. But she was thrilled by the Communist Party's links to revolu-

tionaries around the world. The utopian aspects of the CPUSA's program also captivated her. As Queen Mother Moore's son, Thomas Warner, recalled, "She joined the Communist Party because she dreamed of making a better world."[92]

Scottsboro also enthralled Bonita Williams. This is evident in her poem "Fifteen Million Negroes Speak," which was published in the *Harlem Liberator*, the official newspaper of the League of Struggle for Negro Rights, in 1933. Viewing Scottsboro as a powerful symbol of Jim Crow, black exploitation, and poverty, the poem vividly shows how the case, as well as Communist anti-racist militancy, captured her freedom dreams.

> We will march to Washington
> In workers solidarity, Black and White
> Not only with thousands of petitions
> But to demand a Bill of Civil Rights
> Fifteen million Negroes are weary
> Of being jim-crowed every place
> Their lives are burdened and dreary
> As the most exploited race
> Fifteen million people are stirring
> Soon their voices will be heard
> When they unite their struggles
> Like a great thundering herd

This poem's reference to the "Free the Scottsboro Boys March" in Washington suggests that she may have helped organize the demonstration and marched in it. There is no archival record, however, to confirm this. To be sure, she understood Scottsboro as crucial to the black struggle for self-determination. Calling for black-white unity, the poem ends with Williams's defiant demand for black equality. Clearly, she embraced the Black Belt thesis and Communism. But for Williams and Moore, black nationalism remained at the core in defining their worldviews and subjectivities.[93]

While the Party's militant call for the Scottsboro defendants' freedom was instrumental in bringing Moore and Williams into the CPUSA, their decisions to join the Party had as much do with the state of crisis in which most traditional black protest groups found themselves during the early Depression. Women's clubs had lost touch with black working-class women. The UNIA was in disarray. The NAACP and Father Divine's Peace Mission

shunned mass action. For two determined activists like Moore and Williams, the dynamic social justice movements linked to the Communist Party offered exciting viable alternatives for advancing black freedom domestically and globally.[94]

Moore's and Williams's early years in the Communist Left highlight black working-class women's key role in building grass-roots support in Harlem for the Scottsboro defendants. Both women joined the International Labor Defense and plunged into the Scottsboro movement. They were not alone. More than four thousand Harlem residents joined the ILD in 1933.[95] From street corners, Moore enthusiastically canvassed for Scottsboro on behalf of the ILD and gained a reputation as a powerful stepladder speaker whose oratory was inflected with the cadences of southern black churches. Similarly, Williams was an effective orator.[96] Street-level organizing provided Moore and Williams with a political education, enabling them to perfect their organizing skills in real time and with everyday Harlem residents.[97] Communist-affiliated movements also helped black women radicals come together. Moore and Williams eventually became close friends, with Queen Mother Moore fondly remembering Williams as "so darling, so sincere" for her tireless work on behalf of Harlem women.[98]

For Moore and Williams, the Communist Left provided a powerful alternative education. As Queen Mother Moore recounted decades later, "They [the Communist Party] taught me the science of society." She added that it was in the CPUSA "where [she] . . . really learned to struggle."[99] She took classes at the Harlem Workers School, absorbing lessons about history, Marxism-Leninism, the Negro Question, organizing, and public speaking. She cherished this knowledge for the rest of her life. Given that Williams attained leadership positions in Communist-affiliated groups, she certainly would have been obligated to have taken these classes as well. Moore's and Williams's initial involvement in the CPUSA provided institutional support to their community work, but it also initiated a psychological transformation. Given that Moore had not completed elementary school, her Communist education filled a void in her life. This knowledge provided her with an analytical framework not only to understand the world and her place within it, but to nurture a belief that she could radically change it. The same was surely true for Williams.[100]

Moore and Williams also had pragmatic reasons for enlisting in the Party. Although Queen Mother Moore claimed that she lived in the elite Sugar Hill

section of Harlem when she enlisted in the Party, her life at the time was apparently far less secure than she portended years later. During the first half of the Depression, she worked in a Manhattan laundry factory and as a domestic. After becoming unemployed, she received home relief. She and her husband apparently separated.[101] Considering that Communists were building inroads into the Harlem middle class, she may have viewed the Party as a means for upward social mobility. Bonita Williams may have drawn similar conclusions. For Harlem Communist Party leaders, Moore's and Williams's expertise as grass-roots organizers, as well as their connections to the Garvey movement and local community groups, made them attractive recruits. For these reasons, Williams and Moore, as well as Harlem Communist Party officials, had reasons—many of which were more practical and pragmatic than idealistic—in being mutually interested in the other.

Moore's recruitment sheds light on the Harlem Communist Party's ambivalence toward black nationalism. Because she had joined the ILD, Moore mistakenly believed at first that she had also joined the Communist Party. But she learned through a conversation with a Party member that this was not the case. Soon after this encounter, she signed her CPUSA membership card. From this episode, she learned: "They [Communists] didn't just recruit anybody. They usually tested you out to see how sincere you were."[102] Soon after signing a membership card, she claimed to have discovered that "other people in the Communist Party was waiting for me to 'get right. . . .'" She added, "Because I had come out of the Garvey movement, they never really did trust me."[103] These are strong allegations. However, they cannot be verified. Was Queen Mother Moore reading back a history for herself that constructed a narrative that foreshadowed her eventual break from the Communist Party, thereby validating the strident nationalist politics that she adopted following World War II? This is hard to say. But it is true that Communist officials often remained cool toward black nationalism. Despite the CPUSA's call for "Negro liberation," Party officials punished, even expelled, black Communists for allegedly embracing "bourgeois nationalism." The Party also opposed racially separatist political organizing and social gatherings among black Communists during the entire Old Left period.[104]

However, Moore's and Williams's street-level location in the more ideological freewheeling ILD placed them outside of Party leaders' direct control during the early 1930s. This provided Moore and Williams with more political latitude than ranking black male party officials with strong nation-

alist politics, or even Louise Thompson, who was close to the CPUSA leadership and had traveled to the Soviet Union. Even if Williams and Moore had wanted to sojourn to the Soviet Union, they lacked the class status and connections with Party officials that had enabled Thompson to travel there. So in contrast to Thompson, who had traveled to the Soviet Union, had hobnobbed with Harlem intellectuals and Party leaders, and had acquired a thorough knowledge of Marxism-Leninism prior to enlisting in the CPUSA, Moore and Williams did not have connections with the Communist Party or with Harlem elites before they enlisted in the Party at the grass-roots level. For now, Moore and Williams could maintain their nationalist politics without facing serious sanction from Party officials. Indeed, Scottsboro was key in attracting black women to the Communist Left. But they traveled multiple paths into it.

The League of Struggle for Negro Rights

While black women traveled separate roads into the Communist Left and were positioned differently within it, they found opportunities for working together through the League of Struggle for Negro Rights. Like its predecessor, the American Negro Labor Congress, the Harlem-based LSNR never became a mass organization as Party officials had hoped.[105] Still, in Harlem the LSNR served as a site for exchange between first- and second-generation black Communist women and a site where they carried out visible community work. Black women were prominent in the group. Its executive board included Louise Thompson, Bonita Williams, Maude White, and Williana Burroughs. Audley Moore was not involved with the organization.[106] There is no record of Grace Campbell's involvement in the group; in fact, neither Louise Thompson Patterson nor Audley Moore mentioned meeting Campbell. However, Williana Burroughs and Maude White surely shared their memories of Communist struggles in the 1920s with Thompson and Williams.[107]

The LSNR emerged as an important site for black left feminist advocacy. This was most evident in Burroughs's work. She headed the group's women's division, led LSNR-sponsored mass actions around Scottsboro and housing, and served on the editorial board of the group's newspaper, the *Harlem Liberator*. In addition to providing Burroughs with opportunities to agitate on black women's behalf with the Communist Left, the LSNR enhanced Burroughs's reputation in Harlem as a leading Communist. It was this noto-

riety that helps explain why she ran for New York City comptroller on the CPUSA ticket in 1934. She won nearly thirty-one thousand votes, the most ever received at that time by a Communist candidate running for New York public office, underscoring her popularity within the community.[108] However, personal tragedy eclipsed her impressive electoral showing. In June 1933, Burroughs lost her teaching job in the New York public schools for her outspoken support of an embattled, white, left-wing leader of her teachers' union, which was affiliated with the American Federation of Labor. This was the second time she had unjustly lost a teaching job. Unemployed and surely infuriated with losing her job, Burroughs returned to the Soviet Union in October 1935 in search of better professional opportunities, leaving her husband at home. She would not return to the United States for ten years.[109] Burroughs's ordeal is telling. Signaling what was to come during the Cold War, her job loss illustrates how the state persecuted black women radicals for their Communist Party membership. For now, however, most black women radicals went about their work in fighting for racial equality and social justice.

Survival Issues

Theodore Bassett, the Harlem Communist Party's chief of agitation and propaganda during the mid-1930s, claimed that black women comprised "70% of our membership." Most of these women, he added, were concentrated in the unemployment movement.[110] His comments are instructive. They suggest not only that everyday Harlem women were more actively involved in the Communist Left than black men but also that the Party's Marxist-Leninist ideology was not the primary factor in attracting these women. Instead, it was the Party's visible presence on the streets fighting for racial justice and championing the community's survival that won their allegiance.[111] Indefatigable grass-roots Party organizers and leaders, with strong nationalist sympathies and working-class backgrounds, such as Bonita Williams and Audley Moore, were largely responsible for this development. Placing black working-class women's well-being at the center of the Harlem Communist Party's agenda, black left feminists reinterpreted the Black Belt thesis by challenging its masculinist framings of black self-determination.

No person was more central to these struggles than Bonita Williams. She played a central role in leading mass movements in Harlem around cost-of-living issues from the mid-1930s through World War II, directly touching

the lives of many black women and children.[112] Communists did not invent campaigns against high-priced food in Harlem. For years, Harlem nationalists and consumer groups had vocalized the community's resentment toward white merchants who monopolized the neighborhood's grocery businesses, often sold expensive, poor quality food, disrespected black patrons, and sometimes sexually harassed black women and children. Nationalists picketed white grocers and petitioned city officials. Consumer groups, such as the Young Negroes Cooperative League, led by the young Ella Baker, the future, revered civil rights activist of the 1960s, established economic cooperatives. There is no evidence indicating that Williams worked with Baker. But the former surely knew that Communist-led protests were part of wider efforts.[113]

In June 1935, Williams formed and chaired the Party-affiliated Harlem Action Committee against the High Cost of Living, a group composed almost exclusively of working-class women. The group sponsored the well-publicized mass action on 3 June 1935, in which one thousand protestors forced white grocers along 125th Street to cut meat prices. By any measure, this action was a resounding success. In the days immediately following, the *Amsterdam News* praised the Party and specifically credited Williams for keeping the community's frustrations with the high cost of living in the public spotlight in the wake of the recent Harlem riot.[114]

Williams linked her community work with nationalist struggles in the Caribbean. In May 1938, at a mass meeting held at the Abyssinian Baptist Church, she and Richard Moore denounced the recent shooting of striking Jamaican sugarcane workers by British forces. This strike was part of a wave of anti-colonial unrest across the Anglophone Caribbean during the late 1930s. That she hailed from the Caribbean surely helps explain her interest in these upheavals.[115]

Women in the Harlem Communist Party also led struggles around other pressing community concerns. Audley Moore and Bonita Williams helped block evictions, led rent strikes, and worked closely with the non-Communist Consolidated Tenants League. Williams picketed racially discriminatory Harlem businesses in "Don't Buy Where You Can't Work" campaigns. On the labor front, Moore helped organize domestic workers and a union in 1938 on her job at the Works Progress Administration's (WPA) garment project in Harlem. The massive facility employed nearly thirty-five hundred women, most of whom were black, Puerto Rican, and Italian. The

Party assigned her to unionize her co-workers, a task for which she was well suited. As a southern migrant who had toiled since her teenage years in menial jobs and, more recently, had collected home relief to provide for herself and her young child, she could easily relate with her co-workers' struggles to survive. Given these experiences and her powerful oratory skills, she surely articulated the reasons for building a union in a language her co-workers easily understood and subsequently won their trust.[116]

The Harlem Communist Party leadership rewarded Moore for her hard work. In 1938, her comrades elected her chair of the Harlem Communist Party's Women Commission and executive secretary of the Upper Harlem Section. By the end of the decade, Moore had moved up the ranks of the Harlem Communist Party and into the public spotlight due largely to her hard work in fighting for black working-class women's well-being.[117]

The involvement of the Harlem Communist Party's women's leadership in consumer campaigns elucidates their broader political vision. They were equally comfortable in working behind the scenes as they were in leading large crowds in street-level movements. Black Communist women's anti-capitalist politics contrasted from the "buy black" strategies espoused by black nationalists and the mutual aid approaches employed by women's clubs, the church, and consumer movements for improving black living conditions. For black Communist women, these strategies failed to address the structural origins of poverty and racism and the need for a comprehensive social safety net. While their approach differed from those of non-Communists, the consumer activism of the women in the Harlem Communist Party also challenged the CPUSA's stance on the importance of consumption to the socialist struggle. Communist-affiliated campaigns nationwide won some impressive victories around cost-of-living issues. However, the Party's over-whelmingly male leadership paid mostly lip service to consumer movements, remaining convinced that the shop floor was the key site for class struggle. Black Communist women in Harlem categorically rejected this line of reasoning. Similar to the work of black women radicals in the earlier Harlem Tenants League, Depression-era Harlem women leftists rejected the false distinction between the public and private spheres by appreciating the connections between consumption and production. Women participants in Depression-era consumer movements, observes the historian Annelise Orleck, "had no doubt that their work in the home was linked to the labor of their husbands in fields and factories, to the national economy, and to

rapidly expanding government agencies."[118] Like their predecessors, Moore, Williams, and others understood how capitalism exploited black women as blacks, as mothers, and as workers, thereby positioning them at the vanguard for social change. Given this perspective, they saw the fight around the cost of living as critical both to protecting and demanding respect for black womanhood and motherhood. Black women radicals also connected these campaigns to broader struggles for socialism, black self-determination, and women's equality.[119]

Despite the Party's ambivalence toward consumer movements, the importance of Harlem Communist women's activism around consumption should not be dismissed. This work had tremendous impact on Harlem, particularly on working-class women. Taking to Harlem's streets, winning concessions from merchants, and gaining public attention to pressing community concerns amounted to powerful transformative experiences and political educations for their participants. These actions enabled Harlem activists to appreciate their collective power and the connections between their personal plights, structural inequalities, and public policy.[120]

For many Harlem women, Party-led campaigns around consumption and other community concerns were important gateways into struggles for labor and civil rights, and against fascism in the coming years. These struggles also attracted several new black women recruits, some of whom emerged as important leaders in the Harlem Communist Party. One of these women was Rose Gaulden, a charismatic migrant from Georgia and a dependable organizer who directed mass campaigns around housing and health services. Like Williams and Moore, Gaulden maintained close relationships with black nationalists and was an able orator. Gaulden would collaborate with Moore and Williams in street-level CPUSA campaigns around housing and for black political power through World War II, revealing how black female working-class activists formed a community and shared common interests.[121]

The efforts of working-class activists like Moore, Williams, and Gaulden did not translate into a significant increase of blacks into the Harlem Communist Party's rank-and-file or the national CPUSA by the mid-1930s. The low numbers and high turnover rates of blacks in the Party alarmed CPUSA officials. Nationally, black rank-and-file membership increased from about two hundred in 1929 to nearly one thousand by 1931. In January 1932, the Harlem Communist Party counted only about seventy-five black mem-

bers.[122] However, counting the black Party members diminishes the importance of the Harlem Communist Party's street-level activists. The key significance of their work rested not so much in enlisting blacks as Party members but rather in mobilizing thousands of Harlem residents around Scottsboro and survival issues. The activism of Moore, Gaulden, and Williams suggests that it was working-class black female grass-roots organizers with strong nationalist leanings, not middle-class intellectuals like Louise Thompson, who were central to building the Harlem Communist Party.

The grass-roots organizing of Harlem Communist women provides insight into the dynamics of black Communist working-class women's leadership. Their credibility rested not with middle-class Harlem intellectuals and Party leaders, as in the case of Thompson, but in their reputations on Harlem streets as effective, trustworthy community activists who were steeped in the cultural traditions of Harlem's southern and Caribbean migrant populations. In this sense, Williams, Moore, and Gaulden were not only positioned differently within the Communist Left than Thompson. These working-class leaders spoke in a different political language and operated in different social worlds than Thompson.

Black women were not the only grass-roots organizers in Harlem. Black men and white Communists also took part in street-level work in Harlem. The black Communist Abner Berry is one example. A Texas native from working-class origins, he was one of the Harlem Communist Party's best community liaisons, who, like Moore, possessed the uncanny ability to relate with everyday people and to win their trust. In its efforts to promote black-white unity, the Party assigned white Communists, such as the New York Jewish Communist George Charney, to Harlem.[123]

While the Harlem Communist Party counted black male and white grass-roots organizers, black women proved to be the most effective Party organizers in Harlem. In contrast to white organizers assigned to Harlem by the Party, black female Communists possessed organic connections to the neighborhood. They had lived there for years, and they were intimately familiar with the community's concerns. Since black communities viewed grass-roots leadership as the preserve of black women, black Communist women were better positioned than their black male counterparts in serving as community leaders. But black women's location at the grass roots was not simply a function of cultural factors; sexism within the Harlem Communist Party also explains why black women operated largely behind the scenes.

Black Communist men concentrated power within their hands. Given this, the street-level campaigns where Moore worked and the intellectual circuits in which Thompson traveled provided black women with the most accessible channels to lead. It seems that the Harlem Communist Party viewed grass-roots organizing largely as women's work, revealing again how the black Left was hardly immune from the sexist thinking of the day. While black women, such as Bonita Williams and Audley Moore, eventually gained formal leadership positions within the Party, they never enjoyed the same kind of influence within the CPUSA as their black male counterparts. But black women radicals did not complacently accept their status. In the coming years, they increasingly vocalized their frustration with the CPUSA's neglect of black women's issues both within and without the Party.

The Soviet promise and Scottsboro captured the imaginations of a small group of black women as the United States reeled under the Depression in the early 1930s. Louise Thompson, Thyra Edwards, Audley Moore, and Bonita Williams came from different social, political, and geographic locations. But they all made the Communist Left a principal site of their activism. Their initial involvement in the CPUSA set the stage for their radical political work for the rest of their lives. They became Marxists. But they came to Marxism in ways Marx could have neither envisioned nor comprehended. Their lived experiences as black women cleaning the kitchens of white women under the constant threat of sexual assault by white men, dealing with the trauma of migration, traveling to the Soviet Union, and confronting racist, paternalist white reformers radicalized a small community of black women. This knowledge, together with unprecedented global social and economic turmoil, cultivated their black left feminism. Fighting for black women's freedom and dignity was at the center of this agenda. Internationally, black women radicals looked to the Soviet Union as a beacon of hope. Deeply impressed with Soviet women's enhanced rights, black women leftists sought to build transnational political alliances with women through the Communist Left. The New Woman personas of the Party's black women and their identification with Soviet women often challenged images of middle-class respectability. In pursuing this politics, black Communist women both reinterpreted the Black Belt thesis by locating women of color as the vanguard of change and rejected the political programs of traditional black protest groups. Black left feminists were forging a new politics.

But black left feminism not only changed the lives of black Communists.

Black left feminism also made an imprint on Harlem. Through their tireless, behind-the-scenes activism and visible leadership of Communist-affiliated groups, black women radicals helped transform the Harlem Communist Party from a small, sectarian organization into a dynamic social movement focused on winning racial equality and securing the community's survival. It was this passion for justice, coupled with black women radicals' coalitional approach to organizing, that well prepared them for the future. As the international Left looked with alarm toward the rise of fascism in Western Europe and the prospects of another world war, the CPUSA now counted on a talented group of black women leaders. In the coming years, they would not only play a crucial role in building anti-fascist movements within black communities; they would also continue to advance their cardinal belief that advancing black women's freedom was essential for dismantling all the systems of human oppression.

..

Toward a Brighter Dawn

Black Women Forge the Popular Front, 1935–1940

> I was like millions of Negro people, and white progressives and people
> stirred by this [Scottsboro] heinous frame-up. I was impressed by the
> Communist speakers who explained the reasons for this brutal crime
> against the young Negro boys; and who related the Scottsboro case to the
> struggle of the Ethiopian people against fascism, and Mussolini invasion.
> Friends of mine who were Communists began to have frequent discussions
> with me. I joined the Party in February 1936 and was assigned to work in
> the YCL [Young Communist League] shortly after.
>
> CLAUDIA JONES TO WILLIAM Z. FOSTER, 6 DECEMBER 1955

The Communist Party's ability to intertwine support for the defense of
Ethiopia with Scottsboro was critical to recruiting the young Claudia Jones
into the Communist Left during the mid-1930s. She was one of several
black women who entered the CPUSA during the Popular Front, the period
when the CPUSA, upon directives from the Seventh Congress of the Com-
munist International in Moscow in August 1935, officially abandoned Third
Period Communism and built left-liberal coalitions to stem the spread of
fascism. Committed to Popular Front internationalism, anti-racism, and
anti-fascism, Jones by the late 1930s had emerged as one of the CPUSA's
most promising young leaders.

This chapter seeks to rethink the Popular Front through the lives of
black women radicals. These women were at the forefront in forging a
"black Popular Front." The historian Penny Von Eschen defines this as a

World War II–era "second incarnation" of the Popular Front of the 1930s in which "black civil rights and anti-colonial activists—invigorated by crumbling European hegemony and the domestic upheavals of war—forged an anti-colonial, anti-fascist, anti-racist politics."[1] In this chapter, I draw on this term to show how black women radicals advanced their own variant of Popular Front feminism, a left-wing feminist politics emerging out of Popular Front movements of the 1930s and 1940s, through their organization building, public speaking, cultural work, international travel, and journalism.[2] Extending their work from the early Depression, black left feminists understood black women as the key agents of transformative change and appreciated their freedom as inseparable from campaigns against fascism and colonialism, and for union rights, civil rights, and women's equality. For these leftist women of color, black women remained the barometer by which to measure democracy at home and abroad, as well as the Party's commitment to progressive change.

The first part of the chapter traces the importance of anti-fascism in the making of black women radicals. I do this through examining the entry of Claudia Jones and Esther Cooper into the CPUSA. Their radicalizations are instructive. They reveal how black women from different social and geographic backgrounds saw anti-fascism as a powerful vehicle for fighting against racial inequalities and social injustice outside of traditional black protest groups. The chapter then examines how black women radicals were primary actors in forging domestic and international linkages. Their interest in the Spanish Civil War, the most significant international crisis for the global Communist movement during the Popular Front, was critical to this. Some black women radicals traveled there, witnessing the war firsthand. Spain became a terrain that fostered a "black women's international" committed to defeating fascism. Spain was also critical to black women radicals' efforts in building the cultural front.[3]

Next, the chapter examines the ongoing development of a black women's radical intellectual tradition through their writings. Anticipating arguments made in the Communist Left in the post–World War II era and by black feminists of the 1970s, Louise Thompson, Esther Cooper, and others formulated the most probing black left feminist theoretics to date of black women's multiple oppressions. Their work advanced their nascent triple oppression paradigm and vanguard center approach to politics, critiquing both the racism and sexism within the Popular Front and white Communist women's

Popular Front feminism, which typically constructed womanhood as universally white. The chapter concludes by looking at controversies within the Harlem Communist Party around interracial marriages between black male and white female Communists. Some black women vocally opposed these unions. These controversies revealed larger, persistent tensions within the Communist Left around race, gender, class, sexuality, and power that were exacerbated by the Popular Front. Exposing black women's status as outsiders within the Communist Party, these controversies also illustrated how black women radicals understood the personal as political. Taken together, their varied political journeys speak to the ongoing process by which black women came together through the Communist Party, built black and multiracial radical transnational movements, and formulated black left feminist thought during the Popular Front. Above all, their activism illustrates how a community of black women radicals continued to see in the Communist Left a powerful alternative to women's clubs, the church, and civil rights and black nationalist groups for advancing black freedom and black women's dignity globally.

Often referred to by scholars as the "heyday" of American Communism, the Popular Front, which was known in the United States by 1938 as the Democratic Front, provided the background in which black women radicals carried out their work. Declaring "Communism is Twentieth Century Americanism," the CPUSA deemphasized Marxist-Leninist language and promoted a leftist populism linking the CPUSA's program to the American revolutionary heritage. The Party now enthusiastically backed President Roosevelt's New Deal. Appealing to trade unionists, artists, intellectuals, white housewives, and civil rights and women's organizations like never before, the CPUSA's membership soared from about thirty thousand members in 1934 to nearly eighty thousand in 1938.[4]

The Popular Front contained important implications for the Negro Question. The Party deemphasized its call for the self-determination of the Black Belt and decolonization. As such, it dissolved the League of Struggle for Negro Rights. Through the "Negro People's Front," the auxiliary to the Popular Front in African American communities, Communists focused on winning civil rights and jobs. The Party backed the National Negro Congress (NNC), a black united front organization formed in 1936 in Chicago that was committed to civil rights, anti-fascism, and internationalism. The most influential black Popular Front organization, the NNC briefly rivaled

the National Association for the Advancement of Colored People (NAACP) as the leading African American protest organization.[5] At the same time, new black women's organizations emerged. These included Mary McLeod Bethune's National Council of Negro Women (NCNW), formed in 1935, as well as Alpha Kappa Alpha's National Non-Partisan Council and the International Ladies' Auxiliary of the Brotherhood of Sleeping Car Porters, both established in 1938. Inspired by insurgent social movements of the 1930s and the New Deal, these organizations championed black working-class women's issues.[6]

The Popular Front contained contradictory implications on the Woman Question. The CPUSA did not relinquish its official economically determinist line on women's oppression that was adopted in the early 1920s. But due to women's efforts, the Communist Left saw an upsurge of activity around "women's work" and a wave of literary work focused on the non-economic sources of women's oppression. The Party's National Women's Committee became more active than it had been for years. At the same time, in an effort both to conform to mainstream American values and to disabuse public perceptions of its advocacy of free love, the Party promoted traditional understandings of women as mothers and of the family, abandoning critiques of the bourgeois family, home, and prevailing sexual mores as sites of social intervention. This move mirrored the Soviet Union's conservative turn on family policy. Similarly, U.S. labor during the 1930s increasingly promoted a masculine culture, envisioning women as mothers and framing labor rights as a masculine struggle. Outreaching to politically mainstream, middle-class women in the YWCA, the League of Women Voters, and the Parent Teachers Association, the CPUSA backed national campaigns in support of birth control and the "Women's Charter," a progressive alternative to the National Woman's Party's Equal Rights Amendment. Women's membership in the CPUSA soared. By 1938, women comprised 25 percent of Party membership, or about twenty-five thousand members, a significant proportion of whom were white, native born, and middle class.[7]

As the CPUSA launched the Popular Front, two landmarks of the New Deal—the Social Security Act and the National Labor Relations Act (Wagner Act)—became law in 1935. The interplay between these laws and massive social upheavals of the period precipitated a new wave of social justice movements and led to the formation of the Congress of Industrial Organizations

(CIO). For Communists, these were heady days, signaling a more progressive political order on the horizon.[8]

Internationally, the Italo-Ethiopian War and the Spanish Civil War profoundly shaped black women radicals' lives during the Popular Front. The fascist Italian invasion of Ethiopia in 1935 infuriated black people around the world, prompting them to see black struggles in global terms like never before. Viewing Ethiopia as the last remaining independent African nation, they called for its defense. In Harlem, nationalist stepladder orators enjoyed renewed visibility on the neighborhood's streets. Also, Communists organized the Provisional Committee for the Defense of Ethiopia, a Popular Front group that brought together Harlem Communists and nationalists in building mass support in the neighborhood for the besieged country.[9]

The Spanish Civil War also captured black radicals' attention. The war had its origins in long-standing political and social instability. Its immediate causes were tied to the failure of the Second Republic, formed in 1931, to maintain political order. In the elections of 1936, a coalition of liberals, socialists, anarchists, and Communists defeated right-wing parties. Claiming that Communists and anti-clerics dominated the government, General Francisco Franco led a military insurrection against the new government in July 1936.[10] The Loyalist (Republican) government initially might have easily suppressed the uprising. But Loyalists had few international allies. Pursuing policies of non-aggression, the United States, France, and Great Britain refused to sell the Loyalists arms. This strategy benefited Franco, whose army received troops and arms from fascist Italy and Nazi Germany. Within months, Franco's forces (Nationalists) captured most of the country, threatening the capital, Madrid. Soviet military aid and the formation of the International Brigades under the call of the Communist International in the fall of 1936 saved Madrid from Franco's advancing army. In the next two years, thirty-five thousand volunteers from nearly fifty countries fought in the International Brigades. Three thousand two hundred Americans fought in the Abraham Lincoln Battalion, including eighty to one hundred African Americans.[11]

For black radicals around the world, the Spanish Civil War was an extension of the fascist Italian conquest of Ethiopia and a symbol of people of color's subjugation globally. Seizing upon this sentiment, Communists began using the slogan "Ethiopia's fate is at stake on the battle fields of

Spain." Sponsoring mass rallies for Loyalist Spain in Harlem and other black communities, the Communist-led Negro's People Committee to Aid Spain called for volunteers to fight in Spain. It was within this internationalist context that black leftist women pursued their work.[12]

Ethiopia, Spain, and the Making of Black Women Radicals

The Italo-Ethiopian War and the Spanish Civil War were critical in radicalizing black women during the Popular Front. No two women better exemplified this than Claudia Jones and Esther Cooper. There were significant differences in their socioeconomic and geographic backgrounds, and their journeys into the Communist Left. However, there were important similarities in their recruitment. First, both women's lived experiences and special concern for the status of black working-class women were critical to their political awakenings. Second, their recruitment demonstrates the key role Communist internationalism and anti-fascism played in detouring a small group of black women who were determined to change the world from traditional black protest groups to a global, multiracial left-wing movement.

Claudia Jones's career as a radical activist was not inevitable. However, coming of age in a poor, Caribbean immigrant family in Depression-era Harlem in addition to her interest in defending Ethiopia prepared the ground for her life's work and black left feminist sensibility. Most of the information about her early life comes from a short, autobiographical letter dated 6 December 1955 to William Z. Foster, the head of the CPUSA. She wrote the letter three days before her deportation to Great Britain and after years of political persecution. Given how American Communists constructed conversion narratives about their turns toward the left, her rendition of her early years must be read critically.[13]

She was born Claudia Vera Cumberbatch in 1915 in Belmont, Trinidad. In 1922, her parents, Sybil and Charles Cumberbatch, migrated to New York in search of a better life. Jones and her three sisters arrived in New York in 1924. Instead of finding a golden land of opportunity in the United States, "our family," she wrote, "suffered not only the impoverished lot of working class native families, and its multi-national populace, but early learned the special scourge of indignity stemming from Jim Crow national oppression."[14] Jones's chronic health problems that she suffered as an adult stemmed directly from living in poverty as a child. Despite these early hardships, Jones remembered that her family maintained a sense of racial pride. Her father,

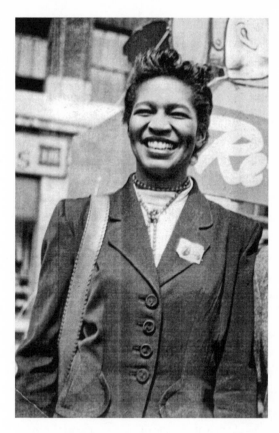

Claudia Jones, circa 1930s.
CREDIT: ESTHER COOPER JACKSON.

she claimed, edited the *West Indian-American*, a community newspaper, stoking her initial interest in political journalism.[15]

Like other black women radicals, black women's suffering was crucial in spearheading Jones's political awakening. A turning point in her life was Sybil Cumberbatch's tragic death when Jones was thirteen. Framing her mother's death as an early epiphany into black women's triple oppression, Jones claimed that Cumberbatch died, in essence, from exhaustion from working long hours in a filthy Harlem garment factory, tending to her family, and confronting racism in the United States. The death of Jones's mother thrust the family deeper into poverty and dashed her dreams of going to college, forcing her to work to help provide for her family. Here her story resembled Audley Moore's life after her parents' deaths.[16]

In her autobiographical letter, Jones emphasized how Ethiopia and the sexism she encountered in nationalist movements facilitated her political awakening. Enraged by the war, she joined the African Patriotic League, a

Harlem-based, neo-Garveyite organization in 1935. However, sexism within the African Patriotic League drove her out. Her decision to bolt from it, the letter suggests, serves as an early example of her frustration with sexism within radical movements as well as her refusal to acquiesce to male chauvinism. Still searching for sites to agitate for Ethiopia's freedom, she found the Communist Party. Impressed with its ability to build mass, multiracial movements in defense of Ethiopia, she believed that the CPUSA offered a viable alternative to Harlem nationalists, who viewed the war narrowly in racial terms and who often shunned mass organizing.[17]

Jones's account of her radicalization should not be taken at face value. It seems hard to imagine how her persecution did not affect how Jones (re)constructed her personal narrative about joining the CPUSA. Reading like a religious conversion narrative, the letter contains a tone of self-righteous certainty in the eventual defeat of capitalism and racism typically embraced by Communist true believers like Jones.

What is certain is that moving into the Communist Left opened a new exciting chapter in Jones's life. She befriended Howard "Stretch" Johnson, a former dancer at the Cotton Club who had become a prominent figure in the Harlem Young Communist League (YCL), and James Ashford, the head of the Harlem YCL.[18] Through these friendships, she joined the CPUSA in 1936. Immediately upon her recruitment, Party officials began grooming her for leadership. In 1937, she was elected at the age of twenty-one to the YCL's national committee. Soon afterward, she became the editor of the organization's official magazine, the *Young Communist Review*.[19]

The Communist Party provided Jones with connections to an interracial community of black and white women committed to radical change. She worked closely in New York with Jessie Scott, a leader in the Brooklyn YCL and the YWCA, and Carmen Lopez Alves, the leader of the Harlem YCL.[20] Also, Jones recruited women into the CPUSA. One of these women was Dorothy Chanellor (Burnham), a Brooklyn College student who joined the Communist Party in 1936. Burnham recalled that Jones and Howard "Stretch" Johnson were the "most influential" people in shaping her activism during these years. Jones's "fantastic" oratory particularly impressed Burnham.[21] For Janet "Ginger" Pinkard, a New Yorker of Russian Jewish background, Jones's "fighting spirit" was the "prime" reason she joined the YCL in 1939.[22] All of these women became lifelong friends and worked together

for decades in leftist movements. Jones must be credited in playing a critical role in fostering a collective consciousness among them.

Jones's involvement in the Popular Front transformed her subjectivity. The best example of this was her decision to adopt "Claudia Jones" as her public name. This occurred at the same time she joined the CPUSA. Curiously, little attention has been given to her name change—perhaps because Jones did not discuss this matter in her writings or with her friends in the Party, who always knew her as "Claudia Jones."[23] The literary scholar Claudia Rosemary May speculates that Jones's desire to protect her immigrant family from government scrutiny explains her use of an alias.[24] But her name may have also signified an act of self-definition for a young woman who was determined to change the world. From Sojourner Truth and Frederick Douglass in the nineteenth century to Malcolm X and Assata Shakur in the twentieth, changing one's name has been one of the most profound ways black people have attempted to liberate themselves from white supremacy and to announce their new identity to the larger world. The same might be said about Jones.[25]

Additionally, Jones's name change may have denoted her growing identification as an African American. She was hardly the only immigrant who had joined the CPUSA and had adopted a new name during the popular front. Several young Jewish Russian-born Communists who emerged as Party leaders during these years also Anglicized their names. They did so in part because the Communist Party promoted the Americanization of its cadre. New Deal upheavals encouraged ethnic populations to begin thinking of themselves increasingly as Americans.[26] Many Communists believed that the United States was moving toward the left and embracing its ethnic pluralism and founding democratic ideals. Her actions fit this profile. In 1938, she applied for U.S. citizenship. The Immigration Naturalization Service, however, denied her application two years later on the grounds of her Communist political activities.[27] (This development would have dire consequences for her life during the McCarthy period.) Her application for U.S. citizenship and her name change should not be interpreted as a rejection of her family or her Caribbean heritage. She remained close with family, and the Caribbean would continue to occupy center stage in her political work for the rest of her life.[28] Indeed, Jones had little difficulty in embracing multiple, complementary identities, proving how the anti-fascist international-

ism of the Popular Front not only brought her into the Communist Left but also transformed her identity and politics.

Esther Cooper's entry into the CPUSA contrasted significantly from Jones's. If Jones's recruitment signaled the importance of grass-roots Popular Front movements in Harlem concerning Ethiopia in radicalizing a young, working-class Caribbean-born woman, then Cooper's shows the impact of Spain in moving a young woman reared in a "talented tenth," southern black family toward the left. Despite the differences between Cooper's and Jones's journeys, both women looked to the Communist Left, not to mainstream black protest groups, for solutions in fighting against racism, fascism, and social inequalities.

Esther Cooper Jackson was born in 1917 in Arlington, Virginia, to George P. Cooper and Esther Irving Cooper. A strong, independent woman, Irving Cooper was a ranking figure in the Arlington NAACP. She inspired in her daughter a sense of independence and an "interest in struggle and doing something about the Jim Crow situation in which we lived," Cooper Jackson recalled.[29] Her father was a decorated World War I army officer. Her parents deeply admired W. E. B. Du Bois. Graduating in 1934 from the reputable all-black Paul Lawrence Dunbar High School in Washington, D.C., Cooper then enrolled in Oberlin College, a prestigious liberal arts school that was the first college in the United States to admit African Americans and white women. It certainly seemed that Cooper was poised to secure her place in the "talented tenth." However, Popular Front movements in support of Spain at Oberlin would change all of this.[30]

Cooper arrived at Oberlin during the most dynamic moments in U.S. student protest prior to the 1960s. Galvanized by social and political upheavals of the Depression, the growing menace of fascism, and a looming world war, leftist and Christian student groups had proliferated at Oberlin and on college campuses across the country by the mid-1930s. They focused on free speech, labor, civil rights, unemployment, peace, and anti-fascism. Support for Spain on American college campuses peaked in 1938 following a nationwide student strike in support of the Republican government led by the American Student Union, a Popular Front anti-war group. Captivated by these campaigns, Cooper became a staunch supporter of Republican Spain.[31] Interest in Dolores "La Pasionaria" Ibárruri, the beloved, highest ranking Communist in the Loyalist government, also stoked her burgeoning left-

Esther Cooper, at the age of two. CREDIT: ESTHER COOPER JACKSON.

wing politics. Cooper idolized Ibárruri, exclaiming years later, "She was a leader . . . of women. She was the revolution."[32] Still, Cooper had no plans of becoming a professional left-wing activist. Instead, she would follow her mother's first steps by pursuing a career in social work, which prompted her to major in sociology. After she graduated from Oberlin in 1938, she headed that fall for the historically black Fisk University in Nashville, Tennessee—upon the invitation of the prominent sociologist Charles Johnson—to earn a master's degree in sociology.[33] Little did she know that her two years there would detour her from a respectable career in social work toward a life of radical political activism.

Resembling Jones's radicalization, Cooper's concern for black women's exploitation helped her become increasingly aware of structural inequalities and the intersections between race, gender, and class. This occurred while she attended Fisk. Her graduate fellowship required that she live and work

at a settlement house located in an impoverished, black Nashville neighborhood near Fisk. Like Williana Burroughs and Louise Thompson, Cooper's disillusionment with social work was a catalyst for her leftward turn. Many of her social work cases involved poor, black women domestics who toiled in wealthy white homes. "[Their plights] helped steer me to radical politics. I felt that no small amount of change could do . . . to really advance the people who were the most oppressed," Cooper Jackson recollected.[34] At the same time, she came under the influence of several leftist Fisk faculty, who invited her to join their study circle. During a meeting, one of her instructors signed her up as a member of the Communist Party. Joining the CPUSA marked a significant break from her parents' racial uplift politics, which did not call for the dismantling of capitalism as a prerequisite for realizing racial equality. For her, Marxism represented an alternative to mainstream black politics. The former offered a powerful framework for explaining social inequalities at home and abroad and in providing links to a global, multiracial community of revolutionaries.[35]

Meeting James E. Jackson Jr., a member of the Communist Party and a founder of the Southern Negro Youth Congress (SNYC), forever changed her life. The two first met in Nashville in 1939 when Jackson came to town to conduct research on behalf of Gunnar Myrdal for his study on race relations in the United States, later published as *The American Dilemma*. Born in 1914, Jackson was reared in Richmond, Virginia, in a middle-class family. Like Cooper's family, Jackson's parents revered W. E. B. Du Bois and embraced racial uplift ideology. But like so many Depression-era young black middle-class people, Jackson moved toward the left. During his freshman year in 1931 at Virginia Union University in Richmond, he joined the Communist Party due to his interest in Scottsboro. After graduating in 1934, he followed his father's footsteps by enrolling in Howard University's pharmacy school. But he moved toward Marxism. At Howard, he met like-minded young black left-wing students, such as Edward E. Strong and Thelma Dale, both of whom would soon emerge as major figures in the black Left. Inspired by the National Negro Congress, in February 1937 they formed the SNYC together with Louis E. Burnham, a student activist at City College, and Christopher Alston, a Communist Party functionary and autoworkers union organizer from Detroit. The SNYC championed civil rights, industrial unionism, and anti-fascism. Due to this work, CPUSA officials had recognized Jackson's leadership potential by 1940.[36] His move toward the left

reveals once again how black women became radicalized differently from black men. Cooper's sensitivity to black women's oppression was a key factor in her trajectory.

Cooper's radicalization bore both similarities and differences from those of her white female contemporaries such as Betty Friedan. Born in 1920 and reared comfortably in a secular Jewish family in Peoria, Illinois, Friedan, like Cooper, possessed a passion for social justice from an early age. Attending the elite, all-women's Smith College in Northampton, Massachusetts, Friedan became radicalized by Popular Front movements on campus, particularly around anti-fascism. Following a similar trajectory as Cooper, "anti-fascism [became] the bridge to [Friedan's] commitment to labor unions that would in turn flower into passion for women's issues," as the biographer Daniel Horowitz has expressed.[37] However, there were distinct differences between their radicalizations. During Friedan's early years, she displayed little sensitivity to racial issues. Nor was an awareness of the intersections between race, gender, and class critical to her radicalization. While Friedan had become more attentive to these issues by the 1940s, black women's status was never a focal point of her work as it was for Cooper.[38]

As Cooper's politics were taking an unexpected turn, so was her personal life. Her friendship with Jackson evolved into a romantic relationship. After Jackson left Nashville, he invited her to attend the SNYC's convention in Birmingham, Alabama, in 1939. The gathering impressed her. In the spring of 1940, Jackson and Ed Strong invited her to serve as the SNYC's office manager at its new headquarters in Birmingham. The invitation came at the same time as her master's thesis caught the attention of Robert Park, a nationally renowned sociologist at the University of Chicago, who offered her a doctoral fellowship. She declined it. Instead, she opted to work for the SNYC. The chance to materialize her commitment to racial democracy was just too good of an opportunity for her to pass up. Marrying Jackson in May 1941 also kept her in Birmingham.[39] By marrying an up-and-coming CPUSA leader, Cooper sealed her break from middle-class reform politics, putting her on a direct trajectory that would lead her to the center of black radicalism and American Communism. So while Esther Cooper and Claudia Jones came from significantly different backgrounds and followed different paths into the CPUSA, anti-fascism captured both women's imaginaries, prompting their enlistment in the Party and showing once again how it became a home for black women radicals.

Black women radicals moved on multiple fronts, domestic and cultural but also international. In keeping with the broad transnational vision of the period, several black women radicals traveled to Spain. These included Louise Thompson, Thyra Edwards, and Salaria Kee, the only African American woman nurse in the International Brigades.[40] Spain changed their lives. The international Left enabled them to travel to a country largely inaccessible to most Americans and to see for themselves the Manichean struggle between fascism and democracy with global implications. Providing a terrain where black women radicals came together, Spain further helped them appreciate the African American freedom struggle in global terms, forge a "black women's international," and bolster their sense of transnational citizenship like never before. Traveling to Spain fostered a sense of personal freedom for black women radicals from prevailing gender and racial conventions. Upon their return home, they collaborated in galvanizing black communities nationally against fascism, highlighting black women's key role in building the black Popular Front.

Their desire to avenge the Italian conquest of Ethiopia and to observe black people fighting in the Spanish Civil War were motivating factors that brought black women radicals to Spain. This was the case of Louise Thompson, who spent several weeks in Spain in August and September 1937. In an interview published in the *Daily Worker* immediately after her trip, she stressed, "My greatest interest was in the American Negro volunteers fighting in the International Brigades and in the Moors fighting with the Fascist Franco. I wanted to see with my own eyes the differences between the two-dark-skinned people fighting on opposite sides of the struggle."[41]

For Salaria Kee, her personal encounters as a black woman with U.S. racism and poverty, together with her anger with the spread of fascism, stoked her interest in Spain. Kee became the most prominent black woman in the international campaign to defend Republican Spain.[42] Born in Georgia and orphaned, she grew up poor in foster families in Akron, Ohio. Looking back at her life, she recollected how these families instilled in her "the belief that democracy could be made to work."[43] But her lived experiences as a young black woman contradicted these beliefs. During high school, she dreamed of becoming either a nurse or a teacher. But she painfully learned that African Americans could neither teach nor work as nurses in Akron.

However, she remained determined to realize her dreams. Upon the encouragement of a black Akron doctor, she enrolled in the Harlem Hospital Training School. She graduated in 1934, working in the hospital's understaffed obstetrical department. Living in Harlem sensitized her to abject poverty and racial discrimination. But it was Ethiopia and Spain that radicalized her. The Italian conquest of Ethiopia incensed her. She befriended a group of black nurses at Harlem Hospital who raised funds for medical supplies for Ethiopia. After the Spanish Civil War erupted, she heard powerful speeches in downtown New York by Spanish refugees and German Jews who had fled the Nazis. These speeches deeply moved her, prompting her to reflect on her own life: "It had seemed [that] in all the things I had wanted to do I had been rejected in my own country." She added, "I didn't know anything about politics. I didn't know anything about Communism. All I knew about was democracy, and anything that wasn't democracy wasn't for me." Following these encounters, she became convinced that defeating fascism in Spain was essential to freeing Ethiopia and realizing democracy for all people. Kee never joined the CPUSA. But she was determined to go to Spain. In March 1937, at the age of twenty-three, she made the trip.[44]

The Communist Left provided the opportunity for black women radicals to travel to Spain. Louise Thompson traveled there under the auspices of an International Workers Order fact-finding tour. One of the most influential Popular Front organizations, the IWO fostered an anti-racist, anti-fascism movement culture celebrating the unique national cultures of its membership while simultaneously promoting pan-ethnic, working-class solidarity. By 1940, the IWO counted 165,000 members. In February 1936, its members elected Thompson national secretary of the IWO's English Section, the organization's second largest division, which consisted of approximately 9,000 native-born white and black Americans. Her election was significant. She was now the highest-ranking black woman in the IWO. In the coming years, she became actively involved in IWO Harlem Lodge 691, further cementing her position as a key bridge between the Communist Left and the Harlem intelligentsia.[45] Given her ranking position in the IWO and her prominence as the leading black Communist woman, she made a fitting choice for the IWO's fact-finding tour to Spain. In Thyra Edwards's case, the Social Workers Committee for the Aid of Spanish Democracy and the North American Committee to Aid Spain funded her trip.[46] The Medical Bureau of the North American Committee to Aid Spanish Democracy paid Kee's way to Spain.[47]

Witnessing the harsh realities of the Spanish Civil War was a transformative experience for black women radicals. For Thompson, traveling to Spain was the most important moment in her life during the Popular Front. Similar to the impact of her trip to the Soviet Union, visiting Spain provided a firsthand opportunity to witness the construction of a revolutionary society apparently committed to international solidarity, anti-colonialism, and anti-racism. Upon her arrival there in August 1937, she was shocked by the massive physical destruction and humanitarian crisis caused by the war. In unpublished memoirs, she observed how Franco's brutal siege "completely wiped out" parts of Madrid.[48] Still, she wrote, Spain "was exciting. The excitement I mean was not a pleasurable thing. Everywhere you could feel the unity of the people in fighting against Franco. The little kids held their hands up in every village we went through," gleefully shouting the Republicans' famous rallying cry: *¡No pasarán!* (They Shall Not Pass!).[49]

Spain had a similar impact on Thyra Edwards. In her newspaper article series, "Thyra Edwards Speaks of Issues, Programs, and Actions," published in the *Chicago Defender* following her trip, she recounted the war's immense carnage. But she also marveled at the Spanish people's determination to be free.[50] Similarly, Salaria Kee never forgot the poverty, death, and destruction she saw in Spain. Looking back on these experiences, she recalled, "When I got to Spain, I saw all the poor people, the shacks they lived in . . . and I had never seen anything like it in all my life. They couldn't read and they couldn't write. My whole concept changed. I had had the feeling that in America only the Negroes suffered and that in other countries where there were no Negroes everything was lovely." Kee came to understand that while black Americans faced virulent oppression they were hardly alone. Other people across the world also faced subaltern conditions. At the same time, she, like Thompson and Edwards, was impressed with the Spanish people's resilience.[51]

Black women radicals saw in Republican Spain a powerful ally to black struggles worldwide against white supremacy, capitalism, and European colonial empires. They met with an international community of anti-fascist intellectuals who had sojourned there. Soon after arriving in Madrid, Thompson contacted her old friend Langston Hughes. He had traveled to Spain in July 1937 to report on black Americans' contributions to the war for the *Afro-American* newspaper.[52] In Madrid, Thompson and Hughes befriended members of the Alianza de Intelectuales, an international, anti-

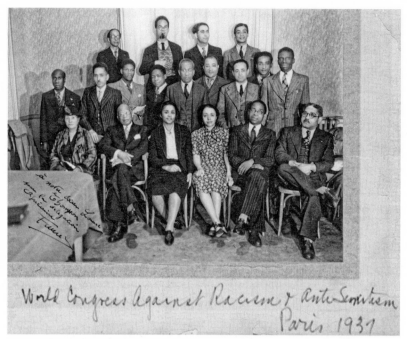

World Congress against Racism and Anti-Semitism, Paris, 1937. Louise Thompson is seated third from the right. Thyra Edwards is seated fourth from the right. William L. Patterson is standing immediately behind Thompson and Edwards. SOURCE: LOUISE THOMPSON PATTERSON PAPERS, MANUSCRIPT, ARCHIVES, AND RARE BOOK LIBRARY, EMORY UNIVERSITY.

fascist writers group.[53] While in Spain, Thompson, Edwards, and Kee met with black volunteers in the International Brigades from the United States, the Caribbean, and Africa. This made a powerful impression upon them.[54]

Black women radicals who traveled to Spain also viewed the war through the lens of gender, pursuing a "black women's international." The war fostered exciting possibilities for alliances between black women radicals and anti-fascist women from around the world that would have been impossible in the United States. One way they did this was coming together while overseas. Edwards and Thompson met in Paris as delegates to the Second World Congress against Racism and Anti-Semitism in September 1937. Exchanging ideas with hundreds of delegates, who claimed to represent sixty million people worldwide, Thompson and Edwards felt a sense of freedom in the city. They also met individually with Kee at her hospital near Madrid. Their warm exchanges helped them see themselves as a group of black women radicals with common global concerns.[55]

Recognizing the relationship between fascism and women's oppres-

sion was another way they forged a "black women's international." Thyra Edwards declared before her trip: "No Force in the world today so threatens the position and security of women as does the rising force of fascism. Fascism degrades women."[56] Following the trip, she commented on the war's cost on women and children, appreciating how rape and orphaning were fundamental features of the conflict. Kee and Thompson drew similar observations. Given Spanish civilians' encounters with death and destruction, black women radicals came to believe that Spanish people, women particularly, shared much in common with black American women. Black left feminists, however, did not view Spanish women only as victims. The former saw the latter as powerful role models and allies for black women struggling to be free. Like Esther Cooper, Thompson came to idolize Dolores Ibárruri after hearing her give a powerful speech in Valencia.[57] Additionally, black women radicals understood African American women's destiny as inseparable from those of women in countries under siege by fascism. Edwards made this point in her journalism. Expressing her excitement about the possibilities of an upcoming conference sponsored by the Women's World Committee against Fascism, she urged black women to attend. She added, "[It was] important that our women turn our attention to close study and participation in developments in Ethiopia, Spain, and China for these truly affect the peace and welfare of all democratic countries and their citizens today." The conference never convened. However, her interest in it illustrates how she, like Kee and Thompson, looked to the global Popular Front, particularly to anti-fascist women, as allies for advancing black women's freedom and democracy for all.[58]

Spain also served as a terrain for enabling black women radicals to challenge normative ideals about respectability and prevailing racial protocols. Traveling overseas unaccompanied by a husband, touring a war zone, openly associating with secular left-wing radicals, and unapologetically calling for transformative change were transgressive moves. Moreover, Spain provided unique professional opportunities for black women radicals. Certainly, this was true for Salaria Kee. The International Medical Unit appointed her as the head surgical nurse in the American unit at a military base hospital near Madrid. She supervised white nurses and treated Spanish civilians and wounded volunteers of all nationalities. Her status as an African American woman circumscribed her professional opportunities back home. But in Spain she finally had the chance to realize her talents.[59] Spain forever

changed her personal life as well. There she met and married her husband, John "Pat" Joseph O'Reilly, an Irish ambulance driver in the International Brigades. Widely reported in the black and Communist press, news coverage celebrated their marriage, framing it as a shining example of how Spain created the possibilities for interracial marriage and brotherhood that were denied back home. Ultimately, Spain was personally and politically liberating for black left feminists.[60] When they returned home, they carried with them once-in-a-lifetime experiences, as well as a new resolve in struggling for radical democracy.

Louise Thompson, Salaria Kee, and Thyra Edwards were at the forefront in building widespread support for Spain in black communities and the Communist Left nationally. Within days of returning home, the IWO featured Thompson, along with Max Bedacht and William Weiner, the IWO's national secretary and president, respectively, as the guests of honor at a memorial dinner for its members killed in Spain. Nearly twenty-five hundred people attended the affair, which was held at the swank Commodore Hotel in New York.[61] Two weeks later, Harlem IWO Lodge 691 threw Thompson a welcome home dinner attended by Harlem luminaries. Soon afterward, she spearheaded the Negro Ambulance Fund for Republican Spain. This campaign raised more than $1,500, shipping a bulletproofed ambulance fully stocked with medical supplies from New York to Spain. Linking the ambulance with defending Ethiopia, the campaign took the position that "Fascism stands for the subordination of women."[62] Kee, Edwards, and Thompson worked together in publicizing this campaign. Efforts like this helped make anti-fascism chic among Harlem intellectuals and middle-class professionals and diffused anti-fascism into black communities.[63]

No black woman was more visible in generating interest in Spain among black communities and the Communist Left than Salaria Kee. Even before she returned home from overseas in May 1938, she had attained celebrity status within black communities and the Communist Left nationwide.[64] Young and vivacious, her gripping life story, time in Spain, and marriage to an Irish volunteer in the International Brigades captured the romanticism of Spain and the essence of Popular Front anti-fascism and interracialism. The Communist Left seized upon this opportunity by promoting Kee as a spokesperson for Spain. She willfully participated. The Negro Committee to Aid Spain sent her with Edwards on a national speaking tour in August 1938. Thompson actively promoted it.[65] The IWO dispatched Thompson on

a month-long speaking tour through the Midwest and the Northeast in late 1937 to build support for Loyalist Spain in the organization and in black communities.[66] The black and Communist press regularly reported their work on behalf of Spain. In 1938, members of the IWO elected Thompson the national recording secretary, making her the only person of color and the only woman on its National Executive Committee. Her election was a significant affirmation of years of dedicated service to the organization.[67]

Black left feminists' support of Spain was linked with their cultural work. This was best evident in Louise Thompson's activism. She was a focal point in building the black cultural front in Harlem. Co-founding the Harlem Suitcase Theater with Langston Hughes was her most significant achievement in this regard. The theater helped Communists appreciate African American culture, especially jazz and the blues, as politically progressive and as the basis of modern American popular culture.[68] The Harlem Suitcase Theater's critically acclaimed play of 1938, *Don't You Want to Be Free?*, embodied this. An agitprop drama, the production creatively used dance, jazz, the blues, and black vernacular to sketch African American resistance from slavery to the Depression-era urban North, calling for an interracial, socialist revolution. The theater helped the Harlem Communist Party grow to nearly two thousand members by 1938, its peak membership during the Depression. Many of its recruits were middle-class intellectuals and professionals, many of whom were acquainted with Thompson and swept up in the anti-fascist fervor. Clearly, the Popular Front bolstered the international profile of black women radicals like Thompson, proving once again how the Communist Left provided unique, exciting opportunities for black left feminists to travel overseas and build and lead transnational, radical multiracial movements.[69]

Black Left Literary Feminism during the Popular Front

As black women radicals took part in Popular Front movements on campus and on the streets of Harlem and traveled internationally, they also wrote. Rarely discussed in studies of 1930s-era literature by left-wing women writers, the Popular Front marked an exciting moment in black left feminist thought. These years saw the publication of several black left feminist writings by Louise Thompson, Esther Cooper, and others. Extending arguments posited by black Communist women since the 1920s, black women radicals of the Popular Front era proffered new formulations on the intersectional nature of black women's redundant oppression. Their writing also in-

terrogated the masculinist framings of black freedom proffered both by the Communist Left and non-Communist black protest organizations, the racial universalism posited by white women leftists, and the racism within the mainstream labor movement. Black women radicals not only made African American women visible; they argued that the Communist Left needed to recognize black women's freedom as an essential component in the struggles for racial equality, women's rights, and democracy. In doing so, black women radicals' common concerns show how they were forming collective identities through their writings, laying the groundwork for post–World War II discussions in the Communist Left and beyond on black women's oppression and militancy.

Black left literary feminism of the 1930s emerged during a prolific moment in writing by Communist women. Grace Hutchins's widely read book, *Women Who Work* (1934), discussed the role of popular culture and family in promoting gender oppression.[70] *Women and Equality* (1935) by Margaret Cowl, the chair of the CPUSA's National Women's Commission (NWC), called on the Party to make women's rights central to its work.[71] The most significant and controversial work during these years was Mary Inman's *In Woman's Defense* (1940). Breaking from the Party's position, she argued that women's household labor was as exploitative and necessary to reproducing capitalist inequalities as working-class men's factory work. Like Hutchins, Inman argued that (white) prostitutes constituted the most oppressed segment of society. Drawing the Communist Left's common but problematic comparison of women's oppression as analogous to racism, she equated "women" with white and "Negroes" with men.[72]

Written in 1935, *The Position of Negro Women* by the Harlem Communist Party leader Eugene Gordon and the veteran radical Cyril Briggs marked the CPUSA's first official theoretical line on black women's oppression. They wrote it upon the urging of the Communist Party's National Women's Commission. Appreciating black women's oppression in intersectional terms, the pamphlet's opening line forcefully declared that "to be both a woman worker and a Negro is to suffer a double handicap." Arguing that black women's relegation to domestic service jobs was "*a matter of capitalist policy*," they charged that black women were "the most exploited" workers [emphasis original]. However, Gordon and Briggs neither articulated a clear program for fighting for black women's equality nor explained what, if any, role black women would play in realizing it. Rather, they looked to the Soviet Union,

where women allegedly had been "emancipated," and to a future socialist revolution in America as solutions for freeing black women.[73]

While Gordon and Briggs wrote the first official Party position on black women, it was black Communist women who blazed the way in articulating new positions on African American women's oppression. Like their predecessors from the 1920s, the writings of black women radicals of the Popular Front era focused on the plight of black women domestic workers and understood their lives in intersectional terms. The most famous in this regard was the muckraking exposé, "The Bronx Slave Market," by the Harlem journalist Marvel Cooke and the activist Ella Baker, which was published in the NAACP's *The Crisis* magazine in 1935. The article detailed the humiliation of being selected by white housewives on street corners for day work, as well as the back-breaking nature of domestic labor. Both writers had ties to Harlem radicals. Cooke was a member of the Communist Party—although not openly, while Baker associated with Socialists and Communists.[74]

Another example of black women radicals' concern for the plight of black household workers was Louise Thompson's lesser-known, but groundbreaking article "Toward a Brighter Dawn," which was published in 1936 in *Woman Today*, the official voice of the CPUSA's National Women's Commission. Like Cooke and Baker, Thompson focused on the infamous "Bronx slave market." She called it "a graphic monument to the bitter exploitation of this most exploited section of the American working class population—the Negro Woman. Over the whole land, Negro women meet this triple exploitation—as workers, as women, and as Negroes."[75]

Thompson's use of the term "triple exploitation" is significant for the history of black feminism, U.S. women's movements, and American Communism. Her use of the term might constitute the first time it explicitly appeared in print. (While Baker and Cooke understood black women household workers' exploitation in intersectional terms, they did not use the term.) In doing so, she posited a useful theoretical paradigm for critically exploring black women's exploitation and agency historically. Rejecting conventional Marxist-Leninist postulations that the shop floor was the site for forging class consciousness and that male factory workers were the revolutionary vanguard, Thompson used the term to challenge the invisibility of black women in discussions of black and women's equality and the labor movement. She implied that black women constituted key agents in realizing socialism and the gauge by which to measure democracy. The term under-

scores the importance of the black left feminism of the 1930s in formulating a paradigm that became the signature of Claudia Jones's postwar journalism and the black feminism of the 1970s.[76]

Meanwhile, "Toward a Brighter Dawn" implicitly critiqued writings by white women leftists of the Depression era. As Michael Denning observes, "The symbolic center of Popular Front womanhood was the garment worker." Through union newspapers, proletarian literature, theatrical productions, and film, white female garment workers and their sympathizers, he argues, promoted a "popular culture of fashion, romance, and celebrity to create a distinct figure of the modern working woman."[77] Thompson challenged this representation. For her, black women domestics symbolized women's oppression and their revolutionary potential. At the same time, she was attentive to racial and class divisions between black and white women. Wage differentials between black and white women, racial discrimination, and inadequate government social relief, she argued, worked in tandem, forcing African American women into domestic service. This created a pool of cheap labor, which white women exploited, freeing them from the drudgery of household labor. But white women were not passive beneficiaries of the status quo. Instead, they were complicit in black women's exploitation. Here, she showed how white women's kitchens were key sites both for (re)producing black women's marginal location and for shaping white women's materiality and identity, bolstering their sense of racial superiority and class privilege. By drawing these conclusions, she racialized and historicized the meaning of "housewife," rejecting the terms "woman" and "worker" as universal, ahistorical categories. Moreover, she rejected the claim by white women leftists such as Mary Inman and Grace Hutchins that white prostitutes constituted the most oppressed segment of society. It is uncertain whether Thompson formulated her arguments in response to these specific works by white women leftists. But in light of her long-standing interest in gender matters, it seems hard to imagine that she was unaware of arguments posited by her white female comrades.[78] Additionally, Thompson did not cite "The Bronx Slave Market." But she was surely aware of the article, given that she knew Cooke.[79]

The latter part of "Toward a Brighter Dawn" criticized mainstream labor's and the Communist Left's neglect of black women, challenging the former's masculinist articulations of black liberation. Thompson demanded that the American Federation of Labor unionize black women domestic workers.

Improving their status, she argued, would benefit the entire trade union movement and better the lives of black families who relied on women's wages for survival. Her concern here illustrates how Thompson, like black women radicals before her, understood how the capitalist process exploited black women as mothers, as workers, and as blacks. She never explicitly used the term "superexploitation" to describe black women's status. However, her triple exploitation paradigm clearly suggested that capitalism unleashed uniquely cruel and unjust forms of exploitation against black women, ideas that Claudia Jones and other black left feminists would substantiate in the coming years.[80]

While Thompson viewed black women as victimized by domestic labor, she hardly portrayed them as victims. Rather, she saw them as active agents fighting for their freedom and dignity. She lauded the Domestic Workers Union, which was led by black women. In doing so, she challenged prevailing cultural representations of black women domestics as servile and unworthy of protection. Additionally, she praised black women delegates at the newly formed National Negro Congress (NNC) for vocally demanding the support of domestic workers unions.[81] So in contrast to Eugene Gordon and Cyril Briggs, who looked to the Soviet Union and a distant revolution for realizing black women's liberation, Thompson looked to black women themselves as fulcrums for transformative change.

Thompson's reference to the NNC is significant. The group helped cultivate black left feminism from its founding and until its dissolution in 1947. A cross section of leading black women leftists and reformers attended the inaugural gathering. This group included the reformer Nannie Helen Burroughs, the South Carolina NAACP leader and Palmer Institute director Charlotte Hawkins Brown, and the legendary clubwoman Mary Church Terrell, as well as Louise Thompson, Thyra Edwards, Maude White, and Marion Cuthbert.[82]

The importance of the NNC as a site for nurturing black left feminism cannot be overstated. The historian Linn Shapiro suggests that female delegates at the NNC's inaugural convention may have readily used the term "triple exploitation."[83] To be sure, participants in the NNC's Women's Division, which drafted the conference's resolution on women's equality, understood gender, race, and class as interlocking systems of oppression. The resolution declared, "The Negro women of America are subjected to three-fold exploitation as women, as workers, and as Negroes, are forced through dis-

crimination into the most menial labor under the worst conditions without organizational protection." Resolutions called for the NNC to build a national domestic workers union.[84] Female delegates also criticized the NNC. The *Amsterdam News* reported that Thompson was "insistent in her demand for fuller recognition of women in the congress proceedings."[85] Her criticism made it clear that the NNC could not realize its objectives if the group neglected black women's issues. "Toward a Brighter Dawn" made many of these same points, suggesting that the NNC's proceedings may have inspired Thompson's arguments. That the term "triple exploitation" may have emerged from the NNC shows that while the Communist Party's positions on race and gender were influential, the black freedom movement and black women's lived experiences remained key sources of black left feminism's ideological inspiration.

Black left feminists continued writing in the coming years on the plight of black domestic workers. Esther Cooper's master's thesis of June 1940, "The Negro Woman Domestic Worker in Relation to Trade Unionism," stands as the most thorough historical and sociological study written during the Depression on the work conditions of black female household laborers and their efforts to unionize. The thesis was a crucial part of Cooper's early intellectual foundation, helping to set the stage for her staunch support for civil rights and radical democracy with special concern for African American women that were trademarks of her life's work. The initial idea for the thesis stemmed from Cooper's observations at Oberlin of poorly paid, non-unionized black women who cooked and cleaned on campus.[86]

Cooper's main argument contended that "the problems faced by Negro women domestic workers [were] responsive to amelioration through trade union organizations." She rejected the mainstream American labor movement's position that domestic workers were "unorganizable." Such claims "have been proven false," she argued, by the success in organizing household laborers in Western Europe and, above all, the Soviet Union. In stark contrast to the United States, she pointed out that in the Soviet Union "the social standing of domestic workers is equal to any other worker." Resembling other black women radicals' belief that the Soviet Union enhanced women's status, Cooper, too, saw the Soviet Union as a model for improving the lives of black women.[87]

Cooper never used the term "triple exploitation" to describe black female domestics' plight. But she advanced an intersectional analysis, noting that

black women domestics "have been discriminated against and exploited with double harshness." Echoing conclusions drawn by Ella Baker, Marvel Cooke, and Louise Thompson, Cooper identified the Bronx slave market as one of the most egregious examples of "human exploitation . . . found in New York City." Like her counterparts, Cooper railed against white housewives for exploiting black women domestics.[88] For these reasons, black women, she argued, constituted the most willfully exploited segment of the U.S. working class.

Because of their location at the bottom of American society, Cooper regarded black women domestics as the vanguard of radical change. The New Deal, she believed, offered black women exciting opportunities to fight for their freedom. She credited Section 7a of the National Industrial Recovery Act of 1933 and the National Labor Relations Act of 1935 for enabling domestic workers to organize. The Domestic Workers Union especially impressed her. Formed in June 1936 in New York, the DWU counted approximately one thousand members in New York. Led by the dynamic organizer and domestic worker Dora Jones, the DWU affiliated with the Building Service Employees International Union of the AFL, making it the only household workers union tied to a national trade union. The DWU won better wages and work rules for its members.[89] For Cooper, the DWU signaled a significant victory for black women wage earners and the entire U.S. working class. These conclusions, together with her support for leftist agendas and the Soviet Union, distinguished Cooper's writings and those of other black women radicals from more politically mainstream discussions of household laborers.[90]

The similarities between Cooper's thesis and writings on domestics by other black women radicals are striking. Like her counterparts, she viewed black women domestics both as the most oppressed and as potentially the most revolutionary segment within American society. She neither cited "Toward a Brighter Dawn" nor "The Bronx Slave Market," but Cooper Jackson claimed that she was aware of the latter article, revealing how these women's ideas mutually informed one another and how these ideas circulated within the Communist Left.[91] For example, the "Draft on Work among Negro Women" by the National Women's Department in January 1937 stated that "the Negro women constitute one of the most important sections of the population and is the most oppressed, being subject to triple exploitation, as women, as workers, and as Negroes."[92]

While they formulated path-breaking ideas about "triple exploitation," black women of the Popular Front era were largely silent about issues of re-

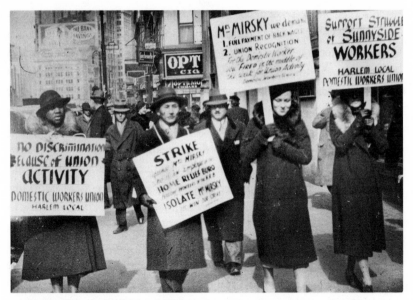

Domestic workers on strike, New York City, 1942. SOURCE: *DAILY WORKER* AND THE *DAILY WORLD* PHOTOGRAPHS COLLECTION, TAMIMENT LIBRARY AND ROBERT F. WAGNER LABOR ARCHIVES, BOBST LIBRARY, NEW YORK UNIVERSITY.

productive rights, domestic violence, and the relationship between sexual freedom and politics. In light of black women domestics' frequent encounters with sexual assault on the job and the African American community's resentment of it, it is surprising that they did not tackle this issue. Perhaps their adherence to ideals of middle-class respectability and a culture of dissemblance, together with the Soviet Union's and the cpusa's growing conservatism on sexuality, helps explain their silence on sexual violence against black women.[93] This is not to suggest that black women radicals were oblivious to the politics of sexuality. They were not. As discussed, Thyra Edwards privately supported free love and Louise Thompson cultivated a public persona as a sexually liberated woman. So while black left feminists' practice often challenged middle-class respectability, their journalisms' silence on sexuality illustrates how they did not completely transcend the gender and sexual politics of their day.[94]

Despite making significant theoretical advances during these years, black left feminist ideas appear to have gained little traction outside small Communist women's circles. The cpusa's Popular Front stance helps explain these developments. Black women's issues slipped between the cracks as the Party deemphasized the Negro Question and reached out to white

middle-class women like never before.[95] Black women's marginality within the CPUSA was also tied to the Party's Janus-like treatment of women's work during the Popular Front. Despite new interest in women's issues, Party leaders remained ambivalent about consumer movements, housewives leagues, and demands for birth control. Nor was the Party as vigilant against male chauvinism within its ranks as it was against white chauvinism. Given this climate, the National Women's Committee shut down in 1940. By the end of the Popular Front, CPUSA officials sought to reimpose orthodoxy on the Woman Question. A vicious campaign to discredit Mary Inman's *In Woman's Defense* was the lynchpin of the Party's efforts in this regard. Officials of the CPUSA commissioned Avram Landy, a senior Party leader, to write a biting retort of Inman's book. Charging that class exploitation constituted the only source of working women's oppression, he categorically rejected Inman's assertion that the CPUSA needed to devote equal attention both to organizing housewives and male factory workers. A heated controversy ensued in the Party around the book, eventually prompting Inman's resignation from the CPUSA.[96] It was these developments that help explain why the Party largely ignored writings by black women radicals during these years. But they did not remain silent. Their frustration with their invisibility within the CPUSA would help fuel controversies around interracial marriage in the Party during the Popular Front.

Controversies around Interracial Marriage

Although black Communist women were publicly silent about sexual freedom and its relation to political struggle, many were vocally critical of black-white marriages within the CPUSA. Long-standing tension within the Communist Left around race, gender, class, and sexuality, exacerbated by the marginal location of black Communist women within the Popular Front, helped produce these divisions. Their response to interracial unions reveals both how black women appreciated the politicized nature of marriage and grappled with their status as outsiders within the Party.

Interracial sex within the CPUSA was a thorny, complex issue from the Party's very beginning. The literary scholar William Maxwell observes, "Even the black Bolsheviks' early hopes for a Communism unafraid of intimate social equality had been realized. But with lopsided effects: interracial heterosexuality in the scope of the party seemed to yield relationships between black men and white women but rarely in reverse."[97] This certainly

was true in Harlem. Several key leaders there, including James Ford, Abner Berry, Howard "Stretch" Johnson, and Theodore Bassett, were married to rank-and-file white women. Party critics during the 1930s often accused the CPUSA of using white women as bait for luring black men into it.[98] Party officials were especially sensitive to these charges. During the 1930s, the National Control Commission, the Communist Party's highest internal disciplinary body, investigated and sometimes expelled black men and white women who were intimately involved when these relationships apparently harmed the CPUSA's standing in black communities. The Party's surveillance of interracial social intimacy within the CPUSA is telling and ironic. It suggests that while the Party officially advocated black-white unity, it was uneasy with it, especially when it involved heterosexual intimacy.[99]

The issue of interracial unions touched a raw nerve among some women in the Harlem Communist Party. Many believed that the CPUSA's promotion of interracialism came at their expense, often leaving them intellectually isolated and without companionship. Louise Thompson's prescient article of 1937, "Negro Women in Our Party," published in the *Party Organizer*, made this case.[100] Marking the first time this volatile issue was discussed in a Party publication, the article appreciated how the personal and political intersected, with devastating implications for black women. Thompson identified Communist Party social events as a key site of interracial sexual tension, emphasizing how black women often felt like "wallflowers" at social events because no one asked them to dance. "These are the things," she wrote, "that hold a lot of Negro women back from the Party. They are not so political, but they do mean a great deal." For these reasons, black women did not "feel that they fit in, they [did] not feel as much a part of it as even . . . Negro men comrades." Thompson's comments implied that black men felt more at home in the Party than black women in part because the latter had sexual access to white women. Urging Communists to devise a more "personal," "human approach" when recruiting African American women, she stressed that their recruitment into the CPUSA was "essential to [the Party's] Negro work." Without question, black women's marginality within the Party troubled her, revealing her sense of social isolation within the Communist Left.[101] Given these realities, she maintained close friendships with the Party's small cadre of black women and with non-Communist black women, suggesting that she had to look largely outside of the CPUSA for community with black women.[102]

While Thompson wrote about interracial sexual tensions, in 1938 a group of black Communist women, under the leadership of the veteran Communist Grace Campbell, presented Harlem Communist Party officials with a resolution calling for the ban of black-white marriages. Unfortunately, a self-generated record of the resolution and the names of the participants besides Campbell does not seem to exist. What evidence does exist about the resolution comes from accounts by white and black male ex-Communists. The former Party ally Claude McKay claims that black Communist women drafted the resolution in Campbell's home, forwarding it to the Communist International in Moscow for its authorization. This is significant. It shows that Campbell remained an influential figure among Harlem Communists, especially women, and still looked to Moscow for settling grievances with her comrades.[103] In response to the resolution, CPUSA officials assigned the Harlem Communist Party troubleshooter Abner Berry to meet with the women. In what was surely a charged meeting, he conveyed the Party's position "that it would be counter-revolutionary for the Party to adopt such a measure." He added, "I was able to convince them that the Party couldn't outlaw such marriages, that it was something that had to be left the decision of each individual. We had to change the social conditions within and outside the Party so that the black woman would come into her rightful place."[104]

Although she did not refer later in life to the resolution or to the specific way that she may or may not have played a role in it, Queen Mother Moore's recollections of her frustrations with interracial unions in the Party shed light on the marriage controversy of 1938. She claimed, "There used to be a lot of white people in Harlem. They used to lead everything we organized . . . and those Jewish women, especially were very aggressive . . . and they all had black men. . . . A black woman, if she took her husband in there, he wouldn't last long, 'cause the white women would grab him."[105] While she never explicitly said it, her comments suggest that at the time she questioned white Communists' racial sincerity.

Moore's testimony is instructive. It suggests that sexual tensions and jealousies pervaded the Harlem Communist Party, infuriating some black women members. For her, these relationships affirmed prevailing racist representations of white women as desirable and beautiful and black women as undesirable and unchaste. Given this, Moore understood marriage as a political issue.

At the same time, Moore's testimony reveals how interracial sexual tensions were intertwined with issues of class, power, and the CPUSA's long-standing discomfort with black nationalism. The Harlem Communist Party's unique political culture, together with Popular Front shifts, helped produce these tensions. Many white Communists assigned to Harlem were young, middle-class college graduates. Self-confident and assertive, many probably did try to dominate Harlem Communist Party life to the frustration of working-class black Communists like Moore. Long-standing racial and economic tensions in Harlem between African Americans and Jews, some of whom owned predatory businesses in the neighborhood, may have stoked Moore's perception of Jewish women's aggressiveness toward black men. At the same time, for many white Communists, working in Harlem marked the first time they associated closely with black people and lived apart from their families and communities.[106] Given the Party's call for black-white unity and the youth of its membership, it is not surprising that white and black Communists became romantically involved. For some black Communist men, sexual access to white women surely was a way "to challenge the [dominant] culture's ultimate symbol of their denied manhood," the historian Sara Evans observes.[107] Some white Communist women probably held their own racialized sexual fantasies about black men as well. Moreover, the masculinist culture within the Harlem Communist Party in which some black and white men competed for access to white women's bodies invariably pitted some black and white women against one another. This is not to suggest that racism was absent within the Harlem Communist Party. It certainly was not. But the CPUSA's obsession with interracialism alienated some African Americans, women particularly, from the Party.

Abner Berry recollects that this was the case: "The thing I came up against most often was that the blacks wanted to be together. They didn't mind on occasion being integrated, but in general, they wanted to be involved in something they could call their own."[108] Party officials, however, viewed all-black gatherings as dangerous manifestations of "nationalism." The CPUSA regularly expelled blacks, even prominent officials, for this apparent "crime."[109] Given the Party's unique political and social movement culture, black women found themselves in a precarious situation. As a minority within a minority in the CPUSA, black women had fewer social and political options than their black male and white female counterparts. Plus, with the Party's efforts to appeal to white women and its deemphasis of the

Negro Question during the Popular Front, black women's issues became even more marginal to the CPUSA.

Moore's Garveyite politics may also help explain her antipathy toward black-white unions during the 1930s. As the historian Mary Rolinson points out, southern, rural Garveyites actively sought to prevent involuntary and voluntary interracial sexual liaisons, sometimes resorting to the punishment of black women under the guise of "protecting the Negro community from white sexual predators and preserving the race against miscegenation."[110] Moore may have embraced these sentiments. Additionally, her frustration with the growing masculinist framings of black political discourse may, too, have contributed to her frustration with black-white marriages. In her community study of interwar black Detroit, the historian Victoria W. Wolcott argues that the Depression era saw a rise in masculinism within black protest groups, subordinating female agency and activism. This development was not limited to Detroit. Given this, Moore and other black Communist women may have felt that they were losing ground on multiple fronts.[111]

Despite their serious grievances with the CPUSA's treatment of black women, both Audley Moore and Louise Thompson opted to stay in the Party. Why? Esther Cooper Jackson's memory about why she and her husband remained in the Communist Party following its collapse after Khrushchev's "Secret Speech" of 1956 and the Soviet invasion of Hungary, answers this question: "When [Jackson] finally decided to stay in and work for the Party, I remember some relative asked me about this question. I said, 'We feel like it was our Party.' When there were disagreements with some decision, we said, 'Yes, we don't agree with that. But this Party is as much ours as it is theirs. Why should we give it over to people we think are leading it in the wrong direction in which it is going?'"[112] This reasoning also applies to Moore and Thompson. They saw the Party as theirs. Given this sense of ownership, they expected the CPUSA's program to reflect and respond to their concerns.

Black women's grievances with their marginal status within the CPUSA did lead to some changes within the Party's social culture. In response to calls for banning black-white marriages, Theodore Bassett took it upon himself to teach white male Communists how to dance. Many claimed that they were too intimidated to dance with African American women at Party socials. Several young, black Communist men recognized the political importance of having black girlfriends and wives. In what some called "a movement back

to the race," some black male Communists ended relations with their white girlfriends.[113] According to Cooper Jackson, her husband, Ed Strong, and Louis Burnham made a "deliberate choice" to marry black women.[114]

Black women in the Party, too, took an active role in encouraging marriages between black Communists. Dorothy Burnham recalled that Claudia Jones "helped to promote [her] marriage" with Louis Burnham in 1940.[115] For black Communist men, marrying black women was also a practical necessity when organizing, especially in the South. As Cooper Jackson recollected, "If you were going to work in the South, you needed to have a black wife and family." But this is not to say that these relationships formed primarily for political reasons. These women and men had much in common besides their politics. Often from similar backgrounds, these couples were young, idealistic, and very much in love.[116]

Racial considerations also factored in Louise Thompson's marriage to William L. Patterson in September 1940. Their relationship began in the early 1920s in Oakland, where they first met. However, they did not become romantically involved until years later. She neither wrote about nor mentioned later in life whether the controversy around black-white unions influenced her decision to marry. However, she did claim that black Communist women in New York "were overjoyed to see that a leading . . . black party member had married a black woman. We [Thompson and Patterson] felt it was important in terms of activities and work to stay within the race."[117]

While marriages between black women and white men were rare in the Party, they did occur. Claudia Jones married Abraham Scholnick, a white, rank-and-file Communist of Russian Jewish heritage, in September 1940. It is unclear how they met or what role the Party may or may not have played in bringing them together. Perhaps the couple and CPUSA officials hoped their marriage would symbolize a union between a dynamic, black female national leader and a rank-and-file, white Communist. During World War II, Thyra Edwards married a Jewish man, Murray Gitlin, an official in the United Jewish Appeal, a non-Communist philanthropic Jewish organization. Also, Maude White married a Jewish Communist. These women's decisions to marry white Jewish men are additional examples of how black left feminists often challenged conventional racial protocols.[118]

While the Communist Left created unique opportunities for blacks and whites to come together romantically, these relationships could sometimes be emotionally painful and personally challenging for their participants. The

experiences of the white Jewish Communist Janet "Ginger" Pinkard is but one example. After her first husband, who was white, died in World War II, she moved from New York to Chicago. There, she began dating black men. Some black Communist women were suspicious of her motives, intimating that she dated black men to learn if "black men were good at sex." She felt insulted. Things only seemed to get worse. In 1951, the Party expelled her for "white chauvinism" for commenting at a Party social that her black boyfriend was "poor." Her expulsion was a "nightmare." She contemplated suicide because her "whole life had been in the movement." Eventually rejoining the CPUSA, in 1960 she married the black Communist and actor Fred Pinkard. But their marriage had ended by the late 1960s. In retrospect, she believed that black nationalist sentiment at the time contributed to their divorce. While Pinkard's expulsion occurred in the early 1950s, her challenging experiences in interracial romantic relationships surely resembled those of Communists of the Popular Front era.[119]

At the same time, the Party saw many lasting interracial unions. Ernest Kaiser, the noted Schomburg Library bibliophile who participated in the Harlem Writers Guild in the 1950s and wrote for *Freedomways: A Quarterly Review of the Negro Freedom Movement*, remained happily married for decades to his white wife, Mary Kaiser. She, too, actively participated in leftist, anti-racist politics, working on the *Freedomways* staff.[120]

It is important to remember that black-white unions within the Communist Party took place within a larger social and historical context. That racial antagonisms existed within the Communist Party should come as no surprise when de jure Jim Crow in the South and de facto segregation in the North were still in place and European empires subjugated most of the darker world. Still, no other interracial political organization in the United States in the 1930s was more committed to black-white unity and racial equality than the CPUSA. The Party's unique movement culture did often foster loving marriages and lasting friendships across racial lines. Racial tensions certainly existed within the CPUSA. But it also brought people together across racial lines in ways otherwise unknown before and even after the 1930s.

The Popular Front represented an exciting moment in the history of black left feminism. Anti-fascism was critical to radicalizing Claudia Jones and Esther Cooper, steering them away from black nationalist and mainstream black protest groups, respectively. Black women radicals not only

were crucial to forging the black Popular Front. They also made it their own. Through their organizing, journalism, social networks, cultural work, and public speaking, they played visible roles in galvanizing black communities nationally in support of Spain and in building a "black women's international," demonstrating how black women radicals operated on multiple fronts and geographic locations. Through their writing, black Communist women formulated new theoretical positions on the Negro and Woman questions. Placing black women at the center of analysis and recognizing the personal as political, the burgeoning "triple oppression" paradigm advanced by black Communist women moved Marxism-Leninism and black feminism in new directions. However, black women radicals' social isolation in the Party and the interracial marriage controversy exposed deep racial, class, gender, sexual, and political divides within the Communist Left. Still, black women not only opted to stay in the CPUSA; they worked to strengthen it. They remained convinced that despite its limitations, the Communist Party still represented an exciting alternative to women's clubs, the church, and black nationalist and civil rights groups for advancing black freedom and black women's dignity. So as the winds of war blew around the world, black Communist women were ready to stand on the front lines in new struggles against racism, women's inequality, fascism, and empire.

........................

Racing against Jim Crow, Fascism, Colonialism, and the Communist Party, 1940–1946

> Together, all youth shall build the future and establish a just democratic peace, for with Hitler defeated the collapse of the armies of Hirohito and Mussolini will soon follow. For this purpose and in this spirit all young Americans, Negro and white, must and will fight for victory.
>
> CLAUDIA JONES, *LIFT EVERY VOICE — FOR VICTORY!*, 1942

> I miss you, Sweetheart, unendingly, and love you in immeasurable, geometric proportions.
>
> JAMES E. JACKSON JR. TO ESTHER COOPER, BURMA, 13 FEBRUARY 1945

On 18 April 1942, twenty-three-year-old Esther Cooper delivered the opening address of the Fifth All-Southern Negro Youth Conference held at the historically black Tuskegee Institute in Tuskegee, Alabama. It was the group's first conference since the United States had officially entered World War II.[1] Her report, "Negro Youth Fighting for America," was her inaugural address as the newly elected executive secretary of the Southern Negro Youth Conference (SNYC). Emphasizing black southern youth's centrality "to the resolute prosecution of the war for a speedy victory," she focused special attention on black women. The SNYC, she declared, "recognize[d] the importance of [black] women in winning the war," which was vital "for the preservation of democracy in the world." Stating that black women were "an important part of the total woman labor supply needed in this crisis," she argued that their inclusion into trade unions, as well as extending Social Security and

old age benefits to domestic workers, would be crucial for defeating Nazi Germany, Japan, and Italy. She closed by stating that the Allies would win the war and that southern youth—black and white—would lead the way in building a new democratic South and world.[2]

At first glance, her speech resembled prominent African American spokespersons' calls during the war for a "Double Victory," the defeat of fascism abroad and Jim Crow at home, along with a demand for the end of European colonial empires in Africa and Asia.[3] The address also seems consistent with the CPUSA's agenda of racial and economic justice, anti-fascism, internationalism, anti-colonialism, women's rights, and the protection of civil liberties. However, a more nuanced view reveals how Cooper brought a unique interpretation to both of these positions. She, in effect, called for a "triple victory," arguing that fighting for black women's freedom was critical to defeating Jim Crow, fascism, and colonialism. Urging progressives to foreground black women's struggles in the left-wing agenda, she appreciated black women's lives in intersectional and transnational terms, and understood their status as the gauge by which to measure democracy in the United States and globally.

In this chapter, I argue that black left feminists were at the forefront of radical social change in the United States during the war. They were vital to building the wartime black Popular Front, championing black women's rights, expanding ties with mainstream African American political leaders and clubwomen, and forging international linkages like never before. Black Communist women accomplished this through their community activism, journalism, public speaking, and international travel. Through this work, they constructed their own variant of Popular Front feminism that viewed the struggles against fascism, Jim Crow, colonialism, and black women's oppression across the diaspora as conjoined and regarded black women as the political vanguard. By embracing this position, black women radicals attempted to re-center the Communist Left by making black women's freedom a primary war objective.

These were exciting years for black women radicals. Claudia Jones, Esther Cooper, Louise Thompson Patterson, Audley Moore, and others received national recognition in the Communist Left and black communities for their political accomplishments. Appreciating the personal as political, black Communist women continued to contest prevailing ideas and practices of female respectability, femininity, and masculinity within the pub-

lic and privates spheres. Some black women radicals started families. But these were difficult times, too, for some black Communist women. They continued to battle against sexism, racism, and sectarianism within the Party's ranks. This was most evident in Audley Moore's journey through the wartime Communist Left. Her growing frustration with racism and sexism within the Party, together with its deemphasis of the Black Belt thesis during the war, prompted her to begin rethinking her Communist affiliation by 1945. Her decision revealed deeper tensions within the Party related to issues of race, gender, class, and politics, particularly the uneasy relationship between Communism and black nationalism. Tracing the varied journeys of black women radicals through the wartime Communist Left speaks to how they fought on multiple fronts to advance their black left feminist agendas against Jim Crow, colonialism, and women's inequality. Their intersectional approach also secured their voices in left-wing settings that were not always responsive to black women radicals' special concerns. Indeed, black women radicals sometimes took positions on issues of race, gender, and class that were to the left of the Communist Party's official stance on these matters. Their efforts prove once again how they pursued an innovative black radical feminist politics that both adhered to and modified the central tenets of American Communism.

Black women radicals carried out their work in a context of a world war that fueled black militancy.[4] The Double V slogan coined by the *Pittsburgh Courier* captured this sentiment. A. Philip Randolph's threatened march on Washington for black inclusion in war industries forced President Franklin D. Roosevelt in June 1941 to issue Executive Order 8802. It barred racial discrimination in war industries and established the Fair Employment Practice Commission to implement the order. Grass-roots black militancy pushed the National Association for the Advancement of Colored People, the National Council of Negro Women, and other black civic organizations in more radical directions. The war witnessed the resurgence of the National Negro Congress (NNC) and the formation of new black protest groups, such as the Congress of Racial Equality, the Council on African Affairs, and the March on Washington Movement. Nearly one million blacks served in the U.S. armed forces.[5]

The historian Penny Von Eschen describes World War II as a "diasporic moment," a time when "African American political discourse was keenly informed by and deeply responsive to events in Africa, in the Caribbean, and

throughout the colonized world."[6] For black Americans, President Roosevelt's "Four Freedoms," the Atlantic Charter, the formation of the UN, and anti-colonial fervor across the Global South signaled that colonialism's days were over. By the war's end, the National Association for the Advancement of Colored People, the Universal Negro Improvement Association, the left-wing Council on African Affairs, and the National Council of Negro Women all understood the African American freedom struggle as inextricably linked with independence movements in Africa and Asia.[7]

The war also saw the recomposition of African American communities. More than 1.6 million blacks migrated to the urban North and West during the war in search of better lives. Black union membership soared from 100,000 in 1935 to 1,250,000 by 1945.[8] Economically, black women's material status improved. During the war, the percentage of black women working in the industrial sector tripled while the percentage of domestics declined from 60 percent to 45 percent. Despite making some economic progress, they were still located at the bottom of the work force and earned only sixty-one cents for every dollar made by white women.[9]

The war years saw dramatic shifts in Communist Party lines. Following the Nazi-Soviet Non-Aggression Pact of August 1939, Moscow directed the CPUSA abruptly to end the Popular Front and call for a "united front against the war." The party readopted the Popular Front and vocally called for the United States to enter into the "people's anti-fascist war" after Nazis invaded the Soviet Union in June 1941. The Tehran Conference of 1943 between Joseph Stalin, Franklin Roosevelt, and Winston Churchill convinced Earl Browder, the general secretary of the CPUSA, that peaceful coexistence between the United States and the Soviet Union would continue into the postwar years. In response to the Tehran Conference, American Communists pursued what amounted to a pro-capitalist, reformist program. In 1944, the party disbanded. It reinstated itself as the Communist Political Association (CPA), with the hope that it would become a permanent left-faction within the Democratic Party.[10] Given their concern for winning the war, Communists staunchly supported President Roosevelt and backed the "no strike pledge" for unions. While it never officially abrogated its call for black "self-determination," the Party increasingly subsumed the fight for black equality in the struggle against fascism. But the Party officially opposed the Double V slogan on the grounds that it disrupted national unity for winning the war.[11] The wartime Popular Front strategy helped the CPUSA in 1944 to grow to

one hundred thousand members, its largest membership. Ten percent of its members were black. For the first time, Party membership achieved gender parity.[12]

During the war, the Party sought to maintain Marxist-Leninist orthodoxy on gender oppression. Leadership attempted to mobilize women around winning the war and framed women in traditional roles as loyal citizens and protective mothers.[13] But Popular Front feminism survived. With women's rapid entry into factories and other positions traditionally held by men, gender roles switched, rekindling debates within the Communist Left about gender oppression. At the same time, a growing chorus of leftist women equated American women's domesticity with the Nazi discourse of "children, kitchen, church."[14] Elizabeth Hawes's book *Why Women Cry, or Wenches with Wrenches* of 1943 best exemplified these discussions. Although not officially sanctioned by Communist Party officials, the book was widely read in the Communist Left and the labor movement.[15] For Hawes, the war was as much about liberating women from the drudgery of domesticity as it was about defeating fascism and ending colonialism. Identifying male chauvinism and popular culture as important sources of women's subjugation, she called for factory jobs for women as well as for government-run child-care facilities and birth control clinics to liberate women. She discussed racial discrimination encountered by black women factory workers, black-white labor unity, anxieties about black-white sex, and wartime race riots.[16] *Why Women Cry* impressed the young labor journalist Betty Friedan. In 1943, she joined the journalism staff of the left-wing *Federated News* and later the *UE News*, the official magazine of the left-led United Electrical Radio and Machine Workers, a union that was affiliated with the CIO. Like Hawes, Friedan called for progressive coalitions between labor, African Americans, and women. But in the end, white women remained the focus of white women leftists.[17]

From the Grass Roots: Building the Wartime Black Popular Front in Harlem

Black women were highly visible in forging the black Popular Front in Harlem during World War II. These women included Audley Moore, Bonita Williams, Helen Samuels, and Rose Gaulden. Many were from humble backgrounds and had traveled into the Party through Garveyism during the 1930s. Functioning both as grass-roots organizers and visible leaders,

they were at the front lines in leading wartime mass movements focused on everyday Harlem residents' survival and expanding black political power. These campaigns scored some important victories on these issues. Due to these accomplishments, black women in the Party gained local and national reputations in the Communist Left and African American communities. Yet some Harlem Communist women found themselves in a precarious situation. Despite winning praise from their comrades, black women radicals still often functioned as outsiders within the Communist Party. Their location at the interstices of race, gender, and class, together with the Party officials' ambivalence toward black nationalism, explains black left women's uneasy status within the Communist Party. This was most apparent in Audley Moore's complicated relationship with it. Her frustration with Communist leadership had prompted her to reassess her relationship to the Party by the war's end. Her journey and those of other black women radicals during the war speaks again to their varied, shifting relationships with the Communist Left.

Black Communist women were prominent in mass Harlem organizations connected to the popular, charismatic minister and politician Adam Clayton Powell Jr., who openly embraced the black Popular Front agenda. For example, Audley Moore, with the black Communist leader Benjamin J. Davis Jr., was instrumental in helping Powell form the People's Committee. Its goal was to rapidly mobilize Harlem residents to demonstrate and picket. In 1941, the journalist Ann Petry organized Negro Women, Inc., an auxiliary of the People's Committee. She served as its executive secretary until 1947. She was not a Communist, but she worked closely with Communists.[18]

Black women radicals also agitated outside of the Communist Left in struggles around survival issues. Ann Petry headed the Consolidated Housewives League, a non-Communist group that held mass meetings in Harlem around housing, police brutality, and jobs, linking these issues to the Double Victory. These experiences as a community activist and journalist provided Petry with valuable insight into black working-class women's triple oppression, issues she incorporated into her epic novel *The Street* in 1946.[19] Bonita Williams, Rose Gaulden, and Audley Moore sat on the group's executive board, revealing once again how black left feminists understood consumption as a key political issue facing everyday black people.[20]

No black woman radical was more active in non-Communist protest groups than Moore. Working "twenty-five hours, eight days a week . . . with

everything and everybody, everything my people belonged to," she later claimed, Moore joined several non-Communist organizations.[21] These included the NAACP, the Ethiopian World Federation, and the National Council of Negro Women (NCNW). The NCNW served as a key site for her wartime activism. She became a lifetime NCNW member, wrote for its official magazine, *The Aframerican Woman's Journal*, sat on its executive board, and came to know its founder and president, Mary McLeod Bethune.[22] Resembling black women radicals' position on the war, the NCNW adopted a militant civil rights program that understood black women's freedom as a war aim. The NCNW called for the elimination of the poll tax, a federal antilynching law, the protection of civil liberties, the unionization of domestic workers, the opening of white-collar and defense industry jobs to black women, the expansion of Social Security benefits to cover domestic and agricultural workers, and increased government spending on social programs. The NCNW understood these issues in a global context, forging political alliances with women from around the world, especially with women in India.[23] Moore felt at home in the NCNW. Her comfort speaks to how wartime political shifts created new opportunities for political collaborations between black Communist women and clubwomen. The leftward shift in American political culture during the war certainly helps explains this. But so does black women radicals' willingness to work across ideological and organizational boundaries.

Black Communist women played a crucial role in the historic election of the Harlem Communist leader Ben Davis to the New York City Council in 1943. As the first "black red" elected to public office in the United States, Davis's election arguably stands as the most successful wartime black Popular Front campaign.[24] The Communist Party decided to run Davis for office in June 1943 after Adam Clayton Powell resigned his city council seat to run for U.S. Congress in 1944. He picked Davis as his chosen successor, virtually assuring Davis's victory.[25] Reared in a prominent Atlanta family and a graduate of Harvard Law School, Davis was well known in Harlem as a brilliant attorney for defending Angelo Herndon during the Depression.[26] A new proportional representation system in New York opened the field for third party candidates. Communists hoped to capitalize on growing black militancy across the country, especially in the wake of deadly "race riots" in Detroit in June 1943 and in Harlem in August 1943.[27] Internationally, the Soviet Union's inclusion in the Grand Alliance and the Red Army's decisive

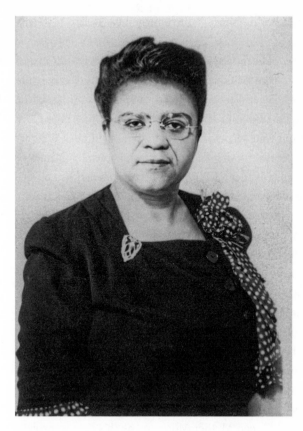

Audley Moore, circa 1940S. CREDIT: THOMAS O. WARNER.

victories over Nazi armies along the Eastern Front enhanced Soviet stature with the American public.[28]

Audley Moore was central to Davis's election. Her work on his behalf stands as her most significant accomplishment as a Communist. Recognizing her proven track record as a leader, Communist officials appointed Moore as the campaign manager of the Citizens Non-Partisan Committee to Elect Benjamin J. Davis Jr. to the city council. Working closely with Adam Clayton Powell, Paul Robeson, and the famed singer Billie Holiday, Moore built an electrifying grass-roots campaign that secured Davis's unprecedented victory. Communists, African Americans in Harlem and across the country, and even people as far away as Algeria celebrated his election. The Communist and African American press featured articles that explicitly credited Moore's crucial role in the campaign.[29] This praise showed how the Communist Left provided an alternative path to upward social mobility for Moore. Following his election, Communist Party officials reassigned her to

Detroit, a site of black labor militancy.[30] She returned to Harlem in March 1945.[31]

Other black women radicals played visible roles in Davis's campaign and on his council staff. Rose Gaulden was a spokesperson for Davis, while the Communist activist Helen Samuels chaired campaign fundraisers for him. These efforts helped assure his landslide reelection in 1945. The Party selected both Moore and Gaulden as alternates to the Communist Political Association's national committee in 1944. Surely these women's prominence in Davis's campaign explains their election.[32] Moreover, their work on behalf of Davis and their involvement in movements around survival issues directly linked Harlem women radicals to wage-earning black women. Personally, these movements fostered a sense of community among black women radicals. Audley Moore, Bonita Williams, Rose Gaulden, and Helen Samuels were more than political associates. They were close friends. Passionately committed to social justice, they believed their collective work was vital to championing the rights and dignity of black people in Harlem and beyond.[33]

At the same time, World War II represented a challenging moment for many women in the Harlem Communist Party. The Party's long-standing ambivalence toward black nationalism, together with racism, sexism, and classism within the Communist Left, prompted some black women to question white Communists' racial sincerity and to rethink their Communist affiliations. In retrospect, Queen Mother Moore made this case to explain her decision to break from the CPUSA in 1950. By the end of the war, Queen Mother Moore claimed that she had become frustrated with how Communists "had relinquished their position . . . that we were a Nation." At the same time, she had an epiphany. She came to realize that the term "Negro" was a white supremacist invention to mentally enslave black people.[34] She described her revelation like a religious conversion: "And then it struck me that we weren't Negroes, but actually Negroes were made out of us . . . Oh my God—I nearly died. Bile began to pile up in me. And one day that bile came out—Oh! I was vomiting from my mouth, on the walls—shooting back and forth. I then went out like a light."[35] According to the scholar Kai Jackson Issa, Moore's story about her "denegroization" stands as a "profound life moment of self-emancipation and personal decolonization from her prior 'Negro' identity, into what she viewed as a new and supremely liberating 'African' self-identity."[36]

Excited about her new revelations, Moore rushed to see Earl Browder, the

general secretary of the CPA, Ben Davis, and other Party leaders. However, her ideas, she claimed, alarmed them: "They couldn't touch it. They began to look upon me as an enemy, 'cause you're not supposed to think out of their realms. So I resigned. I recognized the coldness and aloofness and everything. . . . Here I was searching, and that was no good for them."[37] In her view, Communist officials punished her for questioning the Party's commitment to black self-determination, embracing black nationalism, and thinking independently about the Negro Question.

Queen Mother Moore's narrative is instructive about some black radicals' disillusionment with wartime American Communism. The scholar Nikhil Pal Singh observes "that many important black radicals—including [Richard] Wright, [Ralph] Ellison, Bayard Rustin, Langston Hughes, and Chester Himes—actually distanced themselves from the CPUSA during the war, not because they sought the political mainstream but because they felt the Party was not radical enough and believed it had betrayed a consistent and principled commitment to black self-determination and the primacy of struggles against racism and colonialism."[38] Certainly this was true for Moore. However, her growing disillusionment with the Party was also connected to her status as a black working-class, southern migrant woman. She was an outsider within the Communist Left. Moore's painful encounters with the Party reveal that this was the case. Looking back, she claimed that her reassignment to Detroit was a form of punishment for embracing black nationalism. Her belief was not unfounded. Party leadership often reassigned cadres to different locales after individuals fell out of favor.[39]

Years later, Queen Mother Moore pointed to Davis's bid for New York City Council as an example of alleged Communist duplicity toward blacks and the Party's disrespect toward her. According to her, Davis initially "didn't believe he was going to be elected, and the Communist Party didn't want him elected."[40] After the election, Queen Mother Moore claimed that CPUSA officials and Davis were "shocked" that he had won. Their surprise insulted her. She always believed Davis would win, given her hard work and reputation in Harlem as an effective community organizer.[41] Her insecurities about her intellect and southern working-class background surely made her sensitive to criticism. As she stated years later, "I always had an inferiority complex toward those members who were so well equipped. They could espouse Marxism, Leninism and all of those profound teachings—and I couldn't do it."[42] For these reasons, she may have been especially sensitive to personal

slights coming from middle-class, college-educated male Party officials like Davis who, she believed, never respected her intellect and political acumen.

Moore was not imagining insults directed toward her. Some black Communist men and fellow travelers did view her with contempt. A letter from the novelist Ralph Ellison to his good friend and Communist Richard Wright in 1940 shows that this was the case. In the letter, Ellison described a heated discussion of Wright's acclaimed novel *Native Son* at a meeting of the Harlem Communist Party that Ellison and Moore both attended. Ridiculing her for being allegedly overweight and foul smelling, Ellison excoriated Moore for criticizing a scene in which the novelist's protagonist, Bigger Thomas, makes love to his girlfriend in front of her children. Ellison dismissed Moore's claim on the grounds that she supposedly "had not read the book." He also objected to her assertion that the scene was unrealistic: "Because Negro women did not do such things! She was a Negro woman and she knew."[43] There is no record of her side of the story. Nor was she probably aware of Ellison's letter. Nonetheless, his disparaging remarks about Moore can be seen as part of a larger pattern of racism and sexism that black women encountered in the CPUSA. This incident also sheds light on Moore's politics. Although the story is mediated through Ellison, her alleged criticisms of *Native Son* are consistent with her long-standing concern about denigrating representations of black women as unchaste and hypersexual. Given her firsthand past experiences with being sexually assaulted by white men, she was acutely sensitive to this issue. She expected black men to protect and respect black women.

At the same time, Queen Mother Moore's account of her break from the CPUSA needs to be read carefully in light of her reinvention into a strident black nationalist. Her reasons for breaking from the Party may not have been as apparent as she explained later in life. A letter dated 8 May 1945 (V-E Day) from Moore, Rose Gaulden, Bonita Williams, and Helen Samuels to Earl Browder, the head of the CPA, is a case in point. Their letter praised his leadership of the CPA: "Never shall we forget as Negroes, particularly as women, what you have done to place before America and the world a decent human approach to the Negro people."[44] The letter raises questions. Did they sincerely believe at the time that Browder deserved credit for black advancement during the war? Or was the letter a politically shrewd move to win (or possibly to regain) good favor with Browder on the heels of the Nazis' defeat? Perhaps the answer lies somewhere in between.

The letter forces us to view Queen Mother Moore's testimonies about her break from the CPUSA with some skepticism. She neither mentioned the letter later in life nor discussed her attempts to win good favor with Browder by the war's end. This is not to say that she may not have harbored doubts about Communists' racial sincerity. Nor does the missive invalidate her frustration with the public and private sexism of Communist men directed toward her. But the letter does challenge her narrative that neatly portrays her as a Communist dupe and the Party as racist and opportunist. Her relationship to the Communist Party was more complicated than she claimed. Moore possessed agency. She was politically savvy. The letter shows that she sought to maintain good standing—for whatever reasons—with Party leadership, clearly demonstrating why scholars must carefully interrogate black anti-Communists' testimonies about bolting from the American Communist Party. Political and personal agendas motivated black anti-Communists just as much as they did black Communists.

It is unclear if Moore's close associates—Bonita Williams, Helen Samuels, and Rose Gaulden—drew similar conclusions about the Party or broke from it in the postwar years. But given the complete absence of their names in Party-affiliated periodicals after the late 1940s, it seems likely they did. These women's departures from the CPUSA are significant. They were organic, proletarian, activist intellectuals who functioned primarily as grass-roots organizers. Many had traveled into the Communist Party through Garveyism. The Party's hostility toward black nationalism and the presence of racism, sexism, and elitism within its ranks alienated the very women who were integral in securing the wartime Harlem Communist Party's success. Their exits provide another example of black women's complicated relationship with the Communist Left. On the one hand, it provided them with a unique vehicle for advancing black freedom. On the other, some party leaders never fully appreciated these women's talent and intellect.

National Leadership

While some Harlem Communist women such as Audley Moore began rethinking their affiliation to the Communist Party, other black women such as Claudia Jones and Louise Thompson Patterson moved further into the wartime Communist Left. The Party also recruited new black women into its rank and file. The journeys of Jones and Thompson Patterson, as well as the enlistment of new black women members, is instructive into how the inter-

Claudia Jones marching with the Young Communist League, New York, circa 1940. CREDIT: ESTHER COOPER JACKSON.

play between race, gender, class, and politics functioned in positioning black women in the Communist Left and in shaping their experiences within it.

By 1945, Claudia Jones had eclipsed Louise Thompson Patterson as the leading black woman in the Communist Party. During the war Jones became the educational director of the Young Communist League (YCL) and the editor of *Spotlight*, the official publication of American Youth for Democracy, the YCL's successor.[45] Although she held ranking positions within the Communist Left, Jones maintained close connections to the grass roots. She regularly spoke and canvassed on Harlem street corners. In addition, she came to know black Communist leaders in the Southern Negro Youth Congress (SNYC). These included Esther Cooper, James Jackson, Dorothy Burnham, Louis Burnham, Augusta Jackson, and Ed Strong. Jones attended several SNYC biennial conferences during the war, publicly endorsing the group's program. For a young black woman, not yet thirty, who had been reared in poverty in Harlem by destitute immigrants, becoming a leader in the global Communist movement surely was exhilarating and affirming.[46]

Louise Thompson Patterson remained visible nationally in the wartime Communist Left. Chicago served as her political base during the war. In 1941, she returned to the city of her birth with her new husband, the black

Communist leader William L. Patterson, after the International Workers Order (IWO) reassigned her there. The couple lived on Chicago's South Side until 1949 before returning to New York. As she had done in Harlem, in Chicago she played a key role in maintaining connections between the Communist Left and black intelligentsia, underscoring the importance of black women radicals in building the wartime cultural front.[47]

Living in Chicago placed Thompson Patterson in a city that had been a Communist stronghold since the 1920s. Chicago was also an important site of black radicalism, particularly in the South Side, the city's black neighborhood, which counted nearly three hundred thousand people by 1940. During the Depression, the party organized reading clubs and staged mass demonstrations around Scottsboro, social relief, and jobs. Dynamic individuals, such as Richard Wright, Claude Lightfoot, Geraldyne Lightfoot, and Ishmael Flory—all whom Thompson Patterson personally knew—joined the party during these years. Following the inaugural National Negro Congress in February 1936, the "Negro People's Front" enhanced the left-wing character of black Chicago politics and culture from the Depression into the postwar period.[48]

The IWO served as the principal site for Thompson Patterson's activism in Chicago. Continuing as the highest-ranking African American and woman in the organization, she held several top posts in the IWO. These included president of the Midwest district and national vice-president. During the war, she worked closely with the IWO's national leadership, fraternized with its multiracial rank-and-file membership in lodges across the Midwest, corresponded with prominent black reformers such as Mary McLeod Bethune, and collaborated with Ishmael Flory, the black Chicago Communist leader, and Horace Cayton, the preeminent sociologist and co-writer of what became *Black Metropolis*, later recognized as a classic in urban sociology.[49]

While Thompson Patterson maintained her reputation as a national leader in the Communist Left, she, like Jones, remained closely tied to the grass roots, most prominently through Thompson Patterson's leadership of the IWO's Du Sable 751 Lodge on the South Side. Formed in 1940 and named after Chicago's first settler, the Haitian-born Jean Baptiste Pointe du Sable, the lodge under her directorship thrived as a bustling black political and cultural community center. Black women played a prominent role in Du Sable Lodge 751. It featured the work of black women artists and intellectuals sympathetic to left-wing causes, such as the poet Gwendolyn Brooks, as well as

the visual artists Elizabeth Catlett and Margaret Taylor Goss Burroughs.[50] Counting more than 1,000 members by the war's end, the lodge diffused the iwo's Popular Front program into the South Side. Nationally, the iwo counted 185,000 members at its height in 1947. The group owed its success to leaders like Thompson Patterson.[51]

While established black women radicals like Thompson Patterson continued to thrive during the war years, the Communist Party also recruited new black women into its membership. One of the most important of these women was Charlene Alexander (Mitchell). She emerged as one of the most influential leaders in the Communist Party from the late 1950s through the 1980s. Like black women before her, Mitchell joined the CPUSA because she saw it as an alternative to mainstream black protest groups for advancing black freedom. Born in 1930 in Cincinnati, Ohio, she migrated with her working-class family to Chicago. During the war, she grew up in the Frances Cabrini Housing Rowhouses, which were then racially integrated. Mitchell never imagined becoming a revolutionary. Instead, she took classes at nearby Moody Bible Institute, with plans on becoming a missionary. But widespread racism within the school deeply troubled her. At the same time, young Communists' efforts in picketing racially discriminatory restaurants and movie theaters on Chicago's West Side impressed Mitchell, prompting her enlistment in the American Youth for Democracy in 1943 and the Communist Party in 1946. Although she was not acquainted with Louise Thompson Patterson in the immediate postwar years, they would eventually become close friends, collaborating in several left-wing campaigns from the 1960s onward.[52]

Mitchell moved quickly up the CPUSA hierarchy following her enlistment. In 1955, she moved to Los Angeles as per the party's request. There she became close friends with Cyril Briggs, a veteran and Afro-Caribbean radical who had relocated to Los Angeles in 1944 and remained committed to black liberation and socialism. In 1957, at the age of twenty-seven, she became the youngest person ever elected to the CPUSA's National Committee. For the next thirty years, she remained a ranking Communist Party official.[53]

The experiences of Charlene Mitchell, Claudia Jones, and Louise Thompson Patterson contrasted significantly from those of grass-roots women activists in the Harlem Communist Party, such as Audley Moore. The Party's political culture, together with their locations within the movement, helps explain these women's varying encounters with the Communist Left. While

black liberation was central to Jones, Mitchell, and Thompson Patterson, they did not embrace Moore's burgeoning narrow nationalism or her racial separatism. Instead, Jones, Mitchell, and Thompson Patterson appreciated both the importance of independent black political organizing and multiracial coalition building for advancing black freedom. This approach differed from Moore's and the Party's official position on racial equality. Black women's location within the Communist Left also explains their different encounters with it. Moore functioned primarily in street-level leftist movements. Jones and Thompson Patterson, however, held ranking positions within the Communist Left. These posts offered them some protection from the kind of racism and sexism that Moore readily encountered. In addition, Thompson Patterson's marriage to a ranking black Communist leader provided her with additional cover. This is not to say that Jones, Mitchell, and Thompson Patterson did not encounter sexism and racism within the Party. They did. In their journalism and in Party meetings, they criticized their white comrades for their prejudices. Thompson's article "Negro Women in Our Party" of 1937 and Jones's article "An End to the Neglect of the Problems of the Negro Woman!" in 1949 best evidenced this. Intellectually, Jones, Thompson Patterson, and Mitchell were confident in their mastery of Marxism-Leninism. They could hold their own in intense theoretical political discussions with their comrades, while Moore often felt intellectually insecure in these settings because of her southern, working-class, Garveyite roots. In contrast, Thompson Patterson's college background and friendships with ranking Party leaders and prominent black reformers allowed her to function comfortably in the Communist Left. Given this, these women's journeys through the wartime Communist Left speak both to how it appealed to black women radicals from widely different social backgrounds and alienated some women, particularly those primarily located in street-level movements or sympathetic to black nationalism.[54]

The Southern Negro Youth Congress

The Southern Negro Youth Congress served as a key, wartime site where black women radicals cultivated black left feminism, forged a community of black women radicals, and built the southern black Popular Front.[55] Anticipating the Student Nonviolent Coordinating Committee of the 1960s, activists of the SNYC were the shock troops of struggles for black equality across the Jim Crow South during the war. The organization led campaigns

for voting rights, jobs, desegregation of public accommodations, and labor rights, understanding these issues as inseparable from global struggles against fascism, colonialism, and white supremacy. The leadership of the SNYC consisted of Communists and non-Communists. Its advisory board included distinguished African American reformers, such as Mary McCleod Bethune; Charlotte Hawkins Brown; F. D. Patterson, the president of the Tuskegee Institute; Emory O. Jackson, the editor of the *Birmingham World* newspaper and the head of the Birmingham NAACP chapter; Charles Johnson, a sociologist at Fisk University; and Modjeska Simkins, a leader of the South Carolina NAACP.[56]

Looking toward the future, the SNYC relocated its headquarters from Richmond to Birmingham in 1940. The city was the "American Johannesburg." Birmingham's large black industrial working class toiled in the most menial, dirtiest jobs in the city's steel mills and nearby coalmines. Eighty-five percent of black women wage earners worked as domestics. Segregation was omnipresent. Few blacks could vote. The Klan and police violence helped maintain Jim Crow.[57] In the face of this oppressive situation, blacks were hardly complacent. They resisted the Jim Crow order, with Communists leading the way since the early 1930s. Due to their success in building Depression-era mass movements around jobs, social relief, and Scottsboro, Communists had earned a reputation as a militant alternative to the more staid NAACP and Urban League. However, by the beginning of the war, the local NAACP, under Emory O. Jackson's leadership, had become one of the nation's most militant branches.[58]

From its very beginning, black women were visible leaders in the Southern Negro Youth Congress. Thelma Dale was a founding member of the SNYC and served as its vice-president. Other black women leaders included Rose Mae Catchings (president), Dorothy Burnham (educational director), and Augusta Jackson (editor of its newspaper, *Cavalcade: The March of Southern Youth*). No woman was more prominent in the SNYC than Esther Cooper. Recognizing her leadership skills, her comrades elected her as the organization's administrative secretary in late 1940 and two years later as its executive secretary.[59]

Under Cooper's leadership, the SNYC adopted a militant Double V program. This was evident in her address, "Negro Youth Fighting for America," before the Tuskegee conference in 1942. She was unequivocal about the group's support for the Double V and insisted that black women's freedom

was critical to the war's success. Given the SNYC's support for the war effort, the Tuskegee conference received an official letter of greetings from President Franklin Roosevelt: "Your strength, your courage and your loyalty to your country help assure this victory."[60] This stance challenges the historian Eric Arnesen's recent criticism of black Communists for their alleged "slavish devotion to the Soviet Union, its worship of a totalitarian state, its blatant lack of internal democracy, and its willingness to sacrifice black interests on command."[61] Indeed, the SNYC's war timeline demonstrates its ideological independence from the CPUSA. Certainly, Alabama Communists took seriously directives from the Party's national leadership.[62] But they also had their finger on the black community's political pulse. Opposing the Double V would have been tantamount to political suicide for the SNYC in the Jim Crow South. Black communities' support for the war was inseparable from their demand for rights, jobs, and personal security from racial terror. Recognizing this, Cooper and her comrades formulated a program that reflected their ideological flexibility and genuine concern for both winning black rights and the war.

Serving as the SNYC's executive secretary thrust Cooper into the local and national spotlight as a leading, young civil rights spokesperson. She frequently spoke at rallies at Birmingham's prestigious Sixteenth Street Baptist Church, which would become the headquarters of the city's civil rights movement two decades later and the scene of the horrific bombing that killed four black girls in 1963.[63] During the war, she worked with the educator Modjeska Simkins, the civil rights activist Septima Clark, and Mary McCleod Bethune, the keynote speaker at the SNYC's conference in Atlanta in 1944. Cooper also met Ella Baker, then the NAACP's director of branches. Interacting with these women bolstered Cooper's commitment to fighting for civil rights and black women's dignity.[64]

Black women officials of the SNYC cultivated indigenous black women leaders in Birmingham. Dorothy Burnham recruited Mildred McAdory, a talented organizer and journalist from humble beginnings, into the organization. In 1942, white police viciously beat and arrested McAdory and three other SNYC activists for their attempts to move the "colored only" sign on a bus in Fairfield, Alabama, a black industrial suburb of Birmingham. The SNYC generated national publicity around the incident with the publication of the pamphlet *For Common Courtesy on Common Carriers*. The group staged a short-lived boycott of Birmingham buses.[65] The campaign

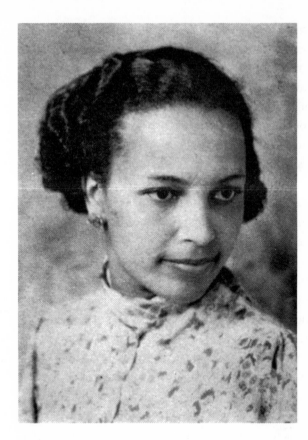

Sallye Bell, 1939. SOURCE:
JAMES E. JACKSON AND
ESTHER COOPER JACKSON
PHOTOGRAPH COLLECTION,
TAMIMENT LIBRARY AND
ROBERT F. WAGNER LABOR
ARCHIVES, BOBST LIBRARY,
NEW YORK UNIVERSITY.

impressed E. D. Nixon, a civil rights and trade union leader based in Mont-gomery, Alabama, who played a crucial role in leading the Montgomery bus boycott of 1955. During the war, he sat on the SNYC's advisory board and collaborated with McAdory. That she inspired Nixon illustrates the under-appreciated importance of black women radicals in laying the groundwork for the civil rights movement.[66]

Sallye Bell Davis was another local woman who emerged as an impor-tant SNYC leader. A schoolteacher deeply committed to social justice, Bell Davis became an important link between the SNYC and Birmingham-area churches, women's clubs, and trade unions. She never enlisted in the Com-munist Party. However, her daughter, Angela, would become perhaps the most famous black Communist of all time.[67]

The SNYC was not exceptional among black left organizations in pro-moting black women leaders. In 1943, Thelma Dale replaced Ed Strong as the head of the New York–based National Negro Congress after he entered the

army.[68] The NNC's executive board also included the Communist Dorothy Funn and Jessie Scott Campbell, a National Youth Administration official who had been actively involved in the YWCA and the Young Communist League during the Depression in Brooklyn. These women were hardly symbolic figureheads; they were recognized leaders of these organizations.[69]

Black left organizations such as the SNYC and the NNC were unique at this historical moment in their promotion of black women as titular heads of secular, mixed-gender black protest organizations. Wartime dislocations did help to create leadership opportunities for women in black left organizations. But it was black leftist women's determination to lead that best explains their visibility in these groups. This outlook served as a common basis for friendship, as Esther Cooper, Dorothy Burnham, Mildred McAdory, Augusta Strong, Claudia Jones, Sallye Bell Davis, and Thelma Dale became lifelong friends.[70]

Years ahead of its time, the SNYC's movement culture encouraged black female and male radicals to recognize the personal as political. According to Cooper Jackson, black Birmingham Communists understood the Woman Question as "an integral part of the whole struggle to change society."[71] They discussed Frederick Engels's *Origins of the Family, Private Property, and the State* in their study circles. Additionally, some SNYC women leaders, in an effort to maintain their sense of independence, continued using their maiden names in public for years to come.[72]

The SNYC promoted models and practices of "progressive black masculinity."[73] Cooper Jackson recalled that black Communist men "thought [that] to be a good Communist you struggled on the woman question."[74] Black Communist men consciously tried to eradicate sexism within their personal lives. James Jackson and Louis Burnham, for example, regularly shared domestic and child-care responsibilities. They encouraged their wives to speak at rallies and to assume leadership responsibilities in the SNYC. The men, however, did not "always live up to this [their anti-sexist politics]," Cooper Jackson insisted.[75] Still, SNYC leaders' efforts in grappling with sexism signals how the group rejected prevailing masculinist articulations of black liberation espoused by most contemporary black protest organizations.[76]

The SNYC's gender politics differed from those of contemporary black women's organizations such as the Ladies' Auxiliary of the Brotherhood of Sleeping Car Porters. The historian Melinda Chateauvert argues, "The Ladies' Auxiliary drew on female domesticity to claim a role in the Brother-

hood" and to demand racial equality and citizenship. This is significant. The Ladies' Auxiliary backed A. Philip Randolph's March on Washington Movement, which equated black freedom with black manhood redemption.[77] In contrast, SNYC women formulated alternative understandings of female respectability and black female leadership based on women's autonomy from traditional gender roles. Additionally, the SNYC was in many respects more progressive on gender matters than the NAACP and the Communist Party's national leadership. The SNYC's consensus style of decision making helps explain this. In contrast to the hierarchical leadership models practiced by the CPUSA and the NAACP, the SNYC's democratic process encouraged women's participation in running the organization.[78]

The realities of segregated Birmingham circumscribed black SNYC women's activism. Few black Birmingham residents could vote. Most local, white CIO leaders opposed racial equality. A climate of fear and intimidation discouraged public and private interracial mixing. At the same time, the late 1930s and early 1940s saw a "little red scare." The Virginia congressman Martin Dies, a staunch segregationist, anti-Communist, and anti–New Dealer, launched a special committee on un-American activities known as the Dies Committee and later as the House Committee on Un-American Activities. The Dies Committee investigated and harassed the Southern Conference on Human Welfare, the largest southern Popular Front organization, as well as the CIO, the SNYC, and southern New Dealers, for their alleged ties to the CPUSA. In this context, Birmingham Communists went to extraordinary lengths to conceal their work from authorities out of fear of being arrested or even killed. So while it was possible for Audley Moore to organize large election rallies for Ben Davis in Harlem and for Louise Thompson Patterson to fraternize with white midwestern IWO members, carrying out this kind of work was practically impossible for black women radicals in Birmingham.[79]

During the war, Birmingham authorities targeted SNYC women leaders, particularly Esther Cooper. She was never beaten by police as was the case for Mildred McAdory. But the police did arrest Cooper in 1941 for organizing coal miners outside of the city.[80] She made city officials nervous. In a private meeting between James Jackson, the Birmingham mayor Cooper Green, and the city's commissioner of public safety Eugene "Bull" Connor, who gained international notoriety twenty years later for his staunch opposition to desegregation, Connor accused Cooper of being a "dangerous woman" for her

work with the SNYC.[81] Local whites were not the only ones uneasy about Cooper. The FBI was too. It opened a surveillance file on her in 1941. During the war, the FBI compiled nearly one hundred pages of reports on her alleged subversive activities in the SNYC and in CPUSA-affiliated groups. The FBI also began surveilling the SNYC, as well as several black women radicals during the early 1940s, including Audley Moore, Claudia Jones, Louise Thompson Patterson, and Thyra Edwards.[82] Authorities also targeted national Communist leaders such as Earl Browder and black reformers such as Mary McLeod Bethune.[83] That black women radicals in the SNYC agitated against Jim Crow in this repressive political climate not only speaks to their bravery but also to their sense of optimism for the future and their commitment to realizing racial democracy in the South.

Marriage, Family, and Community Bonds

For many black women radicals, World War II marked a new phase in their personal lives. Several of them, including Esther Cooper, Augusta Strong, Louise Thompson Patterson, and Dorothy Burnham, became mothers during the war. At the advanced age of forty-one, Louise Thompson Patterson gave birth to her only child, MaryLouise Patterson, in Chicago.[84] In March 1943, Esther Cooper gave birth to the couple's first child, Harriet, named after Harriet Tubman. Her second, Kathryn, was born in 1947 in Detroit.[85] While professional women typically ended their careers after having children, black women radicals, along with their male partners, refused to comply with this prevailing practice. Black leftist women not only attempted to balance the demands of marriage, motherhood, and political activism. They sought to redefine these relationships. Appreciating the personal as political, black women radicals sought to forge marriage and personal relationships based on gender egalitarianism. By any measure, the Communist Left continued to serve as a site where some black women and men forged a transgressive gender and sexual politics that challenged prevailing gender conventions found in women's clubs and the church.[86]

The historians Kathleen A. Brown and Elizabeth Faue write that Communist marriages often "took the form not of direct support or common work but of mutual autonomy and independence."[87] This certainly was true for black Communist couples. James Jackson and Esther Cooper were separated for nearly three years during the war following Jackson's enlistment in the army in June 1943. He served eighteen grueling months in the China-

Burma-India Theater.[88] When he left Birmingham, Harriet was only three months old.[89] Despite being physically separated for an extended time, the Jacksons corresponded daily, exchanging nearly one thousand letters. Like other left-wing activists "separated from their home communities, correspondence served as an important way of maintaining bonds and sustaining political activism," note Brown and Faue.[90] The Jacksons' letters discussed the war, the home front, the SNYC, the CPUSA, family, friends, and plans for having a second child. Erotic poetry filled their letters, revealing how much each partner missed, loved, and dreamed of being reunited with the other. Their letters sustained their love. At the same time, their long separation made Cooper more independent and self-confident, as she had a young child to raise and an organization to run.[91]

Similarly, Louise Thompson Patterson and William Patterson forged a lifetime partnership based on gender egalitarianism. Like Louis Burnham and James Jackson, William Patterson regularly performed household and child-care duties. However, practical necessity, as much as politics, inspired Patterson's actions. Thompson Patterson was the breadwinner, as she worked a variety of jobs during the 1940s and 1950s, including a position in the UN housing agency. Still, his willingness to perform this work illustrates how black radical couples rethought marital relations, understood the personal as political, and embraced progressive models of black masculinity.[92]

Despite some glimpses into black women radicals' marriages, many aspects of their inner lives remain a mystery. This is true of Audley Moore and Claudia Jones. They rarely discussed details about their marriages to friends, colleagues, and, in Queen Mother Moore's case, interviewers later in life. Jones's autobiographical letter of 1955 to William Z. Foster, the Party's national chairman, makes only passing reference to her husband, the white Jewish Communist Abraham Scholnick. Her personal papers are mostly silent about her private life. Similarly, in her interviews in the 1970s and 1980s, Queen Mother Moore consistently declined to answer questions about her marriage to Frank Warner, which apparently ended during the war. She never stated why. What is certain is that the marriage was not a union of equals. While Warner was politically engaged, it was Moore who had acquired national stature as a black radical political activist. The same can be said of Jones's marriage.[93]

The archival record provides some insight into their marriages. Separating in 1944, Jones and Scholnick filed for divorce in absentia in Ciudad

MaryLouise Patterson, Louise Thompson, and William L. Patterson, mid-1940s. SOURCE: LOUISE THOMPSON PATTERSON PAPERS, MANUSCRIPT, ARCHIVES, AND RARE BOOK LIBRARY, EMORY UNIVERSITY.

Juarez, Mexico in 1947. Their divorce papers cited "incompatibility" for dissolving their marriage.[94] They had no children. It is not clear if she ever intended on having any. Her doctor's letter to Jones's attorney during the McCarthy period indicates, however, that she had had a hysterectomy for unexplained reasons at the age of twenty-nine in 1944. Given the intimate nature of this matter, it is not surprising that she did not mention this in her personal papers or in her autobiographical letter.[95] In Moore's case, FBI records claim that Frank Warner was her common-law husband. But this claim cannot be corroborated.[96]

Moore's and Jones's silence about their marriages is telling. It suggests that they constructed personal narratives to show their "resistance to being defined in the context of traditional-male dominated relationship[s]," as Kai Jackson Issa argues.[97] Both women were fiercely independent. Politics dominated their lives. Their unconventional marriages and rumors about their sexual affairs illustrate once again how black women radicals refused to be circumscribed by prevailing gender roles. At the same time, the silence about their inner lives resembled that of many black women artists, entertainers,

and reformers. In her insightful study of the jazz singer Billie Holiday, the cultural scholar Farah Jasmine Griffin observes how Holiday purposefully obfuscated her personal life from public view to protect herself from denigrating representations. Choosing to be a "mystery," Griffin argues, "is the one way [Holiday sought] to maintain a semblance of control" in a world hostile to black women. Black women radicals seemed to have employed a similar strategy.[98]

Black Communist women and their partners raised their children in the radical, oppositional culture of the Communist Left. As a child and a teenager, MaryLouise Patterson frequently attended left-wing political rallies with her parents. She befriended the children of black Communist couples, including the Jacksons, the Strongs, and the Burnhams, who moved to New York by the early 1950s. She also knew Sallye Bell Davis, her husband, Benjamin Davis, and their children, who drove to New York from Birmingham every summer during the 1950s. These families comprised a small, thriving black radical community in New York. At the same time, the Pattersons' Harlem apartment was a center of radical political activity.[99] The country's leading black radicals, including W. E. B. Du Bois, Shirley Graham Du Bois, and Paul Robeson, as well as ranking white Communist Party officials, such as Herbert Aptheker, often gathered in the Pattersons' living room. For MaryLouise Patterson, these encounters from an early age put a human face on Communists: "I can't recall anybody coming into my parents' house, particularly their close friends, who were not really warm and caring, generous, funny people."[100] Like many "red diaper babies," she never followed her parents into the CPUSA. But she did travel to the Soviet Union in the early 1960s, and she maintained throughout her adult life a relationship with the CPUSA and her parents' friends and their children.[101]

Queen Mother Moore rarely discussed raising her son, Thomas Warner. When she did, she often expressed regret that she was frequently away from him for extended periods on Party-related work.[102] But what is certain is that she, like other black Communist parents, desired to raise her child in the politically progressive, multiracial Communist Left. For ten summers from the mid-1930s through the mid-1940s, Thomas Warner attended the Party-affiliated, co-ed, interracial Workers Children Camp (Wo-Chi-Ca) in rural New Jersey, providing him with cherished lifetime memories.[103]

Concerned about her teenage son's safety in Harlem, Moore and Warner moved after the war into the modern United Workers Cooperative Colony

apartment complex located in a verdant Queens neighborhood. "The Coops," as it was called by its residents, bustled with left-wing activity, as many residents were Communists.[104] Warner never joined the CPUSA, but he did enlist in the American Youth for Democracy. Although only nominally integrated — Jewish families comprised the majority of the tenants — Warner nonetheless remembered the Coops as a "progressive place" where he felt at home.[105] Curiously, Queen Mother Moore never mentioned living in the Coops in her oral testimonies. That she moved into an apartment complex occupied mostly by white leftists at the same time as she began adopting her strident black nationalist politics speaks to the complexities and contradictions of her political evolution and to her selective memory in retelling stories about leaving the Party. Despite the gaps in Queen Mother Moore's account of her inner life, her story, as well as those of other black Communist women, reveals how they were years ahead of their time in appreciating the politicized nature of personal life. For them, eradicating structural and legal inequalities was not enough for realizing blacks' and women's liberation. Instead, they believed that forging new kinds of human relationships predicated upon gender egalitarianism and women's independence were critical for achieving democracy.

Internationalism and Overseas Travel

Popular Front internationalism, emerging anti-colonial movements, and international travel had profound and contradictory implications on black women radicals. For Williana Burroughs, her loyalty to the Soviet Union came at a tremendous personal cost. World events played a significant role in Audley Moore's rethinking of her affiliation to the Communist Party. For others, such as Esther Cooper and Thelma Dale, overseas travel and Popular Front internationalism strengthened their bonds to the Communist Left. They continued forging a "black women's international," appreciating black women and women across the emergent Third World as the vanguard of radical social change globally. Black left feminists' travels highlight both how the international Left simultaneously provided some black women radicals with unique connections to the global political stage while stifling and re-orienting others' activism.

Williana Burroughs's ten-year stay in the Soviet Union from 1935 through 1945 shows how allegiance to the Soviet Union could come at a deadly price for black women radicals. During the war, she served as the only English-

speaking shortwave radio announcer for Soviet state radio. For her work, the Soviet government awarded her a commendation at the war's end.[106] Despite these achievements, Burroughs wanted to return to the United States with her two sons as early as 1940. She missed her seriously ill husband. Additionally, she was dissatisfied with her pay. She twice petitioned Soviet officials to grant her permission to return to home. On both occasions, Soviet officials denied her requests on the grounds that they needed a competent English-speaking radio announcer. Soviet interest apparently trumped hers. This decision surely incensed her and was aggravated by the fact that her husband died in 1941. An ailing Burroughs finally returned to New York in November 1945. Tragically, she died a few weeks later. She was sixty-three. The national black press, as well as the mainstream New York and Communist press, reported her death, underscoring her notoriety.[107] Burroughs never publicly disclosed her reactions to being barred from leaving the Soviet Union. Her loyalty to the American Communist Party and to the Soviet Union surely explains her silence. She took whatever issues she may have had with Communists to the grave.

For Audley Moore, it was ironically her affiliation with the Communist Left and the opportunities it afforded for overseas travel that further stoked her black nationalism and prompted her to reassess her membership in the Communist Party. In 1946, she began working as a union organizer for the National Maritime Union (NMU), a CIO-affiliated union with close ties to the CPUSA. By joining the NMU, she worked in a union that was, as the historian Gerald Horne argues, a "fountainhead of Black proletarian intellectual radicalism" and internationalism.[108] The NMU enabled her to travel overseas for the first time in her life. In 1946, she crossed the Atlantic ten times aboard NMU-affiliated merchant vessels while working as a steward for the U.S. army's Civilian Army Department.[109]

Nikhil Pal Singh observes that "the global vision of the black popular front was distinguished by a connective, transnational solidarity that refused to privilege national boundaries or party lines."[110] This applies to Moore. Decades later, she recalled how she searched in vain in Communist bookstores for literature about the Negro Question while on shore leave in England and France. She recalled, "So I went looking for literature that the French had addressed to us through their white working class, you understand? But there was nothing. The English, there was nothing. . . . So I knew that we had nothing to look forward from the white working class helping us with our fight

over there."[111] For her, these encounters constituted another painful example of alleged Communist duplicity toward black people.

Traveling had even more profound implications on Moore's thoughts. Like Richard Wright and Aimé Cesairé, who broke from Communism during and following the war, Moore came to believe that white supremacy was at the core of Western civilization and that Marxism-Leninism did not negate racism. Witnessing the vast physical destruction and misery in Europe caused by the war and speaking with Holocaust survivors exposed the moral bankruptcy of Western civilization. For her, like Cesairé, Wright, and Frantz Fanon, Europe's destruction signaled how the brutal violence waged for centuries by Europeans against people of color had finally come home to roost.[112] Her travels compounded her frustration with her outside-inside status in the Communist Left and growing staunch black nationalism, and she was beginning to see black people globally, not white workers, as the revolutionary vanguard. Black people, in her view, needed to formulate their own revolutionary agenda for self-determination. Racial separatism was essential to black freedom. She was not only moving in new political directions; she was losing her faith in Communism.

If traveling overseas encouraged Audley Moore to reassess her affiliation with the Communist Left, it had the opposite effect on other black women radicals' politics. This was true for Esther Cooper and Thelma Dale. Traveling overseas and attending domestic and international conferences committed to the Popular Front agenda moved these women even further into the Communist Left. By the war's end, they saw the global Popular Front as a powerful site for transnational political activism and building a "black women's international."

This was evident in Esther Cooper's attendance at the World Youth Conference held in London in late 1945 and her one-month stay in the Soviet Union in early 1946. The conference sought to extend the Popular Front agenda into the postwar years and established the World Federation of Democratic Youth (WFDY).[113] Signifying a major event in global decolonization in the immediate postwar period, the gathering called for the end of European colonial empires. Scores of delegates, many of whom became leaders in Third World independence struggles, hailed from Asia, Africa, and the Caribbean. Cooper represented the Southern Negro Youth Congress as its only delegate.[114]

The World Youth Conference was a transformative experience for Cooper,

Esther Cooper Jackson and James E. Jackson Jr. with W. E. B. Du Bois, 1958. CREDIT: ESTHER
COOPER JACKSON.

further stoking her anti-colonial politics and sense of transnational citizen-
ship. She met delegates from across the Global South, including Kwame
Nkrumah, the future founder of Ghana, and Cubans who later participated
in the Cuban Revolution of 1959. The highlight of the conference was getting
to know W. E. B. Du Bois. (Both Du Bois and Nkrumah had attended the re-
cently held Fifth Pan-African Congress in Manchester, England.) Following
the World Youth Conference, she and James Jackson became close politi-
cal allies with Du Bois until his death in Ghana in 1963. These exchanges in
London prompted her to see people of color from Alabama to India, and the
Caribbean to West Africa, as a transnational community who shared a con-
joined past rooted in a history of violent racial and colonial subjugation, as
well as a common future based on their determination to be free.[115]

The World Youth Conference fostered Cooper's growing interest in global
women's rights. In particular, she became interested in women's status in
India through conversing with the Indian left-wing youth leaders Kitty
Boomla and Vidya Kanuga.[116] They were curious about African Ameri-
can women's status and Jim Crow. Cooper cordially invited them to the

next SNYC convention, but Boomla and Kanuga were unable to attend it.[117] Boomla and Kanuga urged Cooper to attend the upcoming International Congress of Women in Paris in November 1945. The gathering established the Women's International Democratic Federation (WIDF), a Popular Front women's rights group that understood women's issues as central to the international Left's agenda. Cooper wanted to attend the conference, but the State Department, for unexplained reasons, refused to grant her a visa to travel to Paris.[118]

While Cooper was unable to go, her SNYC colleague Thelma Dale attended the International Congress of Women as the National Negro Congress's representative.[119] The NNC's *Congress View* newspaper published Dale's glowing account of the conference. She lauded it as an important opportunity to internationalize "the up-hill struggle of Negro women in America," adding, "I am confident that exchange of experience and program with women from the colonial countries, the Soviet Union and many other lands, will help us on our return to make a substantial contribution to democratic developments in the United States."[120] Even sixty years later, she remembered the conference as an "exhilarating experience." In contrast to her daily encounters with segregation back home, Dale moved freely about Paris, appreciating the civility and spirit of international solidarity she felt at the gathering.[121] The conference equally impressed Vivian Carter Mason, an official of the National Council of Negro Women who represented the group at the gathering.[122] The NCNW endorsed the WIDF and its U.S. affiliate, the Congress of American Women (CAW), formed in March 1946.[123] Initially supported by a cross-section of civic, women's, and labor organizations, including the CPUSA and the NCNW, the CAW attempted "to develop a sophisticated analysis of women's oppression that recognized both the importance of women's race and class differences and the need for women to unite on the basis of gender," notes the historian Kate Weigand.[124] Thyra Edwards served as the CAW's executive director, while Thelma Dale, Vivian Carter Mason, and Charlotte Hawkins Brown sat on the group's executive board.[125] The International Congress of Women and the CAW provided unique opportunities for black women leftists and clubwomen to appreciate women of color as the vanguard for global social change and to build transnational, political alliances between women. Moreover, these collaborations exemplify how black club and leftist women increasingly found common ground

during and immediately after the war through the Popular Front and indi-
cate that internationalism had not yet become a dirty word in liberal circles
as it would a few years later.

The politics and location of Esther Cooper and Thelma Dale within the
Communist Left help explain their enthusiasm for the international Left.
None of them were strident black nationalists like Audley Moore. Plus, they
were ranking leaders in Party-affiliated organizations who were treated with
respect from white leftists. Cooper and Dale were politically and personally
invested in strengthening the international Left in ways that Moore was not.

Searching for the "Soviet promise" continued to attract black women
radicals' attention during the war.[126] This was evident in Esther Cooper's
politics. Following the World Youth Conference, she traveled to the Soviet
Union.[127] She spent six unforgettable weeks there. Like other black women
radicals who had previously sojourned to the Soviet Union, Soviet women's
enhanced rights intrigued her. In Moscow, she met her hero, Delores "La
Pasionaria" Ibárruri, the exiled Spanish Communist leader.[128] When Cooper
came home in February 1946, she returned with a new sense of determina-
tion to topple Jim Crow and colonialism. She was also finally reunited with
James Jackson, who had been honorably discharged from the army. The war,
too, bolstered his internationalist sensibility.[129]

No event better captured southern black women's visibility in forging a
wartime progressive global vision than the SNYC's Sixth All-Southern Negro
Youth Legislature held in Columbia, South Carolina, in October 1946. The
gathering was the largest ever SNYC convention and the crowning achieve-
ment of Cooper's activism during the Old Left period. Eight hundred and
sixty-one delegates, black and white, attended the gathering. She presided
over it, proudly introducing W. E. B. Du Bois, the conference's keynote
speaker.[130] His address, "Behold the Land," eloquently linked the struggle
against Jim Crow with global struggles against colonialism, war, capitalism,
and white supremacy. Instantly becoming a classic on the Left, his speech
highlighted his turn toward the radical Left, which came about in no small
part due to his association with Esther Cooper, James Jackson, and their
SNYC comrades, who idolized him. The respect was mutual. Du Bois lauded
the SNYC as "the most promising organization of young people of which I
know."[131] Paul Robeson additionally addressed the conference.[132] The Youth
Legislature's left-leaning agenda, however, discouraged Walter White, the

Esther Cooper (left) with Vidya Kanuga (right), World Youth Conference, London, November 1945. SOURCE: JAMES E. JACKSON AND ESTHER COOPER JACKSON PHOTOGRAPH COLLECTION, TAMIMENT LIBRARY AND ROBERT F. WAGNER LABOR ARCHIVES, BOBST LIBRARY, NEW YORK UNIVERSITY.

head of the NAACP, from attending. Perhaps due to his concern about being associated with known Communists, U.S. representative Adam Clayton Powell of Harlem cancelled his scheduled appearance before the conference. Mary McLeod Bethune, too, declined an invitation to attend the conference for unexplained reasons.[133]

The gathering prominently featured several black women speakers, including Dorothy Burnham, Modjeska Simkins, Charlotte Hawkins Brown, and Florence Valentine, an official with the Miami SNYC. In an address before the conference, Valentine argued that black women had "played an important part in winning the war" and making the United States "an arsenal of the United Nations." However, she called attention to how black women had "been discriminated against and exploited . . . with double harshness" and remained largely relegated to domestic labor. Securing good-paying, unionized jobs, she argued, was critical to realizing black women's economic equality in postwar America.[134] Clearly, Valentine shared black leftist

Esther Cooper and W. E. B Du Bois at the All-Southern Negro Youth Legislature of 1946. CREDIT: ESTHER COOPER JACKSON.

women's long-standing concern for black women's multiple oppressions and their insight that black women's status was the barometer by which to measure democracy at home and abroad.

In the context of the emergent Cold War and anti-Communist hysteria, the conference's popular front agenda alarmed authorities. The FBI's Memphis office warned FBI head J. Edgar Hoover in Washington, D.C., that a "large number of Communists" would dominate the Youth Legislature. Hoover, in turn, dispatched agents to closely survey the gathering. Unaware of being watched by government agents, Cooper and her SNYC colleagues went about their business. But the alarm generated by the conference among authorities signaled gathering storm clouds.[135]

Without question, the war marked a significant moment in the history of black left feminism. Black women radicals could proudly claim that they played a visible role in building movements that helped defeat the Axis powers, secure new rights and opportunities for African Americans, and

initiate decolonization. Audley Moore's role in securing Benjamin Davis's historic election to the New York City Council and Esther Cooper's dynamic leadership of the SNYC are but two examples of this. Black left feminists strengthened their ties with politically mainstream African American protest groups, particularly with clubwomen, like never before. However, there were still significant differences between them. For one, the Communist Left remained the primary site from which black women radicals agitated for black rights and forged transnational political alliances with women and men across the Global South. Also, black Communist women continued to forge a transgressive gender and sexual politics. For them, challenging the masculinist agendas of traditional black protest groups and the Communist Left remained essential to achieving black freedom. Black women radicals and their male comrades also wrestled with sexism in the private sphere, embracing a model of progressive black masculinity. So, while the war helped create new opportunities for black clubwomen and black leftist women to work together, there were still major ideological differences between them.

At the same time, World War II marked an uneasy moment for some black women radicals. Black women adopted positions on race, gender, and class that were sometimes to the left of the CPUSA's official positions on these issues. This certainly was the case of black Left groups such as the Southern Negro Youth Congress, which prominently featured women in leadership positions and centered a progressive gender politics in its program. Audley Moore demanded that the Party re-center the Black Belt thesis in its program. Her outspokenness on this matter, she later claimed, prompted Communist Party leadership to view her as an apostate. She felt betrayed by white Communists. Her decision to rethink her Communist affiliation exposed serious, persistent political, racial, class, and gender divides within the Communist Left. Her frustration also revealed how black women often functioned as outsiders within the Communist Party. These issues remained unresolved as the United States entered the postwar period. Still, Moore for now stayed in the Party. Veteran black Communist women remained committed to advancing their radical agenda through the Communist Left. But times were changing. Within a few short years the Cold War would dramatically alter the domestic and international political landscape, with profound implications for black women radicals.

CHAPTER 5

"We Are Sojourners for Our Rights"
The Cold War, 1946–1956

> We are Sojourners for our rights—
> Till We wake up the
> Conscience of the Land . . .
>
> ANTHEM OF THE SOJOURN FOR TRUTH AND JUSTICE,
> WASHINGTON, D.C., 30 OCTOBER–1 NOVEMBER 1951;
> QUOTED IN *THE WORKER*, 14 OCTOBER 1951

On 1 October 1951, sixty determined African American women stormed past bewildered guards at the doors of the Civil Rights Section of the Department of Justice in Washington. They had come to see the U.S. attorney general, J. Howard McGrath, to demand that the government end racial injustice and terror against African Americans. They were members of the Sojourners for Truth and Justice, a newly formed black left feminist organization led by the veteran radical Louise Thompson Patterson and the young poet and actor Beulah Richardson. Sojourners crowded into the office of Maceo Hubbard, a black Justice Department official. The New York tenants' rights organizer Angie Dickerson forcefully conveyed the group's sentiments: "Sir, we are here to speak our grievances. Our men are lynched, beaten, shot, deprived of jobs, and, on top of it all, forced to become part of a Jim Crow army and go thousands of miles [to] Korea to carry out war to other colored peoples." Hubbard, who listened politely, said that he would pass the group's grievances to Attorney General McGrath, but the delegation never received a meeting or a reply.[1]

From its opening convention in 1951 to its demise less than two years later, the Sojourners defied the Cold War political order. The first and only group during the entire Old Left period explicitly organized "to fight for full freedom of the Negro people and the dignity of Negro womanhood," the Sojourners sought to mobilize black women against Jim Crow, U.S. Cold War domestic and foreign policy, and colonialism.[2] It demanded freedom for the unjustly sentenced, such as Rosa Lee Ingram, a forty-year-old Georgia sharecropper and widowed mother of fourteen, who along with two of her sons faced death for killing in self-defense a white would-be rapist in 1947. Sojourners called for the freedom of W. Alphaeus Hunton, the leader of the Council on African Affairs (CAA) who had been jailed for his left-wing affiliations. It insisted that the U.S. government stop persecuting those who spoke out against racism, colonialism, and the Cold War. These included W. E. B. Du Bois, charged in 1951 as an "agent of a foreign principle in the United States," Paul Robeson, whose passport the Justice Department had confiscated in 1950, and Claudia Jones, who had been arrested in 1951 for allegedly violating the Smith Act of 1940.[3] Like the left-wing Civil Rights Congress (CRC), the Sojourners embraced the causes of human rights, black equality, peace, and international solidarity. The repressive Cold War atmosphere, however, together with the Communist Party's ambivalence toward the group, contributed to the Sojourners' untimely demise.[4]

The Sojourners provides a lens for critically understanding broader trends in black left feminism during the Cold War. These years signaled the best and worst of times for black women radicals. The culmination of decades of struggle by black women radicals, their work during the red scare marked the highest stage of black left feminist praxis during the entire Old Left period. Informed increasingly by a burgeoning Third Worldist and, to varying degrees, prophetic black Christian sensibility, black left feminists formulated their most sophisticated articulations to date of black women's "triple oppression." Directly confronting Cold War policy, black left feminists posited black women across the diaspora as the vanguard center of global radical change. Although they rarely employed the idiom of human rights to describe their work, black left feminists viewed white supremacy, the subjugation of black womanhood, lynching, and black poverty as forms of genocide. These practices, along with political persecution and colonialism, represented a violation of universal, inalienable human freedoms, such as "the right to life," freedom of conscience, and the right of

self-determination protected in the UN's human rights declarations.[5] They advanced positions on race, class, and gender that were in many respects far ahead of the Communist Party, civil rights groups, and women's clubs. This work and their individual and collective identities informed one another, producing an oppositional consciousness steadfastly committed to radical, transformative change.

The Cold War also stands as a key turning point in black left feminism. Just as it was coming together ideologically and organizationally, black left feminism was largely crushed and sidetracked by Cold War repression that came to be known as McCarthyism, revealing the personal and political costs of anti-Communism on black left feminists.[6] Facing relentless government persecution during the McCarthy period, state repression isolated some of the most committed black activists for a brief but crucial moment from the emergent civil rights movement and the global political stage. Their persecution also exposed postwar "anxiety concerning modern sexuality and female roles," as the historian Elaine Tyler May observes, prompting cold warriors to "call for the revitalization of domesticity" as a bulwark against Communism.[7] Constructing womanhood as universally white, heterosexual, and middle class, postwar domesticity helped promote social conformity and silenced political dissent.[8] In response, black left feminists employed "familialism," described by the historian Deborah A. Gerson as "a strategy that made use of the valorization of the family" to portray McCarthyism, not Communism "as the destroyer of family freedom, security, and happiness."[9] This strategy stood in stark contrast to the transgressive gender politics they often practiced prior to the early 1950s, highlighting the creative—and often ironic—ways black Communist women defied the red scare by subverting dominant gender discourses. On the one hand, they suffered under anti-Communist persecution; on the other hand, McCarthyism and decolonization inspired them to think in new ways, to search for new allies at home and abroad, and to build a "black women's international."

Local and global events during the Cold War provided the background against which black left feminists formulated new approaches to fighting for black freedom across the diaspora and for the rights and dignity of black women globally. In the years immediately after World War II, for instance, black radicals and liberals found common ground by calling for human rights and by supporting NAACP initiatives of charging the United States before the UN with violating African Americans' human rights. But black lib-

erals soon retreated because these initiatives, the historian Carol Anderson notes, became "synonymous with the Kremlin and the Soviet-led subversion of American democracy" during the McCarthy period.[10] Black liberal protest groups, such as the NAACP and Mary McLeod Bethune's National Council of Negro Women, began distancing themselves from Communists, adopting what Mary Dudziak has called "Cold War civil rights," a liberal, anti-Communist politics committed to supporting U.S. Cold War domestic and foreign policy with the hope of securing racial reform in return.[11] Barring Communists from its membership in 1950, the NAACP dropped its support for taking Jim Crow before the UN and adopted an anti-Communist, anti-colonialist line. Similarly, the National Council of Negro Women distanced itself from Communists, removing demands for human rights from its constitution and disaffiliating itself from the left-wing Congress of American Women, which shut down in 1950 due to anti-Communist repression.[12]

The speed with which anti-Communism transformed the postwar U.S. political landscape caught black women radicals and their comrades by surprise. Immediately after the war, the Truman administration pursued a policy of containment against the Soviet Union, a former wartime ally. Domestically, the Taft-Hartley Act of 1947 rolled back New Deal labor rights, imposing loyalty oaths on unions and government employees. The contentious presidential campaign of 1948 witnessed the decisive defeat of the Progressive Party candidate Henry Wallace, who staunchly supported the New Deal, civil rights, and peaceful coexistence with the Soviet Union. Enthusiastically backed by Communists, his defeat was a serious blow to Party morale, opening the door for more virulent attacks against labor and radicals. Fearing association with Communism, the CIO expelled eleven of its unions with Communist ties in 1949 and 1950.[13]

In response to the emerging Cold War and to Soviet directives, American Communist leadership in July 1945 reconstituted the CPUSA under the leadership of the veteran Communist William Z. Foster. Jettisoning the Popular Front, Party leadership moved toward the "ultra-left." Communists once again called for socialism and world revolution, waging an internal campaign against what Communists pejoratively called "Browderism." McCarthyism pushed the CPUSA further toward the left. In June 1951, the Supreme Court upheld the convictions of eleven Communist Party leaders ("the CP-11") arrested in 1948 for violating the Smith Act. Soon afterward, authorities indicted "second-string" Party officials under the Smith Act. For

Party leaders, the "Smith Act trials" confirmed that the United States had reached "five minutes to midnight" and that the nation was on the precipice of fascism and war. Convinced that the CPUSA would be outlawed, it created an underground leadership structure that made the Party even more sectarian, secretive, and vulnerable to McCarthyite attacks.[14]

These developments had major implications for the CPUSA's position on the Negro Question. Resurrecting the Black Belt thesis, the Party now framed Jim Crow and black suffering as forms of genocide. Inspired by this position, Communists launched internal campaigns against white chauvinism, which, together with campaigns against Browderism, proved divisive.[15] The postwar years also saw major shifts on the Woman Question. While it received less attention than the Negro Question, the CPUSA officially endorsed a position on gender oppression that for the first time acknowledged the non-economic roots of "male supremacy."[16] In particular, Communists asserted that postwar domesticity resembled the "notion of the 'fascist triple K' (*Kinder, Küche, Kirche*—children, kitchen, church)."[17]

Black Left Feminist Organizing, 1947–50

Black left feminists did not let growing anti-Communist repression quell their radical sensibility nor did they allow the move toward the ultra-left of the CPUSA's leadership prevent them from building black Popular Front movements for human rights and the defense of black womanhood. Indeed, black women radicals were at the forefront, for instance, in building mass movements in defense of black men such as Willie McGee, a Mississippi truck driver sentenced to death in 1945 after his white female lover falsely accused him of rape, and the Trenton Six, a group of men sentenced to death in 1948 for allegedly killing a white shopkeeper in Trenton, New Jersey.[18] As the head of the Harlem branch of the Civil Rights Congress, Audley Moore organized demonstrations in support of McGee. Additionally, Esther Cooper Jackson, who relocated from Birmingham to Detroit in 1947 after the CPUSA reassigned her husband to the Motor City, spoke as the organizational secretary of the Civil Rights Congress of Michigan in support of the Trenton Six.[19]

Black women radicals also took part in organizing mass support for Paul Robeson, who became perhaps the most prominent black spokesperson for human rights victimized by red baiting. White cold warriors and black liberals alike assailed him as a "Communist" and as "un-American" for allegedly commenting at the World Peace Conference in Paris in April 1949

that African Americans would never fight in an anti-Soviet war.[20] In response to this condemnation, the CRC sponsored an open air concert on 4 September 1949 near Peekskill, New York, for Robeson to defend his right to be heard. The event turned violent. White, anti-Communist vigilantes attacked concert goers as they returned home. Robeson's critics blamed him for this violence, further contributing to his status as a political pariah among anti-Communists. Following the concert, the Council on African Affairs, which Robeson chaired, sponsored a national publicity campaign to defend him. As the CAA's director of organization, Louise Thompson Patterson organized his tour. Despite opposition from local authorities, thousands of people came to hear him speak in cities across the country.[21] Esther Cooper Jackson addressed a rally in Detroit, while Claudia Jones spoke out in his defense. Mass support for Robeson showed that he remained beloved within black communities due in no small part to black women radicals, who collaborated and understood that defending him was critical to protecting civil liberties for all African Americans.[22]

The Rosa Lee Ingram case represented the most important site of black women radicals' organizing during the late 1940s.[23] While the CPUSA publicized the case, it was black progressive women who took the lead in freeing Ingram. Practically forgotten today, the Ingram case, like other initiatives of the black Left, "exposed southern Jim Crow regimes to national and international scrutiny, helping to weaken and isolate them on the eve of the southern civil rights movement," argues the historian Martha Biondi.[24] In March 1949, National Committee to Free the Ingram Family was formed in Harlem and affiliated with the CRC. Led by the veteran Communist Maude White Katz, as well as Mary Church Terrell, the founder of the National Association of Colored Women, Ada B. Jackson, an official of the Congress of American Women, and the future Sojourners Claudia Jones, Shirley Graham Du Bois, and Eslanda Robeson, the committee framed Ingram's plight as a violation of human rights in familialist terms.[25]

In her research on the anti-war group Women Strike for Peace, which operated during the Cold War era, Amy Swerdlow views the use of motherhood as a non-feminist basis for making political claims. However, the Ingram campaign illustrates how black women radicals used familialism as a basis for advancing a feminist agenda and contesting Cold War politics.[26] Describing Ingram as "an innocent Negro mother," the committee called attention to her plight as a "widow, sharecropper, and mother . . . [who] de-

fended her honor, virtue, and home" from a white male rapist. For Ingram's supporters, her case represented the interlocking systems of oppression suffered by black women: the rape of black women, the lack of protection for black motherhood, the economic exploitation of black women, whites' refusal of conferring the honorific title of "Mrs." to married black women, and the disfranchisement of black women in the Jim Crow South. Moreover, the case stood as a violation of human rights. "The United States," the committee charged, "[could] intervene for human rights." But instead of freeing her, the United States chose "to pardon hundreds of Nazis [*sic*] criminals responsible for" the Holocaust.[27] In the spring of 1949, the committee sent to President Truman ten thousand Mother's Day cards and a petition with twenty-five thousand signatories demanding Ingram's freedom.[28] In the coming years, the committee and its successor, the Women's Committee for Equal Justice (WCEJ), repeatedly took Ingram's case to the UN. However, in an imperial move U.S. diplomats blocked the UN from discussing the case. This did not deter Ingram's supporters. Anticipating tactics typically associated with the civil rights movement, the WCEJ held interracial women's prayer vigils for Ingram's freedom on the steps of the Georgia statehouse and sent interracial women's delegations to see her in her Georgia prison cell. In response to ongoing domestic and international pressure, Georgia officials eventually released Ingram and her two sons in 1959. Her freedom clearly showed how black women radicals found some success in challenging Cold War politics as the civil rights movement gained momentum.[29]

Ending the Neglect of Black Women: Black Left Literary Feminism

As black women radicals organized mass movements for human rights in the years immediately after the war, they also expressed their concerns in writing. The Cold War witnessed the most prolific moment of black left feminist writing during the entire Old Left period. Linking racial justice, economic equality, peace, international solidarity, the protection of civil liberties, and decolonization to black women's concerns, these works often framed human rights claims in familialist terms. This move illustrated how the Cold War forced black left feminists to downplay their image as strong, independent women. Despite its contradictions and gaps, black left literary feminism prefigured conclusions drawn by black feminists of the 1970s; it thus represents a link between black women's writings from the early twentieth century and the late twentieth century.

No person was more instrumental to shaping these discussions than Claudia Jones. In the postwar years, she emerged as the most prominent black woman in the Communist Left and as a leading theoretician on the Negro Question and the Woman Question. A close ally of William Z. Foster, she was elected in 1945 to the CPUSA's National Committee, making her the only black woman to sit on its executive board. An enthusiastic supporter of the Congress of American Women, she also headed the Communist Party's National Negro Commission and National Women's Commission, both reestablished immediately after the war. It was through her journalism, however, that Jones made her greatest impact on Communist positions on race, gender, and class.[30]

Jones's essay, "An End to the Neglect of the Problems of the Negro Woman!" published in 1949 in the CPUSA's theoretical journal, *Political Affairs*, stands as her most significant achievement as an activist while living in the United States.[31] Carole Boyce Davies observes that it was crucial "in advancing the issues of black women in the CPUSA and thereby informing the party's position on gender and the 'triple oppression' logic that would later characterize its ideological orientation."[32] Years ahead of its times, the essay evidenced Jones's creative use of Marxism-Leninism for advancing her theory of black women's superexploitation and her "amazing ability to link disparate struggles."[33] She wrote it partially in response to "Woman against Myth," an article written by the white progressive Betty Millard in 1948 that portrayed women as universally white and oppressed.[34] Jones also penned the essay under intense political repression. In 1948, authorities arrested her for violating the Immigration Act of 1918 and threatened to deport her due to her affiliation with the CPUSA. It was this concern with growing red scare repression, together with her optimism in postwar black militancy and Third World independence movements, that explains the article's urgent tone.[35]

Key to the article was Jones's innovative discussion of black women's triple oppression. She argued: "Negro women as workers, as Negroes, and as women—are the most oppressed stratum of the whole population." Identifying black women's low wages and social status as domestics as the "highest manifestation of capitalist exploitation," she tied black women's oppression to the genocidal conditions in which black communities lived.[36] She appreciated how the capitalist process exploited black women as mothers and as the breadwinners in segregated, impoverished black communities. Taken together, these issues proved her larger point: "The super-exploitation of

the Negro woman worker is thus revealed not only in that she receives, as woman, less than equal pay for equal work with men, but in that the majority of Negro women get less than half the pay of white women."[37] While black women were victimized, she did not view them as victims. Instead, it was precisely their location at these interstices of multiple oppressions that explained their militancy historically. These conclusions soundly rejected Millard's portrayal of women as universally white and oppressed, illustrating how Jones understood how race, class, and gender both positioned black and white women differently in relation to one another and placed black women at the vanguard of social change.

In the most controversial section of "An End to the Neglect of the Problems of the Negro Woman!" Jones railed against white Communists, in particular women, for their "white chauvinism." She excoriated white Communist women for hiring and exploiting black women domestics and criticized white Communists who opposed interracial marriage. For these reasons, she argued, "a developing consciousness on the woman question today, therefore, must not fail to recognize that the Negro question in the United States is *prior to*, and not equal to, the woman question. For the progressive women's movement, the Negro woman, who combines in her status the worker, the Negro, and the woman is the vital link to this heightened consciousness."[38] Black women's freedom, she argued, was essential to overthrowing capitalism, racism, and sexism. For the women's movement to succeed, white Communist women needed to reject their racial and class privilege and promote black women as leaders.[39] In addition, black Communist men, she stressed, had "a special responsibility . . . [in] rooting out attitudes of male supremacy." Here she was calling, in effect, for a progressive black masculinity. Like other black left feminists, she believed that black male radicals had an ethical obligation to challenge sexism.[40] While black Communist women had leveled many of these charges since the 1930s, "An End to the Neglect to the Problems of the Negro Woman!" marked the first time that these grievances were so systematically theorized and aired so publicly within the CPUSA. In response to these charges, some white Communist women accused her of "reverse chauvinism" and ostracized her, demonstrating how even this ranking Party leader could find herself an outsider within the CPUSA.[41]

One of the most innovative aspects of the piece was Jones's attempt to theorize on black women's multiple oppressions from slavery to the present.

Prefiguring conclusions drawn in Angela Davis's important essay of 1971, "Reflections on the Black Woman's Role in the Community of Slaves," Jones emphasized that black women's status within enslaved communities stemmed both from how West African societies afforded women with a higher degree of status than their European counterparts, and how enslavement created a degree of egalitarianism between black women and men.[42] Like Davis, Jones identified black women as important leaders in the enslaved community and in resistance. White masters recognized black women's militancy, using "legalized rape" to break enslaved women's will and to terrorize the entire enslaved community. Here, Jones appreciated the connections between the rape of black women, racial oppression, and capitalist exploitation, a key point in Davis's essay.[43] Jones also briefly mentioned how emancipation transformed black gender relations, underscoring how she understood gender as socially constructed and historically contingent. Arguing that abolition ushered in a new mode of production characterized by the destruction of communal-based housing and survival strategies in favor of small-scale, black farming, these economic shifts placed "the Negro man in a position of authority in relation to his family." For these reasons, some black men adopted hegemonic masculinity.[44] These conclusions, on one level, bore the stamp of classic Marxist-Leninist thinking on the Woman Question, stressing the importance of class relations in shaping women's status. Yet her arguments also reveal her attempt to advance a more innovative approach, acknowledging the importance of male chauvinism and the family as detriments to black women's well-being.

For Jones, no issue better highlighted black women's triply oppressed status "under American bourgeois democracy moving to fascism and war" than the case of Rosa Lee Ingram. She praised "Mrs. Ingram" as a "courageous, militant Negro mother" exploited by the capitalist order and unjustly imprisoned by a Jim Crow court for defending herself from a white rapist. Echoing conclusions drawn decades earlier by anti-lynching crusader Ida B. Wells-Barnett, Jones asserted that Ingram's case exposed the "hypocritical alibi of the lynchers of Negro manhood who have historically hidden behind the skirts of white women when they try to cover up their foul crimes with the 'chivalry' of protecting 'white womanhood.'"[45] Moreover, the case, she argued, invalidated U.S. criticisms of Soviet human rights abuses and exposed the "hypocrisy" of the United States as the leader of the "free world" before a global audience. Convinced that winning Ingram's freedom would

directly challenge U.S. imperialism, she believed black women and the CPUSA would play a key role in leading global struggles for peace, democracy, and women's equality.[46]

Jones's ideas were not developed in a vacuum. Her argument strikingly resembled Louise Thompson's essay of 1936, "Toward a Brighter Dawn," as well as writings by Esther Cooper, Marvel Cooke, and Ella Baker. Jones did not cite these works. But she later acknowledged that her ideas were part of a "rich heritage of struggle" linked to the activism of black Communist women of the 1920s, such as Grace Campbell and Williana Burroughs, and militant nineteenth-century women reformers like Sojourner Truth, Harriet Tubman, Susan B. Anthony, and Elizabeth Cady Stanton.[47] Jones's acknowledgment of her debt to these women, in particular to black Communist women, is significant. She was consciously aware of how her journalism was part of a longer history of black women's radicalism.

The essay, however, is not without its contradictions. It tends to portray black women as a class and as uniformly progressive. The essay also illustrates the ironies of black left feminists' invocation of familialism, particularly in its discussion of the Ingram case. On the one hand, her appropriation of the "cultural icon of family security" subverted Cold War logic by positing that "the state violat[ed] its own values by attacking families," notes Deborah Gerson.[48] On the other hand, familialism reinforced prevailing assumptions about black women's "natural" roles as mothers and as wives, precluding more critical interrogations of gender and sexuality that might have directly challenged the heteronormative logic undergirding Cold War ideology.[49]

Her use of familialism helps explain Jones's silence on sexuality. In light of how the "politicization of homosexuality was crucial to the consolidation of the Cold War consensus," writes the cultural scholar Robert Corber, familialism countered a prevailing demonization of Communists as sexual deviants threatening national security.[50] Yet familialism precluded open discussions within the Communist Party about sexuality, reproductive rights, and domestic violence. It is important to note that black left feminism of the Cold War era was neither categorically heterosexist nor completely silent on matters of sexuality. The prescient, pro-gay rights arguments in anonymous letters by the progressive journalist, political activist, and lesbian Lorraine Hansberry that were published in the late 1950s in issues of *The Ladder*, the newsletter of the first U.S. national lesbian organization, the Daughters of Bilitis, best evidence this claim.[51] However, these conversations did not be-

come an explicit part of the black feminist agenda until the 1970s. So while Jones's understandings of the relations between race, gender, and class were ahead of their time, most black left feminists during the McCarthy period had little to say openly about sexuality and its relation to politics, revealing how the stifling Cold War atmosphere narrowed the range of black left feminist discussions.[52]

Despite its shortcomings, "An End to the Neglect of the Problems of the Negro Woman!" profoundly influenced the CPUSA's thinking on race, gender, and class. Following its publication, articles about triply exploited African American women regularly appeared in party periodicals. From 1948 through 1953, Jones's weekly column, "Half of the World," published on the Woman Today page in the Sunday edition of the *Daily Worker*, extended arguments made in "An End to the Neglect of the Problems of the Negro Woman!"[53] She produced this work under intense political persecution. Following her arrest in 1948, authorities arrested her two years later for violating the Internal Security Act of 1950 (McCarran Act), which authorized the deportation of the foreign-born who were deemed as "subversive." In 1951, she was arrested for violating the Smith Act. Authorities jailed her for nine months in 1955 before deporting her to Great Britain later that same year, with her health suffering immeasurably. That the state used her writings as evidence in its deportation case against her underscores how cold warriors viewed black left literary feminism as subversive.[54]

No other literary work besides "An End to the Neglect of the Problems of the Negro Woman!" had more of an influence on black left feminism during the Cold War than Beulah Richardson's powerful poem of 1951, "A Black Woman Speaks of White Womanhood, of White Supremacy, of Peace." Like Jones's writings, the poem placed special emphasis on the social consequences of being a black woman in a historically violent, racist, sexist society and understood black women as key agents for human rights and world peace. Although not her original intention, the poem was critical to inspiring the formation of the Sojourners for Truth and Justice.

A dynamic actor and poet, Richardson (who later became known as the Hollywood motion picture star Beah Richards) was born in 1925 in Vicksburg, Mississippi. The daughter of a minister and a schoolteacher, she eventually made her way to Los Angeles to escape Jim Crow. There, she moved toward the left after befriending Paul Robeson, Louise Thompson Patterson, and William L. Patterson. Richardson's interest in the Willie McGee case was

critical to her radicalization. The Civil Rights Congress, led by Patterson, organized a worldwide amnesty campaign on McGee's behalf, denouncing his execution on 8 May 1951. After listening to his widow, Rosalie McGee, condemn his unjust death at a CRC-sponsored rally in Los Angeles, Richardson penned the poem.[55]

"A Black Woman Speaks of White Womanhood, of White Supremacy, of Peace" understands how African American women's disfranchisement, historically linked with prevailing negative images of black womanhood, provide a unique standpoint from which to critique American social inequalities and from which to make political demands for rights, dignity, and respect. In the poem's electrifying opening, Richardson claims:

It is right that I a woman
black,
should speak of white womanhood, My fathers,
my brothers,
my husbands, my sons
die for it—because of it.
Their blood chilled in electric chairs,
stopped by hangman's noose, cooked by lynch mob's fire,
spilled by white supremacist mad desire to kill for profit
gives me that right.

She then connects the lynching of black men with the rape, disfranchisement, and economic exploitation of black women from slavery to the contemporary moment. For Richardson, prevailing cultural representations of black women as unchaste, unattractive, and servile were key in perpetuating black women's marginality and instilling a sense of racial superiority in white women. Moreover, the poem links the rape of enslaved black women with Cold War era "rape frame-up" cases against Willie McGee and the Martinsville Seven, a group of black men in Martinsville, Virginia, executed in 1951 for allegedly raping a white woman, as heinous examples of state-sanctioned genocide against African Americans.[56]

Like Jones, Richardson rejected "woman" as a universal, ahistorical category by focusing on black women's location as domestics and as mothers. However, the poem went one step further than Jones with its outspoken condemnation of white women's complicity in black women's sexual exploitation, asserting that the former's sense of white privilege had histori-

cally prevented them from defending black women's bodies from white men and from acknowledging consensual sexual affairs with black men accused of raping white women. Richardson, like Ida B. Wells-Barnett, broke the silence about the interracial rape of black women and used it to galvanize African American communities into action for promoting social justice and black rape survivors' emotional healing. The poem challenged a tendency within the African American collective memory that has understood the lynching of black men, not the "institutionalized rape of black women[,] . . . as a powerful symbol of black oppression," notes the literary scholar Hazel Carby.[57] In doing so, Richardson posits that reclaiming black women's bodies and beauty constituted key sites of resistance. Evoking the plights of Rosalie McGee and Rosa Lee Ingram, the poem ends by calling on white women to reject white supremacy and to join black women in fighting for global peace and racial equality.[58]

The poem became a smash hit in the Communist Left during the summer of 1951, impressing Thompson Patterson and sparking the beginning of their lifelong friendship, as well as the initial idea for forming an all-black radical women's group.[59] Later that summer, Richardson moved to New York to pursue an acting career. There, she and Thompson Patterson wrote "A Call to Negro Women," the Sojourners' founding manifesto and summons to its inaugural meeting in Washington, D.C., the Sojourn for Truth and Justice.[60]

The Sojourners for Truth and Justice

While black women radicals pursued their local and transnational agendas in left-wing sites, such as the Progressive Party, the Congress of American Women, Paul Robeson's *Freedom* newspaper, the Council on African Affairs, the Civil Rights Congress, the National Negro Labor Council, and the National Committee to Free the Ingram Family, no organization was more important to black left feminism than the Sojourners for Truth and Justice.[61] It marked something new in the history of diasporic feminism, black radicalism, U.S. women's movements, and American Communism because it provided black women radicals a unique opportunity to lead their own organization. Inspired by the writings of Claudia Jones and Beulah Richardson, as well as by postwar U.S. black movements and global decolonization, the Sojourners combined black nationalist and Popular Front organizational strategies with Communist positions on race, class, and gender, advancing a human rights agenda and a vanguard center political approach. The group

fostered collective identities and an oppositional consciousness. Prefiguring the Third World Women's Alliance and the Combahee River Collective, the Sojourners forged a "black women's international." Given this, the Sojourners challenges the historian Amy Swerdlow's conclusions that the Congress of American Women "more than any other feminist organization before or since . . . made racial equality a central plank in its program and incorporated African American women in its leadership."[62]

The Sojourners stands as Thompson Patterson's most significant achievement as an activist. As much as the group owed its inspiration to "A Black Woman Speaks," black women's status as outsiders within the Communist Left also inspired its formation. Thompson Patterson later recalled, "In the Sojourners, we were trying to develop something that would get away from blacks being tokens in the left movement."[63] She added, "[Black] women need at times to talk with each other, that we get tired of being the one or two [black women] to be shown off and to say that we have a mixed organization."[64]

In keeping with the Popular Front, the leadership of the Sojourners included Communist and non-Communist black women, such as the veteran activists Louise Thompson Patterson, Dorothy Hunton, Shirley Graham Du Bois, and Eslanda Robeson, all of whom were members of the CAA executive board, the CRC, and, with the exception of Robeson, the CPUSA. Charlotta Bass, the septuagenarian publisher of the *California Eagle* and the vice-presidential candidate on the Progressive Party ticket in 1952, sat on the Sojourners board. While neither Bass nor the younger leadership, such as Richardson, Frances Williams of Los Angeles, and Alice Childress of New York, were members of the Communist Party, they were actively involved in the Progressive Party and worked closely with known Communists. In addition, the Initiating Committee included Rosalie McGee, Bessie Mitchell, a sister of one of the Trenton Six defendants, Amy Mallard, whose husband was lynched in Georgia, and Josephine Grayson, the wife of one of the Martinsville Seven. These women gave credence to how Cold War repression and racial terror victimized black women and children.[65] However, there is no record indicating that the Sojourners had invited Mary McLeod Bethune and other former, wartime, black liberal female allies to join the group. Given the NAACP's and the NCNW's ban on working with Communists, black women radicals were now largely on their own. Times had changed.

As the group's acting secretary, Richardson announced "A Call to Negro Women" in September 1951.[66] Notes Carole Boyce Davies, the manifesto stands as a landmark in twentieth-century U.S. black feminisms, U.S. women's movements, and transnational feminisms for its ability to speak to a "range of issues . . . that extend[ed] far beyond the narrow gendered formulations that appeared later in mainstream feminist movements" of the 1970s.[67] Combining Popular Front, familialist, and prophetic black Christian language, the "Call" condemned Jim Crow, lynching, the rape of black women, police brutality, black poverty, political persecution of black radicals, and the imprisonment of Rosa Lee Ingram, revealing the continued concern her case generated among black progressive women. In an uncharacteristic break from Communist secularity, the "Call" stated, "We . . . will no longer in sight of God . . . sit by and watch our lives destroyed by unreasonable and unreasoning hate that metes out to us every kind of death it is possible for a human being to die." This statement evidenced the group's effort to appeal to churchgoing black women whose ideas about social justice were informed by prophetic black Christianity.[68] At the same time, this stance shows how the political climate of the Cold War required the Sojourners to mute its secular politics in order to reach a wide audience.

Additionally, the Sojourners stepped directly into Cold War politics. Charging that Jim Crow was the Achilles heel of the United States in its claims as leader of the "free world," the group called for the Korean War's end. Urging black women "to dry [their] tears, and in the spirit of Harriet Tubman and Sojourner Truth, ARISE," the "Call" summoned black women to Washington to "demand of the President, the Justice Department, the State Department, and the Congress absolute, immediate, and unconditional redress of grievances." Identifying with the early black women's club movement, as well as the revered Sojourner Truth and Harriet Tubman as symbols of their own political struggles, the Sojourners sought to portray its black left feminist program as both fundamentally American and as part of a tradition of black women's militancy.[69]

The Sojourners held its inaugural convention in Washington, D.C., from 29 September through 1 October 1951 at the meeting hall of the Cafeteria Workers Union, a left-leaning, CIO-affiliated union composed disproportionately of black women, illustrating the group's efforts to fight for black working-class women's rights. As conference delegates disembarked from their trains at Union Station and headed for the conference, they gleefully

sang the new group's anthem. The gathering made for an impressive affair: 132 women from 15 states answered "A Call," including members of the Initiating Committee and Angie Dickerson, the journalists Halois Robinson and Lorraine Hansberry, both of whom covered the convention for *Freedom*, and Mary Church Terrell, whose presence surely bolstered the women's hopes of building a movement in the tradition of early black women's clubs.[70] Claudia Jones did not attend the conference. A court order barred her from traveling outside of New York. But she praised the group in her "Half of the World" column as "one of the most heartening developments of the Negro liberation movement."[71]

Following the convention, the Sojourners pressed forward with its black left feminist human rights agenda. Several leading Sojourners signed the *We Charge Genocide* petition, delivered to the UN in late 1951 by William L. Patterson on behalf of the Civil Rights Congress. Comparing the contemporary wave of white racial terror in the United States to the Holocaust, the petition charged the United States with genocide and demanded that the UN intervene to protect African Americans' human rights. In early 1952, the Sojourners publicized the murder of the Florida NAACP leader Harry Moore and his wife Harriet, who died when assailants threw dynamite through the Moores' bedroom window on Christmas morning 1951. The assailants were never brought to justice.[72] In a publicly released statement, "Our Cup Runneth Over," which took its title from biblical scripture, Sojourners expressed their outrage that this heinous act occurred on Christmas.[73] Like the Ingram case, the statement focused on Harriet Moore's death as an example of the daily violent assaults against black womanhood in the United States and globally. In response, Sojourners called for five thousand black women to participate in a "March on Washington." Instructing marchers to come veiled, Sojourners framed the demonstration as "a day for mourning for the death of Harriet Moore," calling on President Truman "to stop genocide of Negro people and to guarantee civil liberties to all Americans." The Sojourners never staged the protest. The challenge of organizing a major demonstration in such a repressive political moment may explain why it was not held. But the proposed demonstration illustrated the group's intentions of using direct action, familialist symbols, and prophetic black Christian discourse to publicize Harriet Moore's death and to build support for the group's human rights agenda.[74]

On 23 March 1952 the Sojourners held its Eastern Seaboard Conference

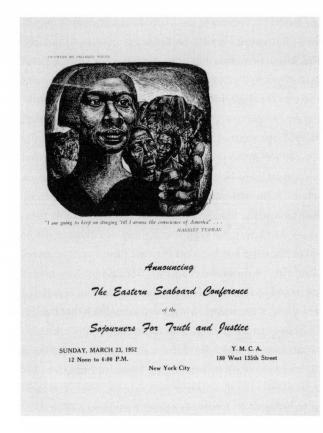

The Eastern Seaboard Conference of the Sojourners for Truth and Justice, 23 March 1952. SOURCE: LOUISE THOMPSON PATTERSON PAPERS, MANUSCRIPT, ARCHIVES, AND RARE BOOK LIBRARY, EMORY UNIVERSITY.

in the Harlem YWCA, marking the group's only major gathering following its Washington convention.[75] Echoing Jones's writings, Thompson Patterson exclaimed in an impassioned speech that the Sojourners could build "the greatest organization in the history of our people because, triply oppressed as we are, we can lead the fight for our people's freedom."[76] One report declared that "Negro women, as women, as Negroes, and as workers are the most oppressed group of the whole population of the United States."[77] Following the gathering, the Sojourners drafted a constitution and formed chapters in Cleveland; Baltimore; Detroit; Philadelphia; Washington, D.C.; Los Angeles; Chicago; San Francisco; Richmond; Hartford; Louisville; and Rocky Mount, North Carolina.[78]

The Sojourners also looked to the global stage to advance its black left feminist agenda. In contrast to the NAACP's and the NCNW's anti-Communist internationalism, the Sojourners sought to take the lead "in the liberation struggle of our people and the fight for peace and freedom in

the nation and in the world."[79] Following the lead of the National Committee for the Defense of the Ingram Family, the Sojourners internationalized the Ingram case. The Sojourners, together with the left-wing Emma Lazarus Federation of Jewish Women's Clubs, based in New York, issued a joint statement in June 1952 to the Fifteenth International Conference on Public Education in Geneva, cosponsored by the United Nations Educational, Scientific, and Cultural Organization (UNESCO). The statement urged the gathering to pass a resolution in support of Ingram's freedom, asserting that "guaranteeing the civil liberties of Negro women is basic to full educational equality for all women."[80] The statement resembled conclusions drawn by Jones and Richardson that white women's liberation was inseparable from black women's freedom. Moreover, the groups' collaboration illustrates how the Sojourners enabled black left feminists for the first time to set the terms of political discussion with white women radicals. Because the Sojourners was an independent organization, its members did not have to answer to anyone but themselves, and they had their own organization behind them providing institutional support for their local and transnational work.

The group's efforts to forge ties with South African female anti-apartheid activists best highlights the group's transnational, feminist, human rights agenda and its collective, militant, diasporic consciousness. African American interest in apartheid, especially among the black Left, increased in early 1952 on the eve of the Campaign of Defiance of Unjust Laws, better known as the Defiance Campaign. Cosponsored by the African National Congress and the South African Indian Congress, the campaign organized massive civil disobedience against the racist government's repression of non-white South Africans' human rights from 6 April 1952, the tercentennial of the first Dutch settlement in South Africa, through early 1953. Black South African women figured prominently in these mass actions, which in some cases led to their imprisonment.[81]

The Sojourners approved an anti-apartheid resolution written by the CAA, described by the historian Francis Njubi Nesbitt as the "first anti-apartheid organization in the United States," at the former's Eastern Seaboard Conference.[82] Highlighting the cross-fertilization of ideas between the groups, the resolution declared that "the struggle of black women in America for freedom and justice is unthinkable as many hundreds of millions of their sisters in the Caribbean, Africa, and Asia are degraded and enslaved by the same pattern of racist oppression which we strive to abol-

ish in our own land," and the resolution lauded women's leadership in "this campaign for human rights in South Africa." Sojourners recognized the relationship between their domestic human rights claims and those of South African women, thereby unveiling the ways in which racist systems of control, while having nuanced formations, operated similarly across geographic boundaries with devastating effects for all people of color.[83]

In accordance with the resolution, the Sojourners sent President Truman and the UN South African delegation letters condemning apartheid, joined a CAA-sponsored demonstration in front of the South African consulate in Manhattan, and corresponded with black, white, and Indian women trade unionists, Communists, and anti-apartheid activists.[84] In letters to them, Charlotta Bass and Louise Thompson Patterson wrote that African American women's freedom was "inextricably linked" to the status of women in South Africa, as well as across Africa. Prefiguring conclusions drawn two decades later by the Third World Women's Alliance and the Combahee River Collective, Bass and Thompson Patterson emphasized that freedom movements led by "colored women in Africa, Asia, and in these United States must lead to the complete emancipation of women throughout the world.[85] Bertha Mkize, the ANC Women's League official, warmly answered the group's letter by thanking its members for having "made it possible the link [between African American and African women] we have always wished for [on] this side of the world."[86] By corresponding with militant South African women activists, the Sojourners accomplished one of its main objectives: forging transnational links with Third World women.

As groundbreaking as the black transnational, feminist, left-wing work of the Sojourners was for its time, the group's familialist framings of black women's freedom and its tendency to view black women monolithically limited its program. On one level, this constituted a useful strategy for imagining political solidarities among a disparate group of women of color from around the world whose social locations were shaped by a shared history of and daily encounters with racism, patriarchy, capitalism, and colonialism. On the other hand, it did not take into account what Chandra Talpade Mohanty later observed—that "systems of racial, class, and gender domination do not have identical effects on women in Third World contexts." In ignoring such complexities, the Sojourners overlooked the very real ways in which race, class, sexuality, and colonialism positioned women of color differently vis-à-vis one another and in relation to their (colonial) nation-state.

Unity Luncheon, Sojourners for Truth and Justice and Emma Lazarus Federation of Jewish Women's Clubs, 23 March 1952, New York. Louise Thompson Patterson (speaking and standing at table). Sitting at right of Thompson Patterson are Dorothy Hunton, Charlotta Bass, Claudia Jones, and Angie Dickerson. SOURCE: AMERICAN JEWISH ARCHIVES.

Members of the Sojourners for Truth and Justice with Paul Robeson, San Francisco, 22 May 1952. Black women radicals were some of the embattled Paul Robeson's most vocal supporters. SOURCE: LOUISE THOMPSON PATTERSON PAPERS, MANUSCRIPT, ARCHIVES, AND RARE BOOK LIBRARY, EMORY UNIVERSITY.

Women of color's divergent political and social locations in this specific historical moment posed serious challenges for bringing Third World women together.[87] An appreciation of social location and of how systems of domination operated in more relational, historically specific terms may have helped the Sojourners formulate a theoretical approach better able to capture both the commonalities and, more important, the particularities of Third World women's lives and their daily, oppositional struggles as potential grounds for forging international solidarities among women of color.[88]

Similarly, the group's celebration of black motherhood and the legacies of Sojourner Truth, Harriet Tubman, and the early black women's clubs tended to reinforce prevailing assumptions about women's "natural roles," thereby precluding more critical discussions of gender, sexuality, femininity, masculinity, and respectability. Given this, the group's program was silent on birth control and reproductive rights, marking a break from the vocal support of left-wing women of the 1930s, including Louise Thompson, for these issues.[89] The postwar Communist Left's conservative stance on sexuality, together with Cold War domesticity, certainly helps explain the silence of the Sojourners on these issues.[90] Calling for reproductive rights would have made the Sojourners even more vulnerable to government repression. While black women radicals had often openly embraced sexually transgressive politics and practices from the 1920s through the 1940s, the Cold War now required them to frame their political demands in more traditional gendered terms. In doing so, black women radicals were unable to completely transcend the middle-class respectability espoused by their mainstream counterparts.

The social composition of the Sojourners also prevented it from building a broad-based, left-wing, black transnational women's organization. Despite its efforts to recruit working-class women by supporting initiatives beneficial to laboring women and often articulating its program in prophetic black Christian terms, members of the Sojourners were mostly urban, middle-class, secular, well-educated women with a radical, leftist, feminist politics. They were second-class citizens in their own country; but in comparison to black women in general overseas (and in the United States), they were relatively privileged. With links to the secular Communist Party, Sojourners surely would have seemed alien to most black working-class women accustomed to supporting protest movements led by charismatic male ministers. These challenges confronting Sojourners resembled those faced by black left feminists since the 1920s. While they were often able to galvanize

black women into action around a variety of issues, black women radicals were less successful in recruiting black women into the Communist Left. Despite its limitations, at the very moment at which many Communist male leaders — black and white — retreated in response to ever increasing government repression, Sojourners went on the offensive. Like their predecessors in the early club women's movement, Sojourners understood that no one else but themselves would fight for black women's freedom. But Communist short-sightedness and McCarthyism soon dashed the group's aspirations of building a new, militant movement of black women.

The Political and Personal Costs of Anti-Communism

At the same time as black women radicals penned their most cutting-edge journalism and built the Sojourners, they suffered tremendously under Cold War repression. With the exception of Claudia Jones's deportation, scholars have largely overlooked the impact of McCarthyism and the CPUSA's internecine fighting during the 1950s on black women radicals.[91] Black left feminists' persecution highlights the political and personal costs of anti-Communism on black women, the gendered contours of Cold War repression against black radicals, and the ambiguities of employing familialism as a strategy of resistance against McCarthyism, as well as the breaks in black left feminism and the postwar black freedom movement.

The demise of the Sojourners provides an example of the destructive impact of anti-Communism and Communist sectarianism on black left feminism during the early 1950s. Despite an auspicious start, the Sojourners never became a mass, transnational organization. The group counted no more than a few hundred members, most of whom lived in New York. The NAACP's bar on Communists prevented Sojourners from participating in local civil rights campaigns led by Ella Baker, the president of the New York NAACP chapter. By the end of 1952 the Sojourners had stopped functioning.[92]

The equivocal relationship the Sojourners had with the Communist Party factored into its demise. Tension between the groups ironically occurred at the moment when the CPUSA had reemphasized "Negro liberation." Despite this stance, the Party neither officially endorsed the Sojourners nor provided the group with the same degree of support that it gave to the Congress of American Women or to black left groups such as the Council on African Affairs or the Civil Rights Congress.[93] Multiple factors explain the

CPUSA's ambivalence toward the Sojourners. Party officials had never before dealt with an all-black, leftist women's group. In addition, the Sojourners became entangled in an internal CPUSA conflict. According to the historian Linn Shapiro, Claudia Jones hoped that the Sojourners could advance her struggle with CPUSA officials over black women's place in the socialist struggle. Jones's involvement in the Sojourners alarmed Party officials, who feared losing one of the Party's most visible black female leaders to what some viewed as a rival organization.[94]

The CPUSA's unease with the Sojourners allegedly led to a confrontation between Jones, Thompson Patterson, and Richardson. Thompson Patterson remembered decades later that Jones approached her and Richardson to convey Party leaders' discomfort with the Sojourners. Whatever Jones said sparked a physical confrontation with Richardson. "I had to pull Beulah off Claudia," Thompson Patterson recalled.[95] If this incident occurred, it contradicts Jones's enthusiastic public support for the organization, complicating her legacy as an outspoken black feminist and suggesting that her loyalty to the CPUSA prompted her to undercut the Sojourners. This altercation speaks to larger tensions between black left feminists. Despite their status as outsiders within the CPUSA and their radical politics, they neither always got along nor shared the same ideological outlook.

The acrimony surrounding the Sojourners prompted Thompson Patterson to rethink the Party's ability to address black women's issues. Despite her frustration with its ambivalence toward the Sojourners, she chose to remain in the CPUSA. Her marriage to a ranking Party leader surely made it difficult for her to split from it. She must have considered that breaking from the Party certainly would have been interpreted by cold warriors as a renouncement of her husband. Whatever the reason she elected to stay, her frustration with it proved again that even in the avowedly racially egalitarian Communist Left, black women radicals had to fight continually for a voice within it.[96]

While the CPUSA's cool response to the Sojourners contributed to its demise, McCarthyism was the key factor in shutting down the organization. From the very beginning of Sojourners, the Justice Department kept close tabs on its every move. Government informants riddled the group, enabling the FBI to accumulate more than 450 pages of surveillance files in little more than one year. Convinced that the Sojourners were a "Communist Front," files detailed the group's supposed "Communist Influence and Participation"

and "Subversive Ramifications."[97] Additionally, the group's efforts to internationalize the Ingram case only verified its "subversive" intentions to officials.[98]

At the same time as authorities targeted the organization, they also harassed individual Sojourners. The Justice Department seized Charlotta Bass's passport in April 1951.[99] In the same month, Louise Thompson Patterson testified in New York State court about her twenty-year involvement in the International Workers Order.[100] In 1953, Joseph McCarthy summoned Eslanda Robeson and Shirley Graham Du Bois to testify before his Senate Special Investigations Committee. Unlike Jones, these women were neither jailed nor convicted. But this repressive political climate surely scared away potential supporters.[101]

Ultimately, the demise of the Sojourners underscores the underappreciated political costs of the "Global Cold War" on black diasporic feminism.[102] The historian Gerald Horne observes that the "Cold War attack was worldwide, with [Communist] parties and progressives [across] the world under siege simultaneously."[103] Nowhere was this more evident than in the United States and South Africa. Both nations' rulers understood black struggles as a "Communist plot." At the same time as U.S. cold warriors targeted the Sojourners, the South African government brutally suppressed the Defiance Campaign.[104] Cold War repressions, therefore, not only suppressed militant black women's activism within each respective nation but also severed organizational ties of international solidarity between black women on both sides of the Atlantic. It would not be until the formation of the Third World Women's Alliance fifteen years later that another women of color protest group in the United States formulated an explicitly left-wing, transnational feminist program like that of the Sojourners.

As cold warriors targeted the Sojourners, authorities also harassed black women radicals and their families. No one's plight better exemplified this than Esther Cooper Jackson's. Like other black leftists, she found herself increasingly on the defensive as the Cold War intensified. This was especially true for black progressives in the postwar South. The red scare and resurgent white supremacy crushed the southern Popular Front.[105] In Birmingham, local CIO leadership, following directives from its national offices, expelled CPUSA-affiliated unions and suspected Communists. The city saw the Ku Klux Klan's resurgence. Birmingham authorities outlawed the CPUSA and intimidated civil rights militants.[106] This repressive political climate forced

the Southern Negro Youth Congress to shut down in 1949, removing a pioneering black militant organization with international connections and progressive gender politics from the political scene.[107]

It was Cooper Jackson's marriage to a leading black Communist that prompted the state to persecute her. On 20 June 1951, authorities indicted James E. Jackson Jr. along with eleven other "second string" Communists Party leaders for violating the Smith Act.[108] (The couple had moved the previous summer from Detroit to New York after the CPUSA had assigned Jackson to its national office and appointed him as its southern regional director.) Neither Jackson nor his comrades advocated the violent overthrow of the U.S. government. But it was the height of the red scare. In a preemptive move, Jackson went underground to avoid arrest. Placed on the FBI most wanted list, he remained in hiding for the next four and one-half years during which time he had absolutely no contact with his family. Authorities never arrested Cooper Jackson nor summoned her to testify before a congressional committee. Nor did they confiscate her passport. Instead, FBI agents determined to ascertain Jackson's whereabouts. They vigilantly surveilled and harassed the Jackson family for nearly five years due to the government's belief that the Jacksons, like other Communist families, represented an international Communist conspiracy that threatened national security and the American way of life.[109] Agents watched Cooper Jackson's home in the black Bedford-Stuyvesant neighborhood of Brooklyn and those of her family and friends around the clock. In one of the government's most aggressive moves against the Jackson family, the FBI coerced four-year-old Kathryn Jackson's nursery school into expelling her. These experiences evidenced how Cooper Jackson and other "Smith Act wives" often bore the brunt of government repression and the burdens of raising children and making a living while their husbands were in hiding or in jail.[110] Additionally, her FBI file during these years reflected authorities' obsession with capturing her "fugitive" husband and surveilling her. In a move anticipating COINTELPRO surveillance of black militants in the 1960s, the FBI compiled hundreds of pages of reports detailing her daily activities, biographical history, and political work.[111]

The long separation and their reunion placed serious strains on their children and marriage. For nearly five years, the Jackson daughters grew up without their father. Cooper Jackson was alone. After James Jackson's return, she claimed, "It wasn't easy to get readjusted again as a family. We had

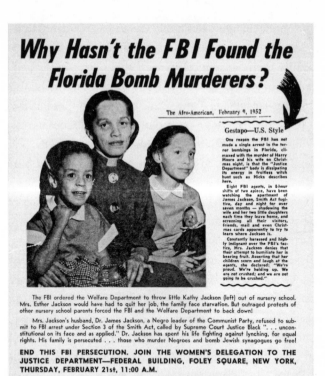

Why Hasn't the FBI Found the Florida Bomb Murderers?

The Afro-American, February 9, 1952

Gestapo—U.S. Style

One reason the FBI has not made a single arrest in the terror bombings in Florida, climaxed with the murder of Harry Moore and his wife on Christmas night, is that the "Justice Department" body is dissipating its energy in fruitless witch hunt such as Hicks describes here.

Eight FBI agents, in 8-hour shifts of two apiece, have been watching the apartment of James Jackson, Smith Act fugitive, day and night for over seven months — shadowing the wife and her two little daughters each time they leave home, and screening all their visitors, friends, mail and even Christmas cards apparently to try to learn where Jackson is.

Constantly harassed and highly indignant over the FBI's tactics, Mrs. Jackson denies that their attempt to humiliate her is bearing fruit. Asserting that her children scorn and laugh at the agents, she declared: "We're proud. We're holding up. We are not crushed; and we are not going to be crushed."

The FBI ordered the Welfare Department to throw little Kathy Jackson (left) out of nursery school. Mrs. Esther Jackson would have had to quit her job, the family face starvation. But outraged protests of other nursery school parents forced the FBI and the Welfare Department to back down!

Mrs. Jackson's husband, Dr. James Jackson, a Negro leader of the Communist Party, refused to submit to FBI arrest under Section 3 of the Smith Act, called by Supreme Court Justice Black ". . . unconstitutional on its face and as applied." Dr. Jackson has spent his life fighting against lynching, for equal rights. His family is persecuted . . . those who murder Negroes and bomb Jewish synagogues go free!

END THIS FBI PERSECUTION. JOIN THE WOMEN'S DELEGATION TO THE JUSTICE DEPARTMENT—FEDERAL BUILDING, FOLEY SQUARE, NEW YORK, THURSDAY, FEBRUARY 21st, 11:00 A.M.

1. Write the Justice Department—Demand the FBI end persecution of the Jacksons.
2. Write President Truman—Demand FBI arrest the Florida bomb murderers of Mr. and Mrs. Harry Moore.
3. Join the national campaign to repeal the Smith Act.

Issued by: BROOKLYN CIVIL RIGHTS CONGRESS—STATE OFFICE, 23 West 26th Street, New York 10, N. Y.

Brooklyn Civil Rights Congress flyer, 1952. CREDIT: ESTHER COOPER JACKSON.

a lot of serious talking to do to decide whether [maintaining the marriage] was worth it or not."[112] Despite these hardships, she persevered. Jackson's absence made her more independent. She raised their children and was the breadwinner, working a variety of jobs, including as a staff person in the office of the New York Urban League. Moreover, her memories of growing up in the Jim Crow South as well as support from family and friends helped her to withstand government repression. She also found support through the Families of Smith Act Victims (Families Committee), an organization composed largely of wives of CPUSA officials indicted under the Smith Act.[113] In an effort to publicize Jackson's plight and those of other Smith Act victims, she worked with the Families Committee, the Civil Rights Congress, the Sojourners, and the National Committee to Defend Negro Leadership.[114]

The small community of black Communist families in Brooklyn was crucial to helping the Jacksons weather McCarthyism. Cooper Jackson's old SNYC comrades Dorothy and Louis Burnham and Ed and Augusta Strong

had relocated from Birmingham to Brooklyn by the late 1940s. Cooper Jackson and her daughters eventually moved into the Strongs' home. The Burnhams lived across the street. Many neighbors were sympathetic to the Jacksons' plight. Louise Thompson Patterson and William Patterson lived nearby in Brooklyn before they moved to Harlem. Sallye and Ben Davis from Birmingham visited New York every summer. All of these couples had young children who regularly played together and could relate to one another's ordeal. Ed Strong, along with his sister-in-law, Constance Jackson, who had stayed with the family, went underground. Phyllis Taylor-Strong, Ed and Augusta Strong's eldest daughter, remembers FBI cars parked on the street near their home and witnessing her mother burning letters in the kitchen oven out of fear that government agents might raid their home and seize documents. These traumatic experiences had long-term effects on her ability to trust new acquaintances.[115]

Dorothy and Louis Burnham's second eldest child, Margaret Burnham, remembers being "just terrified" of constant government surveillance, especially after Ethel and Julius Rosenberg, a Communist couple convicted of spying for the Soviets, were executed in June 1953. Their deaths were especially traumatic for many children of Communists.[116] Still, these black children of Communist parents understood that they "weren't alone," as Margaret Burnham recalled. She added, "It was frightening. But you knew that somehow you were fighting against something." Although their parents rarely spoke about politics with their children, children of Black Communist parents regularly attended left-wing political events with their parents and attended Party-affiliated summer camps where they interacted with other "Smith Act children." Their parents did everything they could to ensure that their children enjoyed a typical childhood, like playing hopscotch and attending birthday parties.[117] Growing up under these difficult circumstances created lasting bonds between them. Many found personal and professional success as adults, proving "that to the degree that the families of the Smith Act victims had support and could achieve a sense of community and connections to others, the children of these families would experience less negative effects of trauma," writes Kathryn Alice Jackson, the Jacksons' second daughter.[118]

Sensing a more hospitable political climate, Jackson surrendered to federal authorities in New York on 2 December 1955. Ironically, he turned himself in the day after the launching of the Montgomery bus boycott. Earlier

that same year, the Afro-Asian Conference convened in Bandung, Indonesia, establishing what later became known as the Non-Aligned Movement.[119] As these events unfolded, Jackson, who had organized bus boycotts in Birmingham during World War II and had known E. D. Nixon, the leader of the Montgomery bus boycott, languished in a New York federal jail, while Cooper Jackson, who had led the Southern Negro Youth Congress and traveled internationally, now concentrated her efforts on freeing her husband.[120] Jackson's year-long trial began in May 1956. He was found guilty and sentenced to two years in prison. The case, however, was thrown out on appeal and helped set the precedent for the Supreme Court's ruling in 1957 in *Yates v. United States* that in essence declared the Smith Act unconstitutional. But his victory was in some ways a pyrrhic one. In the coming years, civil rights organizations feared associations with Communists. Given the level of anti-Communist hysteria and state repression, some of the most committed anti-racist fighters found themselves isolated for a brief but key moment from the emergent civil rights movement and the world stage.[121]

Just as the red scare necessitated that other black left feminists express their claims for social justice in familialist terms, Cooper Jackson articulated her politics in the rhetoric of postwar domesticity. One example of this was her decision to adopt Jackson as her last name. Strategically, adopting her husband's name made it easier for her to be readily identified publicly as James Jackson's wife when she spoke on his behalf. But it also signaled how McCarthyism required her to conform to social norms that wives share their husbands' last names, shedding the transgressive practice of black SNYC women who used their maiden names during the 1940s, a practice that cold warriors read as subversive.[122]

Cooper Jackson's 1953 agitprop pamphlet *This Is My Husband: Fighter for His People, Political Refugee* best illustrated her use of familial ideology for making claims for social justice through valorization of black motherhood. Portraying the government's efforts to capture Jackson as a fascist-like attack against a respectable, unprotected black family, a devoted mother and wife, and the entire African American community, she called attention to how government agents harassed her children. Evoking memories of slavery, she compared the infamous Fugitive Slave Act of 1850 to the "fascist-like" Smith Act and referred to FBI Director J. Edgar Hoover as "the present master of the FBI bloodhounds" in search of Jackson. In addition to demanding the freedom of her husband and all Smith Act victims, she called in essence for

a human rights program: protection of civil liberties, labor rights, peace, and democracy. She expressed, above all, her desire to be reunited with Jackson and support for what he believed.[123]

Given the sensitivity within black communities to the long history of violent breakup of black families, along with recent memories of Nazism, her story circulated widely in the black and Communist press. The most notable story was James L. Hicks's front-page exposé, "Fugitive Red's Family Plagued by FBI Agents," published in February 1952 in the *Afro-American*. The article assailed the FBI for using "Gestapo-like tactics" in harassing the Jacksons.[124]

This Is My Husband provides another example of the ambiguities of familialism. In the pamphlet Cooper Jackson conceded ground to the Cold War order by using the discourse of postwar domesticity to demand her husband's freedom. In doing so, the pamphlet prevented Cooper Jackson from formulating an alternative gender discourse that might have helped destabilize postwar domesticity. Her objective, however, was to publicize her family's and husband's persecution during one of the most politically repressive moments in U.S. history, not to theorize on women's oppression. As a black woman radical living through the McCarthy period whose husband was on the FBI's most wanted list, she had limited political options. In this light, her deployment of familialism can be read as a political performance, one that enabled her to appropriate dominant gender discourses to generate publicity for her plight and her husband's case. So while employing familialism removed critical discussions of sexuality from the table, it also subverted postwar domesticity and McCarthyism, enabling Cooper Jackson to criticize the government, to demand social justice, and to maintain her revolutionary convictions.[125]

The red scare also affected Thyra Edwards's life. Anti-Communism may have been a contributing factor in her decision to move in 1948 to Italy with her white Jewish husband. She left the United States as the Congress of American Women buckled under anti-Communist repression. As the CAW's executive director, she surely must have been nervous about being persecuted, but she was never arrested. In 1953, she returned to the United States, gravely ill, for medical attention. She died soon after that.[126]

Audley Moore's response to Cold War repression and CPUSA political shifts sharply contrasted from Edwards's and Cooper Jackson's. In 1950, Moore resigned from the CPUSA. As discussed in chapter 4, her frustrations with its racism, sectarianism, and sexism triggered her ideological conver-

sion into a strident black nationalist who was now fully self-aware of alleged Communist duplicity.[127] Her conversion story is key to Moore's narrative about her postwar ideological transformation. However, few scholars have critically interrogated these testimonies. I contend that her story stands as another example of how she reinvented her past, which in this case downplayed the importance of the red scare in contributing to her split from the CPUSA.

The Cold War directly affected Moore's life. The red scare decimated the black Popular Front in New York, which activists like her had helped put together. Her long-time associate, the Harlem U.S. representative Adam Clayton Powell, publicly broke from the Communist Left in 1948 out of fear that links to Communists would jeopardize his political career.[128] Red baiters destroyed the political career of Moore's close ally, Benjamin Davis Jr. Fearing widespread black support for the black Communist Harlem councilperson, cold warriors moved against him. One of the defendants in the CP-11 trial, Davis was convicted and sentenced to five years in jail in October 1949. With his political reputation tarnished, Davis lost his reelection bid in November. Moore served as his campaign manager. One month later, red baiters in the city council purged him from office on the grounds that he was a Communist, significantly weakening Communist influence in Harlem. For Moore, Davis's rapid political demise and Powell's break from the Communist Party must have been alarming. Additionally, the NCNW, an organization in which she had been actively involved during World War II, had moved toward the right. She was also briefly involved in the Sojourners. A savvy activist, she surely recognized that the CPUSA's heyday was coming to an end and a political realignment in the African American community was under way.[129]

Martha Biondi argues that "the anticommunist purge in the New York labor movement undermined the dynamic Black-labor-left nexus at the heart of the city's civil rights movement."[130] These developments destroyed Moore's own union, the progressive National Maritime Union (NMU), which was based in New York. Authorities viewed it as a Communist front. In 1948, they jailed the union's secretary, the Jamaican-born Communist Ferdinand Smith for allegedly violating the Smith Act. In 1951, he was deported. His persecution prompted conservative forces within the NMU to expel Smith and other suspected militants of color from the union. With his deportation and the NMU's collapse, "the base from which had emerged a Black proletar-

ian intelligentsia that had served African Americans so well over the years, had been eroded into dust," notes Gerald Horne.[131] The NMU's demise deprived Moore of a site to carry out her work and to earn a living. For her, the union's demise surely was another clear indication that the Communist Left was in decline.

Unlike Ferdinand Smith and Claudia Jones, Audley Moore was neither arrested nor jailed for her Communist affiliations during the McCarthy period. But, like other black left feminists, she underwent intensified FBI surveillance.[132] She did not comment on how government repression may or may not have affected her affiliations with the NMU and the CPUSA. But what is certain is that FBI surveillance frightened her and targeted many of her close associates and organizations to which she belonged. In light of the ferocity of anti-Communist repression and Party sectarianism, she may have concluded that she would have become isolated from her Harlem grass-roots constituents, who were for the most part not Communist rank-and-file members. Disgruntled with sexism, racism, and sectarianism within the Party and neither a hardcore Marxist-Leninist ideologue nor a member of the CPUSA's national leadership like Claudia Jones, Moore may have decided that she had more to lose than to gain by staying in the Party at this repressive political moment. Plus, unlike Louise Thompson Patterson and Esther Cooper Jackson, Moore was not married to a Party leader, affording her with independence to follow her own political path. While she had once seen the Communist Party as the vanguard for black liberation, she now looked to Africa as the harbinger for progressive change. Moore broke from the Party altogether, as did others, to avoid jail or having their careers ruined by the "red" label.[133] Still, leaving the Party was not easy for Moore. Even in 1978, her resignation elicited painful memories: "It wasn't by choice, it broke my heart, because I felt that [the CPUSA] was a vehicle to us to freedom."[134] By leaving the CPUSA, she severed political and social ties that extended back to the 1930s. Her resignation constituted a major blow to the Harlem Communist Party from which it arguably never fully recovered. To be sure, her departure deprived the CPUSA of an organic, proletarian intellectual and one of its most able leaders in Harlem.

Typically, studies of American Communism identify Soviet premier Nikita Khrushchev's "Secret Speech" in March 1956 and the Soviet invasion of Hungary in November 1956 as marking the end of the CPUSA as a viable social movement and as a major turning point in American radicalism.[135]

Fewer scholars have paid attention to how the mid-1950s marked a turning point in black women's radicalism. The McCarthy period signaled the end of an era for black left feminism. Black women who had joined the CPUSA during the 1930s and had gained international reputations as leading spokespersons in struggles for civil rights, racial justice, peace, decolonization, women's rights, and democracy experienced severe government repression and witnessed the destruction of Communist-affiliated organizations with links to global movements. The personal and political costs of anti-Communism on black women radicals should not be underestimated. The red scare crushed the Sojourners. Authorities jailed and deported Claudia Jones. Esther Cooper Jackson and Louise Thompson Patterson focused much of their work on defending themselves and their families from cold warriors. Audley Moore bolted from the CPUSA, due in part to her fear of being persecuted. McCarthyism, in one way or another, briefly isolated them from the emergent civil rights movement and from the global political scene. Yet ironically, it was political repression, together with the CPUSA's leadership's turn toward the ultra-left and global decolonization, that helped inspire black women radicals to carry out their most advanced work to date. Their theorizing on black women's triple oppression was years ahead of its time. Advancing a human rights agenda, they identified black women across the diaspora as the global vanguard for transformative change. Their work was not without contradictions, as evidenced in their appropriation of the postwar discourse of domesticity to make claims for social justice. Still, they maintained their revolutionary convictions in the face of virulent state repression. It was this resilient passion for social justice that inspired them to search for new sites of struggle as the Cold War thawed.

......................................

Ruptures and Continuities, 1956 Onward

Free Angela! Free All Political Prisoners!
SLOGAN OF THE FREE ANGELA DAVIS MOVEMENT

We are here.
Conceived of necessity and with impetuous ardor, born in travail,
 this newest, youngest publication is yet a lusty, bawling infant.
 This is a good world and a good time in which we are born.
 For we are African-American, and our name is *Freedomways*.
INAUGURAL ISSUE OF *FREEDOMWAYS*, SPRING 1961

From 1–7 March 1971, the sixty-nine-year-old Louise Thompson Patterson spoke defiantly across Great Britain on behalf of the black Communist, professor, and political prisoner Angela Y. Davis. Charged in December 1970 with murder, conspiracy, and kidnapping for her alleged role in a failed prison escape on 7 August 1970 in a Marin County, California, courthouse, she faced death. The FBI placed her on its most wanted list. In the ensuing months, her case became an international *cause célèbre*, with Thompson Patterson serving as the executive secretary of the New York Committee to Free Angela Davis and on the executive board of its parent group, the National United Committee to Free Angela Davis (NUCFAD). These organizations, together with the Communist Party of Great Britain, sponsored Thompson Patterson's speaking tour.[1]

Even while approaching seventy, the veteran activist had not lost a step while speaking about Davis's case across Great Britain. Thompson Patter-

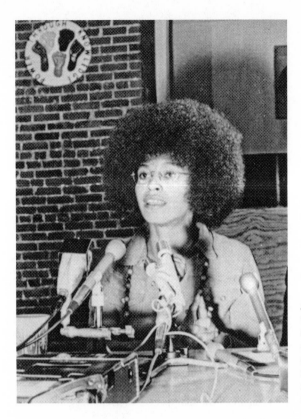

Angela Y. Davis,
18 October 1972,
SOURCE: *DAILY WORKER/*
DAILY WORLD PHOTOGRAPHS
COLLECTION, TAMIMENT
LIBRARY AND ROBERT F. WAGNER
LABOR ARCHIVES, BOBST
LIBRARY, NEW YORK UNIVERSITY.

son eloquently linked Davis's case to black struggles around the world. The tour powerfully illustrated how Thompson Patterson understood, as she had since the 1930s when she visited the Soviet Union and Spain, that traveling overseas and forging international alliances were critical to realizing black liberation. Her support for Davis also demonstrated Thompson Patterson's long-standing commitment to fighting for black women's freedom. For her, Davis's plight, like those of Rosa Lee Ingram and Harriet Moore during the McCarthy period, exposed the intersections between legal injustice, political repression, sexism, racism, and denigrating representations of black womanhood. Thompson Patterson had personal reasons for supporting Davis as well. The veteran radical had known Davis and her family since the 1950s. Due in no small part to Thompson Patterson's efforts, together with international mass pressure, authorities released Davis from prison on 23 February 1972. On 5 June an all-white jury acquitted her of all charges. She was free.[2]

In his insightful biography of William Z. Foster, the historian James Barrett argues that the life of this CPUSA leader, who fled after the height of

McCarthyism to the Soviet Union and died there in 1961, "isolated from the lives and concerns of most American workers," exemplifies how his story and that of the Communist Party "is one of failure."[3] For Barrett, the McCarthy period and Foster's exile marked the denouement of American Communism. On the one hand, he is correct. Wrecked from within by crippling sectarianism and without by government repression, the Party never again counted one hundred thousand members or exercised influence on labor. On the other hand, Barrett overlooks how, as Robin Kelley correctly observes, "the collapse of an organization does not necessarily signify the destruction of a movement or the eradication of traditions of radicalism."[4] Thompson Patterson's leadership in the Free Angela Davis campaign affirms Kelley's point.

By tracing veteran black Communist women's involvement in social movements of the 1960s and 1970s, this chapter examines both the ruptures and continuities in black left feminism after the McCarthy period. As destructive as the red scare was on the Communist Left and on the lives of black women radicals, McCarthyism neither crushed their freedom dreams nor marked the end of intergenerational exchange between younger and older black women radicals. Although many veteran black women radicals followed different paths and in some cases broke altogether from the Communist Left, they continued pursuing a black left feminist agenda after the 1950s, albeit in a political landscape that the red scare had irrevocably transformed. Building mass movements reminiscent of the Popular Front, they mentored young activists involved in civil rights, Black Power, Third World, and feminist movements. Marxism-Leninism continued to inform the work of black women of the Old Left. However, global traveling, the civil rights and Black Power movements, and decolonization transformed their lives, prompting them to continue rethinking Marxism-Leninism in ways that identified black women as the vanguard for global radical change. Given veteran black women radicals' central place in civil rights, Black Power, and Third World movements of the 1960s and 1970s, their stories reveal how these years hardly constituted black left feminism's denouement. Instead, they marked an exciting new chapter in its development.

Free Angela!

Angela Davis's recruitment into the Communist Party in July 1968 and the dynamic international campaign to free her signified the survival of the Old

Left after McCarthyism and further exemplified the direct influence of black left feminism on a new generation of black radicals. Her emergence as perhaps the most famous African American in the U.S. Communist Party's history, as well as her rise as a preeminent black feminist scholar and an international icon to young people globally, was hardly predestined. As a young person, she never imagined becoming a revolutionary icon, let alone a political activist. If anything put her on the path to radical political activism, it was growing up in the Jim Crow South, a progressive family, and a multiracial community of left-wing radicals.[5]

Davis was born in 1944 in Birmingham, Alabama. Her mother, Sallye Bell Davis, played a pivotal role in preparing the ground for her daughter's radical activism as an adult.[6] Her mother was a major figure in the Southern Negro Youth Congress of the 1940s and a close friend of Esther and James Jackson, Louis and Dorothy Burnham, and Augusta and Ed Strong. Her father, Ben Frank Davis, was not an activist. But he owned a gas station, providing the family with a degree of economic independence from whites. Growing up in Birmingham, Davis was keenly aware of segregation and the racial violence around her. In 1948, the Davises were one of the first black families to move into the all-white College Hills neighborhood in Birmingham. In the coming months, more upwardly mobile black families moved in. In an effort to stem the area's racial transformation, the Klan regularly bombed black-owned homes, earning the neighborhood the nickname "Dynamite Hill."[7] Still, despite the virulent white supremacist violence in their midst, Sallye Bell Davis repeatedly emphasized to her children that Jim Crow was neither inherent nor infallible: "This is not the way things are supposed to be. Things will be different." Davis would later take her mother's words to heart.[8]

By any measure, coming of age in a community of black radical families was foundational to fostering Davis's oppositional consciousness. From birth, Davis knew the Burnhams, the Strongs, and the Jacksons. Even after these families departed Birmingham and eventually resettled in New York, the Davises kept in touch with them. During the 1950s, the young Angela spent extended vacations in New York with her family. There, they socialized with the Burnhams, the Jacksons, the Strongs, the Pattersons, and the Apthekers, consisting of Herbert Aptheker, a Communist historian and leader, his wife, the Party activist Faye Aptheker, and their daughter Bettina. Visiting New York not only provided Davis with a respite from Jim Crow Birming-

ham. It also connected her with some of the most radical families in Cold War America. While in New York, she played with these families' children, listened to her parents passionately discuss politics, and watched them socialize with their friends. For these radicals, their politics and friendships were inextricably connected. Davis made this point at a tribute to James and Esther Jackson at New York University's Tamiment Library in 2006: "My relationship to the Jacksons is personal and political, and in thinking about my connection with them over the years, I realize that I cannot undo the entanglement of the personal and the political."[9] The same could be said of her relationships with the Strongs, the Burnhams, the Pattersons, and the Apthekers.

Growing up with children of leftist parents was especially important in stoking Davis's interest in social justice and radicalism. After moving to New York to attend high school, Bettina Aptheker invited Davis to join Advance, a multiracial youth group based in New York and affiliated with the CPUSA that supported civil rights and peace during the early 1960s. The group included the children of prominent black and white Communists such as Margaret and Linda Burnham, Harriet and Kathy Jackson, MaryLouise Patterson, Bettina Aptheker, and Eugene Dennis, the son of Eugene Dennis, a former general secretary of the CPUSA.[10] After graduating from high school, Davis went to Brandeis University in Boston and then studied philosophy in Frankfurt, Germany. In 1967, she returned to the United States to complete her doctorate at the University of California, Los Angeles. In Los Angeles, she became politically involved in the Student Nonviolent Coordinating Committee and associated with the Black Panther Political Party.[11]

Meanwhile, the veteran black Communist leader Charlene Mitchell, who was in her mid-thirties at the time, played a significant role in Davis's enlistment in the CPUSA. They met after Davis moved to Los Angeles. A major figure in the Communist Party since the late 1950s, Mitchell ran for president in 1968 on the CPUSA ticket. She was the first black woman to run for president. On the local level, in 1967 she founded the Che-Lumumba Club, an all-black, CPUSA club in Los Angeles through which Davis officially joined the CPUSA. Based in name and content in the legacies of the slain revolutionary heroes Ernesto "Che" Guevara, a leader of the Cuban Revolution, and Patrice Lumumba, the pan-Africanist, Congolese premier, the club created independent space for young black radicals to carry Marxist-Leninist ideas into the local black liberation movement.[12] Davis admired

Mitchell, who became her mentor and close friend. Given Mitchell's friendship with Davis and the veteran Afro-Caribbean radical Cyril Briggs, as well as her involvement in the postwar Communist Party, Mitchell represented a key link between the black radicalism and feminism of the early twentieth century and that of the 1960s.

If Mitchell's and Davis's friendship points to intergenerational connections between black women radicals, then the amnesty movement on Davis's behalf certainly illustrates black left feminism's survival into the 1970s. The movement's leadership prominently featured several black women who were veterans of the Old Left. The leadership of the New York Committee to Free Angela Davis included Louise Thompson Patterson as the executive secretary and Marvel Cooke as the treasurer, Cooke being a journalist and Communist of the Popular Front era. Charlene Mitchell served as the executive director of the National United Committee to Free Angela Davis. Also prominent in NUCFAD's leadership were Franklin Alexander and Davis's younger sister, Fania Davis Jordan (national co-coordinators), Kendra Alexander, Sallye Bell Davis, and Bettina Aptheker, an official of the CPUSA who later became a leading feminist scholar. Margaret Burnham, the eldest Burnham child, served as one of Davis's attorneys. Drawing on their immense networks, Mitchell, Bell Davis, and Thompson Patterson were instrumental in helping forge broad support for Davis from a multiracial, intergenerational group of prominent Communist and non-Communist activists, intellectuals, artists, politicians, and actors across the country. The group's sponsors included Beah Richards, Alice Childress, Esther Cooper Jackson, Ella Baker, Carmen McCrae, Ruby Dee, Ossie Davis, Maya Angelou, Pete Seeger, William L. Patterson, the Reverend Ralph Abernathy, Coretta Scott King, Coleman Young, and Herbert Aptheker.[13]

The Free Angela Davis movement resembled the colorful Scottsboro and postwar Popular Front movements of the 1930s around Rosa Lee Ingram and Willie McGee. Under Thompson Patterson's leadership, the New York committee organized rallies, marches, and petition drives, galvanizing thousands of ordinary black, Latino/a, Asian, and white people into action. With the slogan "Free Angela, Free All Political Prisoners!" Davis's supporters connected her case to broader demands for social justice, black liberation, women's rights, free speech, peace, and Third World liberation.[14]

The Free Angela campaign revealed tensions between black and white women activists. This was evident in the vocal refusal of the predomi-

nately white leadership of the National Organization of Women (NOW) and Women Strike for Peace to support Davis. They contended that her case was not a feminist issue. Their stance infuriated Thompson Patterson and younger black feminists. Years later, Thompson Patterson recalled that she "didn't feel close to feminists at all." "I'm not anti-feminist," she said, adding that her ambivalence toward white feminists' agendas was a response to their refusal to support Davis.[15] Her frustration with white feminists was hardly unique at this particular moment, as the white middle-class orientation of the women's liberation movement often alienated women of color.[16] Nor was her disappointment with white women activists something new. Surely, the position of NOW and Women Strike for Peace on Davis reminded Thompson Patterson of the grueling political struggles years earlier of black women of the Old Left vis-à-vis white Communist women around the centrality of black women to women's liberation. Although she did not self-identify as a feminist, Thompson Patterson nevertheless viewed Davis's case as a women's issue. Thompson Patterson worked closely with young women of color in the Third World Women's Alliance (TWWA), an organization based in New York that explicitly framed the Davis case as a feminist issue.[17] These women included Frances Beal, the founder of the TWWA, and Linda Burnham, a daughter of the Burnhams who was a leader in the TWWA.[18]

Following her release from prison and her acquittal in 1972, Davis regarded Thompson Patterson as an endeared friend for actively fighting for her freedom. In the coming years, they continued their political collaborations. They worked together with Charlene Mitchell in the National Alliance Against Racist and Political Repression (NAARPR), the successor of NUCFAD, based in New York. With Scottsboro and the Civil Rights Congress as its models, the NAARPR organized mass campaigns across the country to free black political prisoners, defend victims of police brutality, and internationalize U.S. racial injustice. One of the NAARPR's most important victories was its support of an amnesty movement on behalf of Jo Ann Little. She was a black working-class woman from North Carolina who faced death in 1975 for killing a white male prison guard in self-defense after he sexually assaulted her in her prison cell. Thompson Patterson and Mitchell viewed Little's plight, like that of Ingram, as a symbol of the economic exploitation, sexual violation, political persecution, and denigration of black womanhood. Due in no small part to mass international pressure, which the NAARPR helped to garner, a jury acquitted Little, making her the first

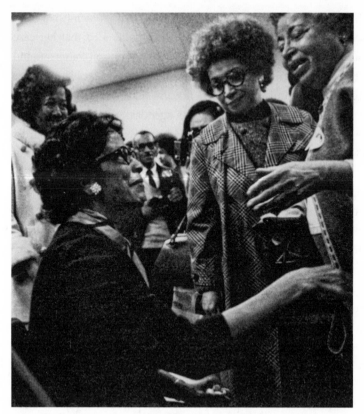

Louise Thompson Patterson with Alice Childress, Sallye Bell Davis (Angela Davis's mother) at a rally in New York City to free Angela Davis, circa early 1970s. SOURCE: LOUISE THOMPSON PATTERSON PAPERS, MANUSCRIPT, ARCHIVES, AND RARE BOOK LIBRARY, EMORY UNIVERSITY.

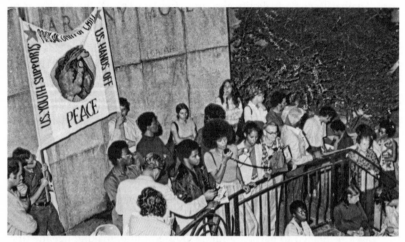

Angela Y. Davis speaking at Chile Rally, 11 September 1973 at the United Nations. SOURCE: *DAILY WORKER/DAILY WORLD* PHOTOGRAPHS COLLECTION, TAMIMENT LIBRARY AND ROBERT F. WAGNER LABOR ARCHIVES, BOBST LIBRARY, NEW YORK UNIVERSITY.

woman in U.S. history to be acquitted using the argument that she used lethal force in self-defense against rape.[19]

In addition to her involvement in the Free Angela Davis movement and the NAARPR, Thompson Patterson mentored young black militants. Just as her home in the 1930s had been a popular destination for intellectuals of the Harlem Renaissance who were interested in left-wing radicalism, Louise and William Patterson's Harlem apartment bustled with meetings during the 1960s and 1970s. The New York Black Panther leadership, as well as the CPUSA's Black Liberation Committee, composed of young and longtime black Communists, regularly met in the Pattersons' living room, showing once again how black radicals of the Old Left continued to influence black militants after the McCarthy period.[20]

One of the last survivors of the Harlem Renaissance, Thompson Patterson was approached by academics, filmmakers, and writers beginning in the 1970s. She generously shared her memories and extensive personal papers with them about such Harlem Renaissance figures as Langston Hughes and Zora Neale Hurston, as well as Paul Robeson, W. E. B. Du Bois, and the black-red encounter. With the assistance of the literary scholar Margaret Wilkerson, Thompson Patterson began working on her memoirs in the late 1980s. By the mid-1990s, however, her health had declined. Consequently, her autobiography was never completed. She died in New York on 27 August 1999 at the age of ninety-seven.[21] Her passing marked the end of an extraordinary life.

Freedomways

No political or cultural formation better highlighted the continuation of black left feminism into the civil rights and Black Power eras than Esther Cooper Jackson's role in co-founding and serving as the managing editor of *Freedomways: A Quarterly Journal of the Negro Movement* from 1961 to 1985. The journal marked her most significant lifetime achievement as a political activist and stood as "probably the most notable and enduring institution established in the 1960s by African Americans who had been active in the Popular Front," notes the literary scholar James Smethurst.[22] As the editorial in the inaugural issue of *Freedomways* confidently proclaimed, Cooper Jackson and her colleagues looked optimistically toward the future and firmly believed that the journal would help advance the U.S. black freedom movement. Under her leadership, *Freedomways* published works on issues that

had been staples of the black Left: racial equality and justice, human rights, anti-colonialism, peace, international solidarity, women's rights, economic justice, and the celebration of black culture. The journal published articles by black male luminaries, such as W. E. B. Du Bois, Paul Robeson, Martin Luther King Jr., Langston Hughes, and Kwame Nkrumah.

Equally important, *Freedomways* signaled the long-standing effort of black left feminists to center women in the black radical agenda. In both its staffing and editorial content, the magazine prominently featured articles, visual art, and poetry by and about black women, some of whom had been active in the Communist Party and the black Left since the 1920s. These women included Shirley Graham Du Bois, Claudia Jones, Louise Thompson Patterson, Beah Richardson, Augusta Strong, Eslanda Robeson, Alice Childress, Dorothy Burnham, Maude White Katz, Gwendolyn Brooks, and Lorraine Hansberry.[23] Works by black visual artists, such as Elizabeth Catlett and Margaret Burroughs, appeared in the journal. It also featured black women on its staff, which was atypical of magazines, even African American periodicals, during the early 1960s. Shirley Graham Du Bois and Margaret Burroughs, veteran black female progressives, served as the journal's associate editor and first art editor, respectively. Younger women like Jean Carey Bond, who had lived in Ghana during the mid-1960s, co-edited the journal during its final years.[24]

Freedomways was more than a magazine. It was an intellectual community bringing together veteran and younger black militant women. The magazine sponsored seminars, book readings, and other cultural events, providing space for the women to take up issues around gender, race, and class and to form collective, oppositional identities. Anticipating the black feminist critiques that developed in the late 1960s and early 1970s concerning the masculinism within black nationalism, the magazine printed comments from "The Negro Woman in American Literature," a conference panel by the New School for Social Research in 1965. In their comments, the *Freedomways* associates Alice Childress, Paule Marshall, and Sarah Wright critically discussed denigrating representations of African American women in black-authored novels and in popular culture. Moreover, *Freedomways* promoted a new generation of black women militants. Some of the earliest work by Alice Walker, Toni Morrison, June Jordan, Audre Lorde, Barbara Smith, and Nikki Giovanni, all of whom would make names for themselves as leading voices in black feminism, appeared in the journal. It also pub-

lished essays by Angela Davis after her release from prison.[25] Her scholarship recognized these intergenerational links. Her groundbreaking book of 1981, *Women, Race, and Class*, includes some of the first scholarly analysis of Communist women's feminist politics. In the book's important chapter "Communist Women," Davis acknowledges women of the Old Left as feminist forebears. Calling attention to the theoretical discussions in the postwar Communist Left on black women's "triple oppression," she recognizes Claudia Jones's article of 1949, "An End to the Neglect of the Problems of the Negro Woman!," as an innovative black feminist text. Clearly, Davis saw herself following an intellectual and political road forged by Jones.[26]

Davis's scholarship and the prominence of black feminist voices in *Freedomways* from its very inception challenges common perceptions that the emergence of black feminism in the 1970s was mainly a result of black women militants' frustrations with black nationalists' misogyny and white feminists' racism. Certainly, these issues helped cultivate new black feminist sensibilities and organizations. However, black left feminism must be recognized as one of the "parents" of so-called second wave black feminism. In other words, the black feminism of the 1970s emerged in part from longer, richly textured black feminist conversations within the Communist Left dating back to the 1920s.[27]

Given this, *Freedomways* has important implications for rethinking both the roots of black feminism of the 1970s and the periodization of postwar U.S. feminism. The journal, for example, preceded by two years the publication of Betty Friedan's *The Feminine Mystique* in 1963, a text widely regarded as "a major turning point in the history of modern American feminism" and "as a key factor in the revival of the women's movement," notes her biographer, Daniel Horowitz.[28] Cooper Jackson's advocacy of black left feminism at this moment stood in stark contrast to the rightward turn of Friedan, who had worked for several years after World War II as a reporter for the *UE News*, the newspaper of the United Electrical Radio and Machine Workers union affiliated with the CPUSA. "Reacting to the terror of anticommunism, redbaiting, and naming names," Friedan, according to Daniel Horowitz, "sought a safer haven in the suburbs" and reinvented herself into an alienated, middle-class housewife following the height of the McCarthy period. In a break from postwar left feminism and labor feminism, Friedan's *The Feminine Mystique* was conspicuously inattentive to race, class, and an internationalist perspective.[29] As a black woman radical whose husband had

been on the FBI's most wanted list and who had been closely surveilled herself, Cooper Jackson did not have the option of retiring to staid, lily-white suburbs. Nor could she have easily found a home in civil rights groups still intent on safely distancing themselves from Communists—even former ones—out of fear of being charged by the government as subversive. In this light, her status as a black woman radical and her location within the American and international political landscape of the early 1960s played a crucial role in shaping her feminist politics in ways that strikingly contrasted with her more famous counterpart.

Cooper Jackson's leadership of *Freedomways* also demonstrated black left feminists' long-standing willingness to perform the invisible work in building black progressive organizations. She drew on her broad networks among renowned black activists and artists to write and to raise funds for the journal. These included John O. Killens and Rosa Guy, co-founders of the left-wing Harlem Writers Guild of the 1950s and its members—Ossie Davis and Ruby Dee, the musicians Abbey Lincoln and Max Roach, and the novelist Louise Meriwether—and non-guild members such as Harry Belafonte. Although often unacknowledged by scholars, Cooper Jackson deserves significant credit for promoting the legacies of W. E. B. Du Bois and Paul Robeson after the Cold War largely isolated them from African American communities. *Freedomways* ran special issues featuring their work and published anthologies of their writings.[30] She was the driving force in organizing the *Freedomways*-sponsored International Cultural Evening on 23 February 1968. Celebrating the centennial of Du Bois's birth, the event commenced the beginning of a yearlong series of international celebrations of his work and legacy. Held at the sold-out Carnegie Hall in New York, the program featured Martin Luther King Jr. as its keynote speaker. In what was one of his last major speeches before his assassination only weeks later, he eloquently praised Du Bois as the father of pan-Africanism. King unequivocally condemned the Vietnam War, and American racism and poverty. He also blasted anti-Communist hysteria for vilifying Du Bois and shrouding his legacy. These positions illustrated not only how King had moved toward the left in his final years but also how venues like *Freedomways* provided him with space to do so.[31]

Freedomways published its last issue in 1985. Strains of operating the magazine on a limited budget were an important factor in ending its run.

Plus, Cooper Jackson was approaching her seventies, and the national and international political climate had swung toward the right.[32]

The journal's shutting down did not mark the end of Cooper Jackson's political work. During the 1990s, the Jacksons gained celebrity-like status among scholars, filmmakers, and activists interested in the origins of the modern black freedom movement, W. E. B. Du Bois and Paul Robeson, and the black-red encounter. Still actively involved in progressive political causes, Cooper Jackson sits on the executive board of the Louis E. Burnham Award, a foundation named after her dear friend that funds scholarly research and grass-roots organizers focused on African American youth, urban politics, and social justice. On 1 September 2007, her political partner and soul mate for sixty-six years passed away. The Jacksons witnessed some of the American Left's greatest triumphs and worst defeats as well as the dismantlement of *de jure* American apartheid and colonialism.[33] Modern black feminism owes a tremendous debt to black left feminists such as Cooper Jackson, a trailblazer in twentieth-century struggles for social justice, racial equality, and women's rights, who played important roles in imparting their knowledge to a new generation of black women militants.

New Directions

For some black women of the Old Left, the Cold War did mark a break in their lives and affiliation with the U.S. Communist Left. This was evident in the lives of Claudia Jones and Queen Mother Moore. Jones pursued her work in new geographical locations while Queen Mother Moore severed her ties with Communists. Although both women operated outside of the U.S. Communist Left following the McCarthy period, their experiences in the CPUSA weighed heavily on their work. Like those black women who maintained ties to the U.S. Communist Left, both Jones and Moore shared a commitment toward mentoring young black radicals and building new black radical movements.

Jones relocated to London after her deportation from the United States in December 1955, beginning one of the most exciting periods in her entire career as a radical activist. Although Jones never found a home in the Communist Party of Great Britain, she remained a committed Marxist-Leninist and staunch supporter of the Soviet Union and the People's Republic of China until her untimely death in 1964.[34] In London, Jones formed several

Esther Cooper Jackson and James E. Jackson Jr. in their home in Brooklyn. PHOTOGRAPH BY AUTHOR, 2003.

Dorothy Burnham speaking before the Louis E. Burnham Award meeting, February 2010, Schomburg Center for Research in Black Culture, New York City. A photograph of Louis Burnham is in the background. PHOTOGRAPH BY AUTHOR.

dynamic organizations outside of the Communist Left that were committed to socialism, peace, decolonization, black liberation, human rights, and Third World solidarity. These groups included the *West Indian Gazette and Afro-Asian Caribbean News* newspaper and the Committee of Afro-Asian-Caribbean Organisations. Through these organizations, Jones emerged as an important mentor to a community of London-based, young African, Afro-Caribbean, and Asian artists, writers, and activists. Founding the Caribbean Carnival in London's black Notting Hill neighborhood in January 1959 marked Jones's crowning achievement in Britain. The largest festival of its kind in Europe today, the carnival regularly draws more than one million people.[35]

While Jones forged new friendships and political associations in London, she also maintained her relationships with black women radicals based in the United States. Until her death, she regularly exchanged warm letters with Halois Robinson, a journalist, Communist, and former Sojourner, Dorothy Burnham, and Eslanda Robeson. Jones also met with Charlene Mitchell and Louise Thompson Patterson when they traveled through London; in fact, Jones and Thompson Patterson reconciled their differences over the Sojourners when the latter stopped over in London in 1960 on her way to the Soviet Union. These encounters demonstrate that while McCarthyism removed her from the United States, it hardly severed her connections to a transnational community of black women radicals.[36]

Of the women chronicled here, no one's political trajectory shifted more dramatically during and after the 1950s than Queen Mother Moore's. Following her break from the CPUSA, she moved forward in formulating her idiosyncratic black nationalist politics that creatively weaved together Garveyism, Ethiopianism, Marxism-Leninism, feminism, and Third Worldism and rejected interracialism. Key to her ideological transformation was her adoption of the title "Queen Mother" as the centerpiece of her new political identity. (The "queen mother" was the royal genealogist in the nineteenth-century Asante empire in modern-day Ghana.)[37] Her new identity as "Queen Mother Moore," together with her tireless, vocal support for pan-African unity, black self-determination, and reparations, made her an international icon among black nationalists. During her numerous visits to Africa in the 1960s and 1970s, African rulers treated her as a revered elder and visiting head of state.[38]

While her "Queen Mother" persona represented a break from her past, she never abandoned lessons she had learned in the Communist Party. Beginning in the early 1950s, she mentored a new generation of black militants, training them in nationalism and Marxism. She tutored Malcolm X. She worked closely with the early Black Power leader Robert F. Williams, and with young militants in the Revolutionary Action Movement (RAM), the Progressive Labor Movement, the African People's Party, the Republic of New Africa, the New York chapter of the Black Panther Party, and the Congress of African People.[39]

Queen Mother Moore's founding of the Universal Association of Ethiopian Women (UAEW) best illustrates the enduring influence of black left feminism on her politics. She formed the UAEW in 1957 in New Orleans, where she resided periodically. The group had no organizational ties to the CPUSA. Yet the UAEW's tactics and programs bore the stamp of the CPUSA and black left feminism. Surely inspired by Scottsboro, the Civil Rights Congress, and the Sojourners, the UAEW built mass movements in black working-class communities in New Orleans, New York, and Los Angeles around rape frame-up cases involving black men and white women, interracial rape and involuntary sterilization of black women, welfare rights, economic justice, and the death penalty. Reminiscent of early Cold War campaigns to free Willie McGee and Rosa Lee Ingram, the UAEW internationalized lynching and the rape of black women by framing these issues as human rights violations and by appealing to the UN for redress. In its demands for human rights, intersectional and internationalist sensibility, and black working-class membership, the UAEW in many respects represents a missing link between the black Old Left and Black Power and the black feminism of the 1970s.[40]

But Queen Mother Moore's work moved in new directions after she left the CPUSA. From the early 1960s until her death in 1997 at the age of ninety-eight, Moore was at the center of building support for reparations within black communities across the diaspora. Her pamphlet of 1963, *Why Reparations? Reparations Is the Battle Cry for the Economic and Social Freedom of More Than 25 Million Descendants of American Slaves*, represents the first major theoretical work of the modern reparations movement. Indeed, her campaign on behalf of reparations may constitute her most lasting significance.[41]

Ruptures

Although black left feminism survived the McCarthy period, the legacy of the red scare and a generational divide did shroud its legacy from some young black feminists. Frances Beal discovered Claudia Jones's work after forming what later became the Third World Women's Alliance in 1968 and penning her seminal article, "Double Jeopardy: To Be Black and Female," published in Toni Cade Bambara's path-breaking volume, *The Black Woman: An Anthology* in 1970. Moreover, the TWWA named its newspaper *Triple Jeopardy*, vividly illustrating how the group took into account black women's triple oppression. Clearly, the TWWA's explicitly anti-imperialist, anti-racist, anti-capitalist, and anti-sexist platform, along with Beal's article, resembled the radical, intersectional, transnational black feminist agenda championed by Jones, the Sojourners for Truth and Justice, and other black women of the Old Left. Similarly, Barbara Smith, the co-founder of the Combahee River Collective, was completely unaware of the Sojourners when she formed what was arguably the most path-breaking black feminist organization of the 1970s. That neither Beal nor Smith was initially aware of her predecessors' work illustrates how some black feminists of the 1970s had to reinvent the wheel.[42] However, the Cold War did not completely erase the legacy of the Sojourners. Dorothy Burnham, the leader of the Southern Negro Youth Congress, a Sojourner, and a longtime Communist, shared her memories of the black progressive women's group with the Sisters against South African Apartheid (SASAA), a Brooklyn-based black women's organization founded in 1986 by the activist Rev. Karen Smith Daughtry.[43]

Younger and older black women radicals' stance on gender and sexuality issues represented the most significant difference between them. For younger women, appreciating sexuality as a site of social intervention was vital to social change. Some young black women such as Frances Beal believed that the CPUSA's apparent economic determinism prevented it from grasping the complexities of gender oppression.[44] Her observations were not unfounded. Through the 1970s, the CPUSA largely dismissed sexual orientation, reproductive rights, domestic violence, and homophobia as important political issues. Even *Freedomways* largely overlooked these issues. Instead, *Triple Jeopardy*, the TWWA's and the Combahee River Collective's consciousness-raising sessions, and the Combahee River Collective State-

ment of 1977 became the spaces where ground-breaking conversations took place about the links between sexuality and politics.[45]

The contrasting relationship black women of the Old Left and younger black feminists held toward the women's liberation movements stands as another significant difference. Many young black women who self-identified as "feminists" held ambivalent views toward the white, middle-class orientation of the women's liberation movement. This was the case for Barbara Smith, Frances Beal, and Linda Burnham. Still, they nevertheless refused to dismiss the women's liberation movement. They grappled with its limitations, but they still claimed the women's movement as their own.[46]

This was not true of most veteran black women radicals. Louise Thompson Patterson expressed ambivalence toward groups such as Women Strike for Peace and the National Organization of Women for refusing to support Angela Davis. Queen Mother Moore was even more vocal in her hostility toward mainstream feminism. She dismissed it as an "alien ideology" promoted by middle-class white women.[47] Her position on the women's movement was part of her broader, complicated gender and sexual politics. On the one hand, she called for women's full participation in black movements and centered black working-class women's issues in her work. On the other hand, she also opposed women-centered agendas and called for women's subordination to men. She staunchly opposed interracial unions, viewed abortion as a form of genocide against black people, and advocated polygyny. Late in life, she enthusiastically endorsed the Million Man March of 1995, an event widely criticized by black feminists for its apparent patriarchal, heterosexist agenda.[48] Her gender and sexual politics affirm the claim of the black feminist theorist E. Frances White that black nationalism is often progressive in relation to white supremacy and conservative in relation to the internal organization of black communities.[49]

In the context of the times, Queen Mother Moore's positions on gender and sexuality were hardly unique. Many Black Power and civil rights organizations often equated black liberation with black male redemption, espousing heterosexist ideals that silenced the voices of black gays and lesbians.[50] Similar to Moore's stance on abortion, black nationalist organizations such as the Nation of Islam and the Black Panther Party viewed abortion as a form of genocide. Many black women shared her criticisms of white feminists' racism and middle-class orientation.[51] Internationally, the rise of religious fundamentalism, narrow nationalism, and the liquidation of the secular left

across much of the late twentieth-century world corresponded with renewed calls for patriarchy.[52]

Some younger black feminists took exception to Queen Mother Moore's gender and sexual politics. This was true for Frances Beal. For her, Queen Mother Moore's call for black women's subordination was not only reactionary. It was outright dangerous. Beal found it ironic and troubling that Moore remained "silent" when black nationalist men "called for black women to walk ten steps behind them when she had never done this herself." Her iconic status as an elder, female veteran radical, Beal believed, validated black nationalist men's misogyny.[53] However, some of Queen Mother Moore's young female associates took a different view. While most disagreed with her stance of polygyny, they nevertheless shared her discomfort with the agenda of white middle-class feminism and deeply admired Queen Mother Moore as a symbol of confident, dignified womanhood.[54]

Black feminist scholarship of the 1970s also revealed the intellectual breaks with their predecessors on the relation between sexuality, culture, and politics. This is most evident in the work of Angela Davis. Although informed by black left feminism, her scholarship, most notably, *Blues Legacies and Black Feminism: Gertrude "Ma" Rainey, Bessie Smith, and Billie Holiday*, broke from the Old Left by recognizing the links between sexuality, race, and politics as sites of intervention and social transformation.[55]

These differences on the issue of sexuality speak largely to generational divides between older and younger black radical women. The former came of age during the Depression. Jim Crow and European colonial empires were still firmly in place. The Communist Left was in its heyday, and the Soviet Union had captured the imaginations of radical young people worldwide. While they often practiced non-normative sexualities, most black left feminists viewed sexuality as a private affair and lacked a discourse and space for interrogating these issues.[56] Younger black women came of age during the 1960s as the sexual revolution and women's and gay liberation movements challenged prevailing gender and sexual conventions. These developments, together with the legacies of the Cold War, which largely shrouded the work of women of the Old Left, help explain why younger black radical women drew these conclusions. So while U.S. rulers and black reformers from the 1920s through the 1950s often viewed black Communist women's politics and personal practices as transgressive and subversive, some younger black feminists saw their predecessors' gender and sexual politics as conserva-

tive.[57] This suggests that while there were real connections between black women of the Old Left and younger black feminists, there were also concrete ideological differences between them.

Contested Legacies

Black leftist women are finally beginning to receive scholarly attention. However, it remains to be seen how scholars and non-academics will acknowledge their radical political work in light of contemporary state-sanctioned assaults on civil rights, immigrant rights, and civil liberties in this post-9/11 world. Recent works by Carole Boyce Davies, Kevin Gaines, and Patricia J. Saunders on Claudia Jones have begun to address these very issues.[58] In *Left of Karl Marx*, Boyce Davies argues that the criminalization of Jones as an "alien red" by the U.S. government during the McCarthy period anticipated contemporary practices of criminalization, incarceration, and deportation.[59] Patricia J. Saunders affirms Boyce Davies's point, arguing that Jones's deportation has relevance for understanding "our contemporary condition of state-sanctioned 'disappearances and deportations' and incarcerations due to political beliefs."[60] Here, I would like to extend this conversation by charting how the radical politics and legacies of Claudia Jones and Queen Mother Moore have been shrouded, misrepresented, and co-opted by some radicals of color, the media, and state authorities.

No doubt, the legacy of McCarthyism together with the contemporary hysteria around "terrorism" are key factors explaining the erasure of black women radicals from popular memory and the historical record. But these are not the only factors. Part of this explanation also lies in how left-wing radicals of color and black nationalists themselves have sometimes erased black women radicals' encounters with the CPUSA and their left-wing feminist politics.

This is true of Claudia Jones. In an effort to recognize her significant interventions in Marxism-Leninism, the Claudia Jones Memorial Committee, under the leadership of Abhimanyu Manchanda, a radical born in Sri Lanka who was Jones's political collaborator and romantic partner, interred her ashes to the left of Karl Marx's grave in London's Highgate Cemetery in early 1965. In 1983, the Claudia Jones Memorial Committee placed a gravestone next to Marx's tomb bearing the inscription: "Valiant fighter against racism and imperialism who dedicated her life to the progress of socialism and the liberation of her own black people."[61] Curiously, a reference to her

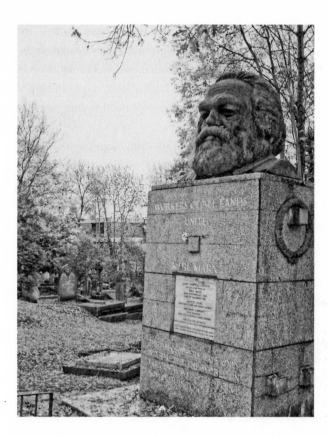

Tomb of Karl Marx, Highgate Cemetery, London. Claudia Jones's tombstone is located immediately to the left of Marx's grave. PHOTOGRAPH BY AUTHOR, 2003.

commitment to black women's liberation is conspicuously absent from the tombstone. This is significant. As this book and other scholars have showed, it was her path-breaking theoretical writings on the triply exploited status of black women that stands as her most significant contribution to Marxism-Leninism, one that the postwar U.S. Communist Left widely recognized. That her colleagues, in particular, her political associate and partner, did not see to it that the tombstone mentioned her radical black feminist politics is telling. This move speaks to their masculinist framings of black liberation and how black, left, and Third World movements have often been ambivalent if not openly hostile to feminist agendas.[62] Her tombstone inscription, therefore, is emblematic of the erasure of black left feminism within black radicalism.

Jones's legacy remains contested today. In October 2008, the British Royal Mail Service issued a stamp honoring six "Women of Distinction" in the United Kingdom, among them Jones. The stamp features a dignified photo-

graph of her, with the inscription: "Activist, Civil Rights, Claudia Jones." The official press release stated, "Claudia Jones, the prominent Civil Rights activist is featured on the 72p stamp. Born in Trinidad, she was brought up in Depression-era Harlem, New York. She arrived in England in 1955 and it was from her base in London's Notting Hill that she continued to campaign for the rights of UK's black community."[63]

On one level, the stamp is a significant milestone. Jones was the only black woman honored by the Royal Mail Service in this special series of stamps on distinguished British women. Calling attention to her work in organizing the now world-famous Notting Hill carnival, the stamp recognizes a black woman activist who had been vilified and persecuted by U.S. cold warriors. Tellingly, no such stamp has been issued by the U.S. government.

At the same time, the stamp shrouds the radical aspects of Jones's work. The press statement released by the British postage service upon the stamp's issuance is a case in point. The statement did not mention her Communist affiliation or political persecution. Like her tombstone, the press release additionally failed to acknowledge her radical feminist politics.[64] Indeed, the stamp's reference to her as a "civil rights" activist, not as a "Communist," is significant. Erasing her radical demands for human rights and socialism, the stamp rewrites the history of black struggles in the civil rights era by de-linking their domestic agendas from militant demands for decolonization and, in some cases, black women's liberation. In this regard, the stamp can be interpreted as a co-optation of Jones's life and legacy. More broadly, the stamp can be read as part of a broader liberal, "post-racial" discourse that seeks to elide the violent history of colonialism, white supremacy, and anti-Communist repression and obfuscate intractable present-day racial and structural inequalities that Jones so steadfastly opposed.[65]

Similarly, Queen Mother Moore's admirers often overlook her involvement in American Communism. Obituaries published in the black and mainstream media mostly elided her affiliation with the CPUSA. This is curious given how Queen Mother Moore readily acknowledged in oral histories her affiliation with the Communist Party and its importance in teaching her how to organize.[66] Without question, her life and legacies remain contested terrain between black nationalists, on the one hand, and, on the other, leftist activists and scholars sympathetic to the Communist Party's agenda.

Certainly, the erasure of these women's affiliations with the Communist Party and their commitment to radical change is hardly complete. There are

several efforts to recognize Jones's legacy as one of the twentieth century's most important black revolutionary thinkers. These include the London-based Claudia Jones Organisation, an Afro-Caribbean women's community group established in 1982, which annually lays a wreath on her grave. This book and the growing body of scholarship and academic symposia focused on recovering the radical, feminist, diasporic politics of Claudia Jones, Queen Mother Moore, and other black women are reassuring examples of how these women's leftist politics are rendered visible.[67]

Still, time will tell as to how scholars will use black women radicals to reconfigure canonical narratives of black radicalism, black feminism, U.S. and transnational women's movements, and American Communism. But these are more than simply academic questions. They are political questions. Given the current shape of global political affairs in which states across the world are suppressing dissent and civil liberties in the name of fighting "terror" and promoting "national security," telling these women's stories is instructive not only for interpreting the world but also for transforming it.

Conclusions

Angela Davis electrified the audience. She was the keynote speaker of the Black Women and the Radical Tradition Conference held on 28 March 2009 in the auditorium of the City University of New York's Graduate Center. This one-day symposium both celebrated the life and legacy of Davis's close friend and mentor Charlene Mitchell and critically examined twentieth-century black women's radicalism. Given the conference's objectives and Davis's iconic stature, together with the recent inauguration of Barack Obama as the first black president of the United States, the excitement in the packed auditorium was palpable.

Looking back on her life, Davis credited Mitchell for bringing her into the Communist Party: "I learned what it meant to be a Communist, what it meant to be citizen of the world from Charlene."[68] Recounting Mitchell's achievements as a visible personality in the CPUSA and the black Left since the 1940s, Davis lauded Mitchell for mentoring her and leading the world-wide amnesty movement that saved her from certain death.[69] Davis then spoke about her mother. She stated emphatically: "I was walking a path . . . already established by my mother," who had passed away in 2007 at the age of ninety-three.[70] Davis then briefly discussed Sallye Bell Davis's involvement in the Southern Negro Youth Congress, acknowledging it as a pioneer-

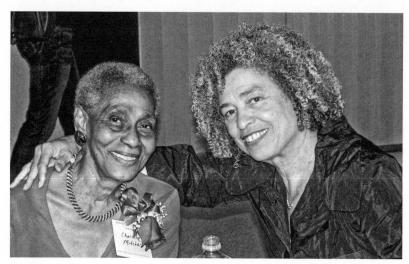

Charlene Mitchell and Angela Y. Davis at Black Women and the Radical Tradition Conference, New York City, 28 March 2009. PHOTOGRAPH BY AUTHOR.

ing civil rights group in which women, like her mother, were prominent. Davis emphasized how women of the SNYC were ahead of their time in addressing issues of race, gender, and class and appreciating black women as the political vanguard. The audience listened attentively to her address. Following her remarks, she received a rousing standing ovation.

Davis's address is significant. By acknowledging her mother, Mitchell, and the SNYC, Davis revealed that she was keenly aware that her life and work were inextricably linked to a tradition of black women's radicalism closely connected with the Communist Party. She outlined a genealogy of intersectional thought and black women's radicalism that stretched from the early twentieth century into the early twenty-first and that was internationally focused. Through sharing her warm memories of her mother and Mitchell, Davis reminded the audience that the personal is invariably political. Above all, her address and the conference reveal growing academic and non-academic interest in uncovering the neglected radical aspects of black women's history and the awareness that this radical past contains invaluable lessons for creating a more democratic present and future.

This conference and Davis's remarks capture the key themes of this book, in which I have sought to recover a distinct radical black feminist politics forged by a community of black leftist women who made the Com-

munist Party the primary site of their activism. Grace Campbell, Williana Burroughs, Bonita Williams, Thyra Edwards, Louise Thompson Patterson, Audley "Queen Mother" Moore, Esther Cooper Jackson, Dorothy Burnham, Beulah Richardson, Charlene Mitchell, and Sallye Bell Davis emerged as visible leaders within the international Left. They hailed from different geographic and social backgrounds and traveled different roads into the Communist Left. They saw it as a powerful alternative to black mainstream protest groups for agitating for civil rights, women's equality, jobs, labor rights, affordable food and housing, peace, and decolonization. Believing that all people could live free of oppression, these women dedicated their lives to radically changing the world. Many paid a tremendous personal price for their politics. However, their stories are neither of total defeat nor of complete triumph. Black women radicals were not without contradictions. They were unsuccessful in building and leading movements that overthrew capitalism, white supremacy, colonialism, and patriarchy. But to judge them on this would do a disservice to their remarkable work and legacy, as well as their interventions in black feminism, black radicalism, American Communism, and U.S. and transnational women's movements.

The key historical significance of these women rests in their forging of black left feminism. Combining black nationalist and Communist positions on race, gender, and class with their own lived experiences, black women radicals formulated a distinct, innovative brand of feminist and radical politics within the Old Left Communist Party. They pursued this politics through their journalism, grass-roots organizing, global traveling, and personal relations. But while Communism informed black left feminism, the two were not synonymous. This was most evident in black Communist women's formulation of a theory of "triple oppression." Understanding women of color's lives in intersectional terms, black left feminists viewed triply oppressed black women across the diaspora as both the most subjugated segment of the working class and the political vanguard. These conclusions challenged the Communist Left's tendency to portray the "working woman" as white and the "Negro worker" as male. In doing so, black Communist women argued that the Party's ability to address black women's issues represented the acid test for the CPUSA's support for both the Negro Question and the Woman Question. This was a bold position. In essence, black left feminists argued that black working-class women's concerns were central, not peripheral, to

the socialist struggle. By advancing this position, black women radicals challenged the masculinist framings of black liberation often espoused within the Communist Left and black nationalist and civil rights organizations.

Meanwhile, through forging a "black women's international," black left feminists formulated their own variant of black internationalism. The Soviet Union was central to their global outlook. Traveling there transformed their politics and subjectivities. Captivated by "the Soviet promise" for building a new society, they gained a new understanding of the global contours of white supremacy, class exploitation, imperialism, and gender oppression, bolstering their sense of transnational citizenship. Their Soviet encounters also provided a sense of personal freedom and autonomy from prevailing racial and gender conventions that they had never known in the United States. Given this, internationalism appealed differently to black women radicals than it did to black male radicals and white Communists. They returned home more confident and energized to take part in social justice struggles. At the same time, black women radicals looked beyond the Soviet Union for revolutionary inspiration and support. Inspired by anti-colonial movements across the Global South, black women radicals attempted to build ties of political solidarity between black women in the United States and their sisters across the diaspora, women in the emergent Third World, and white women sincerely committed to racial justice and equality.

Black women's affiliation with the Communist Left was often contentious and complicated. On the one hand, they attempted to be disciplined Communists. They regularly followed Party directives, sometimes supporting policies that were indefensible. On the other hand, they often functioned as outsiders within the CPUSA, never fully enjoying equal say in Communist affairs. They grappled with sexism, racism, and sectarianism within the Communist Left, sometimes vocally criticizing white Communist women and men and black men for their chauvinism and neglect of black women and their issues. Writings by Maude White Katz, Louise Thompson Patterson, and most famously, Claudia Jones, illustrate this. Due to their criticisms of Communist policies and their marginal location as black women within a predominately white male organization, some black Communist women, such as Grace Campbell and Audley Moore, became bitter and disillusioned with the CPUSA, ultimately bolting from it. Others stayed. Whatever path these women followed through the Communist Left and its unique movement culture fundamentally transformed their subjectivities. They formed

lasting friendships and romantic unions, sometimes across the heterosexual and color line, raised children, and found community within the Communist Left. These women left an indelible mark on the Communist Party.

While uncovering the history of black left feminism reconfigures narratives of American Communism and black radicalism, it also reveals a radical tendency within black women's history. Too often, scholars cast early and mid-twentieth-century black women's activism as uniformly progressive and located exclusively within the club movement, church, and nationalist organizations. Black Communist women's lives show that this was hardly the case. Black leftist women shared much in common with their non-Communist sisters. Like them, black women radicals were adept in agitating on multiple fronts, pursuing pragmatic approaches to political organizing, and working with a broad range of everyday people and earning their trust.

At the same time, the Communist Left served as a viable alternative to the church and club movement for theorizing the multidimensionality of black women's oppression and fighting for dignity and rights on a global scale. In contrast to their non-Communist counterparts, black women radicals firmly believed that capitalism was an anathema to black freedom and black women's well-being. In particular, black women forged a politics and subject position that often challenged bourgeois respectability. Rejecting the class elitism of some club and church women, black Communist women argued that middle-class notions of respectability could not ensure black women's protection and dignity. Some women, like the young Louise Thompson, flaunted their New Woman sensibility. Others, such as Esther Cooper Jackson and her female and male comrades in the Southern Negro Youth Congress, consciously decided to tackle sexism within public and private spheres. Decades ahead of their time, Cooper Jackson and her comrades proffered progressive models of black masculinity. For black Communist women and their male comrades, making new women and men was just as important to black liberation and socialism as dismantling Jim Crow and colonialism. For these women one of the most exciting aspects of the Communist Left was how it provided space to appreciate the connections between the personal and the political.

Black Communist women came to recognize that they constituted a community and that their work was connected to a tradition of black women's radicalism stretching back to the nineteenth century. The short-lived So-

journers for Truth and Justice best exemplified this view. Inspired by the nineteenth-century abolitionists, the women's rights advocates Sojourner Truth and Harriet Tubman, and the early club movement, the Sojourners attempted to build a radical, transnational movement of black women committed to racial justice, human rights, peace, decolonization, and the respect for black womanhood. The group exemplified black women radicals' efforts in forging a collective identity through their shared experiences, their solidarities, their radical, transnational political vision, and their frustrations with the Communist Left. The group, however, was not successful in accomplishing these goals. Cold War repression, CPUSA ambivalence, and political tension between individual Sojourners prevented the group from taking off. Yet the group's destruction did not silence black women radicals. They continued building new movements after the 1950s, informed both by their past experiences in the Old Left and by civil rights, Black Power, and decolonization. Indeed, the years from the 1920s through the 1950s stand as one of the most dynamic periods in twentieth-century black feminism. Black women in the Communist Left were central to forging this radical black feminist praxis, and while black feminist generations have not always acknowledged their links, these connections emerge through scholarly analysis and historical reconstruction through human links like the women featured here.

Given the absence of memoirs and extensive organizational records, there is much that we may never know about these women's extraordinary lives. What we can say for certain is that their work was ahead of its time. Yet tensions occasionally erupted between them. They were not always on the same political page. And the state sometimes targeted them. Yet, they remained committed to changing the world. Their passion for justice and resilience in the face of seemingly insurmountable obstacles speaks to the importance of contests around struggles for democracy and social justice for confronting and negotiating power and marginalization, citizenship and disenfranchisement, locally and internationally, then and particularly now.

Without question, the political and socioeconomic realities of our post-9/11 world are significantly different from those black left feminists confronted in their day. These different times require new solutions, strategies, and movements. Whatever paths twenty-first-century black women, feminists of color, and their allies choose to follow, the activism and complex lives of black Communist women certainly provide immeasurable guidance for fighting for a more just, democratic, peaceful world for us all.

Introduction

1. Quoted in Barton, "Revolt of the Housewives," 18–19; DW, 4 June 1935.
2. DW, 4 June 1935; Audley "Queen Mother" Moore, interview by Mark Naison, 12; Naison, *Communists in Harlem during the Depression*, 136; McDuffie, "Long Journeys, 206–7.
3. DW, 4 June 1935.
4. Ibid., AN, 28 May 1938, May 3, 1947; Audley "Queen Mother" Moore, interview by Mark Naison, 1972, 12; Naison, *Communists in Harlem during the Depression*, 149–50.
5. I should note that many of the women discussed in this book deliberately did not use their married names throughout their lives. To honor these decisions, I will use the surname they used during the historical moment under inquiry or when I directly quote or cite an interview conducted with them later in life. I will employ a similar system in the case of Audley Moore, who had adopted the title "Queen Mother Moore" by the late 1950s.
6. In this book, the term "Communist Left" describes a broad array of organizations and individuals that associated with and to varying degrees supported the program of the Communist Party. Similarly, the term "black Left" refers to a wide range of protest organizations with ties to the Communist Party.
7. Washington, "Alice Childress, Lorraine Hansberry, and Claudia Jones," 185, 193–98.
8. "Combahee River Collective in Guy-Sheftall, *Words of Fire*, 231–40; Roth, *Separate Roads to Feminism*, 11–14; Crenshaw, "Mapping the Margins."
9. Springer, *Living for the Revolution*, 106–12; Roth, *Separate Roads to Feminism*, 121–24.
10. Weigand, *Red Feminism*, 7–8; Cott, *The Grounding of Modern Feminism*, 53–81, 117–42.

11. Collins, *Black Feminist Thought*, 2nd ed.; Guy-Sheftall, *Words of Fire*.

12. For discussions of masculinist articulations of black freedom, see Estes, *I Am a Man!*; Lubiano, "Black Nationalism and Common Sense"; R. M. Williams, "Living at the Crossroads"; E. White, "Africa on My Mind."

13. Butler, *Freedoms Given, Freedoms Won*, 210–11; Hine, "African American Women and Their Communities in the Twentieth Century," 15–16.

14. Hine, "African American Women and Their Communities in the Twentieth Century," 1–23.

15. Mutua, "Introduction," xi.

16. For a small sampling of this work, see Collier-Thomas, *Jesus, Jobs, and Justice*; Giddings, *Ida*; Giddings, *When and Where I Enter*; U. Taylor, *The Veiled Garvey*; Higginbotham, *Righteous Discontent*; Gray White, *Too Heavy a Load*, 21–211; Rief, "Thinking Locally, Acting Globally"; Shaw, *What a Woman Ought to Be and to Do*; E. Brown, "Womanist Consciousness."

17. This book joins a growing body of literature on black women's encounters with the U.S. Communist Party and the international Left. See Boyce Davies, *Left of Karl Marx*; Harris, "Running with the Reds"; Gore, "From Communist Politics to Black Power"; Welch, "Spokesman of the Oppressed?"; Weigand, *Red Feminism*, 97–113; Horne, *Race Woman*.

18. McDuffie, "Long Journeys," 9; Boyce Davies, *Left of Karl Marx*, 29–95.

19. Boyce Davies, *Left of Karl Marx*, 2, 3. The work of the historian Kevin K. Gaines also provides a useful foundation for uncovering these connections. He argues that "the origins of black feminism existed in a symbiotic relationship to a black radical culture of internationalism, largely based in northern black urban centers such as Harlem and Chicago." Gaines, "From Center to Margins: Internationalism and the Origins of Black Feminism," 294.

20. Marx, *Capital*, 1: 188–246, 655–67, 772–802, 3: 958–61, 971–91.

21. Boyce Davies, *Left of Karl Marx*, 42.

22. Ibid., 38, 39.

23. Those in the Communist Left referred to the peak years of anti-Communist repression, roughly 1951 through 1956, as the "McCarthy period." Taking a cue from the historian Ellen Schrecker, I use the term "McCarthyism" broadly in referring to postwar anti-Communist hysteria and state repression against Communists and suspected Communists. Schrecker, *Many Are the Crimes*, ix–xx.

24. Boyce Davies, *Left of Karl Marx*, 131–233.

25. Thompson, "Toward a Brighter Dawn"; Cooper, "The Negro Woman Domestic Worker in Relation to Trade Unionism"; Jones, "An End to the Neglect of the Problems of the Negro Woman!" *Political Affairs* reprinted the article as "An End to the Neglect of the Problems of Negro Women," 53, no. 3 (March 1974): 28–42.

26. James, "Resting in Gardens, Battling in Deserts," 4.

27. Gore, Theoharis, and Woodard, Introduction to *Want to Start a Revolution?*, 5, 13–14. The sociologist Belinda Robnett coined the term "bridge leadership" in her

monograph, *How Long? How Long? African-American Women in the Struggle for Civil Rights*, 19–35.

28. McDuffie, "'I wanted a Communist philosophy, but I wanted us to have a chance to organize our people,'" 181–95.

29. McDuffie, "The March of Young Southern Black Women," 85–89.

30. Harris, "Running with the Reds," 32.

31. Quoted in Wolcott, *Remaking Respectability*, 8.

32. Ibid., 1–9; For additional discussions of black women and respectability, see Higginbotham, *Righteous Discontent*, 185–229; Williams, *The Politics of Public Housing*; E. White, *Dark Continent of Our Bodies*.

33. S. Hall, "The Work of Representation."

34. Richardson, "A Black Woman Speaks of White Womanhood, of White Supremacy, of Peace"; McDuffie, "A 'New Freedom Movement of Negro Women,'" 85–86.

35. Collins, *Black Feminist Thought*, 2nd ed., 69.

36. hooks, *Black Looks*, 4.

37. Higginbotham, *Righteous Discontent*, 185–229.

38. Gore, Theoharis, and Woodard, *Want to Start a Revolution?*; Springer, *Living for the Revolution*, 106–12; Roth, *Separate Roads to Feminism*, 121–24. For additional discussions of intergenerational exchange between black radicals who came of age before and after the McCarthy period, see Young, *Soul Power*; Smethurst, *The Black Arts Movement*; Wilkins, "Beyond Bandung."

39. Scharf and Jensen, *Decades of Discontent*; Rupp and Taylor, *Survival in the Doldrums*.

40. Roth, *Separate Roads to Feminism*, 77.

41. Springer, *Living for the Revolution*; Nadasen, *Welfare Warriors*; Roth, *Separate Roads to Feminism*. For additional investigations of black women's engagement with "second wave feminism," see S. Gilmore, *Feminist Coalitions*; Valk, *Radical Sisters*.

42. Roth, *Separate Roads to Feminism*, 16.

43. Ward, "The Third World Women's Alliance," 121.

44. Quote appears in Premilla Nadasen's section, "Black Feminism—Waves, Rivers, and Still Water," in the article by Laughlin et al., "Is It Time to Jump Ship?," 98.

45. Quoted in Dubois, "Eleanor Flexner and the History of American Feminism," 84; Swerdlow, "The Congress of American Women"; Horowitz, *Betty Friedan and the Making of the Feminine Mystique*; Landon Storrs, "Left-Feminism, the Consumer Movement, and Red Scare Politics in the United States, 1935–1960."

46. Cobble, *The Other Women's Movement*, 3.

47. The term is credited to the political scientist Cedric J. Robinson's magnum opus, *Black Marxism*. Robinson understands the black radical tradition as a shared revolutionary consciousness and vision rooted in African-descended people's ontological opposition to racial capitalism, slavery, and imperialism. In drawing

these conclusions, Robinson understands black radicalism and Marxism as "two programs for revolutionary change," appreciating the latter, despite its universalist claims, as "a Western construction—a conceptualization of human affairs and historical experiences of European peoples mediated, in turn, through their civilization, their social orders, and their cultures." Marxism, in Robinson's view, remains grounded to its own detriment in the racialism deeply embedded within Western civilization. For these reasons, Marxism fails to understand the histories of black resistance and complexities of black life. Robinson, *Black Marxism*, 1, 2.

48. Boyce Davies, "Sisters Outside"; Gaines, "Locating the Transnational in Postwar African American History"; Saunders, "Woman Overboard."

49. Boyce Davies, "Sisters Outside," 218.

50. Gaines, "Locating the Transnational in Postwar African American History," 197.

51. Saunders, "Woman Overboard," especially 209–15.

52. Boyce Davies, "Sisters Outside," 221; Gaines, Locating the Transnational in Postwar African American History," 201–2; Saunders, "Woman Overboard," 215–16.

53. I am borrowing the term "freedom dreams" from Robin D. G. Kelley's insightful study, *Freedom Dreams*.

54. For works on collective identity formation, see Rupp and Taylor, "Forging Feminist Identity in an International Movement"; Springer, *Living for the Revolution*, 1–4, 122–30; Taylor and Whittier, "Collective Identity in Social Movement Communities."

55. Springer, *Living for the Revolution*, 2.

56. Chela Sandoval, quoted in Springer, *Living for the Revolution*, 14. See also, Sandoval, *Methodology of the Oppressed*, 53–61.

57. Springer, *Living for the Revolution*, 1–4, 122–30.

58. For additional insightful discussions of the gendered and sexual contours of black internationalism, black nationalism, and pan-Africanism, see Stephens, *Black Empire*; Holcomb, *Claude McKay, Code Name Sasha*; Taylor, *The Veiled Garvey*, 64–90; Boyce Davies, *Black Women, Writing, and Identity*; E. White, "Africa on My Mind."

59. Boyce Davies, "Sisters Outside"; Gaines, "Locating the Transnational in Postwar African American History," 195–96; Saunders, "Woman Overboard," 209–16.

60. Edwards, *The Practice of Diaspora*, 243, 244. Recent scholarship has extended Edwards's analysis of black internationalism. West, Martin, and Wilkins, *From Touissant to Tupac: The Black International since the Age of Revolution* is but one example. "At the core of black internationalism" they argue, "is the ideal of universal emancipation, unbounded by national, imperial, continental, or oceanic boundaries—or even by racial ones" (xi). However, women's voices, gender, and sexuality are largely absent in their understanding of black internationalism.

61. Edwards's omission of black women's involvement in the "black international" is curious in light of how his book does look at Afro-Caribbean women's central role in leading Parisian black literary groups that embraced a radical diasporic vision. Edwards, *The Practice of Diaspora*, 119–86.

62. Quoted in Carew, *Blacks, Reds, and Russians*, 1, 3.

63. Matusevich, "Journeys of Hope," 61.

64. In her introduction, Carew acknowledges that her book focuses primarily on the experiences of fourteen black American male travelers to the Soviet Union. See Carew, *Blacks, Reds, and Russians*, 7. K. Baldwin, *Beyond the Color Line and the Iron Curtain*; Holcomb, *Claude McKay, Code Name Sasha*.

65. Gaines, *American Africans in Ghana*, 25–26, 76, 202.

66. Patterson and Kelley, "Unfinished Migrations," 27.

67. My thinking here is informed by Rebeccah E. Welch's insightful essay "Gender and Power in the Black Diaspora," 310.

68. Schrecker, *Many Are the Crimes*, xii–xv.

69. For a few examples, see Palmer, *James P. Cannon and the Origins of the American Revolutionary Left*; Barrett, *William Z. Foster and the Tragedy of American Radicalism*; Storch, *Red Chicago*; Klehr and Haynes, *The Soviet World of American Communism*.

70. Cruse, *The Crisis of the Negro Intellectual*. It should be noted that Cruse's thesis lives on. See Arnesen, "'No Graver Danger.'"

71. Kelley, *Hammer and Hoe*; Naison, *Communists in Harlem during the Depression*; Horne, *Black and Red*; Painter, *The Narrative of Hosea Hudson*; Biondi, *To Stand and Fight*; Solomon, *The Cry Was Unity*; Singh, *Black Is a Country*, 100–33; Bush, *We Are Not What We Seem*, 102–39; Von Eschen, *Race Against Empire*.

72. Kelley, *Hammer and Hoe*, xiii–xiv; Solomon, *The Cry Was Unity*, 38–51, 68–91.

73. Mishler, *Raising Reds*, 2.

74. Collins, *Fighting Words*, 3–10.

75. Ransby, *Ella J. Baker and the Black Freedom Movement*, 4; Lee, *For Freedom's Sake*, 85–102.

76. McDuffie, "Long Journeys," 21–40, 154–71, 204–16, 233–36, 323–40, 401–11, 483–88; Ahmad, *We Will Return in the Whirlwind*, 7–21.

77. J. Hall, "The Long Civil Rights Movement and the Political Uses of the Past"; E. Gilmore, *Defying Dixie*; Theoharis and Woodard, *Freedom North*; Gore, Theoharis, and Woodard, Introduction to *Want to Start a Revolution?*, 1–11.

78. Cha-Jua and Lang, "'The Long Movement' as Vampire"; Lieberman and Lang, *Anticommunism and the African American Freedom Movement*, 1–12.

79. I am borrowing the term "personal costs" from Lee, *For Freedom's Sake*, ix.

80. Jones, "An End to the Neglect of the Problems of the Negro Woman!"; McDuffie, "A 'New Freedom Movement of Negro Women,'" 83–88.

81. McDuffie, "A 'New Freedom Movement of Negro Women,'" 95–97; Boyce Davies, *Left of Karl Marx*, 99–166.

82. For debates about the usefulness of the CPUSA and Communist International records archived at The Russian State Archive of Social and Political History (RGASPI) in Moscow and now largely available at the Library of Congress in Washington, see Haynes, "Reconsidering Two Questions"; Schrecker and Isserman, "The Right's Cold War Revision."

83. Louise Thompson Patterson's unpublished memoir, Louise Thompson Patterson Papers.

84. Barrett, "*Was* the Personal Political? Reading the Autobiography of American Communism," 404.

85. Claudia Jones to William Z. Foster, 6 December 1955, Howard "Stretch" Johnson Papers; Welch, "Gender and Power in the Black Diaspora," 76–77.

1. Black Communist Women Pioneers

1. Robert A. Hill, *Marcus Garvey and the UNIA Papers*, 4: 688.

2. *The Messenger* (November 1920): 138.

3. McDuffie, "'[She] devoted twenty minutes condemning all other forms of government but the Soviet,'" 229; Kornweibel, *Seeing Red*, 30–32, 151–52, 153–54.

4. Stansell, *American Moderns*, 7–8; White, *Too Heavy a Load*, 112–15.

5. Trotter, *Great Migration in Historical Perspective*, 1, 2.

6. Turner, *Caribbean Crusaders and the Harlem Renaissance*, 154.

7. Gaines, *Uplifting the Race*, 14.

8. Quoted in White, *Too Heavy a Load*, 24.

9. Ibid., 21–55, 56–86; Giddings, *Ida*; Wolcott, *Remaking Respectability*, 11–48; Higginbotham, *Righteous Discontent*; Harris, "Running with the Reds"; Shaw, *What a Woman Ought to Be and to Do*.

10. Foster, *History of the Communist Party of the United States*, 171–85; Rod Bush, *We Are Not What We Seem*, 90–120.

11. Perry, *Hubert Harrison*, 1: 243–80; Kelley, "'But a Local Phase of a World Problem,'" 1055–66; Bush, *We Are Not What We Seem*, 90–120.

12. Palmer, *James P. Cannon and the Origins of the American Revolutionary Left, 1890–1928*, 87–134; Foster, *History of the Communist Party of the United States*, 171–72, 269–75.

13. "Theses of the Fourth Comintern Congress on the Negro Question," in Degras, *The Communist International, 1919–1943*, 1: 398–401; "Resolution of Communist International, October 26, 1928," in *The Communist Position on the Negro Question* (New York: Workers Library Publishers, 1934), 56–64; Solomon, *The Cry Was Unity*, 17–21, 40.

14. W. Goldman, *Women, the State, and Revolution*; Halle, *Woman in Soviet Russia*; Carleton, *Sexual Revolution in Bolshevik Russia*, 5–11.

15. W. Goldman, *Women, the State, and Revolution*, 1–253; Carleton, *Sexual Revolution in Bolshevik Russia*, 3, 6, 19–112; D'Emilio, *Sexual Politics, Sexual Communities*, 56.

16. Robinson, *Black Marxism*, 175–184.

17. White, *Too Heavy a Load*, 89.

18. Paris and Brooks, *Blacks in the City*, 4; Minutes of 8 November 1911, 11 September 1912, 3 June 1912, NLPCW meetings, L. Hollingsworth Wood Papers, box 53, NLPCW Minutes, Treasurer's Reports, Receipts, 1911–1913 folder; Citation Cer-

tificate of Death, No. 13623, Grace Campbell, 9 June 1943, the City of New York, Department of Records and Information Services; Hicks, "Confined to Womanhood," 75–76.

19. White, *Too Heavy a Load*, 39.

20. Quoted in *NYA*, 6 September 1924; Hicks, "Confined to Womanhood," 77–80; Grace Campbell, Death Certificate; *Savannah Tribune*, 19 August 1911, reprinted in Tuskegee Clipping File, reel 1, 53–353 (microfilm); U.S. Fourteenth Census 1920, http://persi.heritagequestonline.com; Hicks, "Confined to Womanhood," 75–76.

21. Quoted in Higginbotham, *Righteous Discontent*, 203; Wolcott, *Remaking Respectability*, 11–48.

22. Gross, *Colored Amazons*, 87.

23. *Savannah Tribune*, 19 August 1911.

24. Gaines, *Uplifting the Race*, 31.

25. *DW*, 29 December 1945, in Williana Burroughs, NY Bureau File, 100-390-21, FBI.

26. Turner, *Caribbean Crusaders and the Harlem Renaissance*, 5–7.

27. Maude White Katz, interview by Ruth Prago; Solomon, "Recovering a Lost Legacy," 7.

28. Gaines, *Uplifting the Race*, 136.

29. Makalini, "For the Liberation of Black People Everywhere," 125; Hicks, "Confined to Womanhood."

30. W. James, "Being Red and Black in Jim Crow America," 54.

31. Hubert H. Harrison broke from the SPA in 1917 due to his discomfort with the wide-spread racism within the organization and its class reductionism of the Negro Question. He pursued his revolutionary nationalist vision in his newly formed, Harlem-based Liberty League. However, A. Phillip Randolph, Chandler Owen, and Frank Crosswaith remained in the SPA. Perry, *Hubert Harrison*, 1: 220–327.

32. Robert A. Hill, *Marcus Garvey and the UNIA Papers*, 4: 688.

33. Makalani, "For the Liberation of Black People Everywhere," 2.

34. At its peak in 1923, the ABB claimed thirty-five hundred members in the United States and the Caribbean. Its strident anti-capitalism and its call for forging alliances with the nascent Communist Left and with white trade unionists distinguished the ABB's program from those of the Garvey movement (UNIA) and of the NAACP. The ABB initially also sought to work with the Garvey movement. However, relations between the ABB and UNIA quickly deteriorated due to mutual suspicion and Briggs's ill-conceived, failed effort to highjack the UNIA convention of 1922. Russian State Archive (hereafter RA) 515/1/37; Makalani "For the Liberation of Black People Everywhere," 57–168.

35. Cyril Briggs to Theodore Draper, letter, 17 March 1958, Theodore Draper Papers, box 31, folder Negro-Briggs, Cyril.

36. "Theses of the Fourth Comintern Congress on the Negro Question," in Degras, *The Communist International*, 1: 398–401; Solomon, *The Cry Was Unity*, 17–21.

37. Solomon, *The Cry Was Unity*, 4–5, 8–21.

38. Ibid.; RA 515/1/575/35–55; Makalani, "For the Liberation of Black People Everywhere," 207–29.

39. Hobsbawm, *Revolutionaries*, 3.

40. Robert A. Hill, *Marcus Garvey and the UNIA Papers*, 4: 688.

41. P-138 to Bureau of Investigation, 4 March 1921, RG 65, BS 202600-667-307, FSAA Records, reel 7, 304.

42. Watkins-Owens, *Blood Relations*, 79, 93; RG 65 Casefile OG 76064, FSAA Records, reel 9, 864–865; U.S. Fourteenth Census, Helen Holman, http://persi.heritage questonline.com.

43. In 1925, the school board reinstated her job after it lifted the ban on employing married women teachers. Subsequently, she began teaching high school in Queens. DW, 1 May 1934.

44. Ibid.

45. Ibid.; HL, 18 November 1933.

46. Huiswoud was one of two black people to attend the inaugural convention of what became the Workers Party. In 1922, he attended the Fourth Comintern Congress in Moscow, participating in the deliberations on the Negro Question with Claude McKay. Turner, *Caribbean Crusaders and the Harlem Renaissance*, 11–14, 89–90, 99–108.

47. "Some Women I Have Known Personally, Campbell, Grace," in Hermina Dumont Huiswoud Papers (hereafter HDH Papers), box 1, Essays on Women folder.

48. Turner, *Caribbean Crusaders and the Harlem Renaissance*, 154.

49. Maude White Katz, interview by Ruth Prago; Solomon, "Recovering a Lost Legacy," 7.

50. D. Baldwin, *Chicago's New Negroes*; Storch, *Red Chicago*.

51. Weigand, *Red Feminism*, 15.

52. RA 515/1/631/28–29; RA 515/1/362/7; RA 515/1/362/11, 33; DW, 29 November 1929; Shapiro, "Red Feminism," 55–59.

53. Robert A. Hill, *Marcus Garvey and the UNIA Papers*, 4: 688.

54. Makalani, "For the Liberation of Black People Everywhere," 120.

55. RG 60, Casefile 198940-283, 27 January 1923, FSAA Records, reel 15, 469; RA 515/1/37/11–12; AN, 23 February 1927; Makalani, "For the Liberation of Black People Everywhere," 169–89.

56. Makalani, "For the Liberation of Black People Everywhere," 120–123, 128.

57. RA 515/1/575/35–49; 515/1/575/68; 515/1/575/61; 515/1/720/3–4; NC, 3 November 1928.

58. "Some Women I Have Known Personally, Campbell, Grace," in HDH Papers, box 1, Essays on Women folder; Makalani, "For the Liberation of Black People Everywhere," 85.

59. Kuumba, *Gender and Social Movements*, 56–57.

60. "Some Women I Have Known Personally, Campbell, Grace," HDH Papers, box 1, Essays on Women folder.

61. U. Taylor, *The Veiled Garvey*, 41–90, 144–45; Ransby, *Ella Baker and the Black Freedom Movement*, 173–92; Lee, *For Freedom's Sake*, 86–102.

62. Kornweibel, *Seeing Red*, 26, 30–32; Watkins-Owens, *Blood Relations*, 79, 93; RG 65 Casefile OG 76064, FSAA Records; U.S. Fourteenth Census 1920, Helen Holman.

63. U. Taylor, *The Veiled Garvey*, 64.

64. Ibid., 64–90; McDuffie, "'[She] devoted twenty minutes condemning all other forms of government but the Soviet,'" 234–35.

65. Watkins-Owens, *Blood Relations*, 71, 79, 93.

66. Quoted in ibid., 92; P-138 to Bureau of Investigation, 11 June 1921, RG 65, BS 202600-667, FSAA Records, reel 7, 343–344; Turner, *Caribbean Crusaders and the Harlem Renaissance*, 53–54.

67. Joseph, *Waiting 'Til the Midnight Hour*, 12, 17–18; Turner, *Caribbean Crusaders and the Harlem Renaissance*, 58–59.

68. My thinking on this matter is informed by the historian Ula Y. Taylor's insightful article "Street Strollers."

69. Floyd-Thomas, "Creating a Temple and a Forum," 4, 7; Ethelred Brown, "A Brief History of the Harlem Unitarian Church," 11 September 1949, E. Ethelred Brown Papers, box 1, folder 8.

70. Brown, "A Brief History of the Harlem Unitarian Church," E. Ethelred Brown Papers, box 1, folder 8; "Some Women I Have Known Personally, Campbell, Grace," HDH Papers, box 1, Essays on Women folder.

71. Scharfman, "On Common Ground,," viii, 3.

72. Ibid., 3.

73. Turner, *Caribbean Crusaders and the Harlem Renaissance*, 69–70; Christian, "Marcus Garvey and the Universal Negro Improvement Association," 163–65; Martin, *African Fundamentalism*.

74. Stansell, *American Moderns*, 225–72.

75. Gates, "The Black Man's Burden," 129.

76. Holcomb, *Claude McKay, Code Name Sasha*, 4. McKay briefly enjoyed prominence in the global Communist Left due to his attendance at the Fourth Communist International Congress in Moscow in 1922. There, he helped draft the resolution on the Negro Question. Solomon, *The Cry Was Unity*, 40–42; McKay, *The Negroes in America*.

77. Cott, *The Grounding of Modern Feminism*, 74; Buhle, *Women and American Socialism, 1870-1920*, 246–87; D'Emilio and Freedman, *Intimate Matters*, 229–35.

78. A. Davis, *Blues Legacies and Black Feminism*.

79. NW, 2 February 1924.

80. NW, 6 January 1926.

81. McDuffie, "'[She] devoted twenty minutes condemning all other forms of government but the Soviet,'" 234–35.

82. "Resolution of the Communist International, October 26, 1928" in *The Communist Position on the Negro Question*, 57, 60, 62; Solomon, *The Cry Was Unity*, 68–91.

83. Kelley, *Race Rebels*, 114.

84. "Resolution of the Communist International, October 26, 1928," 62.

85. Makalani, "For the Liberation of Black People Everywhere," 252.

86. Constitution, Harlem Tenants Association, Richard B. Moore Papers, box 5, folder 10; NC, 20 April 1929; AN, 5 June 1929; Makalani, "For the Liberation of Black People Everywhere," 263–64.

87. Following the issue of the Black Belt thesis, the Party formed the Negro Department, a national commission charged with overseeing Communist "Negro work." RA 515/1/1685/21–22.

88. NC, 20 April 1929, 25 May 1929; DW, 22 November 1929, 1 June 1929; AN, 5 June 1929, 12 June 1929, 16 January 1929, 23 January 1929; Makalani, "For the Liberation of Black People Everywhere," 261–64.

89. Makalani, "For the Liberation of Black People Everywhere," 261–64.

90. M. Anderson, "The Plight of Negro Domestic Labor."

91. Hunter, *To 'Joy My Freedom*, 74–97; Coble, *Cleaning Up*, 223–50.

92. Higginbotham, *Righteous Discontent*, 211–29.

93. NC, 8 August 1928; Solomon, *The Cry Was Unity*, 100.

94. RA 515/1/1685/21–22, 31–40.

95. RA 515/1/1685/32.

96. Palmer, *James P. Cannon and the Origins of the American Revolutionary Left, 1890–1928*, 316–49.

97. DW, 30 October 1929.

98. AN, 1 January 1930; DW, 11 September 1929; *Liberator*, 7 December 1929, 14 December 1929; Solomon, *The Cry Was Unity*, 99–100; Naison, *Communists in Harlem during the Depression*, 24.

99. Solomon, *The Cry Was Unity*, 100; Turner, *Caribbean Crusaders and the Harlem Renaissance*, 178.

100. DW, 16 February 1924.

101. NYA, 18 April 1925, 25 April 1925.

102. NYA, 18 April 1925.

103. Ibid.

104. Boyce Davies, *Left of Karl Marx*, 38–39.

105. NYA, 18 April 1925.

106. Quoted in R. Gilmore, *Golden Gulag*, 5; A. Davis, *Abolition Democracy*.

107. R. Gilmore, *Golden Gulag*, 5.

108. Makalani, "For the Liberation of Black People Everywhere," 128; Shapiro, "Red Feminism," 55–59; RA 515/1/360/1–14; RA 515/1/360/83–87.

109. NC, 8 August 1928; Solomon, *The Cry Was Unity*, 100.

110. NC, 8 August 1928.

111. M. White, "Special Negro Demands," 11. The NTWIU was affiliated with the Communist-affiliated Trade Union Education League (TUEL), later renamed the Trade Union Unity League (TUUL).

112. Foster, *History of the Communist Party of the United States*, 254; NC, 23 February 1929.

113. Du Bois, *Black Reconstruction*, 700; Roediger, *Wages of Whiteness*.

114. M. White, "Special Negro Demands," 11.

115. Carew, *Blacks, Reds, and Russians*, 1, 3.

116. Giddings, *Ida*, 283–304; Terrell, *A Colored Woman in a White World*, 72–99; Rief, "Thinking Locally, Acting Globally."

117. Quoted in Solomon, *The Cry Was Unity*, 91; Turner, *Caribbean Crusaders and the Harlem Renaissance*, 143. Claude McKay coined the term "magic pilgrimage" in reference to those blacks who endeavored to travel to the Soviet Union during the early 1920s. The term is quoted in K. Baldwin, *Beyond the Color Line and the Iron Curtain*, 14.

118. Maude White Katz, interview by Ruth Prago; Solomon, "Recovering a Lost Legacy," 7; McClellan, "Africans and Black Americans in the Comintern Schools, 1925–1934."

119. Maude White Katz, interview by Ruth Prago.

120. Ibid.; Brocheux, *Ho Chi Minh*, 36–37; Horne, *Mau Mau in Harlem?*, 10, 90, 98; Turner, *Caribbean Crusaders and the Harlem Renaissance*, 191; Haywood, *Black Bolshevik*, 155–65.

121. Maude White Katz, interview by Ruth Prago.

122. Ibid.; Solomon, "Recovering a Lost Legacy," 7.

123. Ibid.

124. "Some Women I Have Known Personally, "Mme Litvinov," HDH Papers, box 1, Essays on Women folder; Turner, *Caribbean Crusaders and the Harlem Renaissance*, 191.

125. Turner, *Caribbean Crusaders and the Harlem Renaissance*, 192–224.

126. PV, 5 January 1946; Turner, *Caribbean Crusaders and the Harlem Renaissance*, 190–91; Joyce Moore Turner, e-mail message to author, September 8, 2008.

127. RA, 495/37/68/45.

128. Turner, *Caribbean Crusaders and the Harlem Renaissance*, 149.

129. Ibid., 143.

2. Searching for the Soviet Promise

1. Carew, *Blacks, Reds, and Russians*, 115–39.

2. Quoted in L. Patterson, unpublished memoirs, "Chapter on Trip to Russia—1932," Louise Thompson Patterson Papers (hereafter LTP Papers) 2002, box 20, folder 2, 47; K. Baldwin, *Beyond the Color Line and the Iron Curtain*, 22.

3. Miller, *Remembering Scottsboro*; Howard, *Black Communists Speak on Scottsboro*; Goodman, *The Stories of Scottsboro*; Carter, *Scottsboro*.

4. Thompson, "My Southern Terror," 327.

5. Greenberg, *Or Does It Explode? Black Harlem in the Great Depression*, 42–64.

6. Solomon, *The Cry Was Unity*, 185–206; Kelley, *Hammer and Hoe*, 78–80.

7. Singh, *Black Is a Country*, 66.

8. Watts, *God, Harlem U.S.A.*

9. Naison, *Communists in Harlem during the Depression*, 19–22.

10. White, *Too Heavy a Load*, 69–169; Stein, *The World of Marcus Garvey*, 248–56.

11. Carter, *Scottsboro*, 3–50; Herndon, *Let Me Live*.

12. Naison, *Communists in Harlem during the Depression*, 126–65.

13. Solomon, *The Cry Was Unity*, 233–75; Naison, *Communists in Harlem during the Depression*, 95–165.

14. Carew, *Blacks, Reds, and Russians*, 1, 3, 4.157–83.

15. Thompson took the last name of her stepfather, Hadwick Thompson, with whom she lived during her early childhood years. MaryLouise Patterson, interview by author.

16. "Louise Alone Thompson Patterson: A Celebration of her Life and Legacy," program of memorial, 25 September 1999, n.p. in possession of author; Louise Patterson, interview by Ruth Prago, tape 1. Louise Thompson Patterson was one of the first African American women to graduate from Berkeley; MaryLouise Patterson, interview by author.

17. CD, 8 September 1928, 3 March 1929, 9 September 1933; Martin and Martin, "Thyra J. Edwards," 163–64.

18. Naison, *Communists in Harlem during the Depression*, 43.

19. L. Patterson, "Chapter 3, Harlem in the 1920s," draft in unpublished memoir, 17–18, 27; Louise Patterson, interview by Ruth Prago, tapes 1, 2, 3.

20. T. Patterson, *Zora Neale Hurston and a History of Southern Life*, 32–49; AN, 29 December 1934; L. Patterson, "Chapter 3, Harlem in the 1920s," draft in unpublished memoir.

21. Hirth, *Gay Rebel of the Harlem Renaissance*.

22. Brown and Faue, "Revolutionary Desire," 281; Thyra Edwards to Etha Bell, 14 April 1934, Thyra Edwards Papers, Chicago History Museum, Chicago, IL, box 1, folder 1.

23. Evelyn Crawford, telephone interview by author. Crocco and Waite, "Education and Marginality"; Horne, *The End of Empires*, 96–100.

24. Louise Thompson Patterson, interview, 6 August 1989, 37–38, LTP Papers, box 28, folder 25; Congregational Education Society, "Annual Report, 1931–1932" (Boston: Congregational House, n.d.) in Congregational Education Society Records, 1816–1956, box 1, subseries A, folder 8; CD, 15 November 1930.

25. CD, 28 November 1931, 19 November 1932; Martin and Martin, "Thyra J. Edwards," 165–68.

26. Quoted in AN, 23 December 1931; Naison, *Communists in Harlem during the Depression*, 68.

27. AN, 17 February 1932, 15 June 1932; RA 515/1/2734/43–44.

28. The International People's College, "IPC—The General Picture," http://www.ipc .dk/en/ipcingeneral.asp; CD, 13 October 1934; AN, 11 October 1933; PC, 31 March 1934.

29. Louise Thompson Patterson to Mama Thompson [Louise Toles], letter, 4 July 1933, LTP Papers, box 2, folder 9; Matusevich, "Journeys of Hope," 61.

30. Quoted in L. Patterson, "Chapter on Trip to Russia—1932," draft in unpublished memoir, 10–12; Rampersad, *The Life of Langston Hughes*, 1: 242–45.

31. *AN*, 23 November 1932.

32. *CD*, 16 June 1934. Chatwood Hall was the pseudonym of Homer Smith.

33. Carew, *Blacks, Reds, and Russians*, 125.

34. The script of *Black and White* traced the black freedom struggle from the Middle Passage to the contemporary Jim Crow South. In the film's climactic scene, the Red Army, which had been contacted by radio by local black workers in Birmingham, Alabama, arrived there and fought side by side with black and white workers in defeating white bosses. After reading the script, a befuddled Hughes concluded that it was "the kind of fantasy that any European *merely* reading cursorily about the race problem in America, but knowing nothing of it at firsthand, might easily conjure up." Quoted in Hughes, *I Wonder as I Wander*, 77.

35. Carew, *Blacks, Reds, and Russians*, 125.

36. The film's cancellation made international headlines, deeply dividing the cast into two hostile factions. Ibid., 115–39.

37. Louise Thompson Patterson, interview by Ruth Prago, tape 3.

38. *CD*, 16 June 1934.

39. *AN*, 23 November 1932.

40. Ibid.; K. Baldwin, *Beyond the Color Line and the Iron Curtain*, 86–148.

41. Thyra Edwards to Etha Bell; Brown and Faue, "Revolutionary Desire," 273.

42. Elliot, *Women and Smoking Since 1890*; Mitchell, "The 'New Woman' as Prometheus."

43. Hine, "Rape and the Inner Lives of Black Women in the Middle West."

44. Brown and Faue, "Revolutionary Desire," 273.

45. Aptheker, *Intimate Politics*, 103.

46. Hughes's sexuality remains shrouded in mystery and controversy. For recent scholarly discussions of Hughes's transgressive sexuality and controversies surrounding it, see S. Vogel, "Closing Time"; Ponce, "Langston Hughes's Queer Blues"; Marshall, *Triangular Road*, 24–27.

47. Rampersad, *The Life of Langston Hughes*, 1: 196.

48. Springer, *Living for the Revolution*, 130–38.

49. W. Goldman, *Terror and Democracy in the Age of Stalin*, 20–25; W. Goldman, *Women at the Gates*, 33–42; D'Emilio, *Sexual Politics, Sexual Communities*, 56.

50. *AN*, 23 November 1932.

51. Dennis, *The Autobiography of an American Communist*, 117–18.

52. Klehr, Haynes, and Firsov, *The Secret World of American Communism*.

53. Solomon, *The Cry Was Unity*, 81–91, 103–4.

54. *CD*, 16 June 1934.

55. Louise Thompson Patterson to Mama Thompson, letter, 24 August 1932, LTP Papers, box 2, folder 9; Hughes, *I Wonder as I Wander*, 169–74.

56. Mullen, *Afro-Orientalism*, 3.

57. "To the Workers and Peasants of Uzbekistan Socialist Soviet Republic," 5 October 1932, LTP Papers, box 2, folder 14; Hughes, *I Wonder as I Wander*, 101–89.

58. Kelley, *Hammer and Hoe*, 100; Kelley, *Race Rebels*, 123–58.

59. Northrop, *Veiled Empire*, 14–24, 285.

60. "'Western' feminist discourses," Mohanty writes, have tended to construct non-"Western" women as an undifferentiated mass of oppressed, backward, timeless women and "Western women as secular, liberated, and having control over their own lives." Mohanty et al., *Third World Women and the Politics of Feminism*, 74; Said, *Orientalism*. For additional discussions of the multiple meanings of veiling and its complex relation to decolonization and modernity, see El Saadawi, *The Hidden Face of Eve*; Frantz Fanon's classic but controversial chapter "Algeria Unveiled" in his *A Dying Colonialism*, 35–68; Moallem, *Between Warrior Brother and Veiled Sister*, 20–29, 40–49.

61. Louise Thompson Patterson, unpublished memoirs, "Chapter on Trip to Russia—1932," 52–53.

62. Edgar, "Bolshevism, Patriarchy, and the Nation," 252.

63. Ibid., 257; Northrop, *Veiled Empire*, 9, 33–68, 183–85, 320; Kamp, *The New Woman in Uzbekistan*.

64. Northrop, *Veiled Empire*, 13.

65. Ibid., 69–101; Edgar, "Bolshevism, Patriarchy, and the Nation," 261–66.

66. Edwards, "The Uses of Diaspora," 66.

67. Grewal and Kaplan, *Scattered Hegemonies*, 1–33; Mohanty et al., *Third World Women and the Politics of Feminism*, 51–80; K. Baldwin, *Beyond the Color Line and the Iron Curtain*, 106–8.

68. Louise Thompson Patterson, interview, 14 May 1987, LTP Papers, box 27, folder 20, 22.

69. CD, 8 August 1936, 3 October 1936.

70. Louise Thompson Patterson, interview, 31 August 1989, LTP Papers, box 32, folder 12, 1, 31. Denning, *The Cultural Front*, 13.

71. The idea for the demonstration did not originate with the Party. Instead, William H. Davis, the editor of the *Amsterdam News*, issued the call for a massive march on Washington immediately following news that local Alabama courts in early April 1933 had reconvicted the Scottsboro defendants and resentenced them to death. For African Americans and the Communist Party, the verdict was especially shocking given how Ruby Bates, one of the two white women allegedly raped by the defendants, recanted her accusations from the bench. Davis's call received spontaneous support from the Harlem community. Thompson, however, soon wrestled control of the protest from Davis on behalf of the CPUSA. As a result, Davis and other more politically moderate black leaders publicly withdrew their support for the action. Naison, *Communists in Harlem during the Depression*, 80–82.

72. Louise Thompson Patterson, interview, 14 May 1987, 28; AN, 19 April 1933; "On to Washington!" flyer, n.d., Clarina Michelson Papers, box 3, folder 5; "Instructions for Marchers to Washington," Clarina Michelson Papers, box 3, folder 5; Naison, *Communists in Harlem during the Depression*, 70–73, 76–78, 85.

73. Thompson, "And So We Marched"; *Washington Times*, 9 May 1933, in LTP Papers, box 12, folder 11; Louise Thompson Patterson, interview, 31 August 1989, 7; AA, 6 May 1933; NYT, 7 May 1933; NYA, 20 May 1933; AN, 17 May 1933; Solomon, *The Cry Was Unity*, 187–88, 240.

74. Harris, "Running with the Reds."

75. Quoted in Miller, Pennybacker, and Rosenhaft, "Mother Ada Wright and the International Campaign to Free the Scottsboro Boys, 1931–1934," 413.

76. Louise Thompson Patterson, interview, 6 August 1989, 11.

77. Louise Thompson Patterson, interview, 18 March 1990, LTP Papers, box 28, folder 28, 17; T. Walker, *Pluralistic Fraternity*, 1–35.

78. Louise Patterson, interview by Ruth Prago, tape 4; Louise Thompson Patterson, interview, 14 May 1987, LTP Papers, box 27, folder 20, 27; Singh, *Black Is a Country*, 69.

79. Thompson, "My Southern Terror," 327–28.

80. *The Complete Report of Mayor LaGuardia's Commission on the Harlem Riot of March 19, 1935*, 7–18; Louise Patterson, interview by Ruth Prago, tape 4; Naison, *Communists in Harlem during the Depression*, 140–41.

81. *The Complete Report of Mayor LaGuardia's Commission on the Harlem Riot of March 19, 1935*, 24; Naison, *Communists in Harlem during the Depression*, 144–45.

82. Naison, *Communists in Harlem during the Depression*, 145.

83. Ibid., 119, 136.

84. Audley Queen Mother Moore, interview by Ruth Prago, 23 December 1981, 4.

85. Ruth Hill, *The Black Women Oral History Project*, 117–18, 120–22, 132; Audley Queen Mother Moore, interview by Ruth Prago, 2–3.

86. Harold, *The Rise and Fall of the Garvey Movement in the Urban South, 1918–1942*, 29–60.

87. Ruth Hill, *The Black Women Oral History Project*, 123.

88. Rolinson, *Grassroots Garveyism*, 131–38.

89. Martin, *Race First*, 151–73; Thomas Warner, interview by author, January 18, 2002; Ruth Hill, *The Black Women Oral History Project*, 126. Queen Mother Moore claimed that she became acquainted with Garvey and frequently attended Black Star Line meetings as his guest of honor. Archival evidence, however, has yet to confirm her claims. Ahmad, *We Will Return in the Whirlwind*, 7.

90. Ruth Hill, *The Black Women Oral History Project*, 126–27; Audley "Queen Mother" Moore, interview by Mark Naison, 3 May 1974, 7; Coble, *Cleaning Up*, 51–76.

91. Quoted in Ruth Hill, *The Black Women Oral History Project*, 132–33; Audley "Queen Mother" Moore, interview by Mark Naison, 7.

92. Thomas Warner, interview by author.

93. *HL*, 14 October 1933.

94. White, *Too Heavy a Load*, 69–169; Stein, *The World of Marcus Garvey*, 248–56; Watts, *God, Harlem U.S.A.*, 113–16.

95. Solomon, *The Cry Was Unity*, 258.

96. Audley "Queen Mother" Moore, interview by Mark Naison, 3; Naison, *Communists in Harlem during the Depression*, 136.

97. U. Taylor, "Street Strollers."

98. Audley "Queen Mother" Moore, interview by Mark Naison, 12.

99. Ruth Hill, *The Black Women Oral History Project*, 135; Audley Queen Mother Moore, interview by Ruth Prago, 9.

100. RA 515/1/3196/31–37; RA 515/1/3817/84–93.

101. "Audley Moore," FBI, New York Bureau File 100-13205, 15 May 1943, 1–3; Harlem Division of the Communist Party, *A Political Manual for Harlem*, 16.

102. Ruth Hill, *The Black Women's Oral History Project*, 132; Audley Queen Mother Moore, interview by Ruth Prago, 7–8; Harlem Division of the Communist Party, "A Political Manual for Harlem," 15.

103. Audley Queen Mother Moore, interview by Ruth Prago, 8, 9.

104. RA 515/1/3817/38–48; Kelley, *Freedom Dreams*, 77; Solomon, *The Cry Was Unity*, 164–84.

105. Solomon, *The Cry Was Unity*, 190–91.

106. *HL*, 3 July 1934; Solomon, "Rediscovering a Lost Legacy," 9.

107. *AN*, 28 July 1934, 30 May 1936.

108. *DW*, 1 May 1934.

109. "Williana Burroughs" file, J. Edgar Hoover to Special Agent in Charge, New York, New York, 15 August 1940, FBI, Bureau file 100-390-1 and 100-390-5, 23 May 1941; *PV*, 5 January 1946, in the FBI files, "Burroughs" file number illegible.

110. Theodore Bassett, interview by Mark Naison, 15 December 1973, in Mark Naison Personal Collection, transcript in author's possession.

111. RA 515/1/3811/103.

112. Consumer movements led by the CPUSA in Harlem were part of a nationwide effort by the CPUSA's New York–based United Council of Working Class Women to galvanize economically distressed communities into action around the high cost of living. Orleck, *Common Sense and a Little Fire*, 215–40; RA 515/1/3976/31–33; RA 515/1/3988/18–19; *AN*, May 3, 1947, 7 June 1947.

113. William Fellowes Morgan Jr. to A. L. King, 10 November 1938; "Can You Afford to Be Shortweighted," flyer, n.d., both in UNIA, Central Division Records, 1919–1959, reel 4, box 11, folder e42; Ransby, *Ella Baker and the Black Freedom Movement*, 82–91.

114. *DW*, 4 June 1935; Naison, *Communists in Harlem during the Depression*, 149–50; Orleck, *Common Sense and a Little Fire*, 215–40.

115. *AN*, 28 May 1938; Horne, *Cold War in a Hot Zone*, 29–40.

116. *AN*, 30 April 1938; "Audley Moore," FBI, New York Bureau, File 100-13205, 15 May

1943, 1; Harlem Division of the Communist Party, USA, *A Political Manual for Harlem*, 16; Naison, *Communists in Harlem during the Depression*, 263–68.

117. "Audley Moore," FBI, New York Bureau File 100-13205, 9 December 1941, 1; Harlem Division of the Communist Party, USA, *A Political Manual for Harlem*, 15–16.

118. Orleck, *Common Sense and a Little Fire*, 218.

119. Ibid., 215–22, 236–40; R. Y. Williams, *Politics of Public Housing*, 54–56; Nadasen, *Welfare Warriors*; Boris, *Home to Work*.

120. DW, 3 September 1937.

121. Charney, *A Long Journey*, 102; DW, 3 September 1937; AN, 24 July 1937, 16 October 1937; Naison, *Communists in Harlem during the Depression*, 215–19, 259–60, 264–65; Audley Moore, Rose Gaulden, Bonita Williams, and Helen Samuels to Earl Browder, Earl Browder Papers, reel 5, series 2, item 118, Negroes, 1929–1945.

122. It should be noted that high membership turnover rates were common in the Party as a whole. Ottanelli, *The Communist Party of the United States*, 42; Naison, *Communists in Harlem during the Depression*, 68.

123. Solomon, *The Cry Was Unity*, 264; Charney, *A Long Journey*, 7–10, 83–121.

3. Toward a Brighter Dawn

1. Quoted in Penny Von Eschen, *Race against Empire*, 19; Singh, *Black Is a Country*, 109–28.

2. Dubois, "Eleanor Flexner and the History of American Radicalism"; Horowitz, *Betty Friedan and the Making of the Feminine Mystique*; Storrs, "Red Scare Politics and the Suppression of Popular Front Feminism."

3. Here I am borrowing the term "cultural front" from Michael Denning. He understands the cultural front as a counter-hegemonic, social democratic culture forged by artists, intellectuals, and writers inspired by the insurgent Popular Front of the 1930s and 1940s. At the heart of the cultural front, Denning argues, was the concept of the "laboring of American culture." The term refers "to the pervasive use of labor and its synonyms in the rhetoric of the period," the "proletarianization," of American popular culture, the "new visibility" of cultural industries during these years, and a social democratic ethos promoting anti-Fascism, international solidarity, civil rights, women's rights, and the CIO's industrial unionism. Although he focuses close attention on the contributions of black radicals such as Langston Hughes, C. L. R. James, and Richard Wright to the cultural front, black women radicals are conspicuously absent from Denning's discussion. Denning, *The Cultural Front*, xvi, xvii, 46–47, 310–12, 452–54, 460–62.

4. Ibid., 3–50.

5. In all, 817 delegates from 585 organizations representing three million members of trade unions, women's clubs, church groups, and fraternal organizations gathered at the National Negro Congress's opening convention in Chicago on

14–16 February 1936. Gellum, "'Death Blow to Jim Crow,'" 26–85; Mullen, *Popular Fronts*; Solomon, *The Cry Was Unity*, 231–310.

6. White, *Too Heavy a Load*, 110–41.

7. Boris, *Home to Work*, 209; Foley, *Radical Representations*, 213–46; Weigand, *Red Feminism*, 24; Gosse, "'To Organize in Every Neighborhood, in Every Home,'" 132–34; Brown and Faue, "Revolutionary Desire," 273–302.

8. L. Cohen, *Making a New Deal*, 283–89; Zieger, *The CIO*, 42–65.

9. W. Scott, *Sons of Sheba's Race*, 3–37, 106–20; Naison, *Communists in Harlem during the Depression*, 138–40, 195–96.

10. Thomas, *The Spanish Civil War*, 13–464.

11. Brandt, *Black Americans in the Spanish People's War against Fascism, 1936–1939*, 4–5; Kelley, *Race Rebels*, 136–37.

12. *DW*, 30 March 1937; Brandt, *Black Americans in the Spanish People's War against Fascism, 1936–1939*, 8–12; Naison, *Communists in Harlem during the Depression*, 193–97.

13. Claudia Jones to William Z. Foster, 6 December 1955, in Howard "Stretch" Johnson Papers; Barrett, "*Was* the Personal Political? Reading the Autobiography of American Communism," 404.

14. Jones to Foster, 1.

15. Ibid., 1, 2; Boyce Davies, *Left of Karl Marx*, xiii, 69. Despite Jones's claims that her father edited the *West-Indian-American*, no archival record has been found to verify this claim.

16. Jones to Foster, 1.

17. Ibid., 3; Naison, *Communists in Harlem during the Depression*, 138–40, 195–96.

18. Naison, *Communists in Harlem during the Depression*, 134–35.

19. Jones to Foster, 3.

20. Ibid.; Dorothy Burnham, interview by author, 11 June 1998.

21. Dorothy Burnham, interview by author, 10 April 1999.

22. Ginger Pinkard, telephone interview by author, 15 September 2002.

23. Dorothy Burnham, email to author, 26 May 2006.

24. C. May, "Nuances of Un-American Literature(s)," 17.

25. For an insightful discussion of the meaning of black people changing their names, see Hartman, *Lose Your Mother*, 8–9; Shakur, *Assata*, 185–86; Painter, "Representing Truth"; Malcolm X, *The Autobiography of Malcolm X*, 199.

26. Isserman, *Which Side Were You On?*, 11.

27. "Claudia Jones," FBI, Washington Bureau 100-72390-33, 16 July 1947.

28. B. Johnson, "*I Think of My Mother*," 79–87.

29. Quoted in Esther Cooper Jackson and James Jackson, interview by author, 13 August 1998. *Northern Virginia Sun*, 10 February 1970, Esther I. Cooper Papers, box 4, Death of Esther Cooper folder.

30. D. Scott, "An Interview with Esther Jackson," 2–3; Esther Cooper Jackson and James Jackson, interview by author, 2 April 1998 (hereafter Jacksons, interview, 2 April 1998).

31. Jacksons, interview, 2 April 1998; R. Cohen, *When the Old Left Was Young*, 134–87.

32. Esther Cooper Jackson, telephone interview by author, 17 November 2002.

33. James Jackson and Esther Cooper Jackson, interview by Louis Massiah, 2 June 1992; Kelley, *Hammer and Hoe*, 202.

34. D. Scott, "An Interview with Esther Jackson," 4; Kelley, *Hammer and Hoe*, 205.

35. Esther Cooper Jackson, telephone interview by author, 17 November 2002.

36. E. Jackson, *This Is My Husband*, 5–20; Jacksons, interview, 2 April 1998; J. Richards, "The Southern Negro Youth Congress," 27–48.

37. Horowitz, *Betty Friedan and the Making of the Feminine Mystique*, 49.

38. Ibid., 102–52.

39. Quoted in Esther Cooper Jackson and James Jackson, interview by author, 13 August 1998, 6; Kelley, *Hammer and Hoe*, 204.

40. Brandt, *Black Americans in the Spanish People's War against Fascism, 1936–1939*, 18; Negro Committee to Aid Spain, *A Negro Nurse in Republican Spain* (New York: Negro Committee to Aid Spain, 1938), Thyra Edwards Papers, box 2, folder 2; Patai, "Heroines of the Good Fight," 80, 87–88.

41. *DW*, 29 September 1937.

42. Brandt, *Black Americans in the Spanish People's War against Fascism, 1936–1939*, 18, 33–37.

43. Quoted in August, "Salaria Kea [*sic*] and John O'Reilly"; Salaria Kea [*sic*] O'Reilly, interview by John Gerassi, 7 June 1980.

44. Quoted in August, "Salaria Kea [*sic*] and John O'Reilly"; The Negro Committee to Aid Spain, *A Negro Nurse in Republican Spain*, 3–7; Salaria Kea [*sic*] O'Reilly, interview by John Gerassi, 7 June 1980, 1–6.

45. RA 515/1/3810/204; RA 515/1/4050/17–18; *NO* (May–June 1938): 19–20, (March 1936): 11, (April 1938): 13; Keeran, "National Groups and the Popular Front," 23; *AN*, 15 February 1936.

46. *AN*, 13 November 1937.

47. The Negro Committee to Aid Spain, *A Negro Nurse in Republican Spain*, 7.

48. Quoted in Louise Thompson Patterson's unpublished memoirs, draft of chapter 7, LTP Papers 2002, box 20, folder 6, 2.

49. Ibid. 2, 3.

50. *CD*, 18 December 1937, 25 December 1937, 1 January 1938; *AA*, 11 December 1937.

51. Quoted in August, "Salaria Kea [*sic*] and John O'Reilly"; The Negro Committee to Aid Spain, *A Negro Nurse in Republican Spain*, 7–10, 13–14.

52. Hughes, *I Wonder as I Wander*, 327–393.

53. Ibid., 319, 332–65; *NO* (November 1937): 19; Louise Thompson Patterson, unpublished memoirs, draft of chapter 7, 2–3.

54. Louise Thompson, "Black Warriors," LTP Papers, box 13, folder 11; *ADW*, 11 October 1937; Negro Committee to Aid Spanish Democracy, *A Negro Nurse in Republican Spain*, 9–11.

55. Commission de Verification des Mandats; "Manifesto of Second World Congress against Racism and Anti-Semitism," both in LTP Papers, box 13, folder 12; Louise

Thompson Patterson, unpublished memoirs, draft of chapter 7, 2–3; AN, 17 September 1937.

56. American League against War and Fascism, press release, 20 February 1937, 1, box 1, AWALF, 1937 folder, American League for Peace and Democracy Collected Records, Swarthmore College Peace Collection, Swarthmore, Penn.

57. Louise Thompson Patterson, unpublished memoirs, draft of chapter 7, 2–3.

58. CD, 1 January 1938.

59. Salaria Kea [sic] O'Reilly, interview by John Gerassi, 7 June 1980, 9–12.

60. Salaria Kee O'Reilly, "Passing Through" (n.b.), International Brigades Association archives, Marx Memorial Library, London, box D-2: D/1 http://irelandscw.com/misc-KeeMemoir.htm; AN, 13 November 1937; CD, 18 December 1937, 12 February 1938; NO (April 1938): 13, (May-June 1938): 26.

61. NO (November 1937): 19; "Talk of Louise Thompson for the Reception Dinner at the Hotel Commodore," Oct. 6 [1937], LTP Papers, box 20, folder 17.

62. "The Negro Ambulance Fund for Republican Spain," flyer, Thyra Edwards Papers, scrapbook, folder 2.

63. Ibid.; NO (November 1937): 19; CD, 18 December 1937; AN, 28 May 1938; Naison, Communists in Harlem during the Depression, 197.

64. Salaria Kea [sic] O'Reilly, interview by John Gerassi, 7 June 1980, 38–70; Brandt, Black Americans in the Spanish People's War against Fascism, 1936–1939, 18, 33–37.

65. Negro Committee to Aid Spanish Democracy List of Sponsors, Thyra Edwards Papers, scrapbook, folder 2; AN, 21 May 1938, 28 May 1938; CD, 18 June 1938; DW, 18 May 1938, 16 August 1938.

66. NO (October 1937): 6; CD, 6 November 1937.

67. AN, 13 November 1937; CD, 18 December 1937, 12 February 1938; NO (April 1938): 13, (May-June 1938), 26; DW, 20 November 1939.

68. Louise Thompson Patterson, unpublished memoir, chapter 8, 8, in LTP Papers 2002, box 20, folder 7; Naison, Communists in Harlem during the Depression, 203–10.

69. AN, 30 April 1938; RA 515/1/4078/75–77; Naison, Communists in Harlem during the Depression, 209–10.

70. Grace Hutchins, Women Who Work (New York: International Publishers, 1934), in Earl Browder Papers, reel 15, series 6, 287.

71. Cowl, Women and Equality, 3.

72. Inman, In Woman's Defense; Weigand, Red Feminism, 28–45.

73. Gordon and Briggs, The Position of Negro Women, 2, 10, 14, 15.

74. Baker and Cooke, "The Bronx Slave Market," 330–31, 340; Marvel Cooke, interview by author, 1 April 1998; Ransby, Ella Baker and the Black Freedom Movement, 76–78, 79.

75. Quoted in L. Thompson, "Toward a Brighter Dawn," 14; Coble, Cleaning Up, 51–75.

76. Boyce Davies, Left of Karl Marx, 29–68.

77. Denning, *The Cultural Front*, 138, 139.

78. Weigand, *Red Feminism*, 28–45, 81; V. May, "Working in Public and in Private," 194–243.

79. Cooke, interview by author, 1 April 1998.

80. L. Thompson, "Toward a Brighter Dawn," 14, 30; Boyce Davies, *Left of Karl Marx*, 29–59.

81. L. Thompson, "Toward a Brighter Dawn," 14, 30.

82. "Call for National Negro Congress," flyer, National Negro Congress Vertical Files; National Negro Congress and Randolph, *Resolutions of the National Negro Congress*, 15–16; Terrell, *A Colored Woman in a White World*, 181; AN, 22 February 1936.

83. Shapiro, "Red Feminism," n. 25, 48.

84. Quoted in National Negro Congress and Randolph, *Resolutions of the National Negro Congress*, 15; J. Davis, *Let Us Build a National Negro Congress*, 19.

85. AN, 22 February 1936.

86. E. Cooper, "The Negro Woman Domestic Worker in Relation to Trade Unionism"; McDuffie, "Long Journeys," 295–96.

87. E. Cooper, "The Negro Woman Domestic Worker in Relation to Trade Unionism," 27, 29–30.

88. Ibid., 98.

89. Ibid., 43–60; Coble, *Cleaning Up*, 62–64, 68; V. May, "Working in Public and in Private," 214–29.

90. E. Cooper, "The Negro Woman Domestic Worker in Relation to Trade Unionism," 98–105.

91. Esther Cooper Jackson, telephone interview by author, 17 November 2002.

92. RA 515/1/4070/1–3.

93. Higginbotham, *Righteous Discontent*, 185–229; Hine, "Rape and the Inner Lives of Black Women in the Middle West."

94. RA 515/1/4078/88–97; Aptheker, *Intimate Politics*, 103–4; Brown and Faue, "Revolutionary Desire," 273.

95. Shapiro, "Red Feminism," 182–89.

96. Landy, *Marxism and the Woman Question*; Weigand, *Red Feminism*, 28–45.

97. Maxwell, *New Negro and Old Left*, 126.

98. Ibid., 126.

99. RA 515/1/3506/27–28; RA 515/1/4165/11–12; Naison, *Communists in Harlem during the Depression*, 280–81.

100. Thompson, "Negro Women in Our Party," 26, 27.

101. Ibid.

102. Solomon, *The Cry Was Unity*, 283.

103. Naison, *Communists in Harlem during the Depression*, 280–81, 282 n. 5; Maxwell, *New Negro and Old Left*, 126–27.

104. Naison, *Communists in Harlem during the Depression*, 137.

105. Ruth Hill, *The Black Women Oral History Project*, 186.

106. Charney, *A Long Journey*, 7–24, 83–121.

107. Evans, *Personal Politics*, 79.

108. Abner Berry, interview by Mark Naison, 20 November 1973.

109. Abner Berry, interview by Naison, 29 July 1974; RA 515/1/3811/153; RA 515/1/3817/
39–48; Naison, *Communists in Harlem during the Depression*, 173–74.

110. Rolinson, *Grassroots Garveyism*, 137.

111. Wolcott, *Remaking Respectability*, 208.

112. Esther Cooper Jackson and James Jackson, interview by author, 13 August 1998.

113. Naison, *Communists in Harlem during the Depression*, 135–36.

114. Quoted in Esther Cooper Jackson, telephone interview by author, 17 November
2002; Ed Strong married Augusta Jackson, an African American native of Brook-
lyn who became a leader in the Southern Negro Youth Congress. Kelley, *Hammer
and Hoe*, 204.

115. Dorothy Burnham, email to author, 10 September 2002.

116. Esther Cooper Jackson and James Jackson, interview by author, April 10, 1999;
Kelley, *Hammer and Hoe*, 204.

117. Kelley, *Hammer and Hoe*, 17; DW, 29 September 1940.

118. "Claudia Jones," FBI, New York Bureau File 100-18676, 23 August 1951, 6; Jones
to Foster, 5; Shapiro, "Red Feminism," 268; Ginger Pinkard, telephone interview
by author, 15 September 2002; Dorothy Burnham, interview by author, 11 April
1998; Martin and Martin, "Thyra Edwards," 173; Esther Cooper Jackson, tele-
phone interview by author, 17 November 2002.

119. Pinkard, telephone interview by author; Fred Pinkard, memorial program circa
August 2004, in author's possession.

120. Ernest Kaiser, interview by author, 26 September 2001.

4. Jim Crow, Fascism, and Colonialism

1. Esther V. Cooper, "Negro Youth Organizing for Victory," 18 April 1942; "Negro
Youth Fighting for America," program, Fifth All-Southern Negro Youth Confer-
ence," 17–19 April 1942, both in Edward E. Strong Papers, box 3, folder 3; McDuf-
fie, "Long Journeys," 371–75.

2. Cooper, "Negro Youth Organizing for Victory."

3. Garfinkel, *When Negroes March*, 77.

4. Horne, *Race War*; Singh, *Black Is a Country*, 101–73.

5. Singh, *Black Is a Country*, 99–109; Marable, *Race, Reform, and Rebellion*, 13–27;
White, *Too Heavy a Load*, 142–75.

6. Von Eschen, *Race against Empire*, 7.

7. Ibid, 69–95; Horne, *The End of Empires*, 144–59; Singh, *Black Is a Country*, 101–33;
Plummer, *Rising Wind*, 125–66; U. Taylor, *The Veiled Garvey*, 143–81.

8. Marable, *Race, Reform, and Rebellion*, 10; Korstad, *Civil Rights Unionism*, 276.

9. Giddings, *When and Where I Enter*, 238; White, *Too Heavy a Load*, 160.

10. Browder, *Teheran*; Isserman, *Which Side Were You On?*, 33–102, 145–48, 184–86.

11. Naison, *Communists in Harlem during the Depression*, 312.

12. Isserman, *Which Side Were You On?* 141–43, 166–69; Shapiro, "Red Feminism," 62.

13. Elizabeth Gurley Flynn, *Women Have a Date with Destiny* (New York: Workers Library Publishers, 1944) in Communism Collection, series I, biography, box 1, folder 3.

14. Rebecca Hill, "Fosterites and Feminists," 76; Weigand, *Red Feminism*, 46–47.

15. Hawes, *Why Women Cry*.

16. Ibid., xiv–xv, 94–104, 139–45.

17. Horowitz, *Betty Friedan and the Making of the Feminist Mystique*, 107–9.

18. AN, 6 December 1941, 2 June 1945; Wald, *Trinity of Passion*, 112–16.

19. Wald, *Trinity of Passion*, 124; Petry, *The Street*. *The Street* tells a gripping story about Lutie Johnson, a single, poor black mother, and her daily struggles to raise her son amid racial discrimination, poverty, and despair in war-time Harlem.

20. Ruth Hill, *The Black Women Oral History Project*, 145; Queen Mother Moore, interview by Ruth Prago, 14, 22–23.

21. Ruth Hill, *The Black Women Oral History Project*, 145.

22. Audley Moore, "Conference Impressions," *Aframerican Woman's Journal* (Summer and Fall 1941): 16, NCNW Records, series 13, box 1, folder 8, National Archive of Black Women's History; NCNW, Second Annual Workshop Registration (n.d.), NCNW Records, series 2, box 1, folder 16; Ruth Hill, *The Black Women Oral History Project*, 139; DW, 20 July 1943.

23. Sue Bailey Thurman, "Behind the Scenes at San Francisco," *Aframerican Woman's Journal* (June 1945): 2; NCNW Records, series 13, box 17; Horne, *The End of Empires*, 194–97; White, *Too Heavy a Load*, 142–75.

24. Ruth Hill, *The Black Women Oral History Project*, 135–36; DW, 20 November 1943; Horne, *Black Liberation/Red Scare*, 97–118.

25. Naison, *Communists in Harlem during the Depression*, 312–13.

26. Horne, *Black Liberation/Red Scare*, 93, 96.

27. Capeci, *The Harlem Riot of 1943*, 100–108.

28. Isserman, *Which Side Were You On*, 127–86.

29. Ruth Hill, *The Black Women Oral History Project*, 135–36; DW, 12 November 1943, 20 November 1943; AN, 6 November 1943, 20 November 1943; FO (January 1944): 15; PV, 19 May 1945; Horne, *Black Liberation/Red Scare*, 97–136.

30. Keeran, *The Communist Party and the Autoworkers' Union*, 205–49.

31. Ruth Hill, *The Black Women Oral History Project*, 135, 138; "Audley Moore," FBI, Detroit Bureau File 100-12344, 14 April 1945, 1–4.

32. AN, 17 June 1944, 17 March 1945, 16 April 1945, 25 January 1947, June 1947; DW, 23 May 1944.

33. Audley "Queen Mother" Moore, interview by Mark Naison, 1972; Audley Moore, Rose Gaulden, Bonita Williams, and Helen Samuels to Earl Browder, Earl Browder Papers, reel 5, series 2, item 118, Negroes, 1929–45.

34. Ruth Hill, *The Black Women Oral History Project*, 135; Issa, "Her Own Book," 144–89; Ahmad, *We Will Return in the Whirlwind*, 10.

35. Audley "Queen Mother" Moore, interview by Mark Naison, 1972.

36. Issa, "Her Own Book," 144.

37. Ruth Hill, *The Black Women Oral History Project*, 135, 138.

38. Singh, *Black Is a Country*, 111.

39. Ruth Hill, *The Black Women Oral History Project*, 135.

40. Ibid.

41. Queen Mother Moore, interview by Ruth Prago, 23 December 1981, 14.

42. Audley "Queen Mother" Moore, interview by Mark Naison, 3 May 1972, 14.

43. Ralph Ellison to Richard Wright, letter, 20 June 1940, Richard Wright Papers, series II, box 97, folder 1314.

44. Moore, Gaulden, Williams, and Samuels to Browder, Earl Browder Papers, reel 5, series 2, item 118, Negroes, 1929–45.

45. Boyce Davies, *Left of Karl Marx*, xxiv.

46. Esther Cooper Jackson and James Jackson, interview by author, 13 August 1998; Claudia Jones to William Z. Foster, 6 December 1955, Howard "Stretch" Johnson Papers.

47. Louise Thompson Patterson, interview, 20 April 1989, 22–25; Margaret Taylor Goss Burroughs, interview by author, 26 February 2003.

48. Ishmael Flory and Cathern Davis, interview by author, 17 September 2003, Chicago; Margaret Taylor Goss Burroughs, interview by author, 26 February 2003, New York; Mullen, *Popular Fronts*, 6–9, 85–87; Haywood, *Black Bolshevik*, 81–280; Drake and Cayton, *Black Metropolis*, 8.

49. Louise Thompson Patterson, interview, 20 April 1989, 22–25, LTP Papers, box 26, folder 2; FO (August-September 1944): 7, 8; CD, 7 October 1944, 3 March 1945, 30 September 1945; correspondences between Louise Thompson Patterson and national IWO officials can be found in the International Workers Order Records, 1927–56, box 6, folders 5–13; Louise Thompson Patterson to Mary McLeod Bethune, 7 December 1944, and Mary McLeod Bethune to Louise Thompson Patterson, 12 December 1944, Mary McLeod Bethune Papers (microfilm), part 2, reel 11: 0398–0399, 0400; Drake and Cayton, *Black Metropolis*.

50. Louise Thompson Patterson, untitled testimony on behalf of the International Workers Order ca. 1950–1951, LTP Papers, box 8, folder 10, 40–43; CD, 7 October 1944, 22 December 1944; FO (August-September 1944): 28, (December 1943): 16–17, 28, (August 1947): 6. Margaret Burroughs married Williana Burroughs's son, Charles, after he returned from the Soviet Union. In 1961, they co-founded what later became known as the DuSable Museum of African American History, the first institution of its kind in the world. Burroughs, interview by author, 26 February 2003.

51. CD, 7 October 1944; Louise Thompson Patterson to Sam Milgram, letter, 23 May 1945, IWO Papers, box 6, folder 8; T. Walker, *Pluralistic Fraternity*, 15.

52. Charlene Mitchell, interview by author, 10 April 1999.

53. Ibid.; Turner, *Caribbean Crusaders and the Harlem Renaissance,* 228.

54. Charlene Mitchell, interview by author, 10 April 1999.

55. The SNYC was one of several Popular Front organizations, including the Southern Conference for Human Welfare, the Southern Tenant Farmers' Union, and the Congress of Industrial Organizations, committed to bringing democracy to the South. J. Richards, "The Southern Negro Youth Congress," 1–4; Lau, *Democracy Rising,* 145–86; Kelley, *Hammer and Hoe,* 195–219.

56. Kelley, *Hammer and Hoe,* 200.

57. Wilson, *America's Johannesburg,* 40, 153–221; Kelley, *Hammer and Hoe,* 19–30.

58. Kelley, *Hammer and Hoe,* 34–56.

59. McDuffie, "Long Journeys," 368–69; Kelley, *Hammer and Hoe,* 202, 205.

60. "Negro Youth Fighting for America," program of the Fifth All-Southern Negro Youth Conference, ca. early 1942, Edward E. Strong Papers, box 3, folder 3.

61. Arnesen, "No 'Graver Danger,'" 19.

62. Kelley, *Hammer and Hoe,* 119–92, 212–13.

63. McWhorter, *Carry Me Home, Birmingham, Alabama,* 23–24, 519–43.

64. Esther Cooper to Mary McLeod Bethune, 7 September 1944; Mary McLeod Bethune to Esther Cooper, 18 September 1944, both in NCNW Records, series 5, box 6, folder 11; Esther Cooper to Charlotte Hawkins Brown, 25 April 1946, box 2, Third Leadership Training School folder, SNYC Papers; Modjeska Simkins to Louis E. Burnham, 17 March 1946, SNYC Papers, box 2, Jackson's Lecture Tour folder; "Souvenir Bulletin, Sixth All-Southern Youth Conference," 30 November–3 December 1944, Atlanta, in "Attend Tuskegee" (n.b.), James E. Jackson and Esther Cooper Jackson Papers, SNYC box, documents, publications folder. (Note that I first accessed the Jackson Papers at New York University before they were reorganized in 2007. All materials Jackson personal papers accessed after this date will be referenced as Jackson Papers 2007.)

65. Dorothy Burnham, interview by author, 10 April 1999; "Mildred McAdory Edelman," memorial service program, Dorothy Burnham personal papers, in author's possession; McWhorter, *Carry Me Home,* 90–91.

66. E. D. Nixon to Esther Cooper, 8 September 1944, Jackson personal papers; McWhorter, *Carry Me Home,* 90–91.

67. Dorothy Burnham, interview by author, 10 April 1999; "Mildred McAdory Edelman," memorial service program; Kelley, *Hammer and Hoe,* 203–4; Angela Y. Davis remarks, "Angela Y. Davis: Legacies in the Making" conference, 1 November 2009, University of California, Santa Cruz.

68. U.S. War Department, "Personnel Placement Questionnaire," 11 January 1944, Jackson Papers 2007, box 1, folder 3.

69. *Congress View* 3, 9 (December 1945), Edward E. Strong Papers, box 6, folder 24; "Souvenir Journal," Southern Youth Legislature, 18–20 October 1946, Edward E. Strong Papers, box 29, folder 5; Baxter, "National Negro Congress, 1936–1947," 308, 309.

70. Dorothy Burnham, interview by author, 10 April 1999.

71. Esther Cooper Jackson and James Jackson, interview by author, 13 August 1998.

72. Ibid.; Kelley, *Hammer and Hoe*, 206.

73. Mutua, "Introduction," xi.

74. Kelley, *Hammer and Hoe*, 207.

75. Esther Cooper Jackson and James Jackson, interview by author, 13 August 1998; Kelley, *Hammer and Hoe*, 206.

76. Estes, *I Am a Man!*

77. Chateauvert, *Marching Together*, 3, 163–87.

78. Robnett, *How Long? How Long?*, 15–35; Ransby, *Ella Baker and the Black Freedom Movement*, 137–47.

79. Sylvia Thompson Hall, interview by author, 18 February 2006; Kelley, *Hammer and Hoe*, 188–92.

80. Kelley, *Hammer and Hoe*, 213.

81. Esther Cooper Jackson and James Jackson, interview by author, 10 April 1999.

82. J. Richards, "The Southern Negro Youth Congress," 137; "Audley Moore," FBI, New York Bureau file, 100–13205, 9 December 1941; Perry H. Lowrey, Subversive Personnel Committee, Federal Security Agency, Washington, D.C., to Thyra Edwards, 19 December 1942, in Thyra Edwards Papers, box 1, folder 4; Boyce Davies, *Left of Karl Marx*, xxiv.

83. Cobb, "Antidote to Revolution," 175–79, 194–200; Isserman, *Which Side Were You On?* 47–48, 54–58, 85–87.

84. "Louise Alone Thompson Patterson: A Celebration of Her Life and Legacy," memorial program, September 25, 1999, in author's possession.

85. Esther Cooper Jackson and James Jackson, interview by author, 2 April 1998.

86. Kelley, *Hammer and Hoe*, 206–7; Rzeszutek, "'All those rosy dreams we cherish.'"

87. Brown and Faue, "Social Bonds, Sexual Politics, and Political Community on the U.S. Left, 1920s–1940s," 16.

88. Esther Cooper Jackson and James Jackson, interviews by author, 13 August 1998, 2 April 1998.

89. Esther Cooper Jackson and James Jackson, interview by author, 13 August 1998.

90. Brown and Faue, "Social Bonds, Sexual Politics, and Political Community on the U.S. Left, 1920s–1940s," 20.

91. World War II-era personal correspondences between the Jacksons in the author's possession; Esther Cooper Jackson and James Jackson, interview by author, 13 August 1998; Rzeszuteck, "'All those rosy dreams we cherish,'" 213–16.

92. MaryLouise Patterson, interview by author, 1 April 1998.

93. Ruth Hill, *The Black Women Oral History Project*, 119; Issa, "Her Own Book," 94.

94. Divorce papers, 6 March 1947, Claudia Jones Memorial Collection, box 1, folder 1.

95. Louis Miller, M.D., letter, 19 December 1952, Mary Metlay Kaufman Papers, box 14, bolder 7.

96. "Audley Moore," FBI, New York Bureau file, 100-61122-23, 6 June 1946.

97. Issa, "Her Own Book," 94; Barrett, "*Was* the Personal Political?," 402.

98. Griffin, *If You Can't Be Free, Be a Mystery*, 157.

99. MaryLouise Patterson, interview by author, 1 April 1998.

100. Ibid.

101. Ibid.; MaryLouise Patterson email to author, 12 November 2008.

102. Ruth Hill, *The Black Women Oral History Project*, 189.

103. Mishler, *Raising Reds*, 94, 96; Thomas O. Warner, interview by author, 18 January 2002.

104. Goldman, *At Home in Utopia*.

105. Thomas O. Warner, interview by author, 18 January 2002.

106. Klehr, Haynes, and Firsov, *The Secret World of American Communism*, 199–202; *AN*, 5 January 1946 in Hermina Dumont Huiswoud Papers, box 1, folder "Essays on Women."

107. *PV*, 5 January 1946; *DW*, 27 December 1945; *PC*, 5 January 1946; *AN*, 5 January 1946; *NYA*, 5 January 1946; *NYT*, 29 December 1945, all in Hermina Dumont Huiswoud Papers, box 1, folder 1; Turner, *Caribbean Crusaders and the Harlem Renaissance*, 149–50.

108. Horne, "Black Thinkers at Sea," 39.

109. Ruth Hill, *The Black Women Oral History Project*, 190; "Audley Moore," FBI, New York Bureau File 100–13205, 18 June 1947, 2.

110. Singh, *Black Is a Country*, 117.

111. Ruth Hill, *The Black Women Oral History Project*, 197.

112. Cesairé, *Discourse on Colonialism*; Fanon, *The Wretched of the Earth*; Wright, *Black Power*.

113. More than six hundred delegates from sixty-two countries and colonies claiming to represent forty million youth attended the World Youth Conference. Esther Cooper Jackson, "Historic London Conference Unites Youth for World," Edward E. Strong Papers, box 7, folder 4, 1–2; *American Youth at the United Nations of Youth: World Youth Conference-1945* (n.b.), 2–5 in SNYC Papers, box 9, World Youth Festival, 1947 folder; Esther Cooper to Louis Burnham, 30 October 1945, letter from London, report in SNYC *Monthly Review* [December 1945?], SNYC Papers, box 9, World Youth Festival, 1947 folder.

114. Esther Cooper Jackson and James Jackson, interview by author, 2 April 1998; Esther Cooper, "Report of the World Youth Conference, October 31-November 1945," Jackson Papers 2007, box 19, folder 44. The World Youth Conference convened soon after the World Federation of Trade Unions and the Fifth Pan-African Congress met in Paris and Manchester respectively. Several African and Caribbean delegates would later become leading figures in postwar independence movements. Some attended all three conferences. Adi and Sherwood, *The 1945 Manchester Pan-African Congress Revisited*; Von Eschen, *Race against Empire*, 45–53.

115. Esther Cooper to Louis Burnham, letter, 5 November 1945, in "Report of the United States Delegation, World Youth Conference," SNYC Papers, box 9, World Youth Federation, 1947 folder; Lewis, *W. E. B. Du Bois: The Fight for Equality*

and the American Century, 1919–1963, 518–19, 523–24; Esther Cooper Jackson and James Jackson, interview by author, 2 April 1998.

116. Cooper to Burnham, 30 October 1945; K. Boomla, "Women and Women Workers in India" (circa October 1945), Elizabeth Gurley Flynn Papers, box 4, folder 19, reel 4208, Tamiment Library and Robert F. Wagner Archives.

117. Cooper to Burnham, 30 October 1945, 27 November 1945, 13 November 1945; all in SNYC Papers, box 9, World Youth Festival, 1947 folder.

118. "Report of the United States Delegation, World Youth Conference"; Congress of American Women, National Constitutional Convention report, 6–8 May 1949, Communism Collection, box 2, folder 20a.

119. Cooper to Burnham, 30 October 1945; "Report of the United States Delegation, World Youth Conference," Women's International Democratic Federation, "Standing Orders," adopted by the Constitutive Congress, 25–30 November 1945, Elizabeth Gurley Flynn Papers, box 4, folder 11, reel 4208, Tamiment Library and Robert F. Wagner Archives.

120. *Congress View* 3, no. 9 (December 1945): 1, Edward E. Strong Papers, box 7, folder 1.

121. Thelma Dale Perkins, telephone interview by author, 11 July 2006.

122. Of the fifteen U.S. delegates at the International Conference of Women, three were African American: Thelma Dale, Charlotte Hawkins Brown, and Vivian Carter Mason. "Women's International Organization Formed," "Women's International Democratic Federation," "Standing Orders," *Aframerican* (December 1945): 17; Vivian Carter Mason, "Report of Meeting in Paris of the Women's International Democratic Federation," *Aframerican* (March 1946): 3, 4, 17, all in NCNW Records, series 13, box 1, folders 19, 20; CD, 26 June 1946.

123. CAW, "A Report from Women of the World" [circa March 1946]; Speech of Vivian Carter Mason from Women of the World Meeting, 8 March 1946, New York, both in NCNW records, series 5, box 8, folder 11.

124. Quoted in Weigand, *Red Feminism*, 47; Swerdlow, "The Congress of American Women"; CAW, *Bulletin* (October 1946), 2; National Constitutional Convention report (n.d.), both in Communism Collection, box 2, folder 20a.

125. CAW, memorandum, 28 February 1946, NCNW records, series 5, box 8, folder 11; CD, 2 March 1946.

126. Carew, *Blacks, Reds, and Russians*.

127. Cooper had no intention of traveling to the Soviet Union when she arrived in London. However, while attending a party for World Youth Conference delegates from the colonial world at the Soviet embassy in London, Russian officials unexpectedly extended an invitation to her and other guests to visit the Soviet Union. Esther Cooper Jackson and James Jackson, interview by author, 2 April 1998.

128. Ibid.

129. DW, 10 March 1946; Harry S. Truman to James E. Jackson Jr. (n.d.), Jackson Papers 2007, box 1, folder 15.

130. "Southern Youth Legislature Souvenir Journal," SNYC Papers, box 29, folder 5; Lau, *Democracy Rising*, 163–71.

131. Quoted in W. E. B. Du Bois to Esther Cooper Jackson, 28 October 1946, Jackson Papers, SNYC box, SNYC correspondence folder; Jackson, *Freedomways Reader*, 6–11.

132. "Southern Youth Legislature Souvenir Journal," SNYC Papers, box 29, folder 5.

133. Esther Cooper to Walter White, letter, 30 September 1946; Walter White to Mrs. Hurley, memo, 2 October 1946; Mrs. Hurley to Walter White, memo, 3 October 1946, all in NAACP Papers, Group II, A527, SNYC folder; "Southern Youth Legislature Souvenir Journal," SNYC Papers, box 6, SNYC folder; Lau, *Democracy Rising*, 163–71.

134. Florence J. Valentine, "Remarks on Jobs and Training for Negro Women Delivered at the Panel on Youth and Labor, Youth Legislature"; "Southern Youth Legislature Souvenir Journal" program; both in SNYC Papers, box 6, SNYC folder.

135. Quoted in "SNYC," FBI, Memphis Bureau File 100-6548-243, 3 October 1946; J. Edgar Hoover to Jack D. Neal, "SNYC," FBI, Washington Bureau File, 100-6548-238, 10 October 1946; "SNYC," FBI, Atlanta Bureau File, 100-452, 20 November 1946, both in Harvey Klehr Papers, box 44, folder 6.

5. "We Are Sojourners for Our Rights"

1. "Sojourn for Truth and Justice, Digest of Proceedings," LTP Papers, box 15, folder 26.

2. Quoted in "5,000 Negro Women Wanted," LTP Papers, box 16, folder 1.

3. "Sojourn for Truth and Justice, Digest of Proceedings"; C. Martin, "Race, Gender, and Southern Justice; Hunton, *Alphaeus Hunton*, 81–92; Schrecker, *Many Are the Crimes*, 97–98, 104–5; Boyce Davies, *Left of Karl Marx*, 147–50; Duberman, *Paul Robeson*, 381–403.

4. Horne, *Communist Front?*

5. Hunt, *Inventing Human Rights*, 15–34; Cmiel, "The Recent History of Human Rights," 119, 124–125; United Nations, Universal Declaration of Human Rights, 1948, www.unhchr.ch/udhr/lang/eng.htm.

6. Lee, *For Freedom's Sake*, ix.

7. E. May, "Explosive Issues," 15.

8. Mollin, *Radical Pacifism in Modern America*, 75.

9. Gerson, "'Is Family Devotion Now Subversive?,'" 152.

10. C. Anderson, *Eyes off the Prize*, 5.

11. Dudziak, *Cold War Civil Rights*; Horne, *Black and Red:*, 201–21; Plummer, *Rising Wind*, 125–65; Singh, *Black Is a Country*, 160–73; Von Eschen, *Race against Empire*, 96–121; G. Gilmore, *Defying Dixie*, 400–444.

12. Mary McLeod Bethune Papers; NCNW 1949 Constitution, NCNW Papers, series, 1, box 1, folder 2; Mary McLeod Bethune to Rev. W. F. Ernsberger, 29 September 1949, Bethune Papers, part 2, reel 2, 0822; Mary McLeod Bethune to William

Patterson, 14 September 1948, Bethune Papers, part 3, reel 9, 0418; C. Anderson, *Eyes off the Prize*, 113–209; Swerdlow, "The Congress of American Women," 310–11.

13. Lipsitz, *Rainbow at Midnight*, 157–201; Schrecker, *Many Are the Crimes*, 35–36.

14. Barrett, *William Z. Foster and the Tragedy of American Radicalism*, 226–51.

15. Foster et al., *The Communist Position on the Negro Question* (New York: New Century Publishers, 1947); Haywood, *Black Bolshevik*, 570–604.

16. Foster, "On Improving the Party's Work on Women," 987–90; Weigand, *Red Feminism*, 86.

17. Rebecca Hill, "Fosterites and Feminists," 76; Weigand, *Red Feminism*, 46–47, 79.

18. Committee to Free the Trenton Six, *Lynching Northern Style* (n.b.), CPUSA Records, Mass Organizations, box 6, folder 62; Horne, *Communist Front?*, 131–54.

19. Esther Cooper Jackson, telephone interview by author, 10 April 2003; "Esther Cooper Jackson," FBI, Detroit Bureau File 100-16825, 26 June 1950, 9; Horne, *Communist Front?*, 122–24.

20. Duberman, *Paul Robeson*, 341–49.

21. The tour made stops in Los Angeles, Chicago, Detroit, and Philadelphia. *California Eagle*, 6 October 1949; Executive Order No. 16, Eugene I. Van Antwerp, Mayor of Detroit, "To All Department Heads, Boards and Commissions," 7 July 1949, 12, both in LTP Papers, box 11, folder 12; *Join the Council on African Affairs*, pamphlet, circa 1950, LTP Papers, box 9, folder 18; Horne, *Communist Front?*, 235–38.

22. *California Eagle*, 6 October 1949, in LTP Papers, box 11, folder 12; "Esther Cooper Jackson," FBI, Detroit Bureau File, 100-47736-73, 26 June 1950, 11–12; "A Message from Claudia Jones . . . This, Too, Is Lynch Law," n.b. [1951?] CPUSA Records, bibliographical files, box 5, folder 5.

23. DW, 21 October 1948, 7 June 1949; "Audley Moore," FBI, New York Bureau File 100–13205, 11.

24. Biondi, *To Stand and Fight*, 77.

25. "If You Would Be Free, Help Free Mrs. Ingram and Her Two Sons," flyer, Mary Church Terrell Papers, box 102–3, folder 256; DW, March 31, 1949; PC, April 16, 1949; AN 2 April 1949; ADW 27 December 1952, 27 August 1959.

26. Swerdlow, *Women Strike for Peace*.

27. "If You Would Be Free, Help Free Mrs. Ingram and Her Two Sons"; C. Martin, "Race, Gender, and Southern Justice," 261–65.

28. "Audley Moore," FBI, NY Bureau File, 100–61122-33, 8 September 1949, 10; "If You Would Be Free, Help Free Mrs. Ingram and Her Two Sons"; AN, 2 April 1949; CD, 16 April 1949; DW, 1 April 1949; ADW, 2 June 1949; C. Martin, "Race, Gender, and Southern Justice," 261–66; Horne, *Communist Front?*, 212.

29. "Report on Georgia Trip, RE: Ingram Case," 14 August 1951; Outline of Activities in Atlanta; "The Case of Mrs. Ingram/Women's Committee for Equal Justice, William L. Patterson Papers, box 208–17, folders 1–3; ADW, 27 August 1959, 29 August 1959; C. Martin, "Race, Gender, and Southern Justice," 264–65.

30. Claudia Jones to William Z. Foster, 6 December 1955, Howard "Stretch" Johnson Papers; McDuffie, "Long Journeys," 432–33.

31. C. Jones, "An End to the Neglect of the Problems of the Negro Woman!"

32. Boyce Davies, *Left of Karl Marx*, 30; Shapiro, "Red Feminism," 57, 278–310.

33. Boyce Davies, *Left of Karl Marx*, 37, 61.

34. Weigand, *Red Feminism*, 67, 78–101; Millard, *Woman against Myth*.

35. Boyce Davies, *Left of Karl Marx*, xxiv.

36. Ibid., 52.

37. Ibid., 53.

38. C. Jones, "An End to the Neglect of the Problems of the Negro Woman!," 63.

39. Kelley, *Freedom Dreams*, 55.

40. C. Jones, "An End to the Neglect of the Problems of the Negro Woman!," 62.

41. Shapiro, "Red Feminism," 283–84.

42. A. Davis, "Reflections on the Black Woman's Role in the Community of Slaves."

43. Ibid., 122–27; C. Jones, "An End to the Neglect of the Problems of the Negro Woman!," 55.

44. C. Jones, "An End to the Neglect of the Problems of the Negro Woman!" 56.

45. Ibid., 63; Giddings, *Ida*, 211–29.

46. C. Jones, "An End to the Neglect of the Problems of the Negro Woman!," 52, 63.

47. C. Jones, "International Women's Day and the Struggle for Peace," 40.

48. Gerson, "'Is Family Devotion Now Subversive?,'" 165, 156–66.

49. Weigand, *Red Feminism*, 56.

50. Corber, *Homosexuality in Cold War America*, 3. See also D. Johnson, *The Lavender Scare*.

51. See *The Ladder* (May 1957): 27; Hansberry, "Simone de Beauvoir and *The Second Sex*, an Unfinished Essay-in-Progress"; Aptheker, *Intimate Politics*, 107, 400–405.

52. Springer, *Living for the Revolution*, 130–38; Aptheker, *Intimate Politics*, 103.

53. Boyce Davies, *Left of Karl Marx*, 77–84.

54. Ibid., 131–66.

55. Hamilton, *Beah*; Horne, *Communist Front?*, 74–98.

56. Richardson, "A Black Woman Speaks of White Womanhood, of White Supremacy, of Peace"; Rise, *The Martinsville Seven*.

57. Carby, *Reconstructing Womanhood*, 39.

58. Richardson, "A Black Woman Speaks of White Womanhood, of White Supremacy, of Peace"; Hobson, *Venus in the Dark*.

59. Richardson, "A Black Woman Speaks of White Womanhood, of White Supremacy, of Peace"; AA, 22 September 1951.

60. "Beulah Richardson," FBI, Los Angeles Bureau File, 100-33586, 18 March 1952, 3.

61. Washington, "Alice Childress, Lorraine Hansberry, and Claudia Jones"; Gore, "From Communist Politics to Black Power," 74–86.

62. Swerdlow, "The Congress of American Women," 306.

63. Louise Thompson Patterson, interview, 6 June 1989, LTP Papers 2002, box 28, folder 20.

64. Louise Thompson Patterson, interview, 16 March 1988, LTP Papers 2002, box 27, folder 31.

65. "A Call to Negro Women," LTP Papers, box 15, folder 26; Rise, *The Martinsville Seven.*

66. *AA*, 22 September 1951.

67. Quoted in Boyce Davies, *Left of Karl Marx*, 83.

68. "A Call to Negro Women"; Collier-Thomas, *Jesus, Jobs, and Justice.*

69. "A Call to Negro Women."

70. *PC*, 18 September 1951; *AA*, 22 September 1951; *FR* (October 1951): 6; *DW*, 7 October 1951. *The Worker*, 14 October 1951; Hamilton, *Beah.*

71. Quoted in *DW*, 25 November 1951.

72. Green, *Before His Time.*

73. Psalm 23:5 (*The New Oxford Annotated Bible, NRSV*).

74. "5,000 Negro Women Wanted" and "Our Cup Runneth Over," LTP Papers, box 16, folder 1.

75. Reservations: Conference and Luncheon, list, LTP Papers, box 16, folder 1.

76. *DW*, 25 March 1952.

77. Untitled report, LTP Papers, box 16, folder 1.

78. Sojourner Constitution, LTP Papers, box 15, folder 26; see correspondences in LTP Papers 2002, box 12, folder 19.

79. Louise Thompson Patterson to Sojourner membership, form letter, 12 June 1952, LTP Papers, box 15, folder 26.

80. Quoted in press release, 8 July 1952 from Sojourners for Truth and Justice to the Fifteenth International Conference on Public Education; Cable from Louise Thompson Patterson and Hilda Freeman to Dr. Margaret Clapp, president, International Conference on Public Education UNESCO, 8 July 1952, LTP Papers, box 16, folder 3; Antler, "Between Culture and Politics."

81. The organizers of the Defiance Campaign demanded that the apartheid government repeal the Group Areas Act, the Suppression of Communism Act, and the Bantu Authorities Act or face massive civil disobedience "to defy unjust laws that subject our people to political slavery, economic misery and social degradation." The 1950 Group Areas Act instated residential segregation of blacks, whites, and "coloureds." The 1950 Suppression of Communism Act outlawed the South African Communist Party, while the 1951 Bantu Areas Act established black homelands administered by local and regional councils. Meriwether, *Proudly We Can Be Africans*, 90–118; C. Walker, *Women and Resistance in South Africa*, 131–38.

82. Nesbitt, *Race for Sanctions*, 2.

83. "Resolution from the Council on African Affairs to the Conference of the Sojourners for Truth and Justice, Sunday, March 23, 1952," LTP Papers 2002, box 13, folder 4.

84. Charlotta Bass to South African Delegation to the United Nations, 5 April 1952, LTP Papers 2002, box 13, folder 4; *AN*, April 5, 1952; *FR* (April 1952): 1, 4; Charlotta

Bass and Louise T. Patterson to Miss Ray Alexander, 5 April 1952; Bertha Mkize to Sojourners, 20 April 1952, both in LTP Papers 2002, box 13, folder 4; C. Walker, *Women and Resistance in South Africa*, 50–51, 93, 129, 140, 155.

85. Charlotta Bass and Louise Thompson Patterson to Miss Baila Page, 5 April 1952; Charlotta Bass and Louise Thompson Patterson to Minna T. Sioga, 5 April 1952, both in LTP Papers 2002, box 13, folder 4.

86. Mkize to Sojourners, 20 April 1952.

87. Mohanty, *Feminism without Borders*, 55; C. Kaplan, "The Politics of Location as Transnational Feminist Critical Practice."

88. Mohanty, *Feminism without Borders*, 53–57.

89. Gosse, "'To Organize in Every Neighborhood, in Every Home.'"

90. The Sojourners was not the only postwar, left-wing women's organization that had retreated on these matters. The Congress of American Women, too, was silent on the relation between sexuality, reproductive rights, and politics.

91. Boyce Davies, *Left of Karl Marx*, 131–212.

92. Ransby, *Ella Baker and the Black Freedom Movement*, 148–69.

93. Shapiro, "Red Feminism," 310.

94. Ibid., 315–18.

95. Louise Thompson Patterson, interview with Margaret B. Wilkerson, 13 April 1988, LTP Papers 2002, box 25, folder 13.

96. Ibid.; MaryLouise Patterson, interview by author, 1 April 1998.

97. "Sojourners," FBI, New York Bureau file 100-384255-57, 25 June 1952, 3.

98. "Sojourners," FBI, Los Angeles Bureau file, 100-1068861-4647, 1 May 1951, 4; C. Anderson, *Eyes off the Prize*, 36–57.

99. "Charlotta Bass," FBI, Washington Bureau file, 100-297187-32, 6 June 1951.

100. "Louise Thompson Patterson," testimony before the *People of New York by Alfred J. Bohlinger, Superintendent of Insurance v. The International Workers Order, Inc.*, 199 Misc. 941 in LTP Papers 2002, box 8, folder 10; Sabin, *Red Scare in Court*, 267–349.

101. Duberman, *Paul Robeson*, 411–12; subpoena, 25 June 1953, Shirley Graham Du Bois Papers, box 17, folder 10.

102. Westad, *The Global Cold War*.

103. Horne, *Black and Red*, 293.

104. Fredrickson, *Black Liberation*, 246–49.

105. McDuffie, "The March of Young Southern Black Women," 92–96.

106. Kelley, *Hammer and Hoe*, 227; Esther Cooper Jackson and James Jackson, interview by author, 10 April 1999.

107. Esther Cooper Jackson and James Jackson, interview by author, 10 April 1999; McWhorter, *Carry Me Home*, 50–51, 62–64, 95, 98; Kelley, *Hammer and Hoe*, 220–31.

108. Barrett, *William Z. Foster and the Tragedy of American Communism*, 238–42.

109. Gerson, "'Is Family Devotion Now Subversive?,'" 152.

110. Esther Cooper Jackson and James Jackson, interview by author, 13 August 1998; *DW*, 15 January 1951, 21 February 1952; Gerson, "'Is Family Devotion Now Subversive?,'" 158; Dennis, *The Autobiography of an American Communist*, 194–204.

111. "Esther Cooper Jackson," FBI, New York Bureau File, 100–402509–63, 29 February 1956; McDuffie, "The March of Young Southern Young Black Women," 92–96.

112. Esther Cooper Jackson and James Jackson, interview by author, 13 August 1998.

113. Ibid.; Gerson, "'Is Family Devotion Now Subversive?,'" 156–66.

114. "An Appeal . . . in Defense of Negro Leadership," in Esther Cooper Jackson's personal papers in author's possession; "A Special Occasion . . ." reel 69, frame 1042; Esther Jackson to W. E. B. Du Bois, 20 March 1953, reel 69, frame 1044, both in W. E. B. Du Bois Papers (microfilm).

115. Phyllis Taylor-Strong, telephone interview by author, 4 April 2008.

116. Margaret Burnham, telephone interview by author, 30 April 2008; Meerpool, "Carry It Forward," 210–13.

117. Margaret Burnham, telephone interview by author, 30 April 2008.

118. Quoted in K. Jackson, "Trauma Survivors," 8; Margaret Burnham, telephone interview by author, 30 April 2008; McDuffie, "The March of Young Southern Black Women," 92–96.

119. Burton, Espiritu, and Wilkins, "The Fate of Nationalisms in the Age of Bandung."

120. *DW*, 5 December 1955; *AN*, 10 December 1955.

121. *U.S. v. Charney: Jackson, Trachtenberg, et al.*, Mary Metlay Kaufman Papers, box 25, folders 1–12; Marable, *Race, Reform, and Rebellion: The Second Reconstruction and Beyond in Black America, 1945-2006*, 26–37.

122. Esther Cooper Jackson and James Jackson, interview by author, 10 April 1999; Gerson, "'Is Family Devotion Now Subversive?,'" 166; Lieberman, *The Strangest Dream*, 133; McDuffie, "The March of Young Southern Black Women," 97.

123. E. Jackson, *This Is My Husband*, 4, 11, 34, 35.

124. Quoted in *AA*, 9 February 1952; *DW*, 18 January 1952, 18 February 1952, 2 April 1953.

125. McDuffie, "The March of Young Southern Black Women," 97–100.

126. *AN*, 18 July 1953; Martin and Martin, "Thyra Edwards," 173–74.

127. Moore's reasons for leaving resembled those of other one-time black Communists, such as Abner Berry, Vicki Garvin, Harold Cruse, Mae Mallory, and Harry Haywood, "who had either been expelled for 'ultraleftism' or 'bourgeois nationalism,' or had bolted the Party because of its 'revisionism'" on the Negro Question during the 1950s, notes Robin Kelley. Kelley, *Freedom Dreams*, 77.

128. Horne, *Black Liberation/Red Scare*, 184, 227.

129. Ibid., 14, 211–43; "Minutes of the First Meeting of the Manhattan Chapter of the Sojourners for Truth and Justice" (n.d.), LTP Papers, box 15, folder 26.

130. Biondi, *To Stand and Fight*, 147.

131. Quoted in Horne, "Black Thinkers at Sea," 47; Horne, *Red Seas*, 167–216.

132. Ruth Hill, *The Black Women Oral History Project*, 198; "Audley Moore," FBI, New

York City Bureau file, 100-61122-27, 18 November 1946, 2, 3; New York City Bureau file, 100-61122-29, 30 January 1947.

133. Anthony, *Max Yergan*, 214–38.

134. Ruth Hill, *The Black Women Oral History Project*, 137.

135. Barrett, *William Z. Foster and the Tragedy of American Communism*, 252–72.

6. Ruptures and Continuities

1. The revolt in the Marin County courthouse left seventeen-year-old Black Panther Jonathan Jackson and a white judge dead. Davis was not directly involved in the crime, but a gun used by Jackson in the revolt was registered in her name. She was also a close friend of Jackson and his brother George Jackson, a Black Panther leader and an inmate in California's infamous Soledad prison. Soon afterward, authorities issued a warrant for her arrest. Knowing that she would be arrested because the guns used by Jackson were registered in her name, she fled before police apprehended her. Immediately afterward, the FBI placed her on its "Ten Most Wanted" list, launching a nationwide manhunt for her. She evaded arrest for two months. However, FBI agents captured her in New York. A. Davis, *Angela Davis: An Autobiography*, 283–346; Aptheker, *The Morning Breaks*.

2. "America—Where It's At"; George Matthews to Louise Patterson, 11 May 1971; Louise Patterson Speaks, flyer; Mrs. Louise Patterson's tour itinerary, all in LTP Papers 2002, box 5, folder 13.

3. Barrett, *William Z. Foster and the Tragedy of American Radicalism*, 273.

4. Kelley, *Hammer and Hoe*, 228.

5. A. Davis, *Angela Davis: An Autobiography*, 77–79; Parmar, *Place of Rage*.

6. "Reflections of a Life," http://www.acenet.edu/Content/NavigationMenu/Programs Services/OWHE/sallye_davis.htm.

7. A. Davis, *Angela Davis: An Autobiography*, 77–79.

8. Angela Y. Davis remarks at Angela Davis Legacies in the Making conference, University of California, Santa Cruz, Santa Cruz, California, 1 November 2009.

9. A. Davis, "James and Esther Jackson," 274.

10. Margaret Burnham, telephone interview by author, 30 April 2008; Aptheker, *Intimate Politics*, 67–69; A. Davis, *Angela Davis: An Autobiography*, 111–12; Bettina Aptheker, telephone interview by author, 10 April 2009.

11. A. Davis, *Angela Davis: An Autobiography*, 77–189.

12. Charlene Mitchell, interview by author, 10 April 1999; A. Davis, *Angela Davis: An Autobiography*, 189–98.

13. National United Committee to Free Angela Davis and All Political Prisoners, form letter, 14 January 1972, Angela Davis Legal Defense Collection, 1970–1972, box 5, folder 3; Aptheker, *The Morning Breaks*, "Dramatis Personae."

14. Aptheker, *The Morning Breaks*, 27–35.

15. Louise Thompson Patterson, interview by Margaret Wilkerson, 13 August 1988, LTP Papers 2002, box 31, folder, 14, 5–6.

16. Springer, *Living for the Revolution*, 28–37.

17. "Angela Raps on Repression," transcription of conversation with TWWA members, NCNW Papers, series 24, Frances Beal, box 4, folder 25; Ward, "The Third World Women's Alliance," 141–42.

18. The lives and work of Linda Burnham and Frances Beal speak again to how the Old Left helped lay the political foundations for the black feminism of the 1970s. Linda was Dorothy and Louis Burnham's third child, while Frances Beal was the daughter of a politically progressive, bi-racial union. She was born in 1940 and raised in Binghamton, New York, and later in New York City. Her mother was Jewish and a member of the CPUSA. Her father, although sympathetic to the Party, was not a member. Linda Burnham, interview by author, 12 September 2006; Frances Beal, interview by author, 12 September 2006.

19. Louise Alone Thompson Patterson: A Celebration of Her Life and Legacy, program of memorial service, 25 September 1999, Harlem, in author's possession; A. Davis, *Angela Davis: An Autobiography*, 399–400; A. Davis, "JoAnne Little." McNeil, "'Joanne Is You and Joanne Is Me'"; Pickard et al., *Dimension of Criminal Law*, 885.

20. Louise Alone Thompson Patterson: A Celebration of Her Life and Legacy; Anthony Monteiro, interview by author, 11 June 2006.

21. Louise Alone Thompson Patterson: A Celebration of Her Life and Legacy.

22. Quoted in Smethurst, *The Black Arts Movement*, 45. The initial idea for *Freedomways* originated with her longtime friends and SNYC comrades, Louis Burnham and Ed Strong, both of whom had worked closely with Paul Robeson's *Freedom* newspaper. Soon after Burnham's untimely death in February 1960 (Strong passed away in 1957), Cooper Jackson formed a collective to launch the journal. Advised by W. E. B. Du Bois, she, along with the collective, raised funds and gathered articles for the magazine's first issue, which was published in the spring of 1961. E. Jackson, *Freedomways Reader*, xx–xxi.

23. Kaiser, "25 Years of *Freedomways*"; Horne and Stevens, "Shirley Graham Du Bois," 106, 108.

24. Margaret Taylor Goss Burroughs, interview by author, 26 February 2003; Jean Carey Bond, interview by author, 9 November 2001.

25. "The Negro Woman in American Literature"; Jean Carey Bond, interview by author, 9 November 2001; Barbara Smith, telephone interview by author, 18 April 2009; Audre Lorde, "Rites of Passage," *Freedomways* 10, 3 (1970), reprint in E. Jackson, *Freedomways Reader*, 355; Audre Lorde, "Prologue"; Giovanni, "The Lion in Daniel's Den"; Jordan, "For Beautiful Mary Brown"; A. Walker, "Rock Eagle," *Freedomways* 11, 4 (1971): 367; A. Walker, "Facing the Way"; B. Smith, "Black Women in Film Symposium"; A. Davis, "Racism and Contemporary Literature on Rape."

26. A. Davis, *Women, Race, and Class*, 149–71.

27. Roth, *Separate Roads to Feminism*, 6–11; Springer: *Living for the Revolution*, 21–44; Nadasen, *Welfare Warriors*; Estes, *I Am a Man!*, 107–30.

28. Horowitz, *Betty Friedan and the Making of the Feminine Mystique*, 197.

29. Ibid., 153, 121–223.

30. Rosa Guy, interview by author, 19 February 2005; Louise Meriwether, interview by author, 10 January 2005; *Freedomways* 3, no. 4 (fall 1963); Editors of *Freedomways, Black Titan*; *Freedomways* 11, no. 1 (1971); Freedomways Associates, *Paul Robeson*; Ossie Davis and Ruby Dee, interview by author, 5 December 2001.

31. E. Jackson, *Freedomways Reader*, xvii–xxx; Esther Cooper Jackson and James Jackson, interview by author, 13 August 1998. For King's move toward the left, see Honey, *Going Down the Jericho Road*.

32. *Freedomways* 25, no. 3 (fall 1985): 134.

33. The Jacksons' decision in 2005 to donate their immense collection of personal papers to the Tamiment Library at New York University was greeted with much anticipated excitement. In celebration of the archive's acquisition of their papers, the historian David Lewis organized a one-day conference, "James and Esther Jackson, the American Left, and the Origins of the Modern Civil Rights Movement: A New York University Symposium," held on 28 October 2006 at the Tamiment Library. Invitation to Inaugural Louis E. Burnham Award, 18 February 2002 in author's possession; *NYT*, 7 September 2007.

34. Soon after Jones's arrival, she joined the Communist Party of Great Britain (CPGB), but she never felt at home within it. Unlike the postwar CPUSA, the CPGB neither witnessed intense discussions about white and male chauvinism nor adopted a staunch anti-imperialist line. In addition, the organization never fully appreciated her abilities as a theoretician and organizer. Undoubtedly, her status as a black woman contributed to her lukewarm reception from the British Communist Party. Boyce Davies, *Left of Karl Marx*, 4, 170, 221–27.

35. Program of "In Tribute": Launch of Claudia Vera Jones Education and Development Trust, 1 November 2003, London, in author's possession; Boyce Davies, *Left of Karl Marx*, 4, 167–89, 225.

36. For the extensive correspondences between Jones and Halois Robinson, see Claudia Jones Memorial Collection, box 1, folder 14, (hereafter CJMC); Committee of Afro-Asian-Caribbean Organisations . . . Invites You to a Discussion with Mrs. Paul Robeson, flyer, CJMC, box 1, folder 20; Claudia Jones to Dorothy Burnham, 11 March 1956, Dorothy Burnham personal papers, in author's possession; Claudia Jones to Eslanda Robeson, 6 June 1960, CJMC, box 1, folder 9; Louise Thompson Patterson, interview, 18 March 1990, LTP Papers 2002, box 26, folder 13, 39–40; Charlene Mitchell, interview by author, 10 April 1999.

37. Aidoo, "Asante Queen Mothers in Government and Politics in the Nineteenth Century," 67; Issa, "Her Own Book," 38–42.

38. During a visit to Ghana in 1972, the Asantehene, the head of the Asante people, formally bestowed the title "Queen Mother" upon her. Issa, "Her Own Book," 42. In the late 1950s, African college students whom Moore had befriended in Harlem gave her the title.

39. Gilkes, "Interview with Audley (Queen Mother) Moore," 151; Muhammad

Ahmad, interview by author, 12 June 2006; Muhammad Ahmad, *We Will Return in the Whirlwind*, 10–13; McDuffie, "I wanted a Communist philosophy, but I wanted us to have a chance to organize our people," 181, 185–88.

40. Nadasen, *Welfare Warriors*; McDuffie, "I wanted a Communist philosophy, but I wanted us to have a chance to organize our people," 189; Gordall, "Audley Moore and the Politics of Revolutionary Black Motherhood," 4–10.

41. Moore, *Why Reparations?*; Biondi, "The Rise of the Reparations Movement"; McDuffie, "I wanted a Communist philosophy, but I wanted us to have a chance to organize our people," 187–88.

42. Frances Beal, interview by author, 12 September 2006; Barbara Smith, telephone interview by author, 18 April 2009; Bambara, *The Black Woman*; Roth, *Separate Roads to Feminism*, 86–98; Ward, "The Third World Women's Alliance," 131–41.

43. Karen Smith Daughtry, telephone interview by the author, June 4, 2007.

44. Frances Beal, interview by author, 12 September 2006.

45. Springer, *Living for the Revolution*, 88–138; J. Nelson, *Women of Color and the Reproductive Rights Movement*, 55–83.

46. Frances Beal, interview by author, 12 September 2006; Linda Burnham, interview by author, 12 September 2006; Springer, *Living for the Revolution*, 28–37.

47. "Black Scholar Interviews: Queen Mother Moore," 47, 48.

48. Ibid.; Shafeah M'Balia, telephone interview by author, 14 September 2006; White, *Too Heavy a Load*, 265; Ransby, "Black Feminism at Twenty-One."

49. E. White, "Africa on My Mind," 76–77.

50. Estes, *I Am a Man!*, 107–30.

51. Nelson, *Women of Color and the Reproductive Rights Movement*, 85–111.

52. Horne, *The Fire This Time*, 3–22, 171–212; Prashard, *The Darker Nations*, xvii–xviii, 119–275.

53. Frances Beal, interview by author, 12 September 2006.

54. Shafeah M'Balia, telephone interview by author, 14 September 2006; Sonia Sanchez, telephone interview by author, 12 January 2009.

55. A. Davis, *Blues Legacies and Black Feminism*.

56. Brown and Faue, "Revolutionary Desire," 273.

57. Frances Beal, interview by author, 12 September 2006.

58. For discussions of Jones's legacy, see Boyce Davies, "Sisters Outside"; Boyce Davies, *Left of Karl Marx*, 131–66; Gaines, "Locating the Transnational in Postwar African American History"; Saunders, "Woman Overboard."

59. Boyce Davies, *Left of Karl Marx*, 131–66.

60. Saunders, "Woman Overboard," 204.

61. Claudia Jones: Militant Negro Anti-Imperialist Leader, funeral program, CJMC, box 2, folder 16; In Memory of Claudia Jones, flyer, CJMC, box 2, folder 15; Boyce Davies, *Left of Karl Marx*, 182–84.

62. Mohanty, *Feminism without Borders*, 57–64.

63. People's World, "UK Honors Claudia Jones with Stamp," 5 March 2009, http://www.pww.org/article/articleview/14748/.

64. Ibid. See also Boyce Davies, "Sisters Outside," 228.

65. Roediger, *How Race Survived the U.S. History from Settlement and Slavery to the Obama Phenomenon*, 212–30; Joseph, *Dark Days, Bright Nights*, 161–229; Wise, *Colorblind*.

66. *Power of the Word* 1, no. 2 (March–May 2001): 1, 6, 20, www.afrikapoetrytheatre .com; http://queenmothermoore.org/; *AN*, 10 May 1997; *NYT*, 7 May 1997.

67. The symposia include the Claudia Jones Memorial Lecture, an annual talk sponsored by the London-based Institute of Race Relations since 2002 and the "Life and Times of Claudia Jones: A Symposium," held at the Schomburg Center for Research in Black Culture on 2 December 1998. See Institute of Race Relations, http://www.irr.org.uk/index.html; "Claudia Jones Organisation," flyer, in author's possession; Sherwood, *Claudia Jones*, 170–75.

68. Remarks by Angela Y. Davis, "Living Justice: The Life and Times of Charlene Mitchell," Black Women and the Radical Tradition Conference, 28 March 2009, New York.

69. Ibid.

70. American Council on Education, "Reflections of a Life," http://www.acenet.edu/ Content/NavigationMenu/ProgramsServices/OWHE/sallye_davis.htm.

BIBLIOGRAPHY

The bibliography is divided into five sections: Manuscript and Photograph Collections; Periodicals and Publications Consulted; Oral Histories and Interviews; Web Sites; and Books, Articles, Other Texts, and Films.

Manuscript and Photograph Collections

American League for Peace and Democracy Collected Records. Swarthmore College Peace Collection, McCabe Library, Swarthmore, Pa.

American West Indian Ladies Aid Society Papers. Schomburg Center for Research in Black Culture, New York Public Library.

Bailey-Thurman Family Papers. Manuscript, Archives, and Rare Book Library, Robert W. Woodruff Library, Emory University, Atlanta.

Baker, Ella J., Papers. Schomburg Center for Research in Black Culture, New York Public Library.

Bass, Charlotta, miscellaneous files. Federal Bureau of Investigation, Washington.

Beal, Frances, Papers. Moorland-Spingarn Research Center, Howard University, Washington.

Bethune, Mary McCleod, Papers, Parts 1–3 (microfilm) (Bethesda, Md.: University Publications of America, ca. 1996). University of Illinois, History, Philosophy, and Newspaper Library, Urbana.

Birmingham World Office Files. Department of Archives, Birmingham Public Library, Birmingham, Ala.

Black Power Movement, The. Part 3, Papers of the Revolutionary Action Movement, 1962–1996 (microfilm) (Bethesda, Md.: LexisNexis, 2002). University of Illinois, History, Philosophy, and Newspaper Library, Urbana.

Browder, Earl, Papers. Library of Congress Manuscript Division, Washington.

Brown, Egbert Ethelred, Papers. Schomburg Center for Research in Black Culture, New York Public Library.

Burnham, Dorothy, Personal Collection. Brooklyn.

Burnham, Louis E., miscellaneous files. Federal Bureau of Investigation, Washington.

Burroughs, Williana, miscellaneous files. Federal Bureau of Investigation, Washington.

Campbell, Grace P., miscellaneous files. Federal Bureau of Investigation, Washington.

Casimir, J. R., Papers. Schomburg Center for Research in Black Culture, New York Public Library.

Childress, Alice, miscellaneous files. Federal Bureau of Investigation, Washington.

Civil Rights Congress Papers. Schomburg Center for Research in Black Culture, New York Public Library.

Communism Collection. Sophia Smith Collection, Smith College, Northampton, Mass.

Communist Party of the United States of America Records: Biographical Files on Communist Activists and Leaders. Tamiment Library and Robert F. Wagner Labor Archives, Bobst Library, New York University.

Communist Party of the United States of America Records: James W. Ford Papers. Tamiment Library and Robert F. Wagner Labor Archives, Bobst Library, New York University.

Communist Party of the United States of America Records: Mass Leaders and Organizations Subject Files. Tamiment Library and Robert F. Wagner Labor Archives, Bobst Library, New York University.

Congregational Education Society Records, 1816–1956. Congregational Library, Boston.

Connor, Eugene "Bull," Papers. Department of Archives, Birmingham Public Library, Birmingham, Ala.

Cooper, Esther I., Papers. Moorland-Spingarn Research Center, Howard University, Washington.

Crawford, Matt N., and Evelyn Graves, Papers. Manuscript, Archives, and Rare Books Library, Robert W. Woodruff Library, Emory University, Atlanta.

Daily Worker/Daily World Photographs Collection. Tamiment Library and Robert F. Wagner Labor Archives, Bobst Library, New York University.

Davis, Angela, Legal Defense Collection, 1970–1972. Schomburg Center for Research in Black Culture, New York Public Library.

Davis, Benjamin J., Jr., Papers. Schomburg Center for Research in Black Culture, New York Public Library.

Draper, Theodore, Papers. Hoover Institute on War, Revolution, and Peace, Stanford University.

Dreiser, Theodore, Papers. Annenberg Rare Book and Manuscript Library, Van Pelt-Dietrich Library, University of Pennsylvania.

Du Bois, Shirley Graham, Papers. Arthur and Elizabeth Schlesinger Library, Radcliff College on the History of Women in America, Cambridge, Mass.

Du Bois, W. E. B., Papers of (microfilm). University of Illinois, History, Philosophy, and Newspaper Library, Urbana.

Edwards, Thyra, Papers. Chicago History Museum.

Emma Lazarus Federation of Jewish Women's Clubs Records, Jacob Rader Marcus Center of the American Jewish Archives, Cincinnati.

Federal Surveillance of Afro-Americans (1917–1925): The First World War, the Red Scare, and the Garvey Movement (microform) (Frederick, Md.: University Publications of America, 1985). University of Illinois, History, Philosophy, and Newspaper Library, Urbana.

Flynn, Elizabeth Gurley, Papers. Reference Center for Marxist Studies, New York.

Flynn, Elizabeth Gurley, Papers. Tamiment Library and Robert F. Wagner Labor Archives, Bobst Library, New York University.

Green, Cooper, Papers. Department of Archives, Birmingham Public Library, Birmingham, Ala.

Hudson, Hosea, Papers. Schomburg Center for Research in Black Culture, New York Public Library.

Hughes, Langston, miscellaneous files. Federal Bureau of Investigation, Washington.

Hughes, Langston, Papers. Beinecke Rare Book and Manuscript Library, Yale University.

Huiswoud, Hermina Dumont, Papers. Tamiment Library and Robert F. Wagner Labor Archives, Bobst Library, New York University.

Hunton, W. Alphaeus, miscellaneous files. Federal Bureau of Investigation, Washington.

Hunton, William Alphaeus, Papers. Schomburg Center for Research in Black Culture, New York Public Library.

International Labor Defense Papers. Schomburg Center for Research in Black Culture, New York Public Library.

International Workers Order Records. Kheel Center for Labor-Management Documentation and Archives, Martin P. Catherwood Library, Cornell University, Ithaca, N.Y.

International Workers Organization Vertical Files. Tamiment Library and Robert F. Wagner Labor Archives, Bobst Library, New York University.

Jackson, Esther Cooper, miscellaneous files. Federal Bureau of Investigation, Washington.

Jackson, Esther, and James, Personal Collection. Brooklyn.

Jackson, James E., Jr., miscellaneous files. Federal Bureau of Investigation, Washington.

Jackson, James E., and Esther Cooper Jackson Papers. Tamiment Library and Robert F. Wagner Labor Archives, Bobst Library, New York University. I first accessed the Jackson Papers at New York University before they were reorganized in 2007. All materials accessed after this date are referenced as Jackson Papers 2007.

Jefferson School of Social Science Papers. Tamiment Library and Robert F. Wagner Labor Archives, Bobst Library, New York University.

Johnson, Howard "Stretch," Papers. Tamiment Library and Robert F. Wagner Labor Archives, Bobst Library, New York University.

Jones, Claudia, Memorial Collection. Schomburg Center for Research in Black Culture, New York Public Library.

Jones, Claudia, miscellaneous files. Federal Bureau of Investigation, Washington.

Jones, Claudia/Marika Sherwood Research Collections. Schomburg Center for Research in Black Culture, New York Public Library.

Kaufman, Mary Metlay, Papers. Sophia Smith Collection, Smith College, Northampton, Mass.

Klehr, Harvey, Papers. Manuscript, Archives, and Rare Book Library, Robert W. Woodruff Library, Emory University, Atlanta.

LaGuardia, Fiorello H., Papers. Municipal Archives of the City of New York.

League of Struggle for Negro Rights, miscellaneous files. Federal Bureau of Investigation, Washington.

Massiah, Louis, Personal Collection. Philadelphia.

Michelson, Clarina, Papers. Tamiment Library and Robert F. Wagner Labor Archives, Bobst Library, New York University.

Moon, Henry Lee, Family Papers, Western Reserve Historical Society, Cleveland.

Moore, Audley, miscellaneous files. Federal Bureau of Investigation, Washington.

Moore, Richard, Papers. Schomburg Center for Research in Black Culture, New York Public Library.

Naison, Mark D., Personal Collection. Brooklyn.

National Association for the Advancement of Colored People Papers. Library of Congress Manuscript Division, Washington.

National Association for the Advancement of Colored People, part 6: The Scottsboro Case, 1931–1950, Papers (microfilm). University of Illinois, History, Philosophy, and Newspaper Library, Urbana.

National Committee for Defense of Political Prisoners Vertical Files. Tamiment Library and Robert F. Wagner Labor Archives, Bobst Library, New York University.

National Council of Negro Women Records. Moorland-Spingarn Research Center, Howard University, Washington.

National Negro Congress, miscellaneous files. Federal Bureau of Investigation, Washington.

National Negro Congress Papers. Schomburg Center for Research in Black Culture, New York Public Library.

National Negro Congress Vertical Files. Tamiment Library and Robert F. Wagner Labor Archives, Bobst Library, New York University.

National Park Service, Mary McLeod Bethune Council House National Historic Site, National Archives for Black Women's History, National Council of Negro Women Records, Washington.

National Republic Records. Hoover Institute on War, Revolution, and Peace, Stanford University.

Patterson, Louise Thompson, miscellaneous files. Federal Bureau of Investigation, Washington.

Patterson, Louise Thompson, Papers. Manuscript, Archives, and Rare Books Library, Robert W. Woodruff Library, Emory University, Atlanta. I first accessed the LTP Papers before they were reorganized in September 2002. All materials accessed after this date are referenced as LTP Papers 2002.

Patterson, Louise Thompson, Vertical Files. Reference Center for Marxist Studies, New York.

Patterson, William L., miscellaneous files. Federal Bureau of Investigation, Washington.

Patterson, William, Papers. Moorland-Spingarn Research Center, Howard University, Washington.

Records of the Communist Party of the United States of America (microfilm copies of Russian State Archive of Social and Political History Fond 515, Opis 1). Library of Congress Manuscript Division, Washington.

Richardson, Beulah, miscellaneous files. Federal Bureau of Investigation, Washington.

Russian State Archives (RA). Library of Congress European Reading Room, Washington.

The Russian State Archive of Social and Political History (RGASPI) refers to documents catalogued by Fond, the number of the collection; Opis, the subseries within the Fond; Delo, the individual file; and List, the document page. The archive uses the four terms in sequence to reference documents. All materials from the archive referred to in this study follow the sequence Fond/Opis/Delo/List after the letters RA, for the Russian State Archive. For example, RA 495/72/144/39–40 refers to Russian State Archive Fond 495, Opis 72, Delo 144, List (pages) 39–40.

The collections used in this study are as follows:

Fond 495	Opis 3 Political Secretariat of the ECCI
Fond 495	Opis 4 Political Secretariat of the ECCI
Fond 495	Opis 14 Political Secretariat of the ECCI
Fond 495	Opis 18 Political Secretariat of the ECCI
Fond 495	Opis 72 Anglo-American Secretariat
Fond 495	Opis 155 Eastern Secretariat Negro Department
Fond 543	Opis 2 International Antifascist Organizations:
	International Women's Committee against War and Fascism

Sojourners for Truth and Justice, miscellaneous files. Federal Bureau of Investigation, Washington.

Southern Negro Youth Congress, miscellaneous files. Federal Bureau of Investigation, Washington.

Southern Negro Youth Congress Papers. Moorland-Spingarn Research Center, Howard University, Washington.

Strong, Edward E., Papers. Moorland-Spingarn Research Center, Howard University, Washington.

Terrell, Mary Church, Papers. Moorland-Spingarn Research Center, Howard University, Washington.

UNIA Central Division Records, 1918–1959. Schomburg Center for Research in Black Culture, New York Public Library.

Warner, Thomas O., Personal Collection. Philadelphia.

West, Dorothy, Papers. Arthur and Elizabeth Schlesinger Library, Radcliff College on the History of Women in America, Cambridge, Mass.

Wood, L. Hollingsworth, Papers. Special Collections, Haverford College, Haverford, Pa.

World Federation of Democratic Youth, miscellaneous files. Federal Bureau of Investigation, Washington.

Wright, Richard, Papers. Beinecke Rare Book and Manuscript Library, Yale University.

Periodicals and Publications Consulted

GOVERNMENT PUBLICATIONS

U.S. Fourteenth Census, 1920

PUBLICATIONS OF THE COMMUNIST PARTY, USA
AND RELATED ORGANIZATIONS

Communist (superseded by *Political Affairs*)
Daily Worker
Daily World
Fraternal Outlook
Labor Unity
Negro Affairs Quarterly
Negro Champion (superseded by *The Liberator,*
 The Negro Liberator, The Harlem Liberator)
Negro History Bulletin
Negro Worker
New Masses
New Order
Party Builder
People's Weekly World
Spotlight
Sunday Worker
Woman Today
Working Woman
Young Communist Review

OTHER NEWSPAPERS AND MAGAZINES

Atlanta *Daily World*
Baltimore *Afro-American*
Birmingham *Age-Herald*
Birmingham *World*
California Eagle
Cavalcade
Chicago Defender
Chicago Tribune
Congress Vue (superseded by *Congress View*)
The Crisis
The Crusader
Freedom
The Messenger
Nation
Negro History Bulletin
Negro World
New York Age
New York *Amsterdam News*
New York Times
People's Voice
Pittsburgh *Courier*
Power of the Word, www.afrikapoetrytheatre.com
Savannah Tribune
Washington Post
West Indian-American

Oral Histories and Interviews

Ahmad, Muhammad (Max Stanford Jr.). Interview by author, 12 June 2006. Philadelphia.

Aptheker, Bettina. Telephone interview by author, 10 April 2009.

Beal, Frances. Interview by author, 12 September 2006. Oakland, Calif.

Berry, Abner. Interview by Mark Naison, 5 July 1977. Oral History Project of the American Left, Tamiment Library, Bobst Library, New York University.

———. Interviews by Mark Naison, 20 November 1973, 29 July 1974. New York. Mark Naison Personal Collection, transcript in author's possession.

Blakely, Delois. Interview by author, 24 January 2002. New York.

Bond, Jean Carey. Interview by author, 9 November 2001. New York.

Bonosky, Phillip. Interview by author, 11 June 1998. New York.

Bracey, H. John, Jr. Telephone interview by author, 10 January 2009.

Burnham, Dorothy. Interviews by author, 11 June 1998, 10 April 1999, and 26 September 2001. Brooklyn.

Burnham, Linda. Interviews by author, 21 June 1998, 12 September 2006. Chicago; Oakland, Calif.

Burnham, Margaret. Telephone interview by author, 30 April 2008.

Burroughs, Margaret Taylor Goss. Interview by author, 26 February 2003. New York.

Cooke, Marvel. Interviews by author, 1 April 1998, 11 June 1998. New York.

Crawford, Evelyn Louise. Telephone interview by author, 11 July 2005.

Crawford, William, and Miriam Crawford. Interview by author, 12 March 1998. Philadelphia.

Daughtry, Reverend Karen Smith. Telephone interview by author, 4 June 2007.

Davis, Ossie, and Ruby Dee. Interview by author, 5 December 2001. New Rochelle, N.Y.

Flory, Ishmael, and Cathern Davis. Interview by author, 17 September 2003. Chicago.

Gordon, Lottie. Interviews by author, 2 April 1998, 11 June 1998. New York.

Guy, Rosa. Interview by author, 19 February 2005. New York.

Hall, Sylvia Thompson. Interview by author, 18 February 2006. New York.

Hunton, Dorothy. Interview by Louis Massiah, 28 May 1992. W. E. B. Du Bois Film Project, Philadelphia.

Jackson, Esther Cooper. Telephone interviews by author, 17 November 2002, 10 April 2003.

Jackson, Esther Cooper, and James Jackson. Interviews by author, 2 April 1998, 13 August 1998, 10 April 1999, 7 December 2003. Brooklyn.

Jackson, James, and Esther Cooper Jackson. Interview by Louis Massiah, 2 June 1992. W. E. B. Du Bois Film Project, Philadelphia.

Levy, Builder. Interview by author, 7 March 2002. New York.

Kaiser, Ernest. Interview by author, 26 September 2001. New York.

Katz, Maude White. Interview by Ruth Prago, 18 December 1981. Oral History Project of the American Left, Tamiment Library, Bobst Library, New York University.

M'Balia, Shafeah. Telephone interview by author, 14 September 2006.

Meriwether, Louise. Interview by author, 10 January 2005. New York.

Mitchell, Charlene. Interview by author, 10 April 1999. New York.

Monteiro, Anthony. Interview by author, 11 June 2006. Philadelphia.

Moore, Audley "Queen Mother." Interview by Mark Naison, 3 May 1972. Oral History Project of the American Left, Tamiment Library, Bobst Library, New York University.

———. Interview by Ruth Prago, 23 December 1981. Oral History Project of the American Left, Series I, Tamiment Library, Bobst Library, New York University.

Muhammad, Saladin. Telephone interview by author, 31 August 2006.

Oral History Project of the American Left, Tamiment Library, Bobst Library, New York University.

O'Reilly, Salaria Kea [sic]. Interview by John Gerassi, 7 June 1980. John Gerassi Oral History Collection, ALBA Audio 18, Tamiment Library and Robert F. Wagner Labor Archives, Bobst Library, New York University.

Patterson, Louise. Interview by Ruth Prago, 16 November 1981. Oral History Project of the American Left, Tamiment Library, Bobst Library, New York University.

Patterson, MaryLouise. Interview by author, 1 April 1998, New York.

Patterson, MaryLouise, and Belle Herman. Interview by author, 16 November 1997, New York.

Perkins, Thelma Dale. Telephone interview by author, 11 July 2006

Pinkard, Janet (Ginger). Telephone interview by author, 15 September 2002.

Sanchez, Sonia. Telephone interview by author, 12 January 2009.

Smith, Barbara. Telephone interview by author, 18 April 2009.

Solomon, Mark. Telephone interview by author, 24 May 2006.

Taylor-Strong, Phyllis. Telephone interview by author, 4 April 2008.

Umoja, Akinyele. Telephone interview by author, 24 August 2006.

Warner, Thomas O. Interview by author, 18 January 2002, Philadelphia.

Web Sites

The International People's College. "Home Page." http://www.ipc.dk/en/ipcingeneral.asp.

United Nations. *Universal Declaration of Human Rights*, 1948. www.unhchr.ch/udhr/lang/eng.htm.

Books, Articles, Other Texts, and Films

Adi, Hakim. "Pan-Africanism and Communism: The Comintern, the 'Negro Question' and the First International Conference of Negro Workers, Hamburg, 1930." *African and Black Diaspora: An International Journal* 1, no. 2 (July 2008): 237–54.

Adi, Hakim, and Marika Sherwood. *The 1945 Manchester Pan-African Congress Revisited.* London: New Beacon Books, 1995.

Ahmad, Muhammad (Maxwell Stanford Jr.). *We Will Return in the Whirlwind: Black Radical Organizations, 1960–1975.* Chicago: Charles H. Kerr Publishing Company, 2007.

Aidoo, Agnes Akosua. "Asante Queen Mothers in Government and Politics in the Nineteenth Century." In *The Black Woman Cross-Culturally*, ed. Filomina Chioma Steady, 65–77. Rochester, Vt.: Schenkman Books, 1981.

Alexander, M. Jacqui, and Chandra Talpade Mohanty, eds. *Feminist Genealogies, Colonial Legacies, Democratic Futures.* New York: Routledge, 1997.

Allen, James S., and Philip Foner, eds. *American Communism and Black Americans: A Documentary History, 1919–1929.* Philadelphia: Temple University Press, 1987.

Anderson, Carol. "The Brother in Black Is Always Told to Wait": The Communist Party, African American Anticommunism, and the Prioritization of Black Equality—A Reply to Eric Arnesen." *Labor: Studies in Working-Class History of the Americas* 3, no. 4 (Winter 2006): 65–68.

———. *Eyes off the Prize: The United Nations and the African American Struggle for Human Rights, 1944–1955.* Cambridge: Cambridge University Press, 2003.

Anderson, Karen Tucker. *Wartime Women: Sex Roles, Family Relations, and the Status of Women during World War II*. Westport, Conn.: Greenwood Press, 1981.

Anderson, Mary. "The Plight of Negro Domestic Labor." *Journal of Negro Education* 5, no. 1 (January 1936): 66–72.

Anthony, David Henry, III. *Max Yergan: Race Man, Internationalist, Cold Warrior*. New York: New York University Press, 2006.

Antler, Joyce. "Between Culture and Politics: The Emma Lazarus Federation of Jewish Clubs and the Promulgation of Women's History, 1944–1989." In *U.S. History as Women's History: New Feminist Essays*, ed. Linda K. Kerber, Alice Kessler-Harris, and Kathryn Kish Sklar, 265–312. Chapel Hill: University of North Carolina Press, 1995.

Aptheker, Bettina. *Intimate Politics: How I Grew Up Red, Fought for Free Speech, and Became a Feminist Rebel*. Emeryville, Calif.: Seal Press, 2006.

———. *The Morning Breaks: The Trial of Angela Davis*. 2nd ed. Ithaca: Cornell University Press, 1997.

Arnesen, Eric. "'No Graver Danger': Black Anticommunism, the Communist Party, and the Race Question." *Labor: Studies in Working-Class History of the Americas* 3, no. 4 (Winter 2006): 13–52.

———. "The Red and the Black: Reflections on the Responses to 'No Graver Danger.'" *Labor: Studies in Working-Class History of the Americas* 3, no. 4 (Winter 2006): 75–79.

August, Bob. "Salaria Kea [*sic*] and John O'Reilly: Volunteers Who Met and Wed in Spain." *Cleveland Magazine* (1975).

Baker, Ella, and Marvel Cooke. "The Bronx Slave Market." *Crisis* 42 (November 1935): 330–31, 340.

Baldwin, Davarian. *Chicago's New Negroes: Modernity, the Great Migration, and Black Urban Life*. Chapel Hill: University of North Carolina Press, 2007.

Baldwin, Kate A. *Beyond the Color Line and the Iron Curtain: Reading Encounters between Black and Red, 1922–1963*. Durham: Duke University Press, 2003.

Bambara, Toni Cade, ed. *The Black Woman: An Anthology*. New York: Washington Square Press, 2005.

Barber, Lucy Grace. "Marches on Washington, 1894–1963: National Political Demonstrations and American Political Culture." Ph.D. diss., Brown University, 1996.

Barrett, James R. "*Was* the Personal Political? Reading the Autobiography of American Communism." *International Review of Social History* 53, no. 3 (December 2008): 395–423.

———. *William Z. Foster and the Tragedy of American Radicalism*. Urbana: University of Illinois Press, 1999.

Barton, Ann. "Revolt of the Housewives." *New Masses* (18 June 1935): 18–19.

Baxter, John Jr. "National Negro Congress, 1936–1947." Ph.D., diss., University of Cincinnati, 1981.

Beal, Frances. "Double Jeopardy: To Be Black and Female." In *The Black Woman: An*

Anthology, ed. Toni Cade Bambara, 109–22. New York: Washington Square Press, 2005.

Bebel, August. *Woman under Socialism*. New York: Schocken Books, 1971.

Belknap, Michael R. *Cold War Political Justice: The Smith Act, the Communist Party, and American Civil Liberties*. Westport, Conn.: Greenwood Press, 1977.

Berg, Manfred. *"The Ticket to Freedom": The NAACP and the Struggle for Black Political Integration*. Gainesville: University of Florida Press, 2005.

Berry, Faith. *Langston Hughes: Before and Beyond Harlem*. Westport, Conn.: Lawrence Hill and Company, 1983.

Biondi, Martha. "Response to Eric Arnesen." *Labor: Studies in Working-Class History of the Americas* 3, no. 4 (Winter 2006): 59–63.

———. "The Rise of the Reparations Movement." *Radical History Review* 87 (Fall 2003): 5–18.

———. *To Stand and Fight: The Struggle for Civil Rights in Postwar New York City*. Cambridge: Harvard University Press, 2003.

"Black Scholar Interviews: Queen Mother Moore." *Black Scholar* 4 (March-April 1973): 47–55.

Blakely, Allison. *Russia and the Negro: Blacks in Russian History and Thought*. Washington: Howard University Press, 1986.

Bloor, Ella Reeve. *We Are Many: An Autobiography*. New York: International Publishers, 1940.

Bloor, Ella Reeve, and Elizabeth Gurley Flynn. "Women in the National Front against Hitler." *Communist* 10, no. 20 (October 1941): 897–909.

Bogues, Anthony. *Black Heretics, Black Prophets: Radical Political Intellectuals*. New York: Routledge, 2003.

Boris, Eileen. *Home to Work: Motherhood and the Politics of Industrial Homework in the United States*. Cambridge: Cambridge University Press, 1994.

———. "The Power of Motherhood: Black and White Activist Women Redefine the 'Political.'" In *Mothers of a New World: Maternalist Politics and the Origin of Welfare States*, ed. Seth Koven and Sonya Michel, 213–45. New York: Routledge, 1994.

Borkenau, Franz. *World Communism: A History of the Communist International*. Ann Arbor: University of Michigan Press, 1962.

Boyce Davies, Carole. *Black Women, Writing and Identity: Migrations of the Subject*. New York: Routledge, 1994.

———. "Deportable Subjects: U.S. Immigration Laws and the Criminalizing of Communism." *South Atlantic Quarterly* 100, no. 4 (Fall 2001): 949–66.

———. *Left of Karl Marx: The Political Life of Black Communist Claudia Jones*. Durham: Duke University Press, 2008.

———. "Sisters Outside: Tracing the Caribbean/Black Radical Tradition." *Small Axe: A Caribbean Journal of Criticism* 28, no. 1 (March 2009): 217–28.

Brandt, Joe, ed. *Black Americans in the Spanish People's War against Fascism, 1936–1939*. New York: Veteran of the Abraham Lincoln Battalion, 1980.

Brocheux, Pierre. *Ho Chi Minh: A Biography*. Trans. Claire Duiker. Cambridge: Cambridge University Press, 2007.

Browder, Earl. *Teheran: Our Path in War and Peace*. New York: International Publishers, 1944.

Brown, Elsa Barkley. "'What Has Happened Here': The Politics of Difference in Women's History and Feminist Politics." *Feminist Studies* 18, no. 2 (Summer 1992): 295–312.

———. "Womanist Consciousness: Maggie Lena Walker and the Independent Order of Saint Luke." *Signs: A Journal of Women Culture and Society* 14, no. 3 (Spring 1989): 610–33.

Brown, Jean Collier. *Household Workers*. Chicago: Science Research Associates, 1940.

Brown, Kathleen A., and Elizabeth Faue. "Revolutionary Desire: Redefining the Politics of Sexuality of American Radicals, 1919–1945." In *Sexual Borderlands: Constructing an American Sexual Past*, ed. Kathleen Kennedy, 273–302. Columbus: Ohio State University Press, 2003.

———. "Social Bonds, Sexual Politics, and Political Community on the U.S. Left, 1920s–1940s." *Left History* 7, no. 1 (Spring 2000): 9–45.

Buechler, Steven M. *Social Movements in Advanced Capitalism: The Political Economy of Cultural Construction of Activism*. New York: Oxford University Press, 2000.

Buhle, Mari Jo. *Women and American Socialism, 1870–1920*. Urbana: University of Illinois Press, 1981.

Buhle, Mari Jo, Paul Buhle, and Dan Georgakas, eds. *Encyclopedia of the American Left*. Urbana: University of Illinois Press, 1990.

Buhle, Paul. *Marxism in the USA: Remapping the History of the American Left*. 2nd ed. London: Verso, 1991.

———. "Young Communist League (and Successors)." *Encyclopedia of the American Left*, ed. Mari Jo Buhle, Paul Buhle, and Dan Georgakas, 872–75. Urbana: University of Illinois Press, 1990.

Burton, Antoinette. *The Postcolonial Careers of Santha Rama Rau*. Durham: Duke University Press, 2007.

Burton, Antoinette, Augusto Espiritu, and Fanon Che Wilkins. "The Fate of Nationalisms in the Age of Bandung." *Radical History Review* 95 (2006): 145–48.

Bush, Rod. *We Are Not What We Seem: Black Nationalism and Class Struggle in the American Century*. New York: New York University Press, 1999.

Butler, Kim D. *Freedoms Given, Freedoms Won: Afro-Brazilians in Post-Abolition in São Paulo and Salvador*. New Brunswick: Rutgers University Press, 1998.

Capeci, Dominic, Jr. *The Harlem Riot of 1943*. Philadelphia: Temple University Press, 1977.

Carby, Hazel V. *Reconstructing Womanhood: The Emergence of the Afro-American Woman Novelist*. New York: Oxford University Press, 1987.

Carew, Joy Gleason. *Blacks, Reds, and Russians: Sojourners in Search of the Soviet Promise*. New Brunswick: Rutgers University Press, 2008.

Carleton, Gregory. *Sexual Revolution in Bolshevik Russia*. Pittsburgh: University of Pittsburgh Press, 2005.

Carter, Dan T. *Scottsboro: A Tragedy of the American South*. Rev. ed. Baton Rouge: Louisiana State University Press, 1979.

Castledine, Jacqueline Ann. "Gendering the Cold War: Race, Class, and Women's Peace." Ph.D. diss., Rutgers, The State University of New Jersey, 2006.

Cesairé, Aimé. *Discourse on Colonialism*. New York: Monthly Review Press, 1972.

Cha-Jua, Sundiata, and Clarence Lang. "'The Long Movement' as Vampire: Temporal and Spatial Fallacies in Recent Black Freedom Studies." *Journal of African American History* 92, no. 2 (2007): 265–88.

Charney, George. *A Long Journey*. Chicago: Quadrangle, 1968.

Chateauvert, Melinda. *Marching Together: Women of the Brotherhood of Sleeping Car Porters*. Urbana and Chicago: University of Illinois Press, 1998.

Childress, Alice. *Like One of the Family: Conversations from a Domestic's Life*. Boston: Beacon Press, 1986.

Christian, Mark. "Marcus Garvey and the Universal Negro Improvement Association: New Perspectives on Philosophy, Religion, and Microstudies, Unity, and Practice." *Journal of Black Studies* 39, no. 2 (November 2008): 163–65.

Claudín, Fernando. *The Communist Movement from Comintern to Cominform. Part One, The Crisis of the Communist International*. Trans. Brian Pearce. New York: Monthly Review Press, 1975.

Clements, Barbara Evans. *Bolshevik Feminist: The Life of Aleksandra Kollontai*. Bloomington: Indiana University Press, 1979.

Cmiel, Kenneth. "The Recent History of Human Rights." *American Historical Review* 109 (2004): 117–35.

Cobb, William A. J. "Antidote to Revolution: African American Anti-Communism and the Struggle for Civil Rights, 1931–1954." Ph.D. diss., Rutgers, The State University of New Jersey, 2003.

Cobble, Dorothy Sue. *The Other Women's Movement: Workplace Justice and Social Rights in Modern America*. Princeton: Princeton University, 2004.

Coble, Alana Erickson. *Cleaning Up: The Transformation of Domestic Service in Twentieth-Century New York City*. New York: Routledge, 2006.

Cohen, Lizabeth. *Making a New Deal: Industrial Workers in Chicago, 1919–1939*. Cambridge: Cambridge University Press, 1990.

Cohen, Robert. *When the Old Left Was Young: Student Radicals and America's First Mass Student Movement, 1929–1941*. New York: Oxford University Press, 1993.

Collier-Thomas, Bettye. *Jesus, Jobs, and Justice: African American Women and Religion*. New York: Alfred A. Knopf, 2010.

Collier-Thomas, Bettye, and V. P. Franklin, eds. *Sisters in the Struggle: African American Women in the Civil Rights–Black Power Movement*. New York: New York University Press, 2001.

Collins, Patricia Hill. *Black Feminist Thought: Knowledge, Consciousness, and the Politics of Empowerment*. Rev. ed. New York: Routledge, 2000.

———. *Black Sexual Politics: African Americans, Gender, and the New Racism.* New York: Routledge, 2004.

———. *Fighting Words: Black Women and the Search for Justice.* Minneapolis: University of Minnesota Press, 1998.

Communist Party Central Committee. *American Working Women and the Class Struggle.* New York: Workers Library, 1930.

The Communist Position on the Negro Question. New York: Workers Library Publishers, 1934.

The Complete Report of Mayor LaGuardia's Commission on the Harlem Riot of March 19, 1935. New York: Arno Press, 1969.

Cooper, Esther V. "The Negro Women Domestic Worker in Relation to Trade Unionism." MA thesis, Fisk University, 1940.

Cooper, Wayne F. *Claude McKay: Rebel Sojourner in the Harlem Renaissance.* Baton Rouge: Louisiana State University Press, 1987.

Corber, Robert J. *Homosexuality in Cold War America: Resistance and the Crisis of Masculinity.* Durham: Duke University Press, 1997.

Cott, Nancy F. *The Grounding of Modern Feminism.* New Haven: Yale University Press, 1987.

———. "'What's in a Name?': The Limits of 'Social Feminism'; or Expanding the Vocabulary of Women's History." *Journal of American History* 76 (1989): 809–29.

Cowl, Margaret. *Women and Equality.* New York: International Publishers, 1935.

Crawford, Vicki L., et al., eds. *Women in the Civil Rights Movement: Trailblazers and Torchbearers, 1941-1965.* Bloomington: Indiana University Press, 1993.

Crenshaw, Kimberlé Williams. *Critical Race Theory: The Key Writings That Formed the Movement.* New York: New Press, 1995.

———. "Mapping the Margins: Intersectionality, Identity Politics, and Violence Against Women of Color." *Stanford Law Review* 43, no. 6 (July 1991): 1241–99.

Crocco, Margaret Smith, and Callie L. Waite. "Education and Marginality: Race and Gender in Higher Education, 1940–1955." *History of Education Quarterly* 47, no. 1 (2007): 573–82.

The Crusader. Reprint, New York: Garland Publishers, 1987.

Cruse, Harold. *The Crisis of the Negro Intellectual.* New York: Quill, 1984.

Cruz-Malavé, Arnaldo, and Martin F. Manalansan, IV, eds. *Queer Globalizations: Citizenship and the Afterlife of Colonialism.* New York: New York University Press, 2002.

Cuthbert, Marion V. "Education and Marginality: A Study of the Negro Woman College Graduate." Ph.D. diss., Columbia University, 1942.

Dalfiume, Richard M. "The 'Forgotten Years' of the Negro Revolution." In *The Negro in Depression and War*, ed. Bernard Sternsher, 298–316. Chicago: Quadrangle 1969.

Davis, Angela Y. *Abolition Democracy: Beyond Empire, Prisons, and Torture.* New York: Seven Stories Press, 2005.

———. *Angela Davis: An Autobiography.* New York: International Publishers, 1974.

———. *Blues Legacies and Black Feminism: Gertrude "Ma" Rainey, Bessie Smith, and Billie Holiday*. New York: Vintage Books, 1998.

———. "James and Esther Jackson: Connecting the Past to the Present." *American Communist History* 7, no. 2 (December 2008): 217–76.

———. "JoAnne Little: The Dialectics of Rape." In *The Angela Y. Davis Reader*, ed. Joy James, 149–60. Malden, Mass.: Blackwell Publishers, 1998.

———. "Racism and Contemporary Literature on Rape." *Freedomways* 16, no. 1 (1976): 25–33.

———. "Reflections on the Black Woman's Role in the Community of Slaves." In *The Angela Y. Davis Reader*, ed. Joy James, 111–28. Malden, Mass.: Blackwell Publishers, 1998.

———. *Women, Race, and Class*. New York: Vintage Books, 1981.

Davis, John P. *Let Us Build a National Negro Congress*. Washington: National Sponsoring Committee, National Negro Congress, 1935.

de Beauvoir, Simone. Trans. and ed. H. M. Parshley. *The Second Sex*. New York: Alfred A. Knopf, 1993.

Degras, Jane, ed. *The Communist International, 1919–1943*. Vols. 1–3. London: Frank Cass and Company, 1971.

D'Emilio, John. *Sexual Politics, Sexual Communities: The Making of a Homosexual Minority in the United States, 1940–1970*. 2nd ed. Chicago: University of Chicago Press, 1998.

D'Emilio, John, and Estelle B. Freedman. *Intimate Matters: A History of Sexuality in America*. 2nd ed. Chicago: University of Chicago Press, 1997.

Denning, Michael. *The Cultural Front: The Laboring of American Culture in the Twentieth Century*. London: Verso, 1997.

Dennis, Peggy. *The Autobiography of an American Communist: A Personal View of a Political Life, 1925–1975*. Westport, Conn.: Lawrence Hill, 1977.

Dixler, Elsa. "The Woman Question: Women and the Communist Party, 1929–1941." Ph.D. diss., Yale University, 1974.

Drake, St. Clair, and Horace Cayton. *Black Metropolis: A Study of Negro Life in a Northern City*. 1945. Rev. and enlarged ed., Chicago: University of Chicago Press, 1993.

Draper, Theodore. *The Roots of American Communism*. New York: Viking Press, 1957.

Duberman, Mark. *Paul Robeson*. New York: Alfred A. Knopf, 1988.

Dubois, Ellen C. "Eleanor Flexner and the History of American Feminism." *Gender and History* 3, no. 1 (April 1991): 81–90.

Du Bois, W. E. B. *The Autobiography of W. E. B. Du Bois*. New York: International Publishers, 1968.

———. *Black Reconstruction in America, 1860–1880*. New York: Antheneum, 1992.

Dudziak, Mary. *Cold War Civil Rights: Race and the Image of American Democracy*. Princeton: Princeton University Press, 2000.

———. "Josephine Baker, Racial Protest, and the Cold War." *Journal of American History* 81 (September 1994): 543–70.

Duncan, Natanya. "The 'Efficient Womanhood' of the Universal Negro Improvement Association: 1919–1930." Ph.D. diss., University of Florida, 2009.

Edgar, Adrienne. "Bolshevism, Patriarchy, and the Nation: The Soviet 'Emancipation' of Muslim Women in Pan-Islamic Perspective." *Slavic Review* 65, no. 2 (Summer 2006): 252–72.

Editors of *Freedomways. Black Titan: W. E. B. Du Bois.* Boston: Beacon Press, 1970.

Edwards, Brent Hayes. *The Practice of Diaspora: Literature, Translation, and the Rise of Black Internationalism.* Cambridge: Cambridge University Press, 2003.

———. "The Uses of Diaspora." *Social Text* 19, no. 1 (Spring 2001): 45–73.

Egerton, John. *Speak Now Against the Day: The Generation before the Civil Rights Movement in the South.* New York: Alfred A. Knopf, 1994.

El Saadawi, Nawal. *The Hidden Face of Eve: Women in the Arab World.* London: Zed Books, 1980.

Elliot, Rosemary. *Women and Smoking since 1890.* New York: Routledge, 2007.

Engels, Frederick. *Origins of the Family, Private Property, and the State.* In *Selected Works* by Karl Marx and Frederick Engels, 3: 191–334. Moscow: Progress Publishers, 1969.

Estes, Steve. *I Am a Man! Race, Manhood, and the Civil Rights Movement.* Chapel Hill: University of North Carolina Press, 2005.

Evans, Sara. *Personal Politics: The Roots of Women's Liberation in the Civil Rights Movement and the New Left.* New York: Vintage Books, 1979.

Fanon, Frantz. *A Dying Colonialism.* Translated by Haakon Chevalier. New York: Monthly Review, 1965.

———. *The Wretched of the Earth.* Translated by Constance Farrington. New York: Grove Weidenfeld, 1963.

Faue, Elizabeth. *Community of Suffering and Struggle: Women, Men, and the Labor Movement in Minneapolis, 1915–1945.* Chapel Hill: University of North Carolina Press, 1991.

Feldstein, Ruth. "'I Don't Want to Trust You Anymore': Nina Simone, Culture, and Black Activism in the 1960s." *Journal of American History* 91 (2005): 1349–79.

Ferguson, Roderick A. *Aberrations in Black: Toward a Queer of Color Critique.* Minneapolis: University of Minnesota Press, 2004.

Floyd-Thomas, Juan Marcial. "Creating a Temple and a Forum: Religion, Culture, and Politics in the Harlem Unitarian Church, 1920–1956." Ph.D. diss., University of Pennsylvania, 2000.

Flynn, Elizabeth Gurley. *Women Have a Date with Destiny.* New York: Workers Library Publishers, 1944.

Foley, Barbara. *Radical Representations: Politics and Form in U.S. Proletarian Fiction, 1929–1941.* Durham: Duke University Press, 1993.

———. *Spectres of 1919: Class and Nation in the Making of the New Negro.* Urbana: University of Illinois Press, 2003.

Foner, Philip. *American Socialism and Black Americans: From the Age of Jackson to World War II.* Westport, Conn.: Greenwood Press, 1977.

Foner, Philip S., and Herbert Shapiro, eds. *American Communism and Black Americans: A Documentary History, 1930-1934*. Philadelphia: Temple University Press, 1991.

Ford, James, and Harry Gannes. *War in Africa: Italian Fascism Prepares to Enslave Ethiopia*. New York: Workers Library Publishing, 1935.

"For United Action against Fascism." *The Communist* 12, no. 4 (April 1933): 323–36.

Foster, William Z. *History of the Communist Party of the United States*. New York: International Publishers, 1952.

———. "On Improving the Party's Work among Women." *Political Affairs* 27, no. 10 (October 1948): 984–90.

Foster, William, et al. *The Communist Position on the Negro Question*. New York: New Century Publishers, 1947.

Fouché, Rayvon. *Black Inventors in the Age of Segregation: Granville T. Woods, Lewis H. Latimer, and Shelby J. Davidson*. Baltimore: Johns Hopkins University Press, 2003.

Franklin, V. P. "Introduction—New Black Power Studies." *Journal of African American History* 92, no. 4 (Fall 2007): 463–67.

Fredrickson, George M. *Black Liberation: A Comparative History of Black Ideologies in the United States and South Africa*. New York: Oxford University Press, 1995.

Freedomways Associates. *Paul Robeson: The Great Forerunner*. New York: International Publishers, 1998.

Friedan, Betty. *The Feminine Mystique*. 1963. Reprint, New York: W. W. Norton, 1997.

Friedman, Andrea. "The Strange Career of Annie Lee Moss: Rethinking Race, Gender, and McCarthyism." *Journal of American History* 94, no. 2 (September 2007): 445–68.

Gaines, Kevin K. *American Africans in Ghana: Black Expatriates and the Civil Rights Era*. Chapel Hill: University of North Carolina Press, 2006.

———. "From Center to Margins: Internationalism and the Origins of Black Feminism." In *Materializing Democracy: Toward a Revitalized Cultural Politics*, ed. Russ Castronovo and Diane D. Nelson, 294–313. Durham: Duke University Press, 2002.

———. "Locating the Transnational in Postwar African American History." *Small Axe: A Caribbean Journal of Criticism* 28, no. 1 (March 2009): 193–202.

———. *Uplifting the Race: Black Leadership, Politics, and Culture in the Twentieth Century*. Chapel Hill: University of North Carolina Press, 1996.

Garfinkel, Herbert. *When Negroes March: The March on Washington Movement in the Organizational Politics for FEPC*. New York: Atheneum, 1969.

Gates, Henry Louis, Jr. "The Black Man's Burden." In *Fear of a Queer Planet: Queer Politics and Social Theory*, ed. Michael Warner, 230–38. Minneapolis: University of Minneapolis Press, 1993.

Gellum, Erik S. "'Death Blow to Jim Crow: The National Negro Congress, 1936–1947." Ph.D. diss., Northwestern University, 2006.

Gendered Domains: Rethinking Public and Private in Women's History; Essays from

the 7th Berkshire Conference on the History of Women. Ithaca: Cornell University Press, 1990.

Gerson, Deborah A. "'Is Family Devotion Now Subversive?' Familialism against McCarthyism." In *Not June Cleaver: Women and Gender in Postwar America, 1945–1960*, ed. Joanne Meyerowitz, 151–76. Philadelphia: Temple University Press, 1994.

Giddings, Paula. *Ida: A Sword among Lions; Ida B. Wells and the Campaign against Lynching*. New York: Amistad, 2008.

———. *When and Where I Enter: The Impact of Black Women on Race and Sex in America*. New York: Quill, 1984.

Gilkes, Cheryl Townsend. "Interview with Audley (Queen Mother) Moore." In *The Black Women Oral History Project*, vol. 8, ed. Ruth Edmonds Hill, 111–201. Westport, Conn.: Meckler, 1991.

Gilmore, Glenda Elizabeth. *Defying Dixie: The Radical Roots of Civil Rights, 1919–1950*. New York: W. W. Norton, 2008.

———. *Gender and Jim Crow: Women and the Politics of White Supremacy*. Chapel Hill: University of North Carolina Press, 1996.

Gilmore, Ruthie Wilson. *Golden Gulag: Prisons, Surplus, Crisis, and Opposition in Globalizing California*. Berkeley: University of California Press, 2007.

Gilmore, Stephanie, ed. *Feminist Coalitions: Historical Perspectives on Second-Wave Feminism in the United States*. Urbana: University of Illinois Press, 2008.

Gilroy, Paul. *The Black Atlantic: Modernity and Double Consciousness*. Cambridge: Harvard University Press, 1993.

Giovanni, Nikki. "The Lion in Daniel's Den." *Freedomways* 11, no. 2 (1971): 191.

Golden, Lily. *My Long Journey Home*. Chicago: Third World Press, 2002.

Goldman, Michal, dir. *At Home in Utopia*. DVD. Filmmakers Collaborative, 2008.

Goldman, Wendy Z. *Terror and Democracy in the Age of Stalin: The Social Dynamics of Repression*. Cambridge: Cambridge University Press, 2007.

———. *Women at the Gates: Gender and Industry in Stalin's Russia*. Cambridge: Cambridge University Press, 2002.

———. *Women, the State and Revolution: Soviet Family Policy and Social Life, 1917–1936*. Cambridge: Cambridge University Press, 1993.

Goodman, James. *The Stories of Scottsboro*. New York: Vintage, 1994.

Gopinath, Gayatri. *Impossible Desires: Queer Diasporas and South Asian Public Cultures*. Durham: Duke University Press, 2005.

Gordall, Janet. "Audley Moore and the Politics of Black Revolutionary Motherhood." Paper in author's possession.

Gordon, Eugene, and Cyril Briggs. *The Position of Negro Women*. New York: Workers Library Publishers, 1935.

Gordon, Linda. *Pitied but Not Entitled: Single Mothers and the History of Welfare*. Cambridge: Harvard University Press, 1994.

Gore, Dayo F. "From Communist Politics to Black Power: The Visionary Politics and Transnational Solidarities of Victoria 'Vicki' Ama Garvin." In *Want to Start a*

Revolution? Radical Women in the Black Freedom Struggle, ed. Dayo Gore, Jeanne Theoharis, and Komozi Woodard, 72–94. New York: New York University Press, 2009.

———. "To Light a Candle in a Gale Wind: Black Women Radicals and Post World War II U.S. Politics." Ph.D. diss., New York University, 2003.

Gore, Dayo F., Jeanne Theoharis, and Komozi Woodard. Introduction to *Want to Start a Revolution? Radical Women in the Black Freedom Struggle*, ed. Dayo Gore, Jeanne Theoharis, and Komozi Woodard, 1–24. New York: New York University Press, 2009.

———, eds. *Want to Start a Revolution? Radical Women in the Black Freedom Struggle*. New York: New York University Press, 2009.

Gosse, Van. "'To Organize in Every Neighborhood, in Every Home': The Gender Politics of American Communists between the Wars." *Radical History Review* 50 (1991): 109–41.

Goulding, Marc. "Vanguards of the New Africa: Black Radical Networks, Communism, and Anti-Imperialism in the 1930s." Ph.D. diss., New York University, 2007.

Grady-Willis, Winston A. *Challenging U.S. Apartheid: Atlanta and Black Struggles for Human Rights, 1960–1977*. Durham: Duke University Press, 2006.

Green, Ben. *Before His Time: The Untold Story of Harry T. Moore, America's First Civil Rights Martyr*. Gainesville: University of Florida Press, 1999.

Greenberg, Lynn. *Or Does It Explode? Black Harlem during the Great Depression*. New York: Oxford University Press, 1991.

Greene, Christina. *Our Separate Ways: Women and the Black Freedom Movement in Durham, North Carolina*. Chapel Hill: University of North Carolina Press, 2005.

Grewal, Inderpal, and Caren Kaplan, eds. *Scattered Hegemonies: Postmodernity and Transnational Feminist Practices*. Minneapolis: University of Minnesota Press, 1994.

Griffin, Farah Jasmine. *If You Can't Be Free, Be a Mystery: In Search of Billie Holiday*. New York: Ballantine, 2001.

Griffin, Farah J., and Cheryl J. Fish, eds. *Stranger in the Village: Two Centuries of African-American Travel Writing*. Boston: Beacon Press, 1998.

Gross, Kali N. *Colored Amazons: Crime, Violence, and Black Women in the City of Brotherly Love, 1880–1910*. Durham: Duke University Press, 2006.

Guy-Sheftall, Beverly, ed. *Words of Fire: An Anthology of African-American Feminist Thought*. New York: New Press, 1995.

Hall, Gloria, et al., eds. *All the Women Are White, All the Blacks Are Men, but Some of Us Are Brave*. Old Westbury, N.Y.: Feminist Press, 1982.

Hall, Jacquelyn Dowd. "The Long Civil Rights Movement and the Political Uses of the Past." *Journal of American History* 91, no. 4 (March 2005): 1233–63.

Hall, Stuart. "The Work of Representation." In *Representation: Cultural Representations and Signifying Practices*, ed. Stuart Hall, 13–74. Walton Hall, U.K.: The Open University, 1997.

Halle, Fannina W. *Woman in Soviet Russia*. London: Routledge, 1933.

Hamilton, Charles V. *Adam Clayton Powell, Jr.: The Political Biography of the American Dilemma*. New York: Atheneum, 1991.

Hamilton, Lisa Gay, dir. *Beah: A Black Woman Speaks*. DVD. Clinica Estetico in association with HBO/Cinemax Documentary Film, 2003.

Hansberry, Lorraine. "Simone de Beauvoir and *The Second Sex*, an Unfinished Essay-in-Progress." In *Words of Fire: An Anthology of African-American Feminist Thought*, ed. Beverly Guy-Sheftall, 128–42. New York: New Press, 1995.

Harlem Division of the Communist Party, USA. *A Political Manual for Harlem*. New York: Harlem Division of the Communist Party, USA, ca. 1939.

Harold, Claudrena N. *The Rise and Fall of the Garvey Movement in the Urban South, 1918-1942*. New York: Routledge, 2007.

Harris, Lashawn. "Running with the Reds: African American Women and the Communist Party during the Great Depression." *Journal of African American History* 94, no. 1 (Winter 2009): 21–43.

Hartman, Saidiya. *Lose Your Mother: A Journey Along the Atlantic Slave Route*. New York: Farrar, Straus, and Giroux, 2007.

Hawes, Elizabeth. *Why Women Cry; Or Wenches with Wrenches*. Cornwall, N.Y.: Cornwall Press, 1943.

Haynes, John Earl. "Reconsidering Two Questions: On Arnesen's 'No Graver Danger'; Black Anticommunism, the Communist Party, and the Race Question." *Labor: Studies in Working-Class History of the Americas* 3, no. 4 (2006): 53–57.

Haywood, Harry. *Black Bolshevik: Autobiography of an Afro-American Communist*. Chicago: Liberator Press, 1978.

———. *Negro Liberation*. New York: International Publishers, 1948.

Hemenway, Robert. *Zora Neale Hurston: A Literary Biography*. Urbana: University of Illinois Press, 1977.

Herndon, Angelo. *Let Me Live*. New York: Random House, 1937.

Hewitt, Nancy A., and Suzanne Lebsock, eds. *Visible Women: New Essays on American Activism*. Urbana: University of Illinois Press, 1993.

Hicks, Cheryl D. "Confined to Womanhood: Women, Prisons, and Race in the State of New York, 1890–1935." Ph.D. diss., Princeton University, 1999.

Higginbotham, Evelyn Brooks. "African-American Women's History and the Metalanguage of Race." *Signs: A Journal of Women in Culture and Society* 17, no. 2 (Winter 1992): 251–74.

———. *Righteous Discontent: The Women's Movement in the Black Baptist Church, 1880-1920*. Cambridge: Harvard University Press, 1993.

Hill, Rebecca. "Fosterites and Feminists: Or 1950s Ultra-Leftism and the Invention of AmeriKKKa." *New Left Review* 228 (1998): 67–90.

Hill, Robert A., ed. *Marcus Garvey and the UNIA Papers*. Vol. 4. Berkeley: University of California Press, 1985.

Hine, Darlene Clarke. "African American Women and Their Communities in the Twentieth Century: The Foundation and Future of Black Women's Studies." *Black Women, Gender, and Families* 1, no. 1 (Spring 2007): 1–23.

———. "Rape and the Inner Lives of Black Women in the Middle West: Preliminary Thoughts on the Culture of Dissemblance." *Signs: A Journal of Women in Culture and Society* 14 (August 1988): 912–20.

Hirth, Thomas W., ed. *Gay Rebel of the Harlem Renaissance: Selections from the Work of Richard Bruce Nugent*. Durham: Duke University Press, 2002.

Ho, Fred, and Bill V. Mullen, eds. *Afro-Asia: Revolutionary Political and Cultural Connections between African Americans and Asian Americans*. Durham: Duke University Press, 2008.

Hobsbawm, Eric J. *Revolutionaries*. New York: New Press, 2001.

Hobson, Janell. *Venus in the Dark: Blackness and Beauty in Popular Culture*. New York: Routledge, 2005.

Holcomb, Gary Edward. *Claude McKay, Code Name Sasha: Queer Black Marxism and the Harlem Renaissance*. Gainesville: University Press of Florida, 2007.

Honey, Michael. *Going Down the Jericho Road: The Memphis Strike, Martin Luther King's Last Campaign*. New York: W. W. Norton, 2007.

———. *Southern Labor and Black Civil Rights: Organizing Memphis Workers*. Urbana: University of Illinois Press, 1993.

hooks, bell. *Black Looks: Race and Representation*. Boston: South End Press, 1992.

Horne, Gerald. *Black and Red: W. E. B. Du Bois and the Afro-American Response to the Cold War*. Albany: State University of New York Press, 1986.

———. *Black Liberation/Red Scare: Ben Davis and the Communist Party*. Newark: University of Delaware Press, 1994.

———. "Black Thinkers at Sea: Ferdinand Smith and the Decline of African American Proletarian Intellectuals." *Souls: A Critical Journal of Black Culture, Politics and Society* 4, no. 2 (2002): 38–50.

———. *Cold War in a Hot Zone: The United States Confronts Labor and Independence Struggles in the British West Indies*. Philadelphia: Temple University Press, 2007.

———. *Communist Front? The Civil Rights Congress*. London: Associated University Presses, 1988.

———. *The End of Empires: African Americans and India*. Philadelphia: Temple University Press, 2008.

———. *The Fire This Time: The Watts Uprising and the 1960s*. Charlottesville: University of Virginia Press, 1995.

———. *Mau Mau in Harlem? The U.S. and the Liberation of Kenya*. New York: Palgrave Macmillan, 2009.

———. *Race War: White Supremacy and the Japanese Attack on the British Empire*. New York: New York University Press, 2004.

———. *Race Woman: The Lives of Shirley Graham Du Bois*. New York: New York University Press, 2000.

———. *Red Seas: Ferdinand Smith and the Radical Black Sailors in the United States and Jamaica*. New York: New York University Press, 2005.

Horne, Gerald, and Margaret Stevens. "Shirley Graham Du Bois: Portrait of the

Black Woman Artist as a Revolutionary." In *Want to Start a Revolution? Radical Women in the Black Freedom Struggle*, ed. Dayo Gore, Jeanne Theoharis, and Komozi Woodard, 95–114. New York: New York University Press, 2009.

Horowitz, Daniel. *Betty Friedan and the Making of the Feminine Mystique: The American Left, the Cold War, and Modern Feminism*. Amherst: University of Massachusetts Press, 1998.

Howard, Walter T., ed. *Black Communists Speak on Scottsboro*. Philadelphia: Temple University Press, 2009.

Hudson, Hosea. *Black Worker in the Deep South*. New York: International Publishers, 1972.

Hughes, Langston. *I Wonder as I Wander*. 1956. Reprint, New York: Hill and Wang, 1993.

Hunt, Lynn. *Inventing Human Rights: A History*. New York: W. W. Norton, 2007.

Hunter, Tera W. *To 'Joy My Freedom: Southern Black Women's Lives and Labors after the Civil War*. Cambridge: Harvard University Press, 1997.

Hunton, Dorothy. *Alphaeus Hunton: The Unsung Valiant*. New York: Eppress Speed Print, n.d.

Hutchinson, Earl Ofari. *Blacks and Reds: Race and Class in Conflict, 1919–1990*. East Lansing: Michigan State University Press, 1995.

Inman, Mary. *In Woman's Defense*. Los Angeles: Committee to Organize the Advancement of Women, 1940.

Issa, Kai Jackson. "Her Own Book: Autobiographical Practice in the Oral Narratives of Queen Mother Moore." Ph.D. diss., Emory University, 1999.

Isserman, Maurice. *If I Had a Hammer: . . . The Death of the Old Left and the Birth of the New*. New York: Basic Books, 1987.

———. "Three Generations: Historians View American Communism." *Labor History* 26, no. 4 (Fall 1985): 517–45.

———. *Which Side Were You On? The American Communist Party during the Second World War*. Middletown, Conn.: Wesleyan University Press, 1982.

Jackson, Esther Cooper. *This Is My Husband: Fighter for His People, Political Refugee*. Brooklyn: National Committee to Defend Negro Leadership, 1953.

———, ed. *Freedomways Reader: Prophets in Their Own Country*. Boulder, Colo.: Westview Press, 2000.

Jackson, James E., Jr. *Revolutionary Tracings in World Politics and Black Liberation*. New York: International Press, 1974.

Jackson, Kathryn Alice. "Trauma Survivors: Adult Children of McCarthyism and the Smith Act." Ph.D. diss., Temple University, 1991.

James, Joy. "Resting in Gardens, Battling in Deserts: Black Women's Activism." *Black Scholar* 29 (1999): 3–5.

———. *Shadowboxing: Representations of Black Feminist Politics*. New York: Palgrave Macmillan, 2000.

James, Winston. "Being Red and Black in Jim Crow America: Notes on the Ideol-

ogy and Travails of Afro-America's Socialist Pioneers." *Souls: A Critical Journal of Black Culture, Politics and Society* 1, no. 4 (Fall 1999): 45–63.

———. *Holding Aloft the Banner of Ethiopia: Caribbean Radicalism in Early Twentieth-Century America*. London and New York: Verso, 1998.

Janken, Kenneth R. "Anticommunism or Anti-Communist Party? A Response to Eric Arnesen." *Labor: Studies in Working-Class History of the Americas* 3, no. 4 (Winter 2006): 69–74.

Johanningsmeier, Edward P. *Forging American Communism: The Life of William Z. Foster*. Princeton: Princeton University Press, 1999.

Johnson, Buzz. *"I Think of My Mother": Notes on the Life of Claudia Jones*. London: Karia Press, 1985.

Johnson, David K. *The Lavender Scare: The Cold War Persecution of Gays and Lesbians in the Federal Government*. Chicago: University of Chicago Press, 2004.

Johnson, E. Patrick. *Appropriating Blackness: Performance and the Politics of Authenticity*. Durham: Duke University Press, 2004.

Jones, Claudia. *Ben Davis, Fighter for Freedom*. New York: New Century Publishers, 1954.

———. "The Caribbean in Britain." *Freedomways* 4, no. 3 (Summer 1964): 341–57.

———. "An End to the Neglect of the Problem of the Negro Woman!" *Political Affairs* 28, no. 6 (June 1949): 51–67.

———. "For New Approaches to Our Work among Women." *Political Affairs* 27, no. 8 (August 1948): 738–43.

———. "For the Unity of Women in the Cause of Peace." *Political Affairs* 30, no. 2 (February 1951): 151–68.

———. "Foster's Political and Theoretical Guidance to Our Work among Women." *Political Affairs* 30, no. 3 (March 1951): 68–78.

———. "International Women's Day and the Struggle for Peace." *Political Affairs* 29, no. 3 (March 1950): 32–45.

———. *Jim-Crow in Uniform*. New York: New Age Publishers, 1940.

———. *Lift Every Voice—For Victory!* New York: New Age Publishers, 1942.

———. "New Problems of the Negro Youth Movement." *Clarity* 1, no. 2 (Summer 1940): 54–64.

———. "On the Right to Self-Determination for the Negro People in the Black Belt." *Political Affairs* 25, no. 1 (January 1946): 67–77.

———. "The Struggle for Peace in the United States." *Political Affairs* 31, no. 2 (February 1952): 1–20.

Jones, Jacqueline. *Labor of Love, Labor of Sorrow: Black Women, Work and the Family, from Slavery to the Present*. New York: Vintage Books, 1985.

Jordan, June. "For Beautiful Mary Brown." *Freedomways* 11, no. 2 (1971): 191.

Joseph, Peniel E. *Dark Days, Bright Nights: From Black Power to Barack Obama*. New York: Basic Civitas Books, 2010.

———. *Waiting 'Til the Midnight Hour: A Narrative History of Black Power in America*. New York: Henry Holt, 2006.

Kaiser, Ernest. "25 Years of *Freedomways*." *Freedomways* 25, no. 3 (Fall 1985): 204–15.

Kamp, Marianne. *The New Woman in Uzbekistan: Islam, Modernity, and Unveiling under Communism*. Seattle: University of Washington Press, 2006.

Kaplan, Caren. "The Politics of Location as Transnational Feminist Critical Practice." In *Scattered Hegemonies: Postmodernity and Transnational Feminist Practices*, ed. Inderpal Grewal and Caren Kaplan, 137–52. Minneapolis: University of Minnesota Press, 1994.

Kaplan, Judith, and Linn Shapiro, eds. *Red Diapers: Growing Up in the Communist Left*. Urbana: University of Illinois Press, 1998.

Keeran, Roger. *The Communist Party and the Autoworkers' Union*. New York: International Publishers, 1980.

———. "National Groups and the Popular Front: The Case of the International Workers." *Journal of American Ethnic History* 14 (Spring 1995): 23–29.

Kelley, Robin D. G. "'But a Local Phase of a World Problem': Black History's Global Vision, 1883–1950." *Journal of American History* 86, no. 3 (December 1999): 1045–77.

———. *Freedom Dreams: The Black Radical Imagination*. Boston: Beacon Press, 2002.

———. *Hammer and Hoe: Alabama Communists during the Great Depression*. Chapel Hill: University of North Carolina Press, 1990.

———. *Race Rebels: Culture, Politics, and the Black Working Class*. New York: Free Press, 1994.

———. "Reconstructing Black (Inter)Nationalism in the Cold War Era." In *Is It Nation Time? Contemporary Essays on Black Power and Black Nationalism*, ed. Eddie Glaude, 67–90. Chicago: University of Chicago Press, 2002.

———. *Yo Mama's Dysfunktional! Fighting the Cultural Wars in Urban America*. Boston: Beacon Press Books, 1997.

Kerber, Linda, Alice Kessler-Harris, and Kathryn Kish Sklar, eds. *U.S. History as Women's History: New Feminist Essays*. Chapel Hill: University of North Carolina Press, 1995.

Kimmel, Michael S. *Manhood in America: A Cultural History*. New York: Oxford University Press, 2006.

Klehr, Harvey, and John Earl Haynes. *The Soviet World of American Communism*. New Haven: Yale University Press, 1998.

Klehr, Harvey, John Earl Haynes, and Fridrikh Igorevich Firsov, eds. *The Secret World of American Communism*. New Haven: Yale University Press, 1995.

Kollontai, Alexandra. *Red Love*. New York: Seven Arts Publishing Company, 1927.

Kornweibel, Theodore. *Seeing Red: Federal Campaigns against Black Militancy, 1919–1925*. Bloomington: Indiana University Press, 1998.

Korstad, Robert Rodgers. *Civil Rights Unionism: Tobacco Workers and the Struggle for Democracy in the Mid-Twentieth-Century South*. Chapel Hill: University of North Carolina Press, 2003.

Korstad, Robert Rodgers, and Nelson Lichtenstein. "Opportunities Found and Lost:

Labor, Radicals and the Early Civil Rights Movement." *Journal of American History* 75, no. 3 (December 1988): 786–811.

Koven, Seth, and Sonya Michel. *Mothers of a New World: Maternalist Politics and the Origins of Welfare States*. New York: Routledge, 1993.

Kruks, Sonia, et al. *Promissory Notes: Women in the Transition to Socialism*. New York: Monthly Review Press, 1989.

Kuumba, M. Bahti. *Gender and Social Movements*. Walnut Creek, Calif.: AltaMira Press, 2001.

Landy, Avram. *Marxism and the Woman Question*. New York: Workers Library, 1943.

———. "Two Questions on the Status of Women under Capitalism." *Communist* 20, no. 9 (September 1941): 818–33.

Lau, Peter F. *Democracy Rising: South Carolina and the Fight for Black Equality since 1865*. Lexington: University of Kentucky Press, 2006.

Laughlin, Kathleen A., et al. "Is It Time to Jump Ship? Historians Rethink the Waves Metaphor." *Feminist Formations* 22, no. 1 (Spring 2010): 76–135.

Lee, Chana Kai. *For Freedom's Sake: The Life of Fannie Lou Hamer*. Urbana: University of Illinois Press, 1999.

Lewis, David L. *W. E. B. Du Bois: The Biography of a Race, 1868-1919*. New York: Henry Holt and Company, 1993.

———. *W. E. B. Du Bois: The Fight for Equality and the American Century, 1919-1963*. New York: Henry Holt and Company, 2000.

Lewis, George. *The White South and the Red Menace: Segregationists, Anticommunism, and Massive Resistance*. Gainesville: University of Florida Press, 2004.

Lieberman, Robbie. *The Strangest Dream: Communism, Anti-Communism, and the U.S. Peace Movement, 1945-1963*. Syracuse: Syracuse University Press, 2001.

Lieberman, Robbie, and Clarence Lang, eds. *Anticommunism and the African American Freedom Movement: "Another Side of the Story."* New York: Palgrave Macmillan, 2009.

Lipsitz, George. *Rainbow at Midnight: Labor and Culture in the 1940s*. Urbana: University of Illinois Press, 1994.

Logan, Rayford. *The Negro in American Life and Thought: The Nadir, 1877-1901*. New York: Dial Press, 1954.

Lorde, Audre. "Prologue." *Freedomways* 12, no. 1 (1972): 31–33.

———. *Zami: A New Spelling of My Name*. Freedom, Calif.: Crossing Press, 1982.

Lubiano, Wahneema. "Black Nationalism and Common Sense." In *The House That Race Built*, ed. Wahneema Lubiano, 232–52. New York: Vintage Books, 1998.

Makalani, Minkah. "For the Liberation of Black People Everywhere: The African Blood Brotherhood, Black Radicalism, and Pan-African Liberation in the New Negro Movement, 1917–1936." Ph.D. diss., University of Illinois, 2004.

Malcolm X. *The Autobiography of Malcolm X*. New York: Ballantine Books, 1965.

Marable, Manning. *Race, Reform, and Rebellion: The Second Reconstruction and Beyond in Black America, 1945-2006*. Jackson: University of Mississippi Press, 2007.

Marks, Carole. *Farewell, We're Good and Gone: The Great Black Migration*. Bloomington: Indiana University Press, 1989.

Marshall, Paule. *Triangular Road: A Memoir*. New York: Basic Civitas, 2009.

Martin, Charles. *The Angelo Herndon Case and Southern Justice*. Baton Rouge: Louisiana State University Press, 1976.

———. "The Civil Rights Congress and Southern Defendants." *Georgia Historical Quarterly* 71, no. 1 (Spring 1987): 25–52.

———. "Internationalizing 'The American Dilemma': The Civil Rights Congress and the 1951 Genocide Petition to the United Nations." *Journal of American Ethnic History* 16, no. 4 (Summer 1997): 35–61.

———. "Race, Gender, and Southern Justice: The Rosa Lee Ingram Case." *American Journal of Legal History* 29, no. 3 (1985): 251–68.

Martin, Elmer P., and Joanne M. Martin. "Thyra Edwards: International Social Worker." In *African American Leadership: An Empowerment Tradition in Social Welfare History*, ed. Iris B. Carlton-LaNey, 163–77. Washington: National Association of Social Workers, 2001.

Martin, Tony. *Race First: The Ideological and Organizational Struggles of Marcus Garvey and the Universal Negro Improvement Association*. Westport, Conn.: Greenwood Press, 1976.

———, ed. *African Fundamentalism: A Literary and Cultural Anthology of Garvey's Harlem Renaissance*. Dover, Mass.: Majority Press, 1983.

Marx, Karl. *Capital: A Critique of Political Economy*. Vol. 1. New York: Penguin Books, 1990.

———. *Capital: A Critique of Political Economy*. Vol. 3. New York: Penguin, 1991.

Matusevich, Maxim. "Journeys of Hope: African Diaspora and the Soviet Union." *African Diaspora* 1 (2008): 53–85.

Maxwell, William. *New Negro and Old Left: African American Writing and Communism between the Wars*. New York: Columbia University Press, 1999.

May, Claudia Rosemary. "Nuances of Un-American Literature(s): In Search of Claudia Jones; A Literary Retrospective of the Life, Times, and Works of an Activist/Writer." Ph.D. diss., University of California, Berkeley, 1996.

May, Elaine Tyler. "Explosive Issues: Sex, Women, and the Bomb." In *Recasting America, Culture and Politics in the Age of the Cold War*, ed. Lary May, 157–70. Chicago: University of Chicago Press, 1988.

———. *Homeward Bound: American Families in the Cold War Era*. New York: Basic Books, 1988.

May, Lary, ed. *Recasting America: Culture and Politics in the Age of Cold War*. Chicago: University of Chicago Press, 1989.

May, Vanessa. "Working in Public and in Private: Domestic Service, Women's Reform, and the Meaning of the Middle-Class Home in New York City, 1870–1940." Ph.D. diss., University of Virginia, 2007.

McAdam, Doug. "Gender as a Mediator of the Activist Tradition: The Case of Freedom Summer." *American Journal of Sociology* 97, no. 5 (March 1992): 1211–40.

McBride, Dwight A. "Can the Queen Speak? Racial Essentialism, Sexuality and the Problem of Authority." *Callaloo* 21, no. 2 (1998): 363–79.

McClellan, Woodford. "Africans and Black Americans in the Comintern Schools, 1925–1934." *International Journal of African Historical Studies* 26, no. 2 (1993): 371–88.

McDuffie, Erik S. "'I wanted a Communist philosophy, but I wanted us to have a chance to organize our people': The Diasporic Radicalism of Queen Mother Audley Moore and the Origins of Black Power." *African and Black Diaspora: An International Journal* 3, no. 2 (July 2010): 181–95.

———. "Long Journeys: Four Black Women and the Communist Party, USA, 1930–1956." Ph.D. diss., New York University, 2003.

———. "The March of Young Southern Black Women: Esther Cooper Jackson, Black Left Feminism, and the Personal Costs of Cold War Repression." In *Anticommunism and the African American Freedom Movement: "Another Side of the Story,"* ed. Robbie Lieberman and Clarence Lang, 81–114. New York: Palgrave, 2009.

———. "A 'New Freedom Movement of Negro Women': Sojourning for Truth, Justice, and Human Rights during the Early Cold War." *Radical History Review* 101 (Spring 2008): 81–106.

———. "'[She] Devoted Twenty Minutes Condemning All Other Forms of Government but the Soviet': Black Women Radicals in the Garvey Movement and in the Left during the 1920s." In *Diasporic Africa: A Reader*, ed. Michael A. Gomez, 219–50. New York: New York University Press, 2006.

McGuire, Danielle. "'It Was Like All of Us Had Been Raped': Sexual Violence, Community Mobilization, and the African American Freedom Struggle." *Journal of American History* 91, no. 3 (December 2004): 906–31.

McKay, Claude. *Harlem: Negro Metropolis*. New York: E. P. Dutton and Company, 1940.

———. *The Negroes in America*. Trans. from the Russian by Robert J. Winter. Ed. Alan L. McLeod. 1924. Reprint, Port Washington, N.Y.: Kennikat Press, 1979.

McNeil, Genna Rae. "'Joanne is You and Joanne is Me'": A Consideration of African American Women and the 'Free Joan Little' Movement, 1974–1975." In *Sisters in the Struggle: African American Women in the Civil Rights–Black Power Movement*, ed. V. P. Franklin and Bettye Collier-Thomas, 259–79. New York: New York University Press, 2001.

McWhorter, Diane. *Carry Me Home: Birmingham, Alabama, the Climactic Battle of the Civil Rights Revolution*. New York: Simon and Schuster, 2001.

Meerpool, Robert. "Carry It Forward." In *Red Diapers: Growing Up in the Communist Left*, eds. Judith Kaplan and Linn Shapiro, 210–13. Urbana: University of Illinois Press, 1998.

Meriwether, James H. *Proudly We Can Be Africans: Black Americans and Africa, 1935–1961*. Chapel Hill: University of North Carolina Press, 2002.

The Messenger: The World's Greatest Monthly. Reprint, New York: Negro University Press, 1969.

Millard, Betty. *Woman against Myth.* New York: International Publishers, 1948.

Miller, James A. *Remembering Scottsboro: The Legacy of an Infamous Trial.* Princeton: Princeton University Press, 2009.

Miller, James A., Susan D. Pennybacker, and Eve Rosenhaft. "Mother Ada Wright and the International Campaign to Free the Scottsboro Boys, 1931–1934." *American Historical Review* 106, no. 2 (April 2001): 387–430.

Mishler, Paul C. *Raising Reds: The Young Pioneers, Radical Summer Camps, and Communist Political Culture in the United States.* New York: Columbia University Press, 1999.

Mitchell, Dolores. "The 'New Woman' as Prometheus: Women Artists Depict Women Smoking." *Woman's Art Journal* 12, no. 1 (Spring–Summer 1991): 3–9.

Moallem, Minoo. *Between Warrior Brother and Veiled Sister: Islamic Fundamentalism and the Politics of Patriarchy in Iran.* Berkeley: University of California Press, 2005.

Mohanty, Chandra Talpade. *Feminism without Borders: Decolonizing Theory, Practicing Solidarity.* Durham: Duke University Press, 2004.

Mohanty, Chandra, et al. *Third World Women and the Politics of Feminism.* Bloomington: Indiana University Press, 1991.

Mollin, Marian. *Radical Pacifism in Modern America: Egalitarianism and Protest.* Philadelphia: University of Pennsylvania Press, 2006.

Moore, Audley. *Why Reparations? Reparations Is the Battle Cry for the Economic and Social Freedom of More Than 25 Million Descendants of American Slaves.* Los Angeles: Reparations Committee Inc., n.d.

Mullen, Bill V. *Afro-Orientalism.* Minneapolis: University of Minnesota Press, 2006.

———. *Popular Fronts: Chicago and African-American Cultural Politics, 1935–1946.* Urbana: University of Illinois Press, 1999.

Mutua, Athena D. "Introduction: Mapping the Contours of Progressive Black Masculinities." In *Progressive Black Masculinities*, ed. Athena D. Mutua, xi–xxviii. New York: Routledge, 2006.

———. "Theorizing Progressive Black Masculinities." In *Progressive Black Masculinities*, ed. Athena D. Mutua, 3–42. New York: Routledge, 2006.

Nadasen, Premilla. *Welfare Warriors: The Welfare Rights Movement in the United States.* New York: Routledge, 2005.

Naison, Mark. *Communists in Harlem during the Depression.* New York: Grove Press, 1983.

Najmabadi, Afsaneh. "Gender and Secularism of Modernity: How Can a Muslim Woman Be French?" *Feminist Studies* 32, no. 2 (Summer 2006): 239–55.

Nash, Michael, and Daniel J. Leab. "*Freedomways.*" *American Communist History* 7, no. 2 (December 2008): 227–37.

National Negro Congress, and A. Phillip Randolph. *Resolutions of the National Negro Congress held in Chicago, Ill., February 14, 15, 16, 1936.* Washington: The Congress, 1936.

Neal, Mark Anthony. *New Black Man.* New York: Routledge, 2006.

"The Negro Woman in American Literature." *Freedomways* 6, no. 1 (1966): 8–25.

Nelson, Claire Nee. "Louise Thompson Patterson and the Roots of the Popular Front." In *Women Shaping the South: Creating and Confronting Change*, ed. Angela Boswell and Judith N. McArthur, 204–28. Columbia: University of Missouri Press, 2006.

Nelson, Jennifer. *Women of Color and the Reproductive Rights Movement*. New York: New York University Press, 2003.

Nesbitt, Francis Njubi. *Race for Sanctions: African Americans against Apartheid*. Bloomington: Indiana University Press, 2004.

The New Oxford Annotated Bible, NRSV. New York: Oxford University Press, 1994.

Northrop, Douglas. *Veiled Empire: Gender and Power in Stalinist Central Asia*. Ithaca: Cornell University Press, 2004.

Orleck, Annelise. *Common Sense and a Little Fire: Women and Working-Class Politics in the United States, 1900–1965*. Chapel Hill: University of North Carolina Press, 1995.

Ottanelli, Fraser M. *The Communist Party of the United States: From the Depression to World War II*. New Brunswick, Rutgers University Press, 1991.

Ottley, Roi. *"New World A-Coming": Inside Black America*. New York: Arno Press, 1968. First published 1943 by Houghton Mifflin Company.

Padmore, George. *The Life and Struggles of Negro Toilers*. London: 1931.

Painter, Nell Irvin. *The Narrative of Hosea Hudson: His Life as a Negro Communist in the South*. Cambridge: Harvard University Press, 1979.

———. "Representing Truth: Sojourner Truth's Knowing and Becoming Known." *Journal of American History* 81, no. 2 (September 1994): 461–92.

Palmer, Bryan D. *James P. Cannon and the Origins of the American Revolutionary Left*. Urbana: University of Illinois Press, 2007.

Parascandola, Louis J. "Cyril Briggs and the African Blood Brotherhood: A Radical Counterpart to Progressivism." *Afro-Americans in New York Life and History* 30, no. 1 (January 2006): 7–18.

Paris, Guichard, and Lester Brooks. *Blacks in the City: A History of the National Urban League*. Boston: Little, Brown and Company, 1971.

Parmar, Pratihba, dir. *Place of Rage*. VHS. Women Make Movies, 1991.

Patai, Frances. "Heroines of the Good Fight: Testimonies of U.S. Volunteer Nurses in the Spanish Civil War, 1936–1939." *Nursing History Review* 3 (1995): 79–104.

Patterson, Tiffany Ruby. *Zora Neale Hurston and a History of Southern Life*. Philadelphia: Temple University Press, 2005.

Patterson, Tiffany Ruby, and Robin D. G. Kelley. "Unfinished Migrations: Reflections on the African Diaspora and the Making of the Modern World." *African Studies Review* 43, no. 1 (April 2000): 11–45.

Patterson, William L. *The Man Who Cried Genocide: An Autobiography*. New York: International Publishers, 1971.

———. *We Charge Genocide*. New York: International Publishers, 1951.

Patton, Cindy, and Benigno Sánchez-Eppler, eds. *Queer Diasporas*. Durham: Duke University Press, 2000.

Perry, Jeffrey B. *Hubert Harrison: The Voice of Harlem Radicalism, 1883–1918.* Vol. 1. New York: Columbia University Press, 2009.

Petry, Ann. *The Street.* Boston: Houghton Mifflin Company, 1946.

Pickard, Toni, Phil Goldman, Renate M. Mohr, and Rosemary Cairns-Way. *Dimension of Criminal Law.* 3rd ed. Toronto: Emond Montgomery, 2002.

Plummer, Brenda Gayle. *Rising Wind: Black Americans and U.S. Foreign Affairs, 1935–1960.* Chapel Hill: University of North Carolina Press, 1996.

Ponce, Martin Joseph. "Langston Hughes's Queer Blues." *Modern Language Quarterly* 66, no. 4 (December 2005): 505–37.

Power of the Word 1, no. 2 (March–May 2001).

Prashard, Vijay. *The Darker Nations: A People's History of the Third World.* New York: New Press, 2007.

Rabinowitz, Paula. *Labor and Desire: Women's Revolutionary Fiction in Depression America.* Chapel Hill: University of North Carolina Press, 1991.

Rampersad, Arnold. *The Life of Langston Hughes.* Vol. 1, *1902–1941, I, Too, Sing America.* New York: Oxford University Press, 1986.

Ransby, Barbara. *Ella Baker and the Black Freedom Movement: A Radical Democratic Vision.* Chapel Hill: University of North Carolina Press, 2003.

———. "Black Feminism at Twenty-One: Reflections on the Evolution of a National Community," *Signs: A Journal of Women in Culture and Society* 25, no. 4 (Summer 2000): 1215–21.

Richards, Johnetta. "The Southern Negro Youth Congress: A History." Ph.D. diss., University of Cincinnati, 1987.

Richards, Yevette. *Maida Springer: Pan Africanist and International Labor Leader.* Pittsburgh: University of Pittsburgh Press, 2000.

Richardson, Beulah. "A Black Woman Speaks of White Womanhood, of White Supremacy, of Peace." New York: American Women for Peace, 1951.

Rief, Michelle M. "Thinking Locally, Acting Globally: The International Agenda of African American Clubwomen, 1880–1940." *Journal of African American History* 89, no. 3 (Summer 2004): 203–22.

Rise, Eric. *The Martinsville Seven: Race, Rape, and Capital Punishment.* Charlottesville: University of Virginia Press, 1995.

Robinson, Cedric. *Black Marxism: The Making of the Black Radical Tradition.* Chapel Hill: University of North Carolina Press, 2000.

Robinson, Nancy Marie. *Christian Sisterhood, Race Relations, and the YWCA, 1906–1946.* Urbana: University of Illinois Press, 2007.

Robnett, Belinda. *How Long? How Long? African-American Women in the Struggle for Civil Rights.* New York: Oxford University Press, 1997.

Roediger, David R. *How Race Survived the U.S. History from Settlement and Slavery to the Obama Phenomenon.* London: Verso, 2008.

———. *Wages of Whiteness: Race and Making of the American Working Class.* Rev. ed. New York: Verso, 1999.

Rolinson, Mary G. *Grassroots Garveyism: The Universal Negro Improvement Asso-*

ciation in the Rural South, 1920–1927. Chapel Hill: University of North Carolina Press, 2007.

Rosengarten, Theodore. All God's Dangers: The Life of Nate Shaw. New York: Alfred A. Knopf, 1974.

Roth, Benita. Separate Roads to Feminism: Black, Chicana, and White Feminist Movements in America's Second Wave. Cambridge: Cambridge University Press, 2004.

Rupp, Leila J. Worlds of Women: The Making of an International Women's Movement. Princeton: Princeton University Press, 1997.

Rupp, Leila J., and Verta Taylor. Survival in the Doldrums: The American Women's Rights Movement, 1945 to the 1960s. New York: Oxford University Press, 1987.

————. "Forging Feminist Identity in an International Movement: A Collective Identity Approach to Twentieth Century Feminism." Signs: A Journal of Women in Culture and Society 24, no. 2 (Winter 1999): 363–86.

Rzeszutek, Sara E. "'All those rosy dreams we cherish': James Jackson and Esther Cooper's Marriage on the Front Lines of the Double Victory." American Communist History 7, no. 2 (December 2008): 211–25.

Sabin, Arthur J. Red Scare in Court: New York versus the International Workers Order. Philadelphia: University of Pennsylvania Press, 1993.

Sahadeo, Jeff. Russian Colonial Society in Tashkent, 1865–1923. Bloomington: Indiana University Press, 2007.

Said, Edward W. Orientalism. New York: Pantheon Books, 1978.

Sandoval, Chela. Methodology of the Oppressed. Minneapolis: University of Minnesota Press, 2000.

Saunders, Patricia J. "Woman Overboard: The Perils of Sailing the Black Atlantic, Deportation with Prejudice." Small Axe: A Caribbean Journal of Criticism 28, no. 1 (March 2009): 203–17.

Scharf, Lois, and Joan M. Jensen, eds. Decades of Discontent: The Women's Movement, 1920–1940. Rev. ed. Boston: Northeastern University Press, 1987.

Scharfman, Rachel. "On Common Ground: Freethought and Radical Politics in New York City, 1890–1917." Ph.D. diss., New York University, 2005.

Schrecker, Ellen. Many Are the Crimes: McCarthyism in America. Princeton: Princeton University Press, 1998.

Schrecker, Ellen, and Maurice Isserman. "The Right's Cold War Revision: Current Espionage Fears Have Given New Life to Liberal Anticommunism." Nation (24–31 July 2000): 23–24.

Schwarz, A. B. Christa. Gay Voices of the Harlem Renaissance. Bloomington: Indiana University Press, 2003.

Scott, Della. "An Interview with Esther Jackson." Abafazi: The Simmons College Journal of Women of African Descent 9, no. 1 (Fall/Winter 1998): 2–9.

Scott, William R. The Sons of Sheba's Race: African-Americans and the Italo-Ethiopian War, 1935–1941. Bloomington: University of Indiana Press, 1993.

Sergrave, Kerry. Women and Smoking in America, 1880–1950. Jefferson, N.C.: McFarland and Company, 2005.

Sernett, Milton C. *Harriet Tubman: Myth, Memory, and History*. Durham: Duke University Press, 2007.

Shakur, Assata. *Assata: An Autobiography*. Chicago: Lawrence Hill Books, 1987.

Shapiro, Linn. "Red Feminism: American Communism and the Women's Rights Tradition, 1919–1956." Ph.D. diss., American University, 1996.

Shaw, Stephanie J. *What a Woman Ought to Be and to Do: Black Professional Women Workers during the Jim Crow Era*. Chicago: University of Chicago Press, 1996.

Sherwood, Marika. *Claudia Jones: A Life in Exile*. London: Lawrence and Wishart, 1999.

Singh, Nikhil Pal. *Black Is a Country: Race and the Unfinished Struggle for Democracy*. Cambridge: Harvard University Press, 2004.

Smethurst, James Edward. *The Black Arts Movement: Literary Nationalism in the 1960s and 1970s*. Chapel Hill: University of North Carolina Press, 2005.

Smith, Barbara. "Black Women in Film Symposium." *Freedomways* 14, no. 3 (1974): 266–69.

Smith, Jessica. *Women in Soviet Russia*. New York: Vanguard Press, 1928.

Solomon, Mark. *The Cry Was Unity: Communists and African Americans, 1917–1936*. Jackson: University Press of Mississippi, 1998.

———. "Recovering a Lost Legacy: Black Women Radicals; Maude White and Louise Thompson Patterson." *Abafazi* (Fall/Winter 1995): 6–13.

Somerville, Siobhan B. *Queering the Color Line: Race and the Invention of Homosexuality in American Culture*. Durham: Duke University Press, 2000.

Sowinska, Suzanne. "American Women Writers and the Radical Agenda, 1925–1940." Ph.D. diss., University of Washington, 1992.

Springer, Kimberly. *Living for the Revolution: Black Feminist Organizations, 1968–1980*. Durham: Duke University Press, 2005.

Stansell, Christine. *American Moderns: Bohemian New York and the Creation of a New Century*. New York: Metropolitan Books, 2000.

Stein, Judith. *The World of Marcus Garvey: Race and Class in Modern Society*. Baton Rouge: Louisiana State University Press, 1986.

Stephens, Michelle Ann. *Black Empire: The Masculine Global Imaginary of Caribbean Intellectuals in the United States, 1914–1962*. Durham: Duke University Press, 2005.

Storch, Randi. *Red Chicago: American Communism at Its Grassroots, 1928–35*. Urbana: University of Illinois Press, 2007.

Storrs, Landon. "Left-Feminism, the Consumer Movement, and Red Scare Politics in the United States, 1935–1960." *Journal of Women's History* 18, no. 3 (2006): 40–67.

———. "Red Scare Politics and the Suppression of Popular Front Feminism: The Loyalty Investigation of Mary Dublin Keyserling." *Journal of American History* 90, no. 2 (September 2003): 491–524.

Streater, John B. "The National Negro Congress, 1936–1947." Ph.D. diss., University of Cincinnati, 1981.

Strong, Anna Louise. *I Change Worlds: The Remaking of an American*. New York: Henry Holt, 1935.

Strong, Augusta. "Southern Youth's Proud Heritage." *Freedomways* 4, no. 1 (1964): 35–50.

Sullivan, Patricia. *Days of Hope: Race and Democracy in the New Deal Era*. Chapel Hill: University of North Carolina Press, 1996.

Swerdlow, Amy. "The Congress of American Women: Left-Feminist Peace Politics in the Cold War." In *U.S. History as Women's History*, ed. Linda K. Kerber, Alice Kessler-Harris, and Kathryn Kish Sklar, 296–312. Chapel Hill: University of North Carolina Press, 1995.

———. *Women Strike for Peace: Traditional Motherhood and Radical Politics in the 1960s*. Chicago: University of Chicago Press, 1993.

Tarrow, Sidney. *Power in Movement: Social Movement and Contentious Politics*. 2nd ed. Cambridge: Cambridge University Press, 1998.

Taylor, Ula Y. "Street Strollers: Grounding the Theory of Black Women Intellectuals." *Afro-Americans in New York Life and History* 30, no. 2 (July 2006): 153–71.

———. *The Veiled Garvey: The Life and Times of Amy Jacques Garvey*. Chapel Hill: University of North Carolina Press, 2002.

Taylor, Verta. "Social Movement Continuity: The Women's Movement in Abeyance." *American Sociological Review* 54 (October 1989): 761–75.

Taylor, Verta, and Nancy E. Whittier. "Collective Identity in Social Movement Communities: Lesbian Feminist Mobilizations." In *Frontiers in Social Movement Theory*, ed. Aldon D. Morris and Carol McClurg Mueller, 104–29. New Haven: Yale University Press, 1992.

Terborg-Penn, Rosalyn, and Andrea Benton Rushing, eds. *Women in Africa and the African Diaspora*. 2nd ed. Washington: Howard University Press, 1996.

Terrell, Mary Church. *A Colored Woman in a White World*. Washington: National Association of Colored Women's Clubs, Inc., 1968.

Theoharis, Jeanne, and Komozi Woodard, eds. *Freedom North: Black Freedom Struggles Outside the South, 1940–1980*. New York: Palgrave Macmillan, 2003.

Thomas, Hugh. *The Spanish Civil War*. New York: Harper and Brothers, 1961.

Thompson, Louise. "And So We Marched." *Working Woman* (June 1933): 6.

———. "My Southern Terror." *The Crisis* (November 1934): 327–28.

———. "Negro Women in Our Party." *Party Organizer* 10 (August 1937): 25–27.

———. "Toward a Brighter Dawn." *Woman Today* (April 1936): 14, 30.

Trotter, Joe William, ed. *The Great Migration in Historical Perspective: New Dimensions of Race, Class, and Gender*. Bloomington: Indiana University Press, 1991.

Turner, Joyce Moore. *Caribbean Crusaders and the Harlem Renaissance*. Urbana: University of Illinois Press, 2005.

Turner, Joyce Moore, and W. Bughardt Turner, eds. *Richard B. Moore: Caribbean Militant in Harlem*. Bloomington: Indiana University Press, 1988.

Tyson, Jennifer, *Claudia Jones, 1915–1964: A Woman of Our Times*. London: Black Sister Publications, 1988.

Valk, Anne M. *Radical Sisters: Second Wave Feminism and Black Liberation in Washington, D.C.* Urbana: University of Illinois Press, 2008.

Vogel, Lise. *Marxism and the Oppression of Women: Toward a Unitary Theory.* New Brunswick: Rutgers University Press, 1983.

Vogel, Shane. "Closing Time: Langston Hughes and the Queer Poetics of Harlem Nightlife." *Criticism* 48, no. 3 (Summer 2006): 397–425.

Von Eschen, Penny. *Race against Empire: Black Americans and Anticolonialism, 1937–1957.* Ithaca: Cornell University Press, 1997.

Wald, Alan M. *Trinity of Passion: The Literary Left and the Antifascist Crusade.* Chapel Hill: University of North Carolina Press, 2007.

Walker, Alice. "The Abduction of Saints." *Freedomways* 15, no. 4 (1975): 266–67.

———. "Facing the Way." *Freedomways* 15, no. 4 (1975): 265.

———. "Rock Eagle." *Freedomways* 11, no. 4 (1971): 367.

Walker, Cheryl. *Women and Resistance in South Africa.* New York: Monthly Review Press, 1982.

Walker, Thomas J. E. *Pluralistic Fraternity: The History of the International Worker's Order.* New York: Garland Publishing, 1991.

Wall, Cheryl. *Women of the Harlem Renaissance.* Bloomington: Indiana University Press, 1995.

Ward, Stephen. "The Third World Women's Alliance: Black Feminist Radicalism and Black Power Radicalism." In *The Black Power Movement: Rethinking the Civil Rights–Black Power Era*, ed. Peniel E. Joseph, 119–44. New York: Routledge, 2006.

Ware, Caroline F. *The Consumer Goes to War: A Guide on Victory on the Home Front.* New York: Funk and Wagnalls, 1942.

Ware, Susan. *Holding Their Own: American Women in the 1930s.* Boston: Twayne Publishers, 1982.

Washington, Mary Helen. "Alice Childress, Lorraine Hansberry, and Claudia Jones: Black Women Write the Popular Front." In *Left of the Color Line: Race, Radicalism, and Twentieth Century Literature of the United States*, ed. Bill V. Mullen and James Smethurst, 183–204. Chapel Hill: University of North Carolina Press, 2003.

Watkins-Ownes, Irma. *Blood Relations: Caribbean Immigrants and the Harlem Community, 1900–1930.* Bloomington: Indiana University Press, 1996.

Watts, Jill. *God, Harlem U.S.A.: The Father Divine Story.* Berkeley: University of California Press, 1992.

Weigand, Kate. *Red Feminism: American Communism and the Making of Women's Liberation.* Baltimore: Johns Hopkins University Press, 2001.

Welch, Rebeccah E. "Gender and Power in the Black Diaspora: Radical Women of Color and the Cold War." *Souls: A Critical Journal of Black Culture, Politics and Society* 5, no. 3 (Summer 2003): 71–82.

———. "Spokesman of the Oppressed? Lorraine Hansberry at Work: The Challenge of Radical Politics in the Postwar Era." *Souls: A Critical Journal of Black Culture, Politics and Society* 9, no. 4 (October 2007): 302–19.

West, Michael O., William G. Martin, and Fanon Che Wilkins, eds. *From Touissant*

to Tupac: *The Black International since the Age of Revolution*. Chapel Hill: University of North Carolina Press, 2009.

Westad, Odd Arne. *The Global Cold War: Third World Interventions and the Making of Our Times*. Cambridge: Cambridge University Press, 2005.

White, Deborah Gray. *Too Heavy a Load: Black Women in Defense of Themselves, 1894–1994*. New York: W. W. Norton, 1999.

White, E. Frances. "Africa on My Mind: Gender, Counterdiscourse, and African American Nationalism." *Journal of Women's History* 2, no. 1 (Spring 1990): 73–97.

———. *Dark Continent of Our Bodies: Black Feminism and the Politics of Respectability*. Philadelphia: Temple University Press, 2001.

White, Maude. "Special Negro Demands." *Labor Unity* 7, no. 5 (May 1932): 11.

Wilkins, Fanon Che. "Beyond Bandung: The Critical Nationalism of Lorraine Hansberry, 1950–1965." *Radical History Review* 95 (Spring 2006): 191–210.

Williams, Rhonda M. "Living at the Crossroads: Explorations in Race, Nationality, Sexuality, and Gender." *The House That Race Built*, ed. Wahneema Lubiano, 136–56. New York: Vintage Books, 1998.

Williams, Rhonda Y. *Politics of Public Housing: Black Women's Struggles against Urban Inequality*. New York: Oxford University Press, 2004.

Wilson, Bobby M. *America's Johannesburg: Industrialization and Racial Transformation in Birmingham*. Lanham, Md.: Rowman and Littlefield Publishers, 2000.

Winter, Ella. *Red Virtue: Human Relationships in the New Russia*. New York: Harcourt, Brace, and Company, 1933.

Wise, Tim. *Colorblind: The Rise of Post-Racial Politics and the Retreat from Racial Equity*. San Francisco: City Lights Books, 2010.

Wolcott, Victoria W. *Remaking Respectability: African American Women in Interwar Detroit*. Chapel Hill: University of North Carolina Press, 2001.

Wolters, Raymond. *Negroes and the Great Depression: The Problem of Economic Recovery*. Westport, Conn.: Greenwood Publishers, 1970.

Woodard, Komozi. *A Nation within a Nation: Amiri Baraka (LeRoi Jones) and Black Power Politics*. Chapel Hill: University of North Carolina Press, 1999.

Woods, Jeff. *Black Struggle, Red Scare: Segregation and Anti-Communism, 1948–1968*. Baton Rouge: Louisiana State University Press, 2004.

Wright, Richard. *Black Power: A Record of Reactions in a Land of Pathos*. New York: Harper Perennial, 1995.

Yates, James. *Mississippi to Madrid: Memoir of a Black American in the Abraham Lincoln Brigade*. Seattle: Open Hand Publishing, 1989.

Young, Cynthia A. *Soul Power: Culture, Radicalism, and the Making of a U.S. Third World Left*. Durham: Duke University Press, 2006.

Zieger, Robert H. *The CIO, 1935–1955*. Chapel Hill: University of North Carolina Press, 1995.

Abyssinian Baptist Church, 75, 85

Advance, 197

African Blood Brotherhood, 33–34, 38–40, 227 n. 34; Grace Campbell's prominence in, 34; masculinist politics of, 37, 51

African National Congress, 178–79

African Patriotic League, 2, 97–98

Afro-American (newspaper), 106, 189

Afro-Asian Conference, 188

Alexander, Kendra, 198

Alpha Kappa Alpha, National Non-Partisan Council, 94

Alston, Christopher, 102

Alves, Carmen Lopez, 98

American Federation of Labor (AFL), 52, 66, 84, 113, 116

American Negro Labor Congress (ANLC), 37–39, 46, 60, 83

American Youth for Democracy (AYD), 138, 141, 151

Amsterdam News (newspaper), 45, 85, 115, 234 n. 71; Louise Thompson Patterson interviewed in, 65, 67–68

Anti-colonialism, 2, 6, 8, 19, 22, 92, 106, 126–27, 151–57, 161–62, 178–79, 192, 195, 202, 207, 214, 217, 220

Anti-fascism, 2, 74, 91–93, 96–110, 124–27, 139–42, 166, 169, 189

Anthony, Susan B., 170

Aptheker, Bettina, 69, 196–98

Aptheker, Faye, 196

Aptheker, Herbert, 150, 196, 198

Arnesen, Eric, 143

Ashford, James, 98

Austin, Fanny, 46–47, 51

Baker, Ella, 21, 36, 51, 85, 112, 116, 143, 170, 182, 192

Bambara, Toni Case, 209

Barrett, James, 24, 194–95

Bass, Charlotta, 174, 179–80, 184

Bassett, Theodore, 84, 119, 122

Beal, Frances, 199, 209–11, 256 n. 18

Bedacht, Max, 109

Berry, Abner, 88, 119, 120

Bethune, Mary McLeod, 65, 94, 132, 139, 147, 157; break from Communists by NCNW and, 163, 174; Esther Cooper Jackson's work with, 143; Louise Thompson Patterson associate of, 76–77, 139

Biondi, Martha, 20, 165, 190

Birmingham, 3, 9, 61, 103; Esther Cooper Jackson moves to, 142; racial and class

Birmingham (*continued*)
politics in, 142–44, 146–47, 184–85, 196; Louise Thompson Patterson arrest in, 77

Black and White (film), 58, 66–67, 72

Black Belt thesis, 29, 37, 43–45, 128, 159, 164, 230 n. 87; black women radicals' rethinking of, 51, 54, 59, 61, 63, 77, 80, 84, 89. *See also* Negro Question

Black church women, 5; activism of, 28; mainstream politics of, 10, 42, 59, 86; middle-class respectability of, 11–12, 27–29, 57, 147

Black feminism and black women's activism, 5–14, 219

Black feminism of the 1970s, 4, 13, 27, 113, 203–4, 208, 256 n. 18. *See also* Black left feminism

Black internationalism, 17–19, 218, 224 nn. 60–61. *See also* "Black women's international"

Black left, 221 n. 6

Black left feminism, 3–6; as a black radical tradition, 14–20, 170, 215–20; historical significance of, 3–23, 215–20; links to civil rights and Black Power of, 12–13, 144, 193–214; as progenitor of black feminism of the 1970s, 13–14, 113, 195–203, 215–20, 225 n. 18; suppression of, 162, 183–92; transnationalism of, 4, 7, 17–19, 22, 26, 45, 53–59, 62–74, 85, 88, 91, 93, 104–10, 126–27, 151–58, 160–62, 165–70, 173–82, 192–94, 205–8, 215–20. *See also* Black feminism of the 1970s; "Black women's international"; Intersectionality; Triple oppression

Black Metropolis (Drake and Clayton), 139

Black nationalism, 78; Communist Party conflict with, 60, 77, 82–83, 121–22, 128, 131, 134–37. *See also* Negro Question; Universal Negro Improvement Association (UNIA)

Black Panther Party, 201, 208, 210

Black Popular Front, 91–92; black women radicals' prominence in, 91–125, 164–82; suppression of, 190–92. *See also* Popular Front

Black Power: gender and sexual politics of, 210–11; Audley "Queen Mother" Moore's influence on, 24, 208–9

"Black radical tradition," 14–15, 223 n. 47

Black Woman, The (Bambara), 209

"Black Woman Speaks of White Womanhood, of White Supremacy, of Peace, A" (Richardson), 11, 22, 171–72, 174. *See also* Richardson, Beulah (Beah Richards); Sojourners for Truth and Justice

Black Women and the Radical Tradition Conference, 215–16

Black women's clubs, 3, 27–28, 80, 93, 125, 165; activism of, 46, 176; mainstream politics of, 57, 59, 68, 86; middle-class respectability of, 51, 59, 69, 147, 162, 181

"Black women's international," 17–19, 27, 53, 60, 92, 104, 107–8, 125, 151, 153, 162, 174, 218. *See also* Black internationalism; Black left feminism

Blues Legacies (Davis), 211

Bond, Jean Carey, 202

Boomla, Kitty, 154–55

"Bourgeois nationalism," 82, 254 n. 127

"Bridge leadership," 10, 222 n. 27

Briggs, Cyril, 33–34, 36–38, 62, 140, 198, 227 n. 34; Grace Campbell's tensions with, 47–48; writings of, 111–12, 114

"Bronx slave market," 79, 112–13, 116

"Bronx Slave Market, The" (Cook and Baker), 112–13, 116

Brooks, Gwendolyn, 139, 202

Browder, Earl, 76, 129, 147; Audley "Queen Mother" Moore and, 134–37

"Browderism," 163–64

Brown, Charlotte Hawkins, 114, 142, 155, 157, 248 n. 122

Brown, E. Ethelred, 41

Brown, Kathleen, 69, 147–48

Burnham, Dorothy, 202, 206, 209; friendships of, 138, 145, 196, 207; marriage and family life of, 123, 147; SNYC leadership of, 142–43, 157

Burnham, Linda, 197, 199, 210, 256 n. 18

Burnham, Louis E., 206; friendships of, 138, 186–87; marriage and family of, 123, 256 n. 18; "progressive black masculinity" of, 145, 148; SNYC leadership of, 102, 123

Burnham, Margaret, 187, 198

Burroughs, Margaret, 202, 244 n. 50

Burroughs, Nannie Helen, 46, 114

Burroughs, Williana, 3, 26, 64, 102, 170, 217, 244 n. 50; activism of, 45, 47, 83–84; early years of, 31; radicalization of, 35; Soviet encounters by, 18, 35, 53, 55–57, 84, 151–52

Butler, Kim D., 13

Buxara, Uzbekistan, 71

California Eagle (newspaper), 174

"Call to Negro Women, A" (Richardson and Thompson Patterson), 173, 175

Campbell, Grace P., 83, 120, 217; ABB and, 33–34, 37–38; black women's concerns about, 30–31, 35, 45, 49–51; Communist Party's tensions with, 37–38, 47–48, 120; early years and family of, 30; enlistment in Communist Party by, 9, 34; friendships of, 32, 36; Harlem Tenants League and, 44–48; Harlem Unitarian Church and, 40–41; middle-class status of, 30–32; "motherist frame" of, 38–39; pioneering role in Communist Party by, 3, 26; radicalization of, 32–33; respectability and, 31, 51; "sexual modernism" of, 42; Socialist Party of America and,

25–26, 33–34; social location in Communist Party of, 37–39, 48, 57; social work of, 9, 30–32, 35, 64; Soviet Union and, 34–35, 53; stepladder speaking of, 40; surveillance of, 25–26; writings of, 49–51

Capital (Marx), 64

Capitalism, 156, 223 n. 47, 227 n. 34; black women radicals' opposition to and theoretics on, 6, 8, 10, 12, 19, 27, 29, 35, 43, 45–46, 48–52, 68, 71, 79, 86–87, 98, 102, 106, 168, 209, 219; Communist Party positions on, 4, 43–44, 111, 129, 163; superexploitation of black working women and, 8, 87, 113–14, 167–68

Carby, Hazel, 173

Carew, Joy Gleason, 18, 62, 67, 225 n. 64

Catchings, Rose Mae, 142

Catlett, Elizabeth, 140

Cayton, Horace, 139

Cesairé, Aimé, 152

Charney, George, 88

Chicago, 3; Louise Thompson Patterson's activism in, 138–40

Chicago Defender (newspaper), 67, 106

Childress, Alice, 174, 198, 200

Civil Rights Congress, 161, 164, 172–73, 176, 182, 186, 199, 208

Civil rights movement, 23, 165, 166; anti-Communism's impact on, 162, 188, 190, 192

Clark, Septima, 143

Claudia Jones Memorial Committee, 212

Claudia Jones Organisation, 215

COINTELPRO, 184

Cold War: gender and sexual politics of, 162, 164, 170, 181, 189; as global phenomenon, 184; impact on black freedom movement of, 21–22, 158, 204; impact on black women radicals of, 8, 13–15, 23, 161–92, 195, 205, 209. *See also* McCarthyism

"Cold War civil rights," 163

Collective identities and community and of black women radicals, 3, 7, 9, 16–17, 27, 46, 57, 59, 89, 93, 98, 134, 141–42, 186–87, 196, 207, 217, 220

Collier-Thomas, Bettye, 6

Collins, Patricia Hill, 11

Combahee River Collective, 13, 174, 179, 209–10

Combahee River Collective Statement, 2, 209–10

Committee of Afro-Asian-Caribbean Organisations, 207

Communist International (Comintern), 17, 23, 28, 36, 62, 91, 95, 225 n. 82; black women radicals' relations with, 55–58, 71, 120; Negro Question resolutions by, 34, 43–44; Woman Question resolutions by, 36–37

"Communist Left," 221 n. 6

Communist Party of Great Britain, 193, 205, 257 n. 34

Communist Party, USA (CPUSA), 1, 2; as alternative to mainstream black politics, 3, 12, 26, 81, 93, 98, 102, 125, 140, 142, 146, 217, 219; anti-fascism of, 98, 127; black women leaders to the left of, 8, 128, 159, 162; black women's grievances with, 21, 51–52, 83, 119–23, 151, 159, 168; black women's national leadership in, 137–41; bohemian- ism of, 42; civil rights groups' break with, 157, 162–63, 174, 190; consumer movements' ambivalence toward, 45–46, 86, 118; formation of, 28–29, 99; demise of, 162–64, 191–92, 194–95; gender and sexual politics of, 42–43, 59, 68–70, 94, 117–24, 147–50, 162, 181, 209–11; ideological shifts of, 62, 121, 129, 163–64; male chauvinism (sex- ism) in, 20–21, 52–53, 55, 57, 92, 98, 118, 128, 134, 136–37, 141, 168, 189, 191, 218, 257 n. 34; National Control Com- mission of, 118; Negro Commission

of, 167; Negro Department of, 45, 47, 230 n. 87; repression of, 22–23, 28–29, 39, 146, 162, 163–64, 182, 184, 190–91, 195, 214, 222 n. 184; secularity of, 175, 181; "ultra-left" position of, 162, 164; white chauvinism (racism) in, 21, 44, 93, 118–24, 152–53, 164, 168, 257 n. 34; women's rights issues and, 37, 69, 111, 113, 118, 209

Communist Political Association (CPA), 129, 134

Communist University of the Toilers of the East (KUTV), 53–54

"Community feminism," 39, 43

Congregational Education Service (CES), 65, 79

Congress of African People, 208

Congress of American Women, 155, 165, 167, 173–74, 182; suppression of, 163, 189

Congress of Industrial Organizations (CIO), 94–95, 163, 244 n. 55; Popular Front agenda of, 130, 146, 152; suppres- sion of, 175

Congress of Racial Equality, 128

Connor, Eugene "Bull," 146–47

Consolidated Tenants League, 2, 85

Consumer movements. See Survival issues

Cooke, Marvel, 112, 116, 170, 198

Cooper, Esther Irving, 100–102

Cooper, George P., 100, 102

Corber, Robert, 170

Council on African Affairs, 128–29, 161, 165, 173, 178–79, 182

Cowl, Margaret, 111

CP-11 trial, 163, 190

Crisis of the Negro Intellectual, The (Cruse), 20

Crisis, The (magazine), 59, 112

Crosswaith, Frank, 33

Crusader (periodical), 42

Cruse, Harold, 20, 225 n. 70, 254 n. 127

"Cultural front," 92, 237 n. 3
Cuthbert, Marion, 65

Daily Worker (newspaper), 2, 45, 47, 49, 76, 104, 171
Dale, Thelma, 156; friendships of, 145; overseas travel of, 151, 153, 155; SNYC leadership of, 102, 142, 144
Daughters of Bilitis, 170
Daughtry, Karen Smith, 209
Davies, Carole Boyce, 6–9, 14–16, 167, 175, 212
Davis, Angela Y., 50, 144, 200, 210; early years of, 196–97; mother's influence on, 211, 215–16; persecution of, 193–95; writings of, 169, 202–3
Davis, Benjamin, Jr., 132–36, 159, 190
Davis, Henrietta Vinton, 39–40
Davis, Ossie, 204
Davis, Sallye Bell, 3, 217; Angela Davis's oppositional consciousness nurtured by, 196; Free Angela Davis Movement and, 198, 200; friendships of, 150, 187; SNYC and, 144–45, 215
"*Décalage*," 73
Dee, Ruby, 204
Denning, Michael, 113, 237 n. 3
Depression, 2, 57, 60
Detroit, 122, 132, 134–35, 147, 164
Dickerson, Angie, 160, 176, 180
Domestic workers, 4, 9, 46, 59, 85, 112–17, 132, 142, 167–68, 172
Domestic Workers Union, 116
Domingo, W. A., 33, 36, 37, 41
"Don't Buy Where You Can't Work" campaigns, 61, 85
Don't You Want to be Free? (play), 110
"Double Victory," 127–29, 131, 142–43
Douglass, Aaron, 64
Douglass, Frederick, 99
Dubois, Ellen, 14
Du Bois, Shirley Graham, 7, 150, 165, 174, 184, 202

Du Bois, W. E. B., 3, 53, 63, 161, 202; Esther Cooper Jackson's friendship with, 100, 102, 150, 154, 156, 204–5, 256 n. 22; Louise Thompson Patterson mentored by, 63, 77, 201
Dudziak, Mary, 163
Du Sable 751 Lodge, 139–40

Edgar, Adrienne, 73
Edwards, Brent Hayes, 17, 73, 224 nn. 60–61
Edwards, Thyra, 3, 17, 59, 114, 217; Communist Left and, 89; Congress of American Women and, 155, 189; early years of, 64; New Woman persona of, 64; Soviet encounters of, 60, 62–63, 66–70, 74; Spanish Civil War encounter of, 104–9; marriage of, 123; radicalization of, 65–66; sexual radicalism of, 64, 68–70, 117; surveillance of, 147, 189
Ellison, Ralph, 135, 136
Emma Lazarus Federation of Jewish Women's Clubs, 178, 180
"End to the Neglect of the Problems of the Negro Woman!, An," 9, 140, 167–70, 203
Executive Order 8802, 128

"Familialism," 162, 165, 170, 182, 189
Families of Smith Act Victims (Families Committee), 186
Fanon, Frantz, 152
Faue, Elizabeth, 69, 147–48
Father Divine, 61, 80–81
Federal Bureau of Investigation (FBI), 23, 26, 147, 149, 158, 183–85, 187–89, 191, 193, 203, 255 n. 1
Feminine Mystique, The (Friedan), 203
Fifth All-Southern Negro Youth Conference, 126, 142–43
Fifth Pan-African Congress, 154, 247 n. 114

Fisk University, 101–2, 142

Flory, Ishmael, 139

Floyd-Thomas, Juan, 41

Ford, James, 66, 119

Foster, William Z., 47, 163; as Claudia Jones's associate, 24, 96, 148, 167; Soviet exile of, 194–95

Franco, Francisco, 95, 104

Friedan, Betty, 103, 130, 203

Freedom (newspaper), 173, 176, 256 n. 22

"Freedom dreams," 15, 224 n. 53

"Free love," 11, 42, 64, 68–69, 94

"Free the Scottsboro Boys March," 59, 75, 80

Freedomways (journal), 124, 201–5. *See also* Jackson, Esther Cooper

Gaines, Kevin, 7, 15, 17, 19, 27, 31, 33, 212, 222 n. 19

Garvey, Amy Ashwood, 39

Garvey, Amy Jacques, 39, 43

Garvey, Marcus, 2, 28, 38–39, 78

Garvey movement. *See* Black nationalism; Garvey, Amy Jacques; Garvey, Marcus; Universal Negro Improvement Association

Garvin, Victoria (Vicki), 7, 254 n. 127

Gates, Henry Louis, 42

Gaulden, Rose, 87–88, 130–31, 134, 136–37

Gerson, Deborah A., 162, 170

Ghana, 154, 202, 207

Giddings, Paula J., 6

Gilmore, Ruthie Wilson, 50

Giovanni, Nikki, 202

Gordon, Eugene, 111, 114

Gore, Dayo F., 7, 10, 12–13

Grayson, Josephine, 174

Great Britain, 8, 95–96, 171, 193, 205, 207, 257 n. 34

Green, Cooper, 146

Griffin, Farah Jasmine, 149–50

Gurley Flynn, Elizabeth, 42

Guy, Rosa, 204

Hall, Chatwood, 67–68, 233 n. 32

Hamer, Fannie Lou, 21, 36

Hansberry, Lorraine, 170, 176, 202

Harlem, 3; Caribbean migrations to, 27; diasporic communities in, 33; impact of anti-Communism on, 190–91; social conditions in, 1–2, 45, 61, 79, 85; stepladder speakers in, 35, 40–41; World War I–era radicalism in, 33

Harlem Action Committee against the High Cost of Living, 2, 85

Harlem Communist Party (Workers Party): activism of, 2, 10, 44, 46, 57, 77, 84–88, 95; black women's leadership in, 2, 46–48, 57, 78, 81–82, 86–87; black working women and, 1–2, 44–47, 81, 84–88; demise of, 191; membership size of, 87–88, 110; Partyline shifts' impact on, 62; racial tensions in, 118–24, 134–36, 141; sexism in, 88–89; whites in, 88

Harlem Hospital, 105

Harlem Liberator (newspaper), 83

Harlem Renaissance, 42, 64, 201

Harlem Riot of 1935, 77, 85

Harlem Riot of 1943, 132

Harlem Suitcase Theater, 110

Harlem Tenants League, 44–48

Harlem Unitarian Church (HUC), 41

Harlem Women Day Workers League, 46

Harlem Writers Guild, 124, 204

Harris, Lashawn, 7, 10

Harrison, Hubert Henry, 33, 36, 41, 227 n. 31

Hawes, Elizabeth, 130

Haywood, Harry, 44, 254 n. 127

Hendrickson, Elizabeth, 40, 44

Hicks, James L., 189

Higginbotham, Evelyn Brooks, 6, 31

Highgate Cemetery, 8, 212–13

Himes, Chester, 135

Holcomb, Gary Edward, 42

Holman, Helen, 35, 39–40, 42

Homosexuality. *See* Sexuality

Hooks, Bell, 11–12

Hoover, J. Edgar, 158, 188

Horne, Gerald, 7, 20, 152, 184, 191

Horowitz, Daniel, 103, 203

Howard University, 30, 102

Hughes, Langston, 64, 66–71, 106, 110, 135, 201

Huiswoud, Hermina Dumont, 26, 32, 36, 41, 44–45, 47–48; Soviet encounters of, 53, 55–56

Huiswoud, Otto, 55

Human rights, 161–80, 189, 192, 202, 207–8, 214, 220

Hunton, Dorothy, 174, 180

Hunton, W. Alphaeus, 161

Hurston, Zora Neale, 64, 201

Hutchins, Grace, 111, 113

Ibárruri, Dolores "La Pasionaria," 55, 100–101, 108, 156

Immigration Naturalization Service, 99

India, 28, 132, 154, 179

Ingram, Rosa Lee, case of: 161, 165–66, 169–70, 173, 175–76, 178, 184, 194, 198–99, 208

Inman, Mary, 111, 113, 118

Internal Security Act of 1950 (McCarran Act), 171

International Brigades, 95, 104, 107, 109

International Congress of Women, 155

International Labor Defense (ILD), 62, 79, 81–82

International Ladies' Auxiliary of the Brotherhood of Sleeping Car Porters, 94, 145–61

International Lenin Institute, 54–55

International People's College, 66

International Workers of the World, 35, 42

International Workers Order, 76–77, 105, 184; Harlem Lodge 691 of, 105, 109; Louise Thompson Patterson's leadership in, 105, 109–10, 139–40, 146

Interracial marriages within Communist Party, 93, 109, 118–25, 168

Intersectionality, 4–5, 24, 217. *See also* Black feminism of the 1970s; Black left feminism; Triple oppression

Interstitial politics, 16

In Woman's Defense (Inman), 111, 118

Issa, Kai Jackson, 134, 149

Italo-Ethiopian War, 95–96, 104, 109; Claudia Jones and, 91, 96–98, 100; Salaria Kee and, 105; Thyra Edwards and, 108

Jackson, Constance, 187

Jackson, Emory O., 142

Jackson, Esther Cooper, 3, 10, 122, 206, 217; adoption of "Cooper Jackson," 188; black women's concern for, 101–3, 115–16, 126–27, 142–43; early years of, 100; enlistment in Communist Party by, 102; Eugene "Bull" Connor and, 146–47; Free Angela Davis Movement and, 198; *Freedomways* and, 201–4, 257 n. 22; friendships of, 138, 145; interracial marriage controversies in Communist Party and, 123; Louis E. Burnham Award and, 205; marriage and family life of, 103, 146–48; middle-class background of, 100, 102; "Negro Youth Fighting for America" speech by, 127, 142; persecution and surveillance of, 23, 146, 158, 184–88, 192; public speaking of, 126–27, 143, 164–65; radicalization of, 92, 96, 100–103, 124; SNYC and, 10, 126–27, 142–45, 156, 157, 159; social location within Communist Left of, 156, 191; Soviet Union and, 115, 156, 248 n. 127; Spanish Civil War and, 100–101, 108, 156; W. E. B. Du Bois and, 102, 154, 156, 158, 202, 204–5; Woman Question and, 143, 145, 154–55, 219; World Youth Congress and, 153–55; writings of, 9, 92, 110, 115–16, 170, 188–89. *See also Free-*

Jackson, Esther Cooper (*continued*)
 domways; Jackson, James E., Jr.; South-
 ern Negro Youth Congress (SNYC)
Jackson, Harriet, 147
Jackson, James E., Jr., 23, 138, 154, 156,
 196, 206; marriage and family life of,
 146–48; persecution of, 185, 188–89;
 "progressive black masculinity" of,
 145; SNYC leadership of, 102–3. *See
 also* Jackson, Esther Cooper
Jackson, Kathryn Alice, 147, 185
James, Joy, 9
James, Winston, 33
Johnson, Charles, 101, 142
Johnson, Howard "Stretch," 98, 119
Jones, Claudia, 3; adoption of "Jones" by,
 99–100; autobiographical letter of, 24,
 96–98, 148–49; black feminism and, 8;
 Communist Party enlistment and, 98,
 103; Communist Party leadership and,
 7–8, 98, 127, 137–40, 167; Communist
 Party tensions with, 141, 168; deporta-
 tion of, 15, 24, 170, 182, 205, 212; divorce
 of, 148–49; early years of, 96–98; era-
 sure and silencing of, 15, 212–14; family
 life, marriage, and personal relation-
 ships of, 96–98, 123, 145, 148–50; grass-
 roots activism of, 138, 165; grave of, 8,
 212–15; health of, 96, 149, 171; Ingram
 case and, 165; legacies of, 14, 212–14;
 London years of, 8, 205, 207; persecu-
 tion and surveillance of, 15, 22, 147, 161,
 167, 170; politics characterized as "radi-
 cal black female subject" by, 8–9, 15, 17;
 radicalization of, 91, 96–100, 124; UK
 postage stamp of, 213–14; writings of,
 9, 22, 113, 141, 167–71, 203
Jones, Dora, 116
Jordan, Fania Davis, 198
Jordan, June, 202

Kaiser, Ernest, 124
Kaiser, Mary, 124

Kanuga, Vidya, 154–55
Katz, Maude White, 26, 32, 83, 114, 165;
 friendships and personal life of, 56,
 123; radicalization of, 36; Soviet en-
 counters by, 53–55; writings of, 51–52,
 202
Kee, Salaria, 104–9
Kelley, Robin D. G., 7, 19, 20, 44, 71, 195
Kenyetta, Jomo, 54
Khrushchev, Nikita, 2, 122, 191
King, Martin Luther, Jr., 204
Kouyaté, Tiemoko Garan, 17
Ku Klux Klan, 142, 184, 196
Kuumba, M. Bahti, 38

Labor Defender (magazine), 51
Ladder (newsletter), 170
La Guardia, Fiorello, 77
Lamb, Belle, 47, 51
Landy, Avram, 118
League Against Imperialism, 17
League of Struggle for Negro Rights
 (LSNR), 2, 60, 80, 83–84, 93
League of Women Voters, 94
Left of Karl Marx (Boyce Davies), 7,
 14–15, 17, 212
Lenin, V. I., 39, 43
Lightfoot, Claude, 139
Lightfoot, Geraldyne, 139
Ligue de Défense de la Race Nègre, 17
Little, Jo Ann, 199–200
"Long civil rights movement" paradigm,
 21–22
Lorde, Audre, 202
"Lovestonites," 47
Lynching, 27–28, 44, 132; black women
 radicals' protest against, 6, 162, 169,
 172, 208

Madrid, 95, 106–8
"Magic pilgrimage" to the Soviet Union,
 53, 58, 231 n. 117
Makalani, Minkah, 33–34, 37

Makonnen, T. Ras, 17

Malcolm X, 99, 208

Mallard, Amy, 174

Mallory, Mae, 254 n. 127

Manchanda, Abhimanyu, 212

March on Washington Movement, 128, 146

Marshall, Paule, 202

"Martinsville Seven" case, 172, 174

Marx, Karl, 8, 64, 89, 212–13

Marxism-Leninism, 4, 26, 29, 50–51, 83, 125, 141, 153, 195; Claudia Jones's rethinking of, 167, 212–13

Mason, Vivian Carter, 155, 248 n. 122

Matusevich, Maxim, 18

Maxwell, William, 118

May, Claudia Rosemary, 99

May, Elaine Tyler, 162

McAdory, Mildred, 143–46

McCarthy, Joseph, 184

McCarthyism, 8, 19, 22–23, 162–64, 182–92, 195, 212, 222 n. 23. *See* Cold War

McGee, Rosalie, 172–74

McGee, Willie, 164, 171–72, 187

McKay, Claude, 42, 53, 120, 228 n. 46, 229 n. 46, 231 n. 117

Meriwether, Louise, 204

Messenger (newspaper), 25, 28

Minh, Ho Chi, 54

Millard, Betty, 167–68

Miller, James A., 76

Million Man March, 210

Mitchell, Charlene, 3, 140–41, 197–99, 207, 215–17

Mkize, Bertha, 179

Mohanty, Chandra Talpade, 72, 179, 234 n. 60

Montgomery bus boycott, 187–88

Moore, Audley "Queen Mother," 3; adoption of "Queen Mother" by, 207; Ben Davis and, 133–36, 190; black nationalism of, 21, 24, 58, 75, 77, 80, 82, 88, 121, 134–35, 137, 141, 152–53, 210–11; Black Power and, 21, 208; black working women's concern for, 60, 75, 77, 85–87, 120–22, 131–32, 136, 208; break from Communist Party and, 21, 82, 134–37, 189–90, 207; Communist Party enlistment of, 75, 77, 81–82; Communist Party grass-roots activism of, 75, 77, 81–83, 85–86, 88–89; Communist Party leadership of, 86, 134; early years of, 78; friendships of, 81, 134; Garveyism of, 10, 78–79, 82, 122, 130, 137, 141, 207, 235 n. 89; gender and sexual politics of, 78–79, 120–22, 210–11; ideological conversion of, 134, 190; marriage and family of, 79, 148, 149–51; oral testimonies of, 24, 151; overseas travel of, 152, 206; radicalization of, 77–79; reparations and, 21, 207–8; Scottsboro and, 79–81, 83, 88; self-narrative of, 24, 136, 189–90; tensions with Communist Party and, 120–22, 133–36, 152–53

Moore, Harriet, 176, 194

Moore, Harry, 176

Moore, Richard B., 33–34, 36, 37, 41, 44, 48, 62

Morrison, Toni, 202

"Motherist frame," 38

Moynihan Report, 13

Mutua, Athena, 6

Mydral, Gunnar, 102

Nadasen, Premilla, 13

"Nadir" in African American life, 27

Naison, Mark, 7, 20

National Association for the Advancement of Colored People (NAACP), 59, 61, 69, 80, 94, 100, 114, 132, 142, 146, 162, 176; anti-Communism of, 156–57, 163, 174, 177, 182

National Association of Colored Women (NACW), 28, 165

National Committee to Defend Negro Leadership, 186

National Committee to Defend Political Prisoners, 75

National Committee to Free the Ingram Family. *See* Ingram, Rosa Lee

National Council of Negro Women (NCNW), 94; anti-Communism of, 163, 174, 177, 190; Audley Moore's affiliation with, 132; World War II–era militancy of, 128–29, 155

National Labor Relations Act (Wagner Act), 94, 116

National Maritime Union (NMU), 152, 190–91

National Negro Congress (NNC), 93–94, 102, 128, 139, 155, 237 n. 5; black women's prominence in, 144–45; as site for black left feminist praxis, 114–15

National Negro Labor Council, 173

National Organization of Women (NOW), 199, 210

National Training School for Women and Girls, 46

National United Committee to Free Angela Davis (NUCFAD), 193, 198–99

National Woman's Party (NWP), 5, 94

National Women's Commission (NWC), 37, 47, 94, 111–12, 167

Nation of Islam, 210

Nazi-Soviet Non-Aggression Pact, 128

Needle Trades Workers Industrial Union (NTWIU), 52, 54–55

Negro Champion (newspaper), 46, 51

"Negro liberation," 82, 176, 182

"Negro People's Front," 93, 139

Negro Question, 5, 217; ABB position on, 34; black Communist women rethinking of, 52, 56, 217–18; Claudia Jones as leading theoretician of, 7, 167, 217; Cold War era and, 164; Comintern 1922 resolution on, 29, 36–37, 228

n. 46, 229 n. 76; Comintern 1928 resolution on, 43–44, 56, 93; Popular Front and, 93, 117, 121–22; Socialist Party position on, 33, 35, 227 n. 31. *See also* Black Belt thesis; Black nationalism

Negro Women, Inc., 131

"Negro Women in Our Party" (Thompson), 119, 141

Negro World (newspaper), 43

Nesbitt, Francis Njubi, 178

New Deal, 93–95, 99, 116, 146; Cold War's impact on, 163

New Masses (magazine), 1

New Negro Movement, 27–28, 30, 33, 61

New Negro radicalism, 28, 33

New Orleans, 78, 208

"New Soviet woman," 29, 42

New Woman, 27; black women radicals' sensibility of, 42, 53, 60, 64, 76, 89, 219

New York Age (newspaper), 49

Nixon, E. D., 188

Nkrumah, Kwame, 154, 202

Northrop, Douglas, 73

Oakland, 63–64, 123

Obama, Barack, 215

Oberlin College, 100–101, 115

"Oppositional consciousness": black women's adoption of, 16, 19, 27, 32, 49, 162, 174, 196

O'Reilly, John "Pat" Joseph, 109

Orleck, Annelise, 86

Other, 11

"Our Women and What They Think" (Garvey), 39, 43

"Outsiders within," 21, 26, 38, 48, 57, 89, 93, 118, 131, 159, 174, 183, 218

Owen, Chandler, 25–26, 227 n. 31

Padmore, George, 17

Painter, Nell Irvin, 20

Park, Robert, 103

Patterson, Louise Thompson, 2; bohe-

mianism of, 9, 64; Communist Party enlistment of, 75–76; Communist Party's tensions with, 119–20, 122, 141, 174, 183; Communist Party's visibility and, 59, 75–77, 105, 138; cultural work of, 76, 110, 139–40; early years of, 63; final years of, 201; Free Angela Davis Movement and, 193–94, 198–200; gender and sexual politics of, 60, 64, 68–70, 76, 199, 219; Harlem Renaissance and, 9, 64, 66, 75, 201; IWO and, 76–77, 105, 109–10, 139–40, 146, 184, 244 n. 49; Langston Hughes and, 64, 66–71, 106, 110, 135, 201; marriages and family life of, 64, 73, 122–23, 147–48, 150, 183; memoirs of, 23, 106, 201; middle-class status of, 64, 75–77, 88; Orientalism of, 72–74; persecution of, 184, 192; radicalization of, 57–58, 64–68; Scottsboro and, 59–60, 62, 66, 74–77; Sojourners for Truth and Justice and, 160, 165, 171, 173–74, 177, 179, 183–84; Soviet encounters of, 58–59, 62–76, 83, 106; Spanish Civil War encounters of, 104–10, 194; writings of, 9, 112–14, 116, 119, 141, 170. *See also* Patterson, William L.; Sojourners for Truth and Justice

Patterson, MaryLouise, 146, 150, 197

Patterson, Tiffany, 19

Patterson, William L., 64, 66, 107, 139, 149, 171, 176, 183, 187, 198, 201; Louise Thompson Patterson's marriage to, 62, 123, 148–49. *See also* Patterson, Louise Thompson

Paul Lawrence Dunbar High School, 100

Pearl, Jeanette, 49

Pennybacker, Susan D., 76

People's Committee, 131

Pinkard, Fred, 124

Pinkard, Janet "Ginger," 98–99, 124

Political Affairs (journal), 166

Popular Front, 49; continuities of, after 1950s, 195, 198, 201; de-emphasis of Black Belt thesis in, 93–94, 121, 128; gender and sexual politics of, 92–93, 111; launching of, 91, 93. *See also* Black Popular Front

Popular Front feminism, 92–93, 127, 130

Position of Negro Women, The (Gordon and Briggs), 111

Powell, Adam Clayton, Jr., 75, 131–33; break with Communist Party of, 157, 190

Practice of Diaspora, The (Edwards), 17

"Prefers Russia Now to Living in America" (Thompson), 67–69

"Prison industrial complex," 50

"Progressive black masculinity," 6, 145, 159, 168

Progressive Labor Movement, 208

Progressive Party, 163, 173–74

Provisional Committee for the Defense of Ethiopia, 95

Racial uplift ideology, 27–28, 39, 102

Rainey, Gertrude "Ma," 42–43

Rampersad, Arnold, 69

Randolph, A. Phillip, 25–26, 33, 128, 146, 227 n. 31

Ransby, Barbara, 21

Rape, 11–12, 78–79, 89, 108, 117, 168–69, 172–73, 175, 199, 201, 208

"Reflections on the Black Woman's Role in the Community of Slaves" (Davis), 169

Representation, 11–12, 113–14, 120, 136, 150, 172, 194, 202

Respectability, 6; black Communist women's practice of, 10–11, 46, 51, 57, 60, 69, 76, 89, 108, 117, 128–29, 146, 181, 219; bourgeois practices of, 27–31, 43

"Revolt of the Housewives" (Barton), 1

Revolutionary Action Movement (RAM), 208

Richardson, Beulah (Beah Richards), 3, 11, 22, 160, 171–75, 178, 198, 202, 217; Claudia Jones's confrontation with, 183. *See also* "Black Woman Speaks of White Womanhood, of White Supremacy, of Peace, A" (Richardson); Sojourners for Truth and Justice

Robeson, Eslanda, 165, 174, 184, 202, 207

Robeson, Paul, 53, 63, 133, 150, 156, 171, 173, 201, 205; black women radicals' support for, 161, 164–65, 180, 202, 204

Robinson, Halois, 176, 207

Rolinson, Mary, 78, 122

Robnett, Belinda, 222 n. 27

Roosevelt, Franklin D., 93, 128–29

Rosenberg, Ethel, 187

Rosenberg, Julius, 187

Rosenhaft, Eve, 76

Roth, Benita, 13

Ruffin, Josephine St. Pierre, 27

Rustin, Bayard, 135

Samuels, Helen, 130, 134, 136–37

Saunders, Patricia J., 6, 15, 17, 212

Scholnick, Abraham, 122, 148–49

Scott, Jessie Campbell, 98, 145

Scottsboro case, 57, 61–62, 89, 91, 102, 139, 142, 234 n. 71; grass-roots Harlem Communist women's activism and, 59–60, 77–81, 83, 88; legacies of, 198–99, 208; Louise Thompson Patterson's visibility in, 59–60, 66, 74–76

Sexuality, 6, 14; black women radicals' discussions and practices of, 7, 11–12, 31, 42, 64, 68–70, 74, 76, 170, 179–81, 189, 210, 219; Cold War and, 162, 170–71; Communist Party and Soviet positions on, 29, 70, 117–19; modern black feminism's positions on, 209–12

"Sexual modernism," 42

Shakur, Assata, 99

Shapiro, Linn, 114, 183

Simkins, Modjeska, 143

Singh, Nikhil Pal, 135, 152

Sisters against South African Apartheid (SASAA), 209

Sixteenth Street Baptist Church, 142

Sixth Congress of the Communist International, 43, 47, 54–56

Slavery, 11, 110, 168–69, 172, 188

Small Axe (journal), 14

Smith, Barbara, 202, 209–10

Smith, Bessie, 42–43

Smith, Ferdinand, 190–91

Smith Act, 23, 161, 163–64, 171, 185–90

Social Security Act, 94; domestic workers excluded from, 126–27, 132

Sojourners for Truth and Justice, 207; antiapartheid protest of, 178–79; anticipation of black feminist of the 1970s and, 174, 179, 209; Communist Party's tensions with, 161, 182; gender and sexual politics of, 181–82, 253 n. 90; Harriet Moore case and, 176; historical significance of, 19, 173–75, 220; human rights and, 160–61, 173, 176–79; Ingram case and, 175, 178; launching of, 171, 173, 175–76; leadership of, 174; legacies of, 208; suppression of, 182–84, 192; triple oppression logic of, 177. *See also* "Black Woman Speaks of White Womanhood, of White Supremacy, of Peace, A" (Richardson); "Call to Negro Women, A" (Richardson and Thompson Patterson); Patterson, Louise Thompson; Richardson, Beulah

Solomon, Mark, 20, 34

South Africa: Defiance Campaign in, 178, 184, 252 n. 81; Sojourners' antiapartheid protest of, 178–79

South African Indian Congress, 178

Southern Negro Youth Congress (SNYC): civil rights activism of, 141–42; Esther Cooper Jackson's leadership of, 10,

126–27, 153, 188; formation of, 102; militant forerunner of Student Non-violent Coordinating Committee as, 10, 141; progressive gender politics of, 145–46; suppression of, 159, 184–85; women's prominence in, 142–45, 196, 215–16, 219. *See also* Jackson, Esther Cooper

Soviet promise, 18, 53, 57, 59–74, 89–90, 156, 218

Soviet Union: Central Asia and, 71–74; utopianism of, 34–35, 57, 70, 80; women's rights and status in, 19, 29, 42–43, 54, 67–68, 70

Spanish Civil War, 3, 95–96; black women radicals' interest in, 92, 95, 100–101, 104–10, 125, 194

Springer, Kimberly, 13, 16

Stalin, Joseph, 2, 70–71, 129

Stansell, Christine, 42

Stanton, Elizabeth Cady, 170

Strong, Augusta, 138, 142, 145, 147, 186, 187, 196, 202, 242 n. 114

Strong, Edward E.: friendships of, 138, 150, 186–87; marriage of, 123, 242 n. 11; persecution of, 187; SNYC leadership of, 102–3, 144–45, 196

Student Nonviolent Coordinating Committee (SNCC), 10, 141, 197

Superexploitation of black women, 8; Claudia Jones's writings on, 167–68; early black Communist women's theoretics on, 27, 48, Louise Thompson Patterson's writings on, 114

Survival issues, 4, 6, 8, 12, 26, 45, 59–61, 79, 84–88, 90, 114, 131, 134

Swerdlow, Amy, 165, 174

Taft-Hartley Act, 163

Taylor, Ula Y., 6, 39

Tehran Conference, 129

Terrell, Mary Church, 53, 114, 165, 176

Theoharis, Jeanne, 10, 12

Theses of the Communist Women's Movement (Comintern), 36–37

"Third period," 43–44, 91

Third World and Global South, 28, 129, 154, 159, 181, 184, 195, 198, 207, 213; black women radicals' support for women in, 28, 72–74, 151, 154–55, 161, 167, 177–82, 218; as term of designation, 19

Third World Women's Alliance (TWWA), 13, 174, 179, 184, 199, 209–10

This Is My Husband: Fighter for His People, Political Refugee (Jackson), 188–89

Thurman, Sue Elvie Bailey, 65

Thurman, Wallace, 64

Toles, Lulu Brown, 63, 66, 69, 71

"Toward a Brighter Dawn" (Thompson), 9, 112–16, 170

"Tragedy of the Colored Girl in Court" (Campbell), 49–50

Transnational citizenship, 16, 19, 56, 104, 153–54, 218

Trenton Six, 164, 174

Triple exploitation. *See* Triple oppression

Triple Jeopardy (newspaper), 209

Triple oppression, 4, 116, 131, 192, 195, 217–18; black feminism of the 1970s and, 4, 13, 203, 209; early articulations of, 26, 48–52; logic in the writings of Claudia Jones and, 7–9, 22, 167–69, 203; logic in the writings of Esther Cooper Jackson and, 115–16; logic in the writings of Louise Thompson Patterson and, 9, 92, 112–15; Sojourners for Truth and Justice and, 161, 177. *See also* Black feminism of the 1970s; Black left feminism; Intersectionality

Truman, Harry, S., 163, 166, 176, 179

Truth, Sojourner, 20, 99, 170, 175, 181, 220

Tubman, Harriet, 20, 147, 170, 175, 181, 220

Tuskegee Institute, 126, 142–43

Unemployed Councils, 45, 54

United Electrical Radio and Machine Workers, 130, 203

United Front as Communist Party strategy, 62, 75–76

United Nations, 129, 157, 163–64, 200; black women radicals' petitions to, 166, 176, 178–79, 208

United Workers Cooperative Colony ("The Coops"), 150–51

Universal Association of Ethiopian Women (UAEW), 208

Universal Negro Improvement Association (UNIA), 2, 5–6, 27–28, 69, 78, 79, 82, 98, 129–30, 137; gender and sexual politics of, 38–43, 69, 122. *See also* Black nationalism; Garvey, Amy Jacques; Garvey, Marcus

Urban League, 30, 61, 64, 142, 186

Valentine, Florence, 157–58

"Vanguard center," 13, 27, 60, 92, 161, 173

Veiling, 73–74, 234 n. 60

Von Eschen, Penny, 91–92, 128

Wallace, Henry, 163

Walker, Alice, 202

Walsh, Ed, 47

Want to Start a Revolution? (Gore, Theoharis, and Woodard), 10, 12–13

Ward, Stephen, 13

Warner, Frank, 79, 148–49

Warner, Thomas O., 80, 150

Washington, Mary Helen, 3, 7

Watkins-Owens, Irma, 40

Wave metaphor, 13–14, 203

We Charge Genocide (petition), 176

Weigand, Kate, 155

Weiner, William, 109

Wells-Barnett, Ida B., 53, 169, 173

West Indian-American (newspaper), 97

West Indian Gazette and Afro-Asian Caribbean News (newspaper), 207

White, Deborah Gray, 6

White, E. Frances, 210

White, Walter, 76, 156; as associate of Louise Thompson Patterson, 65

Whiteness, 52

White women, racism and class privilege of, 4, 8, 31, 50, 113, 120–22, 167–69, 172–73, 198–99, 210

Why Reparations? (pamplet), 208

Why Women Cry, or Wenches with Wrenches (Hawes), 130

Wilkerson, Margaret, 23, 201

Williams, Bonita: black nationalism of, 77, 80, 82, 84, 130; friendships of, 81, 134; grass-roots community organizing of, 2, 60, 77, 84–85, 89, 131; recruitment to Communist Party and, 61–62, 72, 75, 77–82; Scottsboro and, 80; working-class status of, 77, 83

Williams, Frances, 174

Williams, Robert F., 208

Wolcott, Victoria W., 11, 122

"Woman against Myth" (Millard), 167

Woman Question, 5, 20, 29; black women radicals' rethinking of, 52, 145, 168–69, 217–18; Claudia Jones as leading theoretician of, 7, 167, 213; Cold War period and, 164; Communist International resolutions of 1922 on, 36–37, 44, 217; Popular Front and, 94, 118

Woman's Era (newspaper), 27

Woman's Suffrage Party, 35, 42

Woman Today (periodical), 112

"Women of color" as social category, 74

Women, Race, and Class (Davis), 203

Women's Committee for Equal Justice (WCEJ), 166

Women's International Democratic Federation (WIDF), 155

Women Strike for Peace, 165, 199

Women Who Work (Hutchin), 111

Woodard, Komozi, 10, 12

Workers Children Camp (Wo-Chi-Ca), 150

"Working woman," 4, 113, 217

Works Progress Administration (WPA), 85

World Congress against Racism and Anti-Semitism, 107

World Federation of Democratic Youth (WFDY), 153

World Federation of Trade Unions, 247 n. 114

World War I, 26

World Youth Congress, 153–56

Wright, Ada, 74–76

Wright, Andy, 75

Wright, Roy, 75

Wright, Sarah, 202

Xiaoping, Deng, 54

Yates v. United States, 188

Young Communist League (YCL), 98, 138, 145

Zhenotdel, 29, 70

Erik S. McDuffie is an assistant professor in the Department of African American Studies and the Department of Gender and Women's Studies at the University of Illinois, Urbana-Champaign.

Library of Congress Cataloging-in-Publication Data
McDuffie, Erik S., 1970–
Sojourning for freedom : black women, American communism, and the
making of black left feminism / Erik S. McDuffie.
p. cm.
Includes bibliographical references and index.
ISBN 978-0-8223-5033-0 (cloth : alk. paper)
ISBN 978-0-8223-5050-7 (pbk. : alk. paper)
1. African American women—Political activity—History—20th century.
2. African American communists. 3. African American feminists. I. Title.
E185.86.M3125 2011
305.48'896073—dc22 2010054508